Old Worcester:

People and Places

Old Worcester:
People and Places

by

Bill Gwilliam

hb Halfshire Books

Halfshire Books
6 High Street, Bromsgrove
Worcestershire B61 8HQ

First published in Great Britain
by Halfshire Books 1993

ISBN 0 9513525 9 8 Hardback
ISBN 0 9513525 8 X Paperback

Typeset in 10pt Century School Book by
Avon Dataset Ltd, Bidford-on-Avon,
and printed in Great Britain by Cromwell Press Ltd,
Broughton Gifford, Melksham

Contents

Introduction vi

District One: The Cathedral and Sidbury 1

District Two: West of the High Street 23

District Three: West of the Foregate 63

District Four: East of the High Street 89

District Five: The Tything and Beyond 127

District Six: East of the Canal 147

District Seven: Diglis and Battenhall 165

District Eight: West of the River 181

References 199

Index 204

Links with the past

Historic memory can span the centuries with just a few lives. The author remembers J W Willis-Bund who, when a boy, was told by an old lady that her nurse's father, as a young man, was on duty at Worcester bridge during the battle of Worcester in 1651 — near three and a half centuries bridged by five lives.

Acknowledgements

Several people have helped in the preparation of this book. In particular, thanks are due to Tim Bridges, Eric Dickinson, Mike Grundy, Catherine Holland, Pat Hughes, Annette Leech, Colin Roberts and the staffs of the County Record Office and County Libraries.

Illustrations

The author and publishers wish to thank the following for their kind permission to reproduce illustrations:
 Berrow's Newspaper Group Ltd (pp 12, 40, 71, 72, 82, 96, 176, 197)
 The Dyson Perrins Museum Trust (Pieces from the Nelson Breakfast Service)
 Phil Hancock (p 6)
 The late Miss A Taylor (p 19)
 The Trustees of the Madresfield Estate (p 134)
Photographs on pp 51, 57, 128, 140 and all other colour photographs by Max Harper.
Photographs on pp 3, 7, 10, 17, 29, 34, 43, 60, 75, 80, 87, 90, 110, 116, 121, 124, 131, 149, 153, 158, 160, 170, 178, 187 and 191 from the author's own collection.

Introduction

This book has three aims: firstly, to record information about Worcester, parts of which have changed greatly in the last fifty years; secondly, to bring life to those places through the stories of people who lived and worked in Worcester; and, thirdly, to make known facts about the city which are not easily available elsewhere.

Old Worcester: People and Places, therefore, is not a guidebook in the usual sense. The architectural details of the principal buildings have been omitted, for these have been described in books like Pevsner's *The Buildings of England: Worcestershire*; nor is it a civic history, for the main historical events are well documented elsewhere. What are included are the little known incidents surrounding the principal events, such as the attack of the 'camisade' before the battle of Worcester and the escape of Charles at Sidbury Gate.

Much of the information has come from two sources: contemporary newspapers and personal recollections. As far as newspapers are concerned we are indeed fortunate, for Worcester has a unique collection, unmatched in the 18th and 19th centuries by any other provincial city's. Often they are the only sources of information on personalities and on local events, thought in their day to be of little importance. The writers of articles and letters usually had a particular knowledge of a subject, especially in the days before the popular press when the reader would often be a person of considerable literary accomplishments. Here I must acknowledge my debt to the anonymous *Crowquill* of *Berrow's Worcester Journal*, and to Edward Corbett of the *Worcester Herald* — a solicitor turned correspondent — whose knowledge of people in the city between 1865 and 1925 was remarkable. Of the personal recollections, I have recorded facts and stories from old people who knew Worcester in their youth but were unable to write about such things themselves. This oral history was often an urgent task, for once they had gone no amount of documentary research or archaeological digging could have recovered the scenes and events which they knew and witnessed. For them it was a joy to recall those other days, and I am grateful that they should have shared them with me.

Old Worcester: People and Places was privately published for educational purposes in two volumes in 1977. That material has been revised and updated for this new illustrated edition.

Bill Gwilliam

Map 1

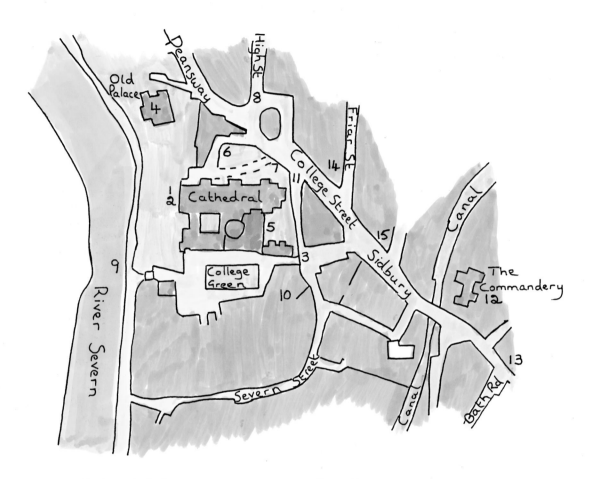

Old Palace

4

Peansway

High St

8

6

7

11

College Street

Friar St

14

1

2

Cathedral

5

3

15

Sidbury

College Green

10

9

River Severn

The Commandery

12

13

Severn Street

Canal

Canal

Bath Rd

1 Early cathedrals
2 The sanctuary
3 Edgar Tower
4 The Old Palace
5 Guesten Hall
6 Charnel house
7 Old and new St Michael's
8 The Lich Gate

9 Water Gate Ferry
10 The Old Prison
11 St Peter's church
12 The Commandery
13 Loch Ryan Hotel
14 Ye Olde Talbot
15 Mrs Henry Wood's birthplace

District One

The Cathedral and Sidbury

Before Worcester

The beginnings of Worcester date from the Bronze Age when, some two thousand years before the birth of Christ, the first settlers arrived; but these were not on the banks of the Severn but on the high terrace east of the city between Elbury Mount and Crookbarrow Hill. Aerial photographs of the high ridge still show circles and squares where once stood early settlements — from Elbury Mount in the north, which retained its defensive terraces until the 1850s, to Crookbarrow in the south, with its steep sides making a defensive mound or lookout, man-made on a natural hill. Cuggan, or Round Hill, at Spetchley commanded the east, and the entrenchments on the precipitous western side of Red Hill (later used by Cromwell) were to guard the most vulnerable point of the fortress. That the Romans used Crookbarrow, probably as a fort and lookout station, is shown by the discovery of Roman coins there in the 18th century.

There is some evidence that in the 1st century AD the Romans occupied an earlier Iron Age fort and made a permanent settlement south of the cathedral, for many Roman coins and artefacts were found in the Old Palace grounds and at Castle Hill when the Norman motte was removed in 1833. In the late 2nd or early 3rd century the defences of the settlement seemed to have been greatly strengthened. Below High Street, 7 feet down, and in other places are Roman roads pointing to a considerable town which might once have contained some fine buildings; and later in the 3rd century outside the walls, on the north side, there developed an extensive iron-producing suburb, for in an area from Broad Street to the railway viaduct and from the river to the Cross was a vast amount of iron slag and cinders. A street 32 feet wide, surfaced with iron slag, connected the workings to the town; and timber remains of a bridge, which crossed the river near the present railway bridge, were identified as Roman.

The beginnings of Worcester

The site of the present city was tidal and swampy, but the ford by the high ground, where the cathedral now stands, was of great importance, for here was the first sure crossing of the tidal river for many a mile. Some time before AD 655, a small mission church was built within the former Roman enclosure and houses and merchants clustered around. Later, alongside it, was built the first cathedral and in 680 Bosel, a monk from St Hilda's Abbey in Whitby, was sent to become the first Bishop of Worcester.

For the next three-and-a-half centuries Worcester was harried by invaders, mostly by the Danes coming up Severn. In Alfred's time the first walls to defend the lower settlement were built; in Norman times Bishop Wulstan built his great cathedral where Oswald's church had stood, and alongside it the Norman sheriff raised the castle mound to guard the ford. So began the city of Worcester, by medieval times the fifth most important city in the land; but on the high ground to the east there still stood the old quadrilateral fortress, two-and-a-half miles from Crookbarrow to Elbury, and three miles from the round hill at Spetchley to the cathedral tump at the river ford.

The early cathedrals of Oswald and Wulstan

Oswald became Bishop of Worcester in 961 at the time of the Danish raids, and when Christian life was well nigh impossible. He saw the solution in the revival of monastic life, the monasteries being a refuge where men could flee from the lawless and sensual world, and from where Christians by religious discipline could influence the world around. The bishop's seat was in an ancient church dedicated to St Peter, but in 983 he built a large, handsome basilica in the monastery he had founded. (St Peter's church remained until the mid-11th century.)

The years that followed were often marked with great violence. In 1041, after the citizens had seized the Danish king's tax collectors who had taken refuge in the tower of the cathedral and put them to death, the king's vengeance fell on the city and it was sacked. The monks fled and took refuge on the island of Bevere; and the cathedral and monastery were set on fire and everything of value was looted. Only after the king's men had departed did the monks return to the ruins. In 1062 Wulstan became Bishop of Worcester and began the great task of rebuilding the cathedral. What remained of Oswald's church was pulled down and the splendid crypt, still intact, was begun in 1084, presumably to house the relics of St Oswald. Wulstan's cathedral was larger than Oswald's and built in the massive Norman style. Even so, it was smaller than the present one, extending from about the bishop's throne westward; and very little remains of it today.

Wulstan's cathedral was one of many being built after the Norman Conquest, and there must have been some difficulty in obtaining a sufficient supply of good workmen, even allowing for the employment of skilled artisans from the Continent. By 1089 the east end was completed — rapid progress — and the monks were able to move in. In the same year the old monastic church of St Mary's was destroyed. Those who would like to gain some idea of what the Norman cathedral of Worcester looked like can do no better than go to Gloucester or Tewkesbury and look at the great Norman naves there.

The sanctuary at Worcester

The privileges of sanctuary were granted to the cathedral in 712. The area of the sanctuary was contained within a circuit around the cathedral, coming up from the river at the Water Gate, between College Green and the site of the old castle (now the King's School), including the north side of Edgar Street (which was called Knoll's End), across Sidbury to Lich Street, running up the south side of that street, and so down between the Bishop's Palace and the cathedral to the river.

This area was entirely free from municipal authority, the bishops alone having all jurisdiction over it, and the privilege of sanctuary was jealously guarded. In 1302 a man fled to Worcester Cathedral, but was followed by many avengers who succeeded in enticing him out and then, notwithstanding the threats of the sacrists and three monks, they beat him nearly to death and afterwards forced him to leave the kingdom. For this offence, however, they were compelled to do a most ignominious penance at the gate of the cathedral.

The privilege of sanctuary offered by the cathedral precincts was abolished in the reign of James I. Nevertheless, in 1671, in reply to certain enquiries made by the Government, the cathedral chapter asserted: 'The City has no jurisdiction within the Cathedral or precincts thereof.' The area of sanctuary had become the parish of St Michael in Bedwardine and was part of the County of Worcestershire. For this reason county justice was administered at one of the inns inside the parish boundary until the municipal changes of 1835, when the parish of St Michael became part of the City of Worcester.

The cathedral and the city

From time immemorial the prior and monks of Worcester (the forerunners of the dean and chapter) were exempt from municipal authority, a position confirmed by Henry IV, who in the year 1400 ordained that:

> No bailiffs, serjeants, ministers or other persons of the City of Worcester, shall hereafter carry or bear any mace or maces, but only in the presence of

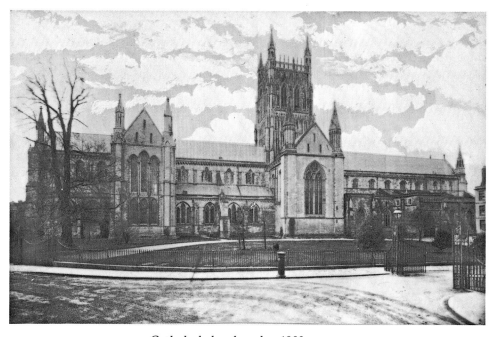

Cathedral churchyard, c.1900

the King or his children, within the Church, Priory and Sanctuary of Worcester; nor intermeddle with the aforesaid liberties.

The mayor and corporation unconsciously infringe this charter whenever they make an official visit to the cathedral with their stately procession of mace bearers. Even the special facilities afforded by custom to members of the corporation to attend the cathedral services were alleged to be a matter of grace. The mayor and aldermen sit in their stalls not by right but only by the 'appointment of ye Dean and Chapter, out of the civil and Christian respects to invite them to the solemn worship of God in the Cathedral'.

The shrines of Oswald and Wulstan

The shrines of Oswald and Wulstan were the most popular of the Midland shrines in the 13th and 14th centuries, the great rebuilding of the choir and Lady Chapel in the 13th century made possible by the fame of the saints of Worcester.

It was Wulstan himself who made the shrine for St Oswald, and it is believed that the wonderful crypt in the cathedral was built for the express purpose of receiving the bones of the saint, being designed so that the crowds of pilgrims could descend one staircase, pass between the rows of columns to the shrine, offer prayers, and pass out by the steps at the other side. The splendid shrine of Wulstan, which seems to have been housed in the choir, was plundered in 1215 when its gold embossments were melted down to pay a fine of 300 marks following the sacking of the city for prematurely siding against King John. It was probably when the shrine was restored in 1218 that Oswald's body was removed from the crypt to a position opposite Wulstan's, a much more convenient arrangement for catering for the enormous increase in pilgrims.

The greatest in the land, including kings, worshipped at the shrines and left their offerings. In 1218 the young King Henry III attended the restoration in state, together with no fewer than ten bishops, ten abbots and priors — all in gorgeous pontificals — and a great many nobles. When Edward I undertook his expedition to France in 1293 he sent a gold ornament and two cloths of gold for the great altar, and three masses weekly were said at Wulstan's shrine for a successful campaign. On his return he brought more gold and gifts, and on his bended knees before St Wulstan's tomb he said to the assembled company: 'What reward shall I give to the blessed Wulstan for all that he hath wrought for me by his holy prayers? This small thing I vow before God and His saints: the sustentation of three monks and two wax lights to burn before the saint shall be provided at my expense.'

In times of trouble the body of the saint was carried in procession, as in 1437 when crops were badly damaged by storms and long continued rain. But in the early 14th century the fame of Wulstan suffered a temporary eclipse, for the monks of Gloucester, now possessing the body of Edward II who had been dreadfully murdered, so advertised the 'miracles' occurring at the ill-used king's tomb that for something like thirty years the pilgrims largely deserted Wulstan and worshipped at the tomb of Edward instead.

In 1538, following Henry VIII's quarrel with the pope, the shrines of Oswald and Wulstan were dismantled and the bones buried on the north side of the altar. The Bishop of Worcester, Bishop Latimer, also removed the image of the Virgin Mary from the Lady Chapel, expressing a wish that 'it may burn in

Smithfield with her old sister of Walsingham, her young sister of Ipswich, with their two other sisters of Doncaster and Penrice'. So ended on this cynical note the cult of 'Our Lady' which had been introduced into our cathedral in about 1200, and the pilgrimage to the shrines of the Worcester saints which had begun very much earlier.

The dissolution of the priory

Two years later, on 16 January 1540, the priory of Worcester also came to an end: after 580 years of occupation by the priors and monks the monastic buildings and estates were surrendered into the hands of the king.

The dissolution of the religious houses began in 1535 when Henry, having broken with the pope, ordered a general visitation of the monasteries. At first only the lesser houses were suppressed, but four years later Thomas Cromwell called for the surrender of all the monasteries. There had been many abuses and Prior More, the last but one at Worcester, had led the life of a country gentleman at Battenhall, spending very little time in the monastery. The priors and monks who submitted were given pensions, but those who resisted were turned out without them. Henry Holbech, the last prior, acquiesced to the charges and became the first dean, and the bulk of the property was returned to the newly-constituted dean and chapter. Eight years later the services were read in English and the old books burned.

The royal tombs

Two important royal tombs can be seen in Worcester Cathedral: that of King John, believed to bear the earliest royal effigy taken from life, and that of Prince Arthur, the eldest son of Henry VII, often said to be the most beautiful tomb of all in British cathedrals.

In 1216 King John was buried between the two great saints, Oswald and Wulstan, in a monk's cowl because, tradition had it, he hoped that at the resurrection his two companions together with the disguise might enable him to evade the vigilance of the gatekeepers of heaven, for the wickedness of his life gave him little chance of being admitted on merit. To people of this century the story reads like a legend embroidered over the years. But when the coffin was opened in 1797, to ascertain the truth of it, the skull was indeed found to be covered with the remains of a monk's cowl, and over the royal robes were the remains of a monk's habit.

John had been in Worcester a month before his death; but his time was running out. Harassed by nobles, threatened by a foreign rival and dying from fever and dysentery his thoughts turned to the city. 'First then,', reads his will (still remaining in the cathedral), 'I desire that my body be buried in the church of the Blessed Mary and S Wulfstan of Worcester.'

Eaton's *Concise History of Worcester* (1829) ends the account of the opening of the tomb with this macabre story: 'On the opening of the Tomb of King John in the Cathedral, a gentleman of this city took a handful of the skeletons of skins of maggots that were in and about the abdomen of the body and angled with them in the Severn and absolutely caught a brace of bleak with them.'

The king's tomb was moved to its present position during one of the

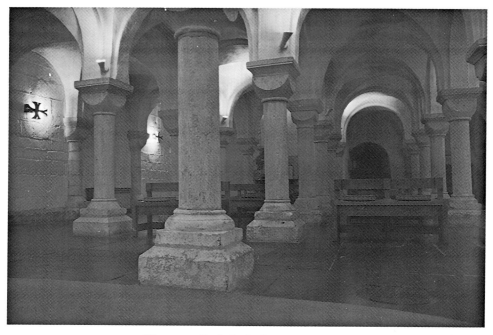

Worcester Cathedral: the restored crypt

restorations and thus the very reason for its being there at all was destroyed. The last restoration in 1874, carried out by the Board of Works, insensitively destroyed the remnants of colour that remained and gilded the whole figure.

Arthur, Prince of Wales, was betrothed to Catherine of Aragon in a Machiavellian attempt to control foreign affairs of state. Both were eleven years of age. Two years later they were married by proxy, the English ceremony taking place in the chapel of Tickenhill Palace at Bewdley on Whit Sunday 1499. Catherine came to England two years later and she and Arthur were married in St Paul's Cathedral; but on 2 April 1502, after only two months' honeymoon at Ludlow Castle, Arthur died.

A great procession brought the young prince to Worcester for burial, one of the greatest scenes of pomp and ceremony ever witnessed in our cathedral, and one of the most moving. The prince was laid in the tomb amidst great weeping and lamentation. 'This was a piteous sight to those who beheld it.'

And well might they have wept could they have realised the outcome of the death of the gentle prince. 'For in this sad scene was one of the greatest 'ifs' in English History.' If Arthur had lived, then Henry would not have come to the throne and the marriage and divorce of Catherine, and the resulting break with the Church of Rome and the sweeping away of the monasteries, might not have happened.

The beautiful chantry erected over Arthur's tomb was decorated with fine heraldry and eighty-eight figures. It was intended to colour these and place on the tomb a bronze or marble figure; but this was never completed, probably because when Arthur's brother Henry married Catherine it was thought expedient to forget the existence of her first husband. Fifty years later the

tomb was mutilated and plastered up, and not until 1788 was the plaster removed and the figures exposed as they are now.

The cathedral library

Over part of the south aisle of the nave is the cathedral library. It contains rare and valuable books and documents of great age, including King John's will and a book printed by Caxton who set up England's first printing press in 1477. It was not until 1461, in the time of Bishop Carpenter, that a library was erected, and then it was placed in the charnel house; but there were collections of books and manuscripts before that, some certainly kept in the cloisters.

When Archbishop Laud made his visitation in 1634 he complained that the chapel called 'Capella Carnaria' had been profaned and turned into a haybarn. Two years later it was fitted up as a school and the schoolhouse was converted into a library. The muniments and charters, far more numerous then than now, were obviously kept in the Edgar Tower and much neglected, for we are told that in 1635 Dean Mainwaring had saved thousands of rolls lying about in the tower, removing them from a damp stone wall and from under a window where rain beat in on them. In the same century the library was moved to the light and spacious chapter house and began to be enriched by the addition of many interesting books. In 1771 Rev J Griffin, headmaster of the cathedral grammar school, compiled a catalogue which filled a large folio volume, but it was not until 1880 that a printed catalogue was produced. A later catalogue showed that the cathedral possessed 35 books printed before 1500 and 277 volumes of medieval manuscripts. A second collection consisting of printed

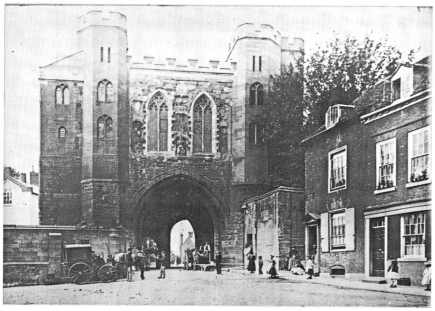

St Mary's Gate (later called Edgar Tower), c.1860. The photographer, Bedford, and his developing wagon can be seen on the left

books numbers about 4,350; and there is a third collection of volumes of manuscripts, charters, accounts, court rolls and other records.

Edgar Tower

Edgar Tower, known as St Mary's Gate until the late 17th century, was the main gate to the royal castle and priory. After the disastrous fire of 1202, when the city and cathedral were burnt, John ordered the Sheriff of Worcester to obtain wood and stone of the best quality to rebuild the gatehouse. The massive wooden gates seen today are mostly original, a complete fourteenth-century two-leaf door.

The tower's original principal figure was probably the Virgin. It is possible that at some time during the Reformation period this was destroyed and replaced by the figure of Edgar which may have been moved from a less central position.

For two or three centuries the figure of King Edgar sat, legs crossed, looking down on all who passed through the gate. Eventually it crumbled to dust, but in the restoration of 1910 an exact copy was made and, with other notables of the past, the old niches on the face of the tower were filled with terracotta figures designed by R F Wells of Chelsea. The dean and chapter first put up the figure of Edgar, and others, including Stanley Baldwin, paid for the rest: Bishop Bosel, the first bishop; Winsin, the first prior; King Ethelred; Sub-king Osric; Duke Ethelred; Ethelfleda; and Florence of Worcester.

The Old Palace, Deansway

Until the year 1842 the Old Palace was the official residence of the Bishop of Worcester. He also had Hartlebury Castle and a London house, but a Royal Commission, looking into church revenues with reforming zeal, concluded that the bishop had no need for two palaces, and reduced his income. The commissioners would have preferred Hartlebury Castle to have gone, but Bishop Pepys decided to release the Worcester residence which was sold in 1846 to the dean and chapter as a deanery, resulting, sadly, in the destruction of the old deanery in College Green, and the Guesten Hall with it. In the 20th century the Palace was found to be unsuitable for the dean, and now serves as a diocesan office.

The Old Palace and the cathedral are the oldest buildings in the city. There was a bishop living here before there was a king of England. The Palace, and the building that preceded it on the same site, have been the homes of a long array of great and mostly good men. They number two martyrs, four saints, several lord chancellors and lord treasurers, one lord president of the Marches, one vice-president of Wales: Ecgwin, the founder of Evesham monastery; Dunstan, the legend of whose lively interview with his Satanic majesty may be recalled; Wulstan, the founder of the cathedral; Cantelupe, the great defender of English liberty against papal aggression; Whitgift, the peacemaker; Prideaux, despoiled by the Puritans; Thomas, renowned for devotion and hospitality; Stillingfleet, the Protestant leader; Lloyd, one of the seven bishops sent to the Tower; Hough, the determined opponent of Roman bigotry; Maddox, one of the founders of Worcester Infirmary; Hurd, the distinguished scholar and friend of George III these are among the more noted men who passed some part of their lives here as bishops of Worcester.

The royal associations of the Palace are many. When Elizabeth I came to Worcester in 1575 she kept her court at the Bishop's Palace for seven days, receiving municipal dignitaries in the great hall; Charles I was in this house in 1644 when Waller and Massey were in pursuit of him; James II stayed at the Palace in 1687; and it was here that George III resided when attending the Three Choirs Festival in 1788.

Guesten Hall

The ruins in the College Green are part of the Guesten Hall which was built in 1320 and formed part of the chain of monastic buildings on the south side of the cathedral. It was a notable building, having a roof thought to be unique of its date, and the finest tracery of any window in Worcester. Inside, on the wall where the dais used to be, was a large seated figure of Our Lord, most imposing even in its mutilated state.

When the Bishop's Palace became the deanery, the prior's lodgings, which since the Reformation had been allotted to the dean, were demolished. It was then found that the Guesten Hall needed restoration. In 1854 the architect, George Street, who had connections with Worcester, was asked to make a series of drawings and presumably to advise on the restoration. The dean and chapter, however, decided against using the chapter fund for the purpose and for a beggarly £1,000, the estimated cost of necessary repairs, this ancient hall was destroyed in 1860 to save the expense of its upkeep. It is a sad comment on the attitude of the cathedral officials of the mid-nineteenth century to the buildings in their care.

The ancient roof was used for the new church at Shrub Hill (Holy Trinity) though the pitch was drastically changed and much alteration to the old timbers took place. That church has been destroyed and the roof has made another journey, this time to the Avoncroft Museum of Buildings, near Bromsgrove, where it has been raised over a new building.

The cathedral charnel house

Immediately north of the main entrance to the cathedral, at a site where now the roadway widens before the north porch, stood the chapel of the charnel house. It ran west alongside the cathedral and parts of the crypt still lie below the roadway. When it ceased to be used as a charnel house is not known but in 1636, when the upper room was fitted out for the cathedral school, the stench was very bad and complaints led to the school being moved five years later to the refectory, where it remained for many years (and which is still used as the school hall).

During the restorations of the 19th century the road through the churchyard to the main door was lowered by over 4 feet to near its original level; for centuries of burials had caused the ground to rise so that one had to descend by steps into the cathedral. This accounts for the high path in front of the Georgian houses in College Yard. During the Second World War, when deep shelters were needed for air raids, blocked cellars under the precentor's house were probed and found to be still filled with bones.

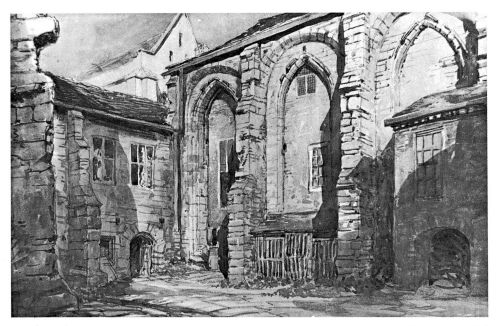

Drawing of the exterior west wall of the Guesten Hall by H H Lines, 1844. The doorway left of centre led to a passage to the cloisters

'Cathedral Bell Stolen!'

In 1863 the *Worcestershire Chronicle* published the startling announcement that one of the great bells of the cathedral, weighing five hundredweight, had recently been stolen. It was 'not known how or when but it must have been within the last few months'.

An American, it seems, who had visited the tower, guided by a young ringer, informed the authorities that there were only seven of the eight bells there. Though the rope and tackle remained, the treble bell had gone. It can't have been an easy robbery for it would certainly have needed pulleys to have taken it down, but the mystery was never cleared up. The story had a happy ending, however, for an appeal was made to replace the bell and cheques rolled in so well that it was possible to place an order for the present peal of sixteen bells.

Old and new St Michael's churches

The old church of St Michael in Bedwardine, founded in 826, stood very close to the cathedral on the north-east side. Around the church were a number of houses which blocked up the northern facade of the cathedral. St Michael's had a tower and at the west end stood the ancient *clochium*, or bell tower, of the cathedral with its lofty spire.

St Michael's was considered the parish church for the whole of the cathedral precincts, and if any marriages were performed at the cathedral they were entered in St Michael's register, the incumbent receiving the fees. Marriages were solemnized here between persons belonging to almost every place in the

country, evidence that the population was more mobile than we often think. Its burial ground had wide use, too, receiving all the prisoners and debtors who died in the county gaol, which was part of the old castle, and the Scots that were slain in the battle of Worcester in 1651.

The old church was demolished and a new church was built in 1839 in the Early English style, with an entrance and frontage in College Street, and adjoining the old Lich Gate. It had a chancel, nave and aisles, a small gallery for 200 people and windows by Hardman of Birmingham. It was little used, however, being closed as a church in 1907 and becoming the Diocesan Records Office.

The Cathedral Grates and Lich Gate

The making of College Street through the cathedral churchyard from the High Street to Sidbury in 1792 followed the clearance of houses which had grown up in the shadow of the cathedral and around St Michael's church. The fine terraced houses in College Yard were also built at that time. In a house on the south side of St Michael's was born Lord Somers, one of Worcester's greatest sons. The house afterwards became an inn called the Plume of Feathers. At the south end of the High Street stood the 'college' (ie cathedral) gateway, known as the Cathedral Grates, though locally it was called the Bishop's Eye. It appears to have been similar in appearance to Edgar Tower. In an appartment in the tower dwelt the college barber.

The Lich Gate, a little down Lich Street, was the old entrance to the cathedral cemetery. It dated from the early 16th century and was the only remaining lychgate of a cathedral in the country. The whole of Lich Street, the church and the Lich Gate were destroyed in the early 1960s.

A great Victorian preacher

During the last quarter of the 19th century Worcester Cathedral was fortunate in having a most distinguished group of officials. Among them was Canon Knox Little, reputed to have been the greatest preacher in the Anglican Church in late-Victorian times. He was subdean until 1917 when he resigned the post at the age of seventy-seven. He became prominent in the Manchester Mission where he held meetings at lunch hours and in the evenings, attracting omnibuses full of people singing hymns, and emptying hotels at lunch hour when he drew hard-headed businessmen to confession. He was on the point of leaving England to join the Episcopal Church of America when Prime Minister Gladstone agreed to see what he could do to keep this powerful High Churchman here. 'Well,' he told the Dean of Manchester, 'I've heard your friend, and notwithstanding that he brought into his sermon academic pictures, Swiss mountain scenery, a ghost story and Oberammergau, it was powerful and earnest, and I have offered him a canonry at Worcester.'

He was a great extempore speaker. In Manchester crowds fought for admission to the church when he was preaching; and at Worcester the nave of the cathedral was crowded to overflowing, hundreds assembling before the doors opened. On Sunday evenings traffic in the High Street was considerable, not surprisingly with congregations averaging around 2,000. It also became something of a parade, for churchgoers donned their best clothes, and poor

people lined the streets to see the well-to-do walk to and from the cathedral in the latest fashions. It even became necessary for the chief constable to arrange a one-way system, something very unusual in those days.

The Water Gate and the ferry

The Priory Ferry, or Cathedral Ferry, worked until the mid-20th century. It had originally been established for the convenience both of monks and milkmaids, who would otherwise have had to be taken the circuitous route through the city to the Severn bridge at the bottom of Newport Street, for there was no riverside walk as there is today.

For the convenience of the boatman, and for defence, the Water Gate — a strong sandstone gate with portcullis and double doors — was built in the high stone walls guarding the city from a river attack. Part of the walls still stand to give some idea of their height at the higher promenade in front of the cathedral west door. William Poer, the cathedral cellarer, built the Water Gate in 1378. The Poer family held much land immediately south of Worcester in Norman and Plantagenet times — on the rent of a lamprey.

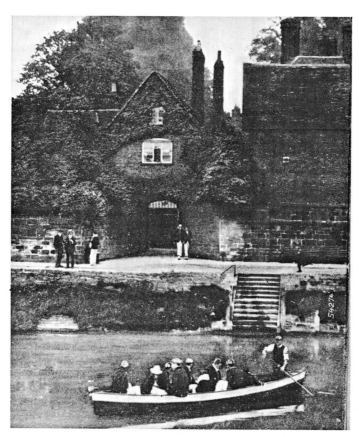

The cathedral ferry at the end of the 19th century

The affray at the ferry

After the dissolution of the priory the ferry and the boathouse passed with the Severn meadows to the new dean and chapter of the cathedral; and in Elizabethan times were the scene of an affray which became a Star Chamber matter, for strong passions disturbed the peace of the cathedral close in the days of transition from the old order to the new.

Sir John Bourne of Battenhall and Holt Castle had been Secretary of State in the previous reign of Queen Mary, and his son, Gilbert, had become a bishop. Both were ardent Roman Catholics and strongly opposed to the changes Elizabeth made. They resented particularly the intrusion into the cathedral precincts of the wives of the clergy, and carried on a vigorous vendetta against the new Protestant bishop, dean and prebendaries. Alternately spoilt by excessive power and soured by misfortune, John Bourne quarrelled with Bishop Sandys and all connected with the cathedral.

One day, while crossing the Severn in the ferry from the College Green, he grossly insulted the wife of the dean and two of the canons' wives who were also crossing. It led to a violent altercation between Bourne's party and members of the dean's household, and a fracas ensued in which swords were drawn and blood was shed. The Privy Council was forced to intervene and after investigation, charge and counter-charge Sir John was committed to the Marshalsea. Only an abject apology secured his release.

Another son, Anthony, was of equally tough temper. On the occasion of a difference between Bishop Sandys and Sir John, Anthony had his sword sharpened publicly by a Worcester cutler and, parading in front of the Palace gates, demanded: 'Where are the Bishop's boys!', challenging one and all to combat. He lost his life not long after — perhaps not surprisingly — in a private quarrel in Gloucestershire.

The Three Choirs Festival and George III

The Three Choirs Music Festival is the oldest surviving festival of its kind in Europe. It started in the early years of the 18th century as an annual meeting of the choirs of Gloucester, Hereford and Worcester who gathered for two days to perform and listen to music, singing matins and giving performances of religious and secular music in the evenings in various buildings to appreciative audiences of 'quality'.

The festival was not regarded as an event of great prestige in the 18th century, but rather as part of the social entertainment that went with the assize week and the races. In fact, the famous singer, Tenducci, was employed to sing in 1767, but when the dean paid him he refused to give a receipt, saying that if it became known that he had performed at the festival he would be invited to sing 'at all the horse-races and cockfights in the kingdom'.

The Three Choirs Festival of 1788, however, was memorable for the presence of a number of members of the royal family: George III, Queen Charlotte, the three eldest princesses and the Duke of York. The visit was the first paid to Worcester by an English sovereign for a century. The king made available the powerful support of his own private band and the choirs were augmented with choirs from Oxford and London and a special chorus of female singers from the north of England. A gallery was erected for the royal visitors at the west end of the nave, lined and faced with crimson silk.

The king heard the performance of the *Messiah* at which 3,000 were present. The enthusiasm for the visit was tremendous, with a great burst of applause when the king returned from the gallery, and a spontaneous singing and playing of *God Save the King*. Many strange and amusing stories have been told concerning the royal visit. Like all the pilgrims who came to Worcester in September, the king visited the battlefields and it is said he was escorted by a descendant of Oliver Cromwell.

The 'Black' or 'Mock' Festival

In the 1860s, as the religious revival gathered strength, there was opposition to the entertainment part of the festivals. Canon Barry preached a charity sermon at the end of the Gloucester Festival in 1874 and indicated that changes would be made the following year at Worcester. The message was clear: musical performances not connected with religious services should have no place in the cathedral; and as is if to emphasise the ominous occasion the organist played the Dead March from *Saul*.

The controversy was tremendous: pamphlets for and against were written and public protest meetings held. Lord Hampton led the attack on the cathedral authorities whom he regarded as clergy of the Oxford Movement edging towards Roman Catholicism, and responsible for the changes. 'Beware of the men in petticoats!', he thundered. Lord Dudley, who had great influence and wealth, was in favour of the change and offered a gift of £10,000 for the restoration of the cathedral, and a guarantee to cover the income lost if the old type of festival was stopped.

In 1875 the dean and chapter refused the use of the cathedral for the festival in the teeth of opposition from stewards, civic authorities and, especially, from the local tradesmen. The style of the meeting was modified: no orchestra or solo artists were engaged, no platforms were set up, no tickets of admission sold, no oratorios permitted — not even the *Messiah*. The result was a three-day festival consisting of six choral services only. It became known as the 'Black' (or 'Mock') Festival, tradespeople decking their windows in deep mourning and cabbies tying mourning crepes around their whips. To add to this, it was a miserably wet week, raining practically the whole time; but on Saturday, when it was over, the sun shone out. Effigies of Dean Yorke and Canon Barry were publicly burnt on Pitchcroft. The following year at Hereford the old-style festival was resumed and the civic authorities jubilantly attended in state; and in 1878 all was back to normal in Worcester, the clergy having wisely capitulated.

Lord Somers and the 'Glorious Revolution'

No native of Worcester has played a more important part in English history than Lord Somers. He was born in the year after the battle of Worcester in an old house beneath the shadow of the cathedral which was swept away at the clearing of the churchyard.

He went to the King's School and later to Oxford; was admitted to the Middle Temple; and at twenty-five was called to the Bar. His opportunity for advancement came when he appeared as junior counsel for the seven bishops who were tried for seditious libel in 1688, at a time when tension between

James II and his subjects was reaching its climax. His brilliant speech, one of the most famous in the annals of the Bar, decided the issue and made his fortune. After the 'Glorious Revolution' which followed a few months later he became MP for Worcester and Solicitor General. Three years later he was appointed Attorney General and was knighted and in another three became Lord Keeper of the Great Seal. Two years more and he was Lord Chancellor and a peer — Baron Somers of Evesham.

He had a firm grasp of constitutional principles but was especially renowned for his moderation and humanity. To him more than any other was given the credit of ensuring that the Revolution of 1688 was a 'bloodless revolution'. The difference between his calm judicial procedure and the bullying methods of Judge Jeffreys was immediately apparent. Against violent public opinion, for instance, he insisted that even a scoundrel like Titus Oates must have a fair trial.

In many ways he was the greatest man of his age, equally eminent as lawyer, orator, statesman, man of letters and patron of learning. Locke and Newton were indebted to him for their advancement; the union with Scotland was largely his work; and he presided over the parliamentary committee which framed the historic *Declaration of Rights*, the modern Magna Carta.

The county prison in the old castle

The old castle was long used as the county prison. Some time between 1621 and 1650 a strong building of brick and stone was erected within its precincts to serve as a house of correction. The entrance was by way of the lane, just south of Edgar Tower and the new buildings of the King's School occupy the site.

Condemned in 1788 by John Howard, the prison reformer, the county magistrates spent £3,431 on its improvement. But the building was old and extremely insecure and there were numerous escapes. Proposals to build a new gaol were put forward in 1802 but nothing was done. In 1807 Chief Baron Macdonald arrived at Worcester for the assize and found that the prisoners in the important cases had vanished! His lordship warned the grand jury that the county would be heavily fined if matters were not put right. This threat hastened the matter and a new prison was built in Salt Lane in 1813.

The old prison had been one of the sights of the city, and on Assize Sunday (the Sunday during or immediately following the assize) prisoners were shown to the crowds, visitors giving 6d to the gaoler for pointing out those to be executed. There was an open ironwork railing between the debtors and the felons and they could communicate as they pleased. The debtors' common room was far too small, and also doubled as a chapel. Nor was there a special room for the condemned criminal: he was simply chained to a post by day near the door of the chapel/common room. There was regular transference of prisoners to the 'transports' which went down river to Bristol, whence they were shipped out to the plantations.

Executions took place on Red Hill and the procession to the gallows was often a rowdy affair, though sometimes there was sorrow at the loss of a young life. *Berrow's Worcester Journal* reported the execution at Worcester of a young soldier aged twenty-three for desertion, 'the condemned man walking with his shroud behind his coffin, from the Gaol to the place of execution, reading from a book — the procession was the most decent and solemn ever seen on such an occasion'.

So many felonies carried the death penalty that there was often a reluctance to carry out the sentence, though a 'hanging judge' might leave a dozen or so in prison awaiting a final word from London. Sometimes the authorities there moved in a strange and cruel way, as the following report shows:

> In the old prison of Worcester was a boy of 13 or 14 years, who had for some offence been sentenced to be hanged, but the judge, because of his age, respited the death sentence, and the London authorities seemed to have gone on extending the respite. In this way, two years went by. The boy in the meantime was allowed a good deal of liberty, so much so that he could have escaped had he so desired. An old inhabitant of Worcester related that one day the boy was playing at ball in the yard with some debtors, full of life and glee, when suddenly to the utter astonishment of the jailor and all his associates, there came an order from London for his execution. Why he remained so long forgotten, and why so extreme severity fell on him, no-one can tell, but his case was considered a very hard one, and was commiserated by the whole City. My informant saw the poor boy conducted to the execution.

St Peter's church

In early times St Peter's church was known as the 'Great' to distinguish it from St Peter the Little which was a chapel at the royal castle of Worcester. By the 1830s it was picturesque but in a ruinous condition; and it was demolished in 1838. A new church was built with the aid of a government grant, designed in brick by the Worcester architect, John Mills, in the early-Victorian Gothic style so much despised by later Victorians who came to regard it as 'the ugliest church in the City'. It was a typical 'prattling box' of the period, with few decorative features, but it held a lot of people. The tombs from the old church were put in the spacious crypt which, like most in the city churches in the 19th century, was a charnel house. St Peter's was demolished in 1976.

St Peter's parish workhouse

In 1746 a parish workhouse was set up in an old half-timbered building in St Peter's Street. It existed well into the 20th century. Parish records show the kind of treatment the less fortunate met. In 1739, for instance: Leonard Darke was to have 'the badche put on his sleeve before the churchwarden relieves him or his wife', a reference to the enforced practice of wearing a large 'P' badge on the arm to show a person was in receipt of parish assistance.

Parish lunatics had the usual barbaric treatment: 'Paid for necessaries for Rd Strayne, 1s. 6d. Two hopsacks for a bed tick for him, 3s. 4d. Straw for him, 6d. A nurse to look after him, 1s. 6d. Paid a man to help chain him, with expenses, 3s. Two staples, a chain and a lock, 8d.'

A 'shotgun' marriage is referred to in 1780: 'Paid to Ann Williams . . . examination and oath touching the father of the child, 2s. A warrant to apprehend father, and expenses of constables and assistants in taking him, £1. 18s.' Sometimes there are happier occasions recorded: 'Paid for the ring, 4s. Licence, £1. 8s. Pd. parson, clerk and sexton, 8s. For the wedding dinner and drink, 11s. 6d.'

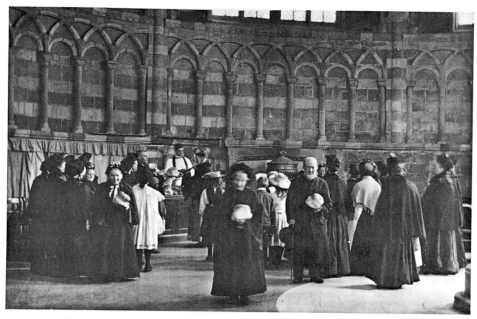

Distribution of the bread dole in the cathedral chapter house, 1909

The Commandery

It was founded by Bishop Wulstan at the end of the 11th century for a master, four brethren and a chaplain. The establishment was at once religious and charitable, one of the houses outside the walls (like St Oswald's) which catered for the reception of wayfarers who arrived after the city gates had closed at night and who otherwise would have had to sleep in the open. It was never connected with the Templars as some have thought, and the name, Commandery, probably derived from the title of a former lay superior.

It has a fine timbered roof of the time of Henry VII; the hall has a dais for the high table; and there is also a screen with a minstrel gallery, a buttery hatch and an ancient balustraded staircase. Around the oldest parts are Georgian additions for, like the Whiteladies in the Tything, more than one family lived there. In the early 19th century industrial buildings were added, alongside the canal, which became a small boot factory owned by Samuel Burlingham, the Quaker; and where it is said the Willises learned their trade. Until recently this part was used as Littlebury's printing works and its early industrial windows overlook Sidbury Lock.

During the battle of Worcester in 1651 the Commandery was in the very heat of the action, and was enclosed in the hurriedly prepared defensive lines which ran from Fort Royal to the Sidbury Gate. The earthworks, bastions and covered way could still be traced in mid-Victorian times.

In one of its rooms the Duke of Hamilton died of wounds received during the

attack on the Parliamentary positions at Perry Wood. His leg was shattered by a cannon shot and he was brought back to the Commandery. After lingering a few days, the duke died of exhaustion in the room still called the 'Duke of Hamilton's Room'. Tradition has it that the body was buried under the floor for a while.

The Cameron family

The Commandery has been home to many notable families but none more interesting than the Camerons. Dr Charles Cameron, the celebrated Worcester physician, and his wife (Anne Ingram) lived in part of it in the latter half of the 18th century. Their eldest son, Rev C R Cameron, married Lucy Lyttleton Butt who, like her sister Mrs Sherwood, wrote books for children, and numbered among her admirers the great Dr Arnold of Rugby School who quoted from them in his sermons.

The second son, Francis, was born at the Commandery in 1780. Always an adventurous boy, he ran away to sea at fourteen and served before the mast. Later a midshipman's commission was secured for him, and he was in the thick of the battle at Cape St Vincent. He became First Lieutenant of *H M Rattler* — but at the age of twenty-three, like many another young man protecting the sugar islands, he died of yellow fever at Jamaica.

The third son was Archibald, born at the Commandery in 1782 and said to be the original of Archie Carlisle in Mrs Henry Wood's *East Lynne*. Despite injury and poor health as a boy he became an attorney in 1804 and eventually head of a firm of solicitors. He was to have married the daughter of James Stillingfleet, Rector of Knightwick and a prebendary of the cathedral, but her parents objected on the ridiculous grounds that they did not want her to marry a man whose name appeared at the foot of every notice on turnpike gates around Worcester! It illustrates the exclusiveness of the cathedral people of that day.

Fifteen years passed before Archibald married the 'clean, wholesome young widow' of Lawyer Hyde. She was Mary Roberts, the daughter of the Rector of Broadway, a young lady of decided views and strong personality, ruling her household with a rod of iron. In strong contrast to her husband, she was constitutionally unsociable and made no attempt to hide her dissatisfaction with the cathedral clergy, declaring they had neither learning nor spirituality. Once a year she gave three dinner parties on successive days: first for the bishop and county people, secondly for leading townsfolk, and thirdly for her husband's humble clients and friends.

Jane Cameron was the youngest daughter of Charles and Anne. Born in 1793, she became known as 'the beauty of Worcester' and the 'Belle of the Hunt Ball'. There was a love affair with Lord Deerhurst, eldest son of the Lord Coventry of the day — but the Camerons were not quite in the same class and she was married off to Captain Thomas Roberts, the brother of Mary Roberts.

In the early 19th century a solicitor named Saunders lived in part of the Commandery. Among his clients was T C Hornyhold of Blackmore Park, near Malvern, a noted sporting squire and said to be the most popular man in Worcestershire; his portrait hung in almost every inn and farmhouse in the county. But he spent money like water. Mortgages piled up and his solicitor became practically the owner of the Blackmore estate. Saunders however saw a way out: the squire was unmarried — and the solicitor had a daughter. And so wedding bells relieved Hornyhold, and his debts became his wife's dowry.

Bishop Gore

Facing the Tewkesbury Road is the Loch Ryan Hotel, a fine late-18th century house that was once the residence of Bishop Gore, Bishop of Worcester from 1902 to 1905. He was the first bishop of the 20th century, and a socialist who refused to live in Hartlebury Castle, preferring to live in closer contact with his people. Unfortunately, just after his move the city adopted the electric tramway system, which resulted in a junction of the London Road and Bath Road lines right outside his house. He found the noise unbearable and was forced to move to the Regency house in Lansdowne Crescent which is now called the Bishop's House. His young niece, Miss Diana Ogilvy, kept house for him and eventually became the first woman mayor of Worcester.

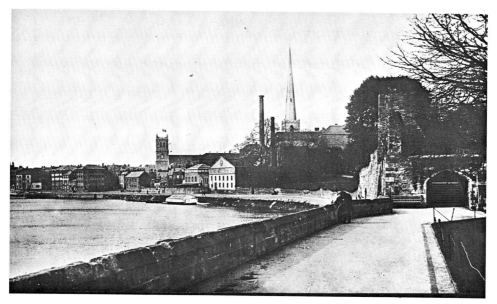

The Cathedral Promenade at the turn of the century

Many clergy found his socialist views unpalatable. On the first Sunday after his enthronement as bishop he snatched a brief interval between cathedral services for a scramble on the Malvern Hills, where he had roamed as a schoolboy. He took an ordinary 3rd class 'cheap return' from Foregate Street, travelling as one of the customary crowd of Sunday afternoon excursionists. It was very characteristic of him but many churchmen were shocked. He shopped at the Worcester Co-op at a time when many local clergy and churchgoers opposed the movement; and he was denounced at the Birmingham Congress by Father Ignatus, 'the seer of visions', who announced he had had 'a vision of Worcester Cathedral falling over'.

Bishop Gore stayed only three years, for he shaped the archdeaconry of Birmingham into the diocese of Birmingham, leaving Worcester to become its first bishop, and devoting a large part of his personal fortune to it.

The old Talbot

Before 1835 the parish of St Michael's was out of the city boundaries and jurisdiction. Both the Talbot and the Hare and Hounds in College Street were widely used for county business, having all the amenities of the town but officially beyond its limits.

The Talbot is still with us, one of the oldest taverns in the county, frequently mentioned in 16th century records as playing an important part in local history. Because it was outside the municipal limits it was frequently used as a convenient place of meeting by county justices. One notable incident occurred there shortly after the Revolution of 1688, when in view of an expected French landing in Devonshire Jacobite suspects were examined at the inn. In 1745, when young Charles Stuart was marching on London, the county justices were again busy, for the city and county had many Jacobite sympathisers. But the Jacobites contented themselves with drinking the health of the 'King over the water and confusion to the Whigs'.

Mrs Henry Wood

The story of Mrs Henry Wood is one of the great success stories of the 19th century. She was born during the great frost of 1814 and a century later 6,000,000 copies of her books had been sold (not counting pirated copies and her huge contribution to magazines).

She was born Ellen Price at 18 Sidbury (called Danesbury House but rebuilt in 1889). Her father was Thomas Price, one of the largest glove manufacturers, who lived near other glovers in Sidbury (Burlingham was at 23 and Dent at 26). Up to the age of seven she was brought up in the home of her grandmother, but when the latter died she went to live with her father at St Mary's Terrace, London Road. She was married in Whittington church to the head of a large banking firm in India and left Worcester, only returning some years later to consult Henry Douglas Carden, the great Worcester surgeon. She suffered from spinal trouble and used a reclining chair to write. Just before her death she was writing *Oswald Cray* and broke down in health as soon as it was completed.

Her popularity lies in her plots rather than her style, with accurate detailed descriptions of the everyday life of the middle and lower classes. She loved to depict life in Worcester and many of her characters were drawn from life, for she described her immediate neighbourhood. Helstonleigh is Worcester, and Lucy Cheverley in *Mildred Arkell* has been described as the counterpart of herself. Other locally set books are *Mrs Halliburton's Troubles*, *The Channings* and *Johnny Ludlow*. In *Mrs Halliburton's Troubles* she wrote of the colony of glovers living in a place called Honey Fair, in reality Upper Park Street, quite close to her home at St Mary's Terrace and unchanged from the days when she knew it until the 1870s.

Her most popular book was *East Lynne*, which appeared in 1861 as a serial in the 'New Monthly Magazine', but was twice rejected by book publishers. It later sold over one million copies and was translated into numerous languages, including Hindu and Parsee. It was certainly melodramatic, but few people know that it is a page from real life, based on a true story about Lord Morley's family, told by Thackeray to Mrs Wood. Earl Morley had married Augusta

Fane Child, the heiress of Osterley Park, and the Lady Isobel of the novel, 'a lovely woman married to a man she despised', according to Lady Shelley, who 'fell in love with Sir Arthur Pagett, and ran off with him in 1808, leaving her husband and a young son. Ten years later the boy had a serious illness and lay dying, and the mother returned to nurse him, unrecognised by all except her former husband. The novel's most famous line — 'Dead, and never called me mother!' — brought the Victorians to tears.

Map 2

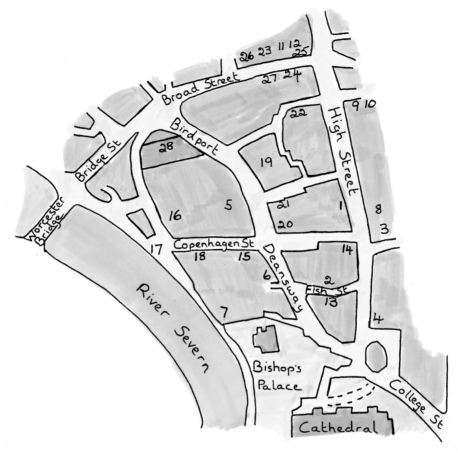

1 The Guildhall	15 Model Dwellings
2 St Helen's church	16 Wherry Inn
3 King's Head Theatre	17 The quays
4 The Elgars' shop	18 The Bridewell
5 St Andrew's spire	19 Lady Huntingdon's church
6 St Alban's church	20 Webb's Factory
7 Warmstry Mansion	21 Factory school
8 Market Hall	22 The Dispensary
9 Berrow's Worcester Journal	23 Glee clubs
10 Worcester Herald	24 Worcester Sauce
11 County banks	25 Kitson's Chemist
12 The Old Bank	26 Midland Bank
13 Fishmongers' Hall	27 'The Synagogue'
14 Cooken Street	28 All Saints church

District Two

West of the High Street

The city walls and gates

Willis-Bund gave a clear outline of the walls in his paper *The City of Worcester During the Great Civil War 1642–46*. He wrote:

> The line of the walls was as follows: starting at the bottom of Dolday, which was then an important street . . . there was on the bridge one of the city gates, the water gate. St Clement's church then stood inside the walls; but so close to it that when the Parliamentary troops pulled down the wall at this point they pulled down the tower of the church, and the parish being poor, could not afford to rebuild it in stone so put up a wooden tower. From this point the wall ran east; remains of it can still be seen on the righthand side in walking up the Butts; it crossed the end of Angel Street, passing through the grounds of the Berkeley Hospital, crossing Foregate Street, through the Hop Market Hotel, along Sansome Street till opposite the Catholic church; the present bend in the street at this point marks a bastion in the wall, it had up to here run almost due east; it now turned south-east, crossed St Nicholas Street and ran along the west side of Watercourse Alley, which represented a stream that from this point formed the ditch. The wall crossed at the top of Silver Street, somewhere near the garden which is now laid out there, and then turned south, running along the back of the gardens of the houses that formed New Street and Friar Street to the top of Sidbury until it reached a point opposite Church Street, then it turned west, just taking in St Peter's church; here it turned north, crossed the brook called Frog Brook, which was afterwards covered in and called Frog Lane, now Diglis Street, and joined the Castle wall.
>
> Another wall was at some subsequent time built outside the Castle wall to the river bank. There does not appear to have been any continuous wall from this point along the river to St Clement's church, the walls only extending part of the way. From the Diglis Corner a wall extended upstream enclosing the Castle, the monastery and, it would seem from the old plans, the house and garden of the Warmstrys, up the passage known as Warmstry's Slip. From here to the end of Quay Street the town was open. From Quay Street another wall extended to the bottom of Newport Street.

John Leland, who came to Worcester in about 1540, considered it to be 'reasonably well walled':

... in the walle be six gates; the bridge gate on Severne, having a goodly square towre over it; a postern gate by St Clements chirche, hard by the northe syd of the bridge; the Fore-gate, a faire piece of worke, standing by north, Sudbyry Gate, standing East in the way to London; St Martins Gate; Trinitie Gate, this is but a posterne.

The Bridgegate, destroyed in the second half of the 18th century, must have been a formidable structure. Wharton, a soldier in Essex's army who came to Worcester in 1642, described it as a 'gate in the middle of the bridge as strong as that on London Bridge, with portcullis'. And as on London Bridge, the heads of criminals were displayed on the Bridgegate, for the head of John Hind, a highwayman who was executed at Worcester in 1652, was mounted there. Hind was a confirmed royalist, robbing only Parliamentarians — even being reputed to have held up Cromwell near Huntingdon. Later his head was removed by night and buried in a city churchyard.

St Clement's Gate was a postern gate which gave access to the river and Pitchcroft, and when St Clement's church was taken down in 1823 all traces of it were removed. The Foregate or Forest Gate stood between the Hopmarket Yard entrance and the gates of the Berkeley Hospital. The gates were removed soon after 1702. St Martin's Gate was a large gatehouse with two roads leading from it, one across Lowesmoor, the other to the Alcester Road. It was through this gate that Charles II escaped at the battle of Worcester, heading north with a sixty-strong entourage. It was demolished in or soon after 1773. The Friars postern gate stood in the walls adjoining the old Greyfriars building and gave the friars access to their cemetery outside the city wall. Sidbury, the great south gate or London Gate, stood close to the present canal bridge. It was the scene of great slaughter in 1651 and provided a lucky escape for Charles II. With Cromwell's guns trained against the gate and every Parliamentarian eager to get at Charles a Worcester citizen, William Bagnall, so goes the legend, guided him to a space between the gate and a broken-down ammunition wagon and the future king reached safety inside the city by crouching under the wagon. Sidbury Gate was destroyed in 1768.

The growth of the city

In the 16th and 17th centuries building had extended outside the Forest Gate (Foregate) north as far as St Oswald's Hospital. In the mid-16th century Leland described it as 'a longe and fayre surburbe by north'. Buildings had overflowed outside Sidbury Gate, clustering around the ancient St Wulstan's Hospital (the Commandery) and in Tybridge Street, from the bridgehead to Cripplegate. During the Civil War, of course, the city suffered great damage and severe fines were imposed by the Parliamentary authorities: after the 1646 siege a capital levy of 25% on every man's estate had been imposed, and after the 1651 disaster an even more severe fine, leaving the city impoverished. But there is evidence to show that recovery began almost immediately, new houses being built from 1646 onwards; and the following century saw the erection of new churches and the general 'gentrification' of the city.

The well-to-do families built fine houses beyond Sidbury Gate on the site of

the demolished fortifications around Fort Royal, Wheatsheaf Hill and Green Hill, and especially lining the highway in the northern liberty, into Claines parish to the Tything. Valentine Green wrote of this latter development that these areas 'hath of late years been selected as a part where one may enjoy retirement without absolutely taking leave of society'. Smaller houses were built beyond St Martin's Gate into Silver Street, and in a few places along the road across Lowesmoor. St John's, too, acquired a few Georgian houses, but it remained almost an isolated village clustering around the church and Bull Ring.

By 1750 the population was about 12,000, for the most part resident within the city walls. The parishes of All Saints and St Andrew's were the most densely populated, containing a third of the city's population. (How things have changed! In 1902 the proportion had been reduced to a twentieth and by the 1970s it was almost nil.)

Beyond the 'liberty post' at the north end of Foregate Street began the parish of Claines which, like St Martin's, has become largely urban during the last 150 years. While St Martin's from the earliest days had an urban nucleus within the city walls, no part of Claines was included in Worcester until the extension of the city boundary in 1837. Up to that date even the dependent tything of Whistones (or Whiston) was a country hamlet, known to the Post Office as 'near Worcester'.

The liberties of the city

Outside the city walls were the liberties of the city, a narrow belt of land which, for the most part, lay within arrow-flight of the embattlements and over which the municipality exercised control. They were mainly kitchen gardens and cow pastures and they remained intact from medieval times right through to the 19th century. The boundaries at the highways were marked by 'liberty posts'. The northern liberty post marking the border between Claines and the city stood a few yards beyond the top of Salt Lane (now Castle Street), and in the south at the Cross at Tewkesbury Lane (now Bath Road) at the bottom of Green Hill. In the west the liberties extended across the Severn to the Bull Ring, and on the east to the old city cemetery at Tallow Hill.

Old street names

In earlier days there were two main types of thoroughfares within the city: the paved 'streets', usually set with round cobblestones, and 'lanes', with their natural earth surfaces hardened through use. When the lanes were paved their names were sometimes changed. Listed overleaf are some of the many changes which have taken place over the centuries (some of the names in the lefthand column themselves corruptions of still older names).

Changes in the city boundaries

The ancient boundaries of the city comprised 318 acres and remained unchanged from medieval times until 1835 when the Municipal Reform Act brought about great changes in the government of the city. In 1837 the liberties were absorbed into the city and its boundaries extended by 966 acres.

Baker (Baxter) Street	to the Shambles	Huxterstrete	to Little Fish Street (now part of Deansway)
Bedlam Lane	to Thorneloe Road		
Bishop Street	to Palace Yard		
Britteport	to Birdport (now part of Deansway)	Incle (Hinton) Lane	to Hylton Road
Brodestrete (Broode Street)	to Broad Street	Mary Vale	to Merryvale
		Melechepyng	to Mealcheapen Street
Castle Grounds	to College Green		
Clap Gate	to St Martin's Gate	Needlers Street and Baynham's (Ballam's) Vine	to Pump Street
Clement's Street	to Tybridge Street		
Cokenstrete (Cooken/ Cuken Street)	to Copenhagen Street	Oxford Road	to London Road
Corncheapen	to Queen Street	Powick Lane (top part)	to Bank Street
Corviserstrete	to Fish Street		
Cut Throat Lane	to Lansdowne Road	St Mary's Steps	to College Precincts
		St Lawrence's Lane	to Union Street
Dishmarket	to Church Street	Salt Lane	to Castle Street
		Sansome Fields	to Sansome Walk
Eport	to Newport Street	Sansome Stile	to Sansome Place
Forest Street	to Foregate Street	Tolley's Hill	to Tallow Hill
Frerenstrete	to Friar Street	Todmorden Knoll	to Edgar Street
Frog Lane (or High Timber Street)	to Severn Street	Town Ditch	to Sansome Street
Gardners Lane	to Shaw Street	Union Lane or Garden Market	to St Nicholas Street
Gloucester (Tewkesbury) Road	to Bath Road	Turkey (Torquay) Street	to Tyebridge Street
Glover Street	to New Street	Withy Walk	to St Paul's Street
Gosethrote (Goosethrottle or Goose) Lane	to St Swithin's Street	Wooden Stair Street	to Quay Street

Thus at a stroke the urban area was more than quadrupled to 1284 acres. The municipal boundary now ran from Salt Lane to Barbourne Brook in Claines parish. In St Martin's parish the boundaries extended from the bottom of Tallow Hill to a line on Shrub Hill and St Catherine's Vale.

The next move to change the boundaries was in 1867 when a Commission of Enquiry was held, resulting the following year in the extension of the parliamentary representation boundary to 2,000 acres, including parts of Hallow, Claines, St John's, St Martin's and St Peter's. Not until 1885 were there moves to make the municipal boundaries the same. In 1914 a further 500 acres were added to the city, chiefly in the Bromwich Road area and south-west of the city. In 1931 Lower Wick, Dines Green, part of Nunnery Wood and Perry Wood were absorbed; and in 1951 the city boundaries were extended to include the rest of Nunnery Wood and Astwood, making the area nearly fifteen times larger than the old walled city. The development is best seen tabulated as follows:

Before 1837	318 acres	1901	3185 acres
1837	1284 acres	1931	3700 acres
1885	2000 acres	1951	4450 acres

Population

In 1646 the number of inhabitants within the city was 7,176; there was also a

large garrison of 2,007, making a total of 9,183. But it was not until the 19th century that accurate figures became available from official census returns:

1801	13,670	1851	29,956	1901	46,771	1951	62,096
1811	16,164	1861	32,837	1911	47,771	1961	65,923
1821	21,542	1871	34,469	1921	49,160	1971	73,445
1831	25,581	1881	35,072	1931	48,833	1981	74,990
1841	28,250	1891	42,908	1939	56,378	1991	81,755

*From Littlebury's Directory, 1922

The old corporation

In the days of the old Corporation of Worcester, before the Municipal Reform Act of 1835, the general body of citizens had no voice in local government. The council was a self-elected body, vacancies being filled at the will of the surviving members.

Membership of the council was esteemed on social grounds, it being regarded as 'the best club in Worcester'. Civic banquets were frequent, and the cost defrayed out of corporation funds. For centuries the corporation consisted of two groups: the Twentyfour and the Fortyeight. The Twentyfour were the inner circle of the old self-elected corporation, corresponding to the aldermen of the present day; the Fortyeight, or common council, were similar to today's councillors. It was a 'closed shop' and no reformers were allowed in. Each body had a special rendezvous, the smaller group meeting at the Globe in Powick Lane, the larger meeting at the Talbot on the Cross, which became a bank, then a club, then the Westminster Bank. Later the Fortyeight met at the Pheasant in New Street, where they had their own bowling green and cockpit. Local government reforms followed the parliamentary reform and before 1835 many Acts were passed; but there was no real authority to see these were carried out.

At the new elections at Worcester all but two of the thirty-six elected were 'reformers'. When they took office it was found that the old council's balance sheet, showing a credit of £1,028, was false; it was in fact £1,170 in debt. To cover the debt the contents of the Guildhall wine cellars, including the old port, the special glory of the aldermen and 'Capital citizens', were sold to the highest bidder, fetching 64s a dozen. The corporation had been in debt before. In 1822 it was obliged to borrow £50 each from twenty members, and the sums were paid off 'out of their savings'. In 1824 the mayor's feasts were suspended.

Municipal privileges

In 1227 Henry III granted the citizens of Worcester, by charter, the privilege of appointing two of their number to act as governors of the temporal affairs of the city. They were known as high bailiff and low bailiff and were allowed to hold office for one year only, the low bailiff usually succeeding as high bailiff for the following year.

Under Philip and Mary's charter of 1555 Worcester was granted the right to carry a silver staff before the aldermen and a gold mace before the bailiffs; and to hold three markets each week, and four fairs annually. In 1621 James I decreed by charter that in future Worcester should be a separate county and

known forever as the 'County of the City of Worcester', with a mayor at its head instead of two bailiffs. There is only a handful of cities which are counties in their own right, and this particular decision led to a complication when the county of Worcestershire built its Shirehall and law courts within the city boundary, believing the city to be part of the larger county. To remedy the mistake, the Shirehall and its grounds, by Act of Parliament, became an island of Worcestershire within the city.

The city has another unique privilege in having two coats of arms. For a long time, however, they were incorrectly used — even appearing wrongly on civic buildings — by being superimposed one on another. Today they are displayed linked, but separated. Originally, Worcester had a 'loving cup' which had belonged to the guilds in or before the 12th century, but in the 1830s the silver, together with that from the corporation forks, spoons and dishes, was melted down and worked up into four maces which are now carried before the mayor. It is very unusual for a city to be permitted four; the great majority have only one.

The Guildhall

The first town hall was a large structure of timber with a piazza in front and, at the end of the piazza, a row of shops. The principal entrance was down a flight of nearly twenty steps and the body of the hall was open to the roof. In those days the gaol and gaoler's house were located there and the gaoler was allowed to sell liquor and other things. This gaol was used for 'citizen' criminals, while the prison in the Foregate housed foreign offenders. The assizes and quarter sessions were held there until 1622.

By the beginning of the 18th century the Guildhall was in a fairly dilapidated state and there was an urgent need to do something about it. Lord Somers proved a powerful ally in high places: materials were purchased in 1717 with gifts from prominent citizens, building was started in 1721 and completed two years later, at a cost of £3,730. The wings were added later, completing what is generally regarded as the finest civic building of the period.

It has always been considered to be the work principally of Thomas White, a Worcester man (though one or two have questioned this). It is certain that he did all the sculpture, except the figures of the two Charles which flank the doorway. White was made a freeman for having made 'a handsome effigy of Queen Anne' which originally stood on a pedestal before the old Guildhall, but was later placed in a niche above the door of the present building. The entablature of arms is the most magnificent in the country and has White's name on it. The top is ornamented with five symbolic statues: at the centre is Justice, blindfolded with sword and balance, Peace with olive branch, and Plenty with cornucopia; at the north end Chastisement; and at the south Hercules, or Labour. White was paid a £30 annuity but at his death in 1748 he was owed £165, which he left in his will to the Worcester Infirmary. (The amount was finally paid in 1753.) The south wing was built in 1727 and became a popular coffee house, and was so maintained until the mid-18th century.

While Judge Wilmot was presiding in the Nisi Prius Court at the Spring assize of 1757 a violent storm blew down a stack of chimneys which fell through the ceiling, killed six men on the spot and injured several others. The

One of old Worcester's 'Charlies', this one outside St Helen's church, c.1910

judge narrowly escaped and had to be rescued through a window. Both county and city courts were held there until the Shirehall was built in 1835. The wings of the Guildhall were let to private individuals until the mid-19th century. In the lower hall are a number of interesting relics of the past: armour and a cannon left behind after the battle of Worcester, and also the chain of a pirate chieftain named Jo Hassem. On the walls are leather buckets and large hooks that were used when fire broke out in the city — certain persons having special buckets when the fire bell was rung from St Andrew's church.

Guildhall restoration

Few people know that for twelve years the fate of the Guildhall remained precariously in the balance as the city council juggled to and fro, first for its demolition, then for complete reconstruction.

In 1866 the Assembly Hall had developed serious faults. The following year the Worcester architects Henry Rowe and W H Bidlake surveyed the structure and found it unsafe. For four years the council debated the problem and eventually the Building and Property Committee recommended plans for the complete rebuilding. In 1872 it was announced that a public competition would be arranged to provide plans for a much larger civic building, an announcement which sparked off a storm of protests. Meetings were held and resolutions were sent to the mayor deploring the council's decision. The protesters were of two kinds: those who were shocked at the decision to destroy the old hall, and those whose sole concern seemed to be with the expense of rebuilding.

In any case, having a competition was one thing but getting the work started was another. In the following year, 1873, the motion for rebuilding was lost by one vote. But the struggle continued. Early in 1875 Alfred Waterhouse, the eminent architect of the town hall in Manchester, was selected to prepare plans for rebuilding and in November of that year he presented an elaborate report, illustrating schemes for a Gothic guildhall with a massive tower, at a cost of £35,000. The news of the decision to involve Waterhouse must have leaked out to his greatest rival, Sir George Gilbert Scott, who wrote the following letter to the town clerk, printed in the magazine *The Builder*:

> I do trust the report is untrue that your Corporation are about to destroy the best and most valued building in your city, next to the Cathedral. I refer to the Town Hall. It is a national example of architecture, and that of a very characteristic and favourite style and period. Its destruction would be a repetition of the disgrace Worcester underwent from the demolition of the Guesten Hall, and would give you in all future time a most unenviable notoriety.

The reference to the Guesten Hall touched a raw spot and consequently, and not surprisingly, the plan had a difficult passage. Nine motions were defeated and eventually the Waterhouse plan was abandoned.

The seesaw decisions continued until at last, in 1878, a decision was made to restore the old building to a scheme prepared by Sir George Gilbert Scott and Henry Rowe. Scott, in fact, died before the work started, and Henry Rowe was left to see the work through to a finish in 1880, at a cost of £22,623. Among the work done was the entire renovating of the Assembly Room with a new ceiling of increased height, coved and richly ornamented.

Oak Apple Day

For many years on Oak Apple Day it was the practice to decorate the Guildhall gates with oak boughs from the Coventry estate in honour of the return of Charles II from exile. At the Restoration in 1660 Worcester had a great celebration, for it was confidently thought that some special mark of appreciation would be shown to the city which had suffered so much during the Civil War. But Charles never returned to Worcester and the new order of chivalry 'The Order of the Royal Oak', of which Sir William Russell, governor of the city during the first seige of 1643, was to be a member, was put aside. Many Royalist sympathisers in the city were disillusioned by the king's selfishness and broken promises, and there was no love for James II who followed. During the Stuart rebellions of 1715 and 1745 the city was, not surprisingly, strongly Whig and Hanoverian.

The celebration of Oak Apple Day was revived by the Tory faction in the city at the end of the 18th century when political views changed mainly because of the fear of what the French Revolution might bring.

The mayors and municipal uniforms

The first mayor was Edward Hurdman who held the office in 1621. He lived in a house on the corner of Broad Street and his monument exists in All Saints

church. Alderman William Lewis seems to have been the only man to be three times mayor of Worcester — in 1844, 1845 and 1846. On the last occasion Edward Lloyd had been installed but died soon after his election and Lewis, then deputy mayor, undertook the office for the remainder of the term. The portrait of Lewis in the Guildhall is by Solomon Cole, of local renown. Edward Lloyd was the last but not the only mayor to die in office: there were four others, two of them in one year, 1723, (Moses Lilley and William Ballard).

The Municipal Reform Act of 1835 enabled the Radicals to bring in sweeping changes and to abolish old privileges, one of these being the wearing of gowns. The colour of the gowns of the mayors and members of the council had been settled by charter: scarlet for the mayor and murray for the ordinary members (though members who had passed through the chair continued to wear their scarlet mayoral robes). For fifty years this was all abolished and aldermen and councillors appeared in public in ordinary civilian clothes. Only the municipal servants wore uniform and they were supplied with very elaborate liveries (meaning that the garments had to be delivered up to their successors in office). These officers included the sword bearer with his magnificent feathered cap, the mace bearers, town crier, hop weigher, wool tester and leather tester.

In the mid-19th century the Worcester sword bearer was known as 'The Worcester Giant' as well he might, for he stood 7 foot 6 inches. His name was Benjamin Holmes and he died in 1892. The city state sword has a blade which dates from the reign of William III and a locket placed on it in 1732 by Mayor Samuel Taylor and Sherrif James Saunders. In 1864 a chain was presented by subscribers to the mayor (who was then, to confuse matters, a man called 'Sherrif') at his house on Shrub Hill, and then by him to the city.

The town crier's calls at Worcester

The city employs a town crier who carries a silver-topped staff and walks a pace or two ahead of the mace bearers when the mayor and corporation process. However, it is many a day since his traditional cries were last heard in the streets of Worcester. This one in the early hours:

> God give you good morning, my masters, past three o'clock, and a fair morning.

Worcester rose early about its work in those days and went to bed early too. If there were some who tarried they would have heard the day's last cry as midnight struck:

> Twelve o'clock. Look well to your locks, your fire and light, and so good night.

Perhaps, better still, would have been the earlier admonition inviting sleep:

> List good people all.
> Past ten o'clock, the hour I call,
> Now say your prayers and take your rest
> With conscience clear and sins confessed.
> I bid you all good night.

The Nonconformist mayors

Not until 1828 were Dissenters allowed to hold public office. When they did there was sometimes an inclination to break with accepted customs. Mr Richard Padmore was the first Nonconformist mayor in 1849. He declined to have a procession to either the cathedral or his place of worship, Angel Street chapel, and would not wear a mayoral robe.

Thomas Rowley Hill, another Nonconformist, returned to the tradition by attending service 'in state' at the cathedral, but discontinued the practice of giving an official breakfast to the city fathers on Sunday morning as a preliminary to the religious observances. Instead, he gave one on a weekday and afterwards the company proceeded to the cathedral. Discreditable scenes used to occur at these breakfasts, however, with grabbing and clutching of food and wine by 'individuals whose appetites were better than their manners' and the practice was discontinued.

Joseph Wood, a well-known builder, was mayor in 1860–61. As a Nonconformist he did not hesitate to enforce his views on Lord's Day observance in the teeth of violent opposition — by closing all shops and beerhouses at certain times on Sundays. Satirical rhymes were sung about him and his effigy was burnt on Pitchcroft. Yet even he did not dare to appoint a Nonconformist as his official chaplain. Not until 1910, in Mr Thomas's year of office, did this happen.

The mayor's chaplain

The mayor's chaplain as we know him is a modern revival of an old custom. In 1614 the Worcester corporation appointed a lecturer 'to preach at the College every Sunday', and this led to disputes, particularly as the lecturer appointed was a Puritan, not at all approved by the cathedral chapter. The chapter wanted one of its own number to be appointed, but the 'City would not suffer a prebend' to hold the appointment. The times were delicate. The Civil War brought ruin to the chapter and to the city and the Restoration found both too impoverished to continue the struggle. In the end the corporation was glad to save the cost of a lecturer and cheerfully left the chapter to do their own preaching.

St Helen's church: the County Record Office

St Helen's is the city's most ancient church, dating back to AD 680 and believed by some historians to be on the site of a Roman temple. It was named after Helen, the mother of Constantine. The present building is mainly 15th century but has suffered drastic restorations. The tower was remodelled in 1820 and in 1879 Aston Webb restored the whole church. The reredos and east window were designed by F Preedy. There was a set of notable bells, cast in 1706 by R Sanders of Bromsgrove, with inscriptions commemorating Marlborough's victories over the French. A family, also named Sanders, who lived in Fish Street, rang the curfew there for many years and when the old bellringer's rheumatism was bad Edward Elgar, a young teenager, often deputised for him. The curfew was rung nightly until 1939 when it was stopped because it was thought it might cause confusion in the war.

There are two notable tombs in St Helens: that of Alderman John Nash, a captain in the Parliamentary forces, and that of Dud Dudley, Royalist general of artillery. In life they were bitter enemies, in St Helen's they lie under the same roof but on opposite sides of the church.

Following the clearance of the overpopulated parish St Helen's was united with St Alban's in 1882; then with St Andrew's and All Saints just before the Second World War; and finally the church closed in 1950. It was a period which saw the destruction of the central churches of St Michael's and St Andrew's and the using of others for new purposes. For some time the fate of SS. Swithun's, Martin's, and Paul's was in the balance. They withstood the pressure but St Helen's became the County Record Office, now a haven for research and a most important feature in the cultural life of the city.

The mystery of Shakespeare's marriage bond

The most treasured possession of the Record Office is the marriage bond of William Shakespeare, which has posed a mystery for scholars. On 27 November 1582 a licence was issued for his marriage to Anne Whateley of Temple Grafton, but the next day a bond was entered into for his marriage to Anne Hathwey (Hathaway) of Stratford-on-Avon. A misrendering of the surname of the bride is possible, but the variation in her place of residence is surprising. A commonly accepted view is that the marriage was a 'shotgun' affair, that Shakespeare had intended marrying Anne Whateley but her rival, several years older than him and already carrying his son, learned of the intention and forestalled her. The presence of these records at Worcester is explained by the fact that until 1918 Stratford-on-Avon was in the Worcester diocese.

The King's Head Theatre

During the 18th century few places had a theatre that was not a barn or some other improvised building. At Worcester the theatre was a wooden building in the yard of the King's Head Inn, opposite the Guildhall in the High Street. The first report we have of it is in the *Worcester Postman* of 4 January 1717 when 'Oedipus, King of Thieves' was performed.

The King's Head Theatre was let to travelling companies and for a number of years it was managed by John Ward and his son-in-law, Roger Kemble, the father of the 'divine Sarah Siddons'. Sarah Kemble, as she was then, made her first appearance there in 1767. After years of drudgery and failure she played at Drury Lane and caused an overwhelming sensation. London was infatuated and the public talked of little else. William Hazlitt, the English critic, wrote: 'To have seen Mrs Siddons was an event in everyone's life.' She reigned for years as the very Queen of Tragedy; and several leading artists of the day — Sir Joshua Reynolds, George Romney, Sir Thomas Lawrence — painted her portrait. There is also an earlier picture of Sarah and her fellow actors at the back of the King's Head in Worcester, this one painted by John Opie, the Cornish portrait and history painter.

Though Worcester's was not an important theatre, yet it was the home of some of the greatest stars of the 18th century stage for, besides Sarah, there were her brother and sister, John and Fanny, for many years at the peak of

their profession. In 1783, however, the old wooden theatre in the inn yard was regarded as no longer worthy of the fashionable provincial capital Worcester had become; and once the new theatre in Angel Street was built there is no further record of the old theatre being used.

The Elgars — father and son

In the High Street Mr W H Elgar (Edward's father) kept a shop which he founded in the early 1860s. He had come to Worcester in 1841 from Dover as a pianist and tuner for a London firm of pianoforte makers. Later, he was joined by his brother, and the business became known as Elgar Brothers. Later still,

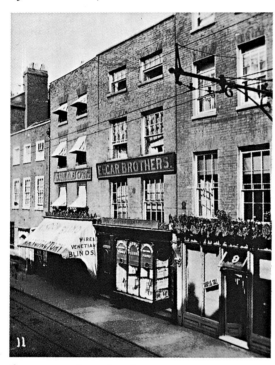

Elgar Brothers, the music shop in the High Street opened by Elgar's father in the early 1860s

it was tranferred to his son, Frank. W H was well to the fore in the musical life of the city. He was an active member of the City Glee Club; he played the violin in the Three Choirs Festival orchestra and was organist at the Catholic church for thirty-five years until 1884 when he was succeeded by his son Edward.

The story of Edward Elgar has often been told. Briefly, after a short spell in a solicitor's office he left of his own accord to start on the struggle of making his way as a professional musician. He had a teaching engagement at a girls' school at Malvern and led the band at the mental asylum at Powick where he composed dances for that institution. (The scores are still there.) He also gave private lessons at Malvern, and at the age of thirty-two married one of his pupils, Alice Roberts, the daughter of a major-general — who immediately showed his displeasure by virtually disowning the couple.

There were years of unrewarding struggle in London and back in Malvern.

Then, when he was around forty, his work was at last recognised, though only in Germany at that stage: England took longer to appreciate him. His *Enigma Variations*, *The Dream of Gerontius*, and the *Pomp and Circumstance Marches* were all composed in Malvern. After his wife's death in 1920 Elgar came back to Worcester to live in his last home at Marl Bank on Rainbow Hill.

The Austins — another musical family

When Elgar was leader of the Worcester Festival Choral Society's band, J W Austin was his second, and on starting the Orchestral Society Elgar entrusted its leadership to Austin, which led to a long and close association between the two men. When printers' proofs of Elgar's new works arrived they went through them together, Elgar playing on the piano and Austin on the violin to detect any errors. As a reward for this labour Elgar always gave the proof copies to Austin, who eventually had a remarkable collection which included *The Dream of Gerontius*, the *Pomp and Circumstance Marches*, *The Kingdom* and Elgar's concertos and symphonies.

Music was in the Austins' blood. Three generations directed the orchestra of the Theatre Royal. J W's father did so for thirty-five years, and J W himself joined the orchestra at the age of twelve, at once winning the notice of touring conductors of opera companies. At one time the theatre orchestra might have been called the Austin band, for there were seven or eight members of the family playing in it.

St Andrew's parish

In the 16th and 17th centuries St Andrew's was a bit of a mixed bag. Poor lists of 1557 suggest it had more than its share of the poor; but proximity to the quay and the High Street attracted a number of rich citizens, so that despite general poverty there were some wealthy parishioners living, in particular, in Copenhagen Street and Quay Street. Some of the pleasure grounds in St Andrew's had terraces overlooking the river with fine views of the Malvern Hills, as the Old Palace garden has today; and its narrow tortuous streets contained a number of good houses. But these were later diverted to business premises or converted into tenements, whilst their large pleasant gardens degenerated into courts and alleys crowded with small squalid dwellings.

Many of these residents held important civic offices, like George Hall, for example, bailiff from 1613 to 1614. Between them the Hall family filled the office of bailiff no less than sixteen times during the 15th and 16th centuries; and one of their members sat in the Convention Parliament of 1600. John Street, bailiff, and George Street, mayor, came from St Andrew's; and other leading families resident in the parish were the Cheatles, the Wylds, a branch of the Commandery family, the Soleys, the Cookseys, the Percys, the Brintons and the Hoopers — all names connected prominently with local affairs for centuries.

In 1750 one third of the population of the whole city lived in the two parishes of St Andrew's and All Saints; by the early 19th century St Andrew's had a vast population. Not until the mid-19th century did the parish take the final plunge, when the growing taste for surburban homes led to the conversion of town houses into offices, warehouses and tenements. In the 1860s St Andrew's

could still count among its residents the Webbs, Stallards, Stephensons and Rowes; after that the fine houses became dingy and dilapidated, used mostly as common lodging houses, now standing among a maze of small dwellings and courts. The clearances which had begun in Birdport in 1910 were halted by the 1914–18 War; but they began again in the 1920s and the area was finally cleared in the late 1940s, including most of the parish church, founded in the 12th century.

St Andrew's spire and the extraordinary repair by kite

The tower and spire of St Andrew's church are all that remain of the building. The spire, surrounded by the College of Technology, was built by the master stonemason and builder, Nathaniel Wilkinson, in 1751; but there was a steeple before Wilkinson's and it is frequently mentioned in records. Noake, for example, quoting from the parish records, writes: '1618, Paid for repayring and mendinge ye wether cocke, 5s.10d., gilding ye cocke £1.' A fatal accident occurred at this time for sums are charged for 'buriall of man who undertook payntinge of ye steeple', and for 'coveringe the grave where the man was buried that was misventured in the church'.

But Wilkinson's spire is unique, the slenderest in the country if you compare its height with its base: it soars 155½ feet high, rising from a 15th-century tower of 90 feet, yet only 20 feet in diameter at the base, and scarcely 7 inches at the top, where it is surmounted by a Corinthian capital and weather vane. This graceful tapering spire has long been known locally as the Glover's Needle.

Extensive restoration has taken place many times but the repair of the spire by kite in 1870 was extraordinary. An article in *The Builder* of 4 June 1870 is worth quoting:

> Mr George Frith, of Coventry, builder, who recently repaired a spire at Hereford by simple and inexpensive means, has been employed in this case also, as in others besides Hereford. Standing on Payne's Meadow, he flew a kite carrying a holding string, which he manoeuvred as to be securely passed over the top stone of the spire and round the rod which supports the weathercock. To this thin kite line was then attached one somewhat thicker which was drawn over, which in its turn gave way to a rope . . . under an inch thick. To this rope was fixed a block . . . which formed the means by which the adventurous climber reached the top. From this was suspended, by means of cords passed through the four corners, a small piece of board, just large enough to form a seat, and to the rope on the other side of the block were fastened large weights, 12 stone in all. The space between the seat and the weights was the height of the spire . . . the weights being a form of counterpoise. The ascent did not occupy more than a minute, being accomplished with the greatest ease. In this ascent, Frith kept himself from the wall with his feet by a walk-like motion. Arrived at the top, he left his seat and stood on the top stone, upon which the crowd below burst into a loud cheer. 'Steeple Jack' answered the cheer from aloft, after which he took off the weathercock, examined it and replaced it. He repaired a defect in the lightning conductor.

Some curious incidents are connected with the repairing of St Andrew's spire.

In 1801, while repairs were being made, a barber named Bayliss shaved several of his customers on the top of it; about the same time a china painter named Cotterill carried to the top a small cup, which he proceeded to paint; and on another occasion, when the weathercock was being repaired, James Powell, a Worcester wine merchant, assisted by James Knight, the editor of the *Worcester Chronicle*, cracked open a bottle of old port on top of the spire.

Beating the bounds

The first essential of parochial organisation was to define and maintain intact the parish limits. For centuries this was done by 'beating the bounds'. When mapping was in its infancy some 200–300 years ago, beating the bounds was a serious business. Knowledge of the boundaries was preserved by oral tradition, so that frequent beatings of the parish border were necessary.

Great precision was observed and the leaders were sworn to keep to traditional limits. At St Andrew's, where the boundary comprised part of the river bed, there was payment for boat hire: the 'beaters' rode up the middle of the Severn prodding the bed of the river with long poles. At St Helen's choirboys were 'bumped' at the corners of the parish (and photographs exist of this ceremony, witnessed by old men, who in their youth were bumped at the same places). In most parishes it was an annual affair and was attended by much merrymaking. Eating and drinking was considered very necessary with all sorts of parochial duties and functions.

St Alban's church

In Deansway stands St Alban's church, the oldest complete church in the city. The 12th century building has none of the stateliness of the rest of the town's churches but rather the appearance of a little country church. It stands on what was once the corner of Fish Street and College Yard, and until the 18th century was still flanked by cottages on the one side and the mansion built by the Warmstry family on the other, with a view across the cathedral meadows. Then the mansion became first the Worcester Porcelain Works and then Dent's glove factory, and the three-storey Model Dwellings supplanted the cottages. Today the church stands almost unnoticed, dwarfed by the College of Technology.

The parish is even older than the building, dating from the days of St Ecgwin; for in 1022 we know it was ordered not to challenge the claim of St Helen's to be the oldest parish church in the city. From 1840 to 1862, during the incumbency of Rev J H Wilding, St Alban's church became a centre of the Oxford Movement, or 'Tractarian teaching', which was so hated but which nevertheless changed the Church of England. Nearby, in 1840, John Nicholson founded his organ works in a cottage in Palace Yard and built his first organ in the Countess of Huntingdon's chapel in Birdport.

The Warmstry Mansion

The Warmstry Mansion stood on the high ground next to the Bishop's Palace where now part of the College of Technology stands. It was a large handsome

early-17th century building crowning the summit of the steep ascent from the river which formed the pleasure garden, commanding the view over the river meadows to the Malvern Hills.

As late as 1837 it was described as 'one of the finest specimens of ancient, internal domestic architecture in the City of Worcester . . . with a few of the old rooms preserved in their original state . . . the library of the house is a lofty and spacious room, wainscoted with oak, carved in various parts with different devices and the arms of the family of Warmstry. The fireplace is of very ample dimensions, with handsome pillars on each side, and the chimneypiece decorated with scrolls extremely well cut. Surmounting it, the Royal Arms of England appear curiously carved, and around the room may still be seen the antique bookshelves with the scalloped border of green cloth remaining quite firm in its texture. Adjoining the library is a small study, fitted up with bookshelves in the same style.'

In the 18th century some of the buildings were used by Doctor Wall for his experimental porcelain works which were to become world famous. Later the great house became Maw's Tile Works and then Dent and Allcroft's glove factory. In the garden, at the river's edge, Stallard's distillery and wine warehouse was built, all ready for the ships which were to bring wine direct from the Continent. Apart from the one vessel which they owned, the *SS City of Worcester*, the ships never came: and in 1853, after only four years of importing wine and brandy from France and Portugal and sending out 'Worcester gin', the boat was sold to Glasgow merchants. Warmstry Slip, which disappeared in the building of the college, preserved memories of the mansion until the 1960s. Halfway up the slip the first barracks for soldiers were erected in the city; and later, in 1722, a group of almshouses known as Jarvis's Almshouses were built there, probably converted from the barracks. These were rebuilt in 1869 and remained until the housing clearances in the 1930s.

The market hall, High Street

When the new theatre in Angel Street was opened in 1779 the yard of the King's Head Inn opposite the Guildhall became a general market, with a jumble of stalls and awnings. But public opinion soon began to favour a special market hall for such activities and in 1804 the King's Head Inn was demolished and in its place a permanent market established with a fine stone frontage dignified by supporting columns bearing the city's arms. In 1849 the mayor, Richard Padmore, presented the building with a handsome clock 'with self-illuminating dial' (by gas) of some 5 feet in diameter, at a cost of £200.

By the 1850s the Great Exhibition building in Hyde Park had set new standards for such public buildings, and in 1857 the market was rebuilt, keeping however the fine stone front. The new market was 233 feet long and almost a copy of the transept of the Crystal Palace. Like the original, the glass roof was supported by hollow cast-iron pillars, which conveyed the rainwater from the roof to the drains. In its day it 'vied with any other of its size in the kingdom alike for its elegance of design and accommodation'. Until the 1939–45 War the market was well used by country people bringing in butter, eggs, bacon and cheese, flowers and other farm and horticultural produce. But postwar plans led to its demolition and in place of the fine market frontage

facing the Guildhall there was erected a most nondescript building surrounding a passage called an 'arcade'. This marked the beginning of the wholesale destruction and tasteless rebuilding of the city's centre which brought condemnation from all parts of the country and came to be known as 'the rape of Worcester'.

Social life at the inns

In the 18th and early 19th centuries the great centres of social life were the inns where regular customers foregathered to smoke and exchange the news of the day with such regularity that each man's chair was reserved for his special use. Each quarter of the city had its favourite tavern and members stuck staunchly to their 'house', growing old, it is said, in the same chairs.

Inns served as clubs for tradesmen and professional men, having a standing chairman who called for order and for songs. John Calvin, a venerable corporation officer, gravely presided in the smoke room of the Golden Lion, High Street, and Mr McMillan, the editor of the *Worcester Herald*, was the lion of the nightly gatherings, filling the role of a local Dr Johnson.

There was no heavy drinking, only home-brewed ale and long churchwarden pipes, the latter playing an important part in the social life of the mid-19th century, and imparting a dignity to the smoke room. The length of the pipe exercised a potent influence upon conversation. Quick repartee was impossible and the necessary deliberate pull afforded time for reflection and for formulating Johnsonian phrases, which delighted the customers of Widow Price, the Golden Lion's buxom landlady.

In the mid-19th century newspapers were costly and few people could read them; and so it was not unusual on the night when the weekly newspaper appeared for someone to read the news aloud for the benefit of the assembled company, with appropriate intervals of course for the serving of liquid refreshments. At the Golden Lion and the Bull's Head opposite the Guildhall a reader was appointed and crowds of listeners used to imbibe the news of the day with their 'baccy and beer'. At the Union Inn, Lowesmoor, a pun announced that the news was read there by a child — but the child was Mr J Child. Once the tax on newspapers was removed in 1855 the practice of public readings in inns continued only where serious tradesmen and artisans gathered.

John Oswen, Worcester's first printer

The High Street was for centuries the street of printers. The first of that craft to practise in Worcester was John Oswen who was licensed in 1549 to print religious works. Worcester was one of the earliest places in the British Isles to have a printing press, preceded only by Tavistock in 1525, Cambridge in 1521, York in 1509, Edinburgh in 1507, London and St Albans in 1480 and Oxford between 1478 and 1486.

Oswen was the most famous of the three printers in Ipswich. He is known to have printed at least twenty-nine works, though very few have been preserved. He is said to have been patronised by Cardinal Wolsey and came west on appointment as official printer for Wales and the Marches, which included the counties of Worcester, Hereford, Gloucester and Salop. Like Caxton and other

early printers he also translated some of the books he printed. His religious views were strongly Protestant and when Queen Mary came to the throne his work ceased. He probably took cover on the Continent; and his books were proclaimed heretical, every possessor being ordered to submit them to the authorities for destruction on pain of summary execution as a rebel. Hence, the extreme scarceness of the volumes.

Berrow's Worcester Journal — the oldest surviving newspaper in the world

The very first newspapers were news-sheets published by 'spies' or reporters frequenting the London coffee houses to keep the gentry aware of what was happening at Court or Parliament, whilst they were back at their country seats. Among the London news-sheets, and the only one to survive, was the *London Gazette* which began publication in 1665, the year of the Great Plague; but it was not a newspaper in the modern sense, for it gave only official Court news. There was no provincial press at all until the 18th century.

In 1709 a four-page newspaper was issued by Stephen Bryan of Worcester every Friday, bearing the title of the *Worcester Postman*. Some time before 1713 it had become six pages, but the last was often blank. Then later it reverted to four pages. It was not a bit like a newspaper of today: it was printed in large type, with no columns, and on much smaller paper, 11 inches by 7 inches. In 1725 the title changed to the *Weekly Journal* and at Bryan's death in 1748 it was purchased by Harvey Berrow. In 1753 Berrow added his name to

The Worcester Post-Man
(later Berrow's Worcester Journal*),*
6 August 1714

the title, for there were 'journals' springing up in many towns; and so it became *Berrow's Worcester Journal* and was published on Thursdays. Upon the death of Berrow it passed through marriage to Mr Tymbs and his son, and then in 1822 Tymbs took into partnership Henry Deighton who by 1836 was the sole owner. Deighton printed and published the paper from 53 High Street, where his family had been booksellers, printers and lithographers for well over a century.

For many years it was the only Conservative paper in the area, and was well supported by the party. Then in the late 1870s the party promoted the idea of its own cheap weekly Tory paper. Instead, it linked officially with Berrow's, now a limited company, and the result was a ½d daily newspaper, the *Worcester Daily Times and Journal*. The first issue came out on 5 January 1880 and both *Berrow's* and the *Daily Times* were printed at the old Unicorn Inn in Broad Street, which provided timely and roomy premises. The *Worcester Daily Times* survived until 1937.

The Worcester Herald and the Holls

At the end of the 18th century William Holl, with the encouragement of Lord Sandys, established a new weekly newspaper called the *Worcester Herald*. The first issue came out on 4 January 1794, printed by Holl at 72 High Street and much favoured by the Whigs. Later under a joint proprietorship of Thomas Chalk and a member of the Holl family it achieved a very extensive circulation. In mid-Victorian days John Noake, as '*Rambler in Worcestershire*' produced invaluable articles for the *Herald* on the county at that time, and in the 1920s Edward F ('Fred') Corbett retraced Noake's steps under the pen name of 'Stroller'.

From the same address in 1834 William Holl also began editing and publishing *The Analyst*, an important natural history periodical, and in 1837 was joint editor, with the celebrated Benjamin Maund of Bromsgrove, of a beautiful magazine known as *The Naturalist*. The Holls were a talented family. Harvey B Holl was a principal contributor to the proceedings of the Malvern Field Club; and Frank Holl was a celebrated Victorian painter, one of whose works — a subscription portrait of Thomas Rowley Hill MP — hangs in the Guildhall.

Worcester — a newspaper centre

No other provincial town or city could match Worcester's newspaper publishing in the 18th and 19th centuries. On 20 December 1834 the *Worcester Guardian* appeared, a weekly newspaper which continued for 628 issues, finishing on 26 December 1848. It was followed by the *Worcester Chronicle*, a radical paper which for many years had a large circulation. It was printed in Copenhagen Street by Messrs Knight and Arrowsmith, the first number issued on 3 January 1838.

In the second half of the 19th century other newspapers appeared, catering for the increased literary interests of the middle and artisan classes. The *Worcester News* was established in 1861 but merged eight years later with another High Street newspaper, the *Worcestershire Advertiser* which made its first appearance on 10 June 1865. In 1937 the *Advertiser* merged with

Berrow's Press to produce a new newspaper, the *Worcester Evening News and Times*, later shortened to the *Worcester Evening News*. Where Boots now stands, the *Worcester Evening Post* started in 1877, continuing until 1883 when it became the *Worcestershire Echo*, a daily Liberal rival to the Tory *Daily Times*. It continued into the 1930s.

The height of Worcester's newspaper activity must have been in 1888 when seven newspapers were being circulated here (not counting the specialist weeklies): *Berrow's Worcester Journal, Worcester Herald, Worcestershire Advertiser, Worcester Chronicle, Worcester Daily Times, Worcestershire Echo, Worcester Sauce*. The latter was a satirical paper with illustrations, published weekly by the Littlebury Press from 1887 to 1889.

Pretty Peggy Cocks

In the 18th century the Cocks family lived in the High Street in a house nearly opposite St Helen's church. They were related to the Somers and Nash families. Lord Somers had died childless and his sole heir was his sister who had married Charles Cocks, the fifth and penniless son of the squire of Castleditch (Eastnor). Until Somers' death however they were always in straitened circumstances. Amusing accounts exist of the matrimonial adventures of their younger daughter, 'Pretty Peggy Cocks' who, being left a very youthful widow by the premature death of the heir of Madresfield, was sent to London to conduct a campaign under the chaperonage of her mother's sister. It resulted in the capture of a young but rising barrister named Yorke and ultimately made Peggy the Countess of Hardwicke. Great wealth eventually came to the Cocks family and a later descendant built Eastnor Castle.

Arthur Cocks — champion

Another member of the Cocks family was the hero of a remarkable military feat that deserves to be more widely known. When Lord Napier was honoured by a civic dinner at the Guildhall in 1868 he drew attention to the presence in the company of a local man who had once been a British 'champion'. In 1848 Arthur Cocks, a member of the Bengal Civil Service, was in Gujerat at the time of the Sikh War. A Sikh swordsman rode defiantly between the two armies challenging the English ranks, in the old way of the East. The Sikhs were fine swordsmen who kept their blades whetted; and it was their boast, and no idle one, that they could lop off a limb at a blow. A few weeks before, an English regiment had received such a drubbing that the regimental surgeon was forced to conclude it could not again be trusted to face the enemy.

No soldier was allowed to leave the English ranks, but it was important to check the demoralising exhibition. As a civil servant Arthur Cocks was under no military restraint and after the taunts of the Sikh he rode at his man. In the clash he received a severe wound but cut down his opponent. In the East the fall of a champion was regarded as an augury, and there was no doubt in the minds of those present that Cocks' achievement made the British success easier and more complete.

County banks

After the Revolution of 1688 English trade and commerce gradually expanded

in the more settled conditions prevailing, and goldsmiths-cum-bankers found no lack of opportunity for financing satisfactory ventures. They became practised in the business of borrowing from one set of customers to lend to others. They also developed a reputation for probity and honourable dealing that was to lay a substantial foundation stone in the economy of the nation. In the 17th century there were no country bankers: each man conducted his own affairs and the movement of hard cash was difficult. The most influential merchants and landed gentry gradually came to open accounts with the London goldsmiths and their primitive banking successors. Thus the monied trader of good repute found himself entrusted with other people's cash and an agent in their affairs. He developed into the country banker with his connections in the city.

The Old Bank

Worcester's first bank in the modern sense was that which for generations was known as the 'Old Bank'. It was established in the middle of the 18th century by Joseph Berwick, though some say by Samuel Wall. It appears both men had had their own banks before; however, their partnership, begun in 1765, dates the Old Bank. Wall was a silk mercer and Berwick had five years earlier been appointed Receiver-General to the County of Worcester. It is believed that he turned that ancient office and its emoluments to particularly good account. The Receivers-General used to receive all quit rents, fee farm rents, and other payments due to the Crown.

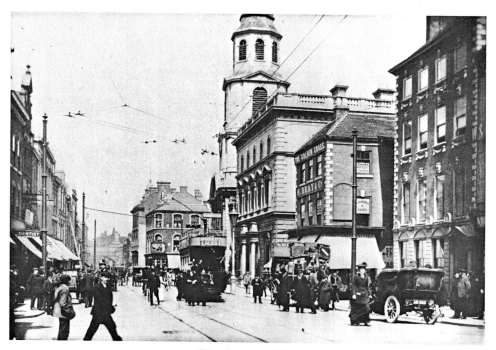

The Cross, c.1910

It is interesting to record that the Worcester and Tewkesbury Old Banks were the only ones in this or the adjoining counties which enjoyed the coveted privilege of issuing private bank notes, and two of only a small number of such favoured banks in the whole country.

The failure of Farley's Bank

County banks grew in great numbers at the end of the 18th century, finding many opportunites for profitable service in financing industry in the period of the industrial and agricultural revolutions. The weakness of the local banks was that their commitments and lendings were not sufficiently widespread. If times were bad for the main industry and heavy withdrawals made, the banker might not be able to obtain loans to meet them. Once there was a breath of suspicion of any difficulty there would be a rush to cash notes or withdraw balances. Often that meant the end of the bank even though, in due time, everyone got twenty shillings for their pound.

In 1825 seventy-three county banks closed, but none in Worcester. There were certainly many alarms though, and there were strange devices to create confidence. The manager of Tewkesbury Bank, for example, heated golden sovereigns on a shovel in the fire to give the impression of minting them on the premises. It was on that occasion that Dr Dixon of Rainbow Hill (on whom *John Halifax, Gentleman* was based) raised a personal loan of £20,000 in gold and, elbowing his way through crowds waiting to withdraw their money, deposited the gold on the counter and 'opened an account'. By example he saved the bank. The grateful banker named his son after him (Sir Dixon Hartland, the last MP for Evesham).

In December 1857 Farley's Bank, which had opened on the Cross in 1798, did not open its doors and great crowds gathered excitedly to read the notice of 'suspension of business' in the window. Despite the presence of Lord Beauchamp, who stood behind the counter in an effort to reassure customers, the bank failed and never resumed business again. It was Farley's Bank on the Cross (now the Westminster Bank) that was celebrated as the Bank of Godolphin, Cross and Godolphin in Mrs Henry Wood's novel *The Shadow of Ashlydyat.*

The Fishmongers' Hall

Fish Street once contained a number of fine half-timbered houses; the finest of them became known as the Fishmongers' Hall, dating back to medieval times. It stood until 1905, but it had been allowed to decay into a dismal ruin and finally collapsed. It had been divided up into nine slum tenements but still had a number of carved oak bargeboards. Under the layers of whitewash four finely carved oak panels were discovered which were sold to Haughton's, the ecclesiastical sculptors nearby. The bargeboards bore the emblematical device — the carving of a fish.

In the 16th century the fishermen of Worcester were restricted to Fish Street in their trading operations. In the Middle Ages and later no-one could trade in the city without a licence, and a rigid scrutiny was kept upon all the fish brought in. In Henry VII's day every fisher paid 1d a day for selling his 'vittell

from the King's bords; also a ½d to the swordbearer for every salmon sold'. The fishermen, according to tradition, could not sell their supply until an alderman or others of the corporation had been round to smell it. Later, two appointed fishmongers were chosen to inspect fish brought into the city to see that it 'was able and seete for man's body'. The 'corrupt and defectyve vittell' was given to prisoners and poor men.

Salmon and apprentices

There was a strong tradition in the city that salmon had once been so plentiful in the river Severn that parents of apprentices in some trades insisted on a clause being inserted in the indentures to the effect that the boys should not be fed on salmon more than three times a week. With the cost of Severn salmon as it is today such a clause seems astounding.

Research into the authenticity of the story is far from conclusive. Nevertheless, it is widespread and can be found in all the towns of the Severn and the Wye, and on other rivers too. Chambers' *A General History of Worcester* (1820) mentions the practice of insisting on the clause in the indenture but so far not a single indenture has been found containing the clause. The present author had the privilege of examining a large number of indentures kept in the parish chest of St Nicholas church many years ago but without success. However, anyone delving into local history knows how persistent are distant events and long-abandoned practices, and despite the absence of firsthand evidence it is unwise to claim that such practices did not exist. It is probable that the salmon story refers to catching of kelts which came down the river helpless and emaciated after spawning. They were easily caught, or often picked up dead, and salted down to make a dreadfully nasty, unwholesome, cheap food.

Cooken Street and the Earl's Post

There were two main streets in St Andrew's parish: Birdport, the main highway through the city from Sidbury Gate to the bridge; and Cooken Street, changed to Copenhagen Street after Nelson's visit to Worcester. It is said that in olden times the cucking (or cuckold) stool, used for the punishment of scolds who were ducked in the river, was taken for that purpose down Cooken Street to the slip near the old Wherry Inn. The stool was also used for the punishment of brewers and bakers who sold bad food and drink.

At the top, on the corner of the High Street, was the Earl's Post, famous for the last stand made by the Royalists at the battle of Worcester in 1651. The name suggests a boundary post and it may well have been the limit of the city in Saxon times. In the 17th century a large house was built on the ancient remains which, at least until 1750, had at its north-east corner an ancient colossal figure of a man carved in wood.

Next down the street, still standing, is a fine Dutch-gabled frontage built about 1660. Its appearance is misleading as the original house was timber built in 1558 on land behind the Earl's Post. Until the 1940s the house was a barber's shop, Mr Harding's, which did much trade with the city councillors

who would pop in from the Guildhall across the street. It was often possible to reconstruct the details of a stormy council meeting while waiting one's turn.

A memorable election

A remarkable election took place at Worcester in 1802 which demonstrates the intrigue and corruption prevalent before the Great Reform Bill of 1832. Before succeeding to the family peerage the 3rd Viscount Ward had represented the city in Parliament for some years, and his son, John William, wished to continue in the 'family seat'.

The Corporation of Worcester, however, had other ideas and proposed the election of Edward Wigley and Abraham Robarts — two candidates for the two seats and therefore no need for a contest. Lord Ward responded by letting it be known that, should his son be elected, coal from his mines which had greatly risen in price due to the war would be sold at half price in the city. The corporation, self-appointed and very much a 'closed body', disapproved of Lord Ward's interference and vetoed any contest; Lord Ward's son had no alternative but to go elsewhere for a seat — but felt he had a score to settle.

On the very day of the nominations, only seven minutes before the close, a third candidate was put forward to the great surprise of the corporation, an unknown gentleman from Great Barr, Joseph Scott by name. In those days voting could last for a week or more, but after four days Mr Wigley found himself at the bottom of the poll (though with only seventeen votes less than the stranger) and realised he could not match the unknown opponent whose resources seemed inexhaustible. Abraham Robarts 'with his accustomed liberality, presented a half-guinea to each freeman of the City who chose to accept it, and the gift was gratefully received by 540 of them'; while the stranger entertained 500 of the poorer of his supporters to a dinner, and 123 of the more respectable to a select banquet at the Hop Pole. Not until the contest was over did it leak out that the last-minute candidate was not only a personal friend but had family connections with the young Mr Ward. Even so, though elected, he did not attempt to repeat his triumph, but retired at the following election with a baronetcy.

Isaac Arrowsmith and the Worcester Political Union

Below the Guildhall yard Isaac Arrowsmith, the stormy radical printer, had his press. He was joint owner and publisher with James Knight of the *Worcester Chronicle*. He retired some time before 1864 and went to Bristol where he published railway guides and the 'Shilling Shockers' for railway travellers, several of which bear his name as author.

Arrowsmith had been the chief spokesman of the Worcester Political Union during the agitation for Parliamentary reform, and when the House of Lords rejected the Reform Bill for the second time he was the leading spirit in a demonstration on Pitchcroft where, on 14 May 1832, a procession of Union members, with flags flying and a band, held a stormy protest meeting. Thousands were present and Arrowsmith gave the opening address. He led further agitation at the Guildhall in 1837 and 1838; and was prominent at all the local Chartist meetings in June 1848, carrying a petition to Parliament in favour of household suffrage and the ballot.

The Worcester Reform Riots

Riots had already taken place in the High Street and elsewhere on 5 November 1831, following the first rejection of the Reform Bill by the House of Lords. Much terror had been caused by the news of severe rioting at Bristol, known as the 'anti-Wetherall riots'. Sir Charles Wetherall was Recorder of Bristol and connected by marriage with some Worcester families. His fanatical opposition provoked the riots at Bristol and for some days the rioters took over the city and burned down public buildings. It was feared that similar riots would follow the day of protest organised at Worcester; 400 special constables were sworn in and the mayor, Henry Clifton, sent a request for the 7th Hussars to be stationed at Droitwich.

The day passed quietly with meetings and petitions until a fire broke out at the back of a shop in the High Street. Crowds gathered, a squabble started, the hose of the fire engine was cut and the mob took this as a signal. Windows were smashed in the Foregate and the bells of the city churches were tolled to give warning. The mayor sent for the military but in the interim addressed the rioters, promising to release those already taken to gaol, but refusing to release all the prisoners in gaol which the mob was urging. On their arrival at 1.15 am the Hussars were stoned by the crowd and as the mayor read the Riot Act he too was struck by a stone and ordered the military to clear the streets. A fight took place and several were cut by sabres, but none seriously. Thirty people were taken into custody but most were conditionally released. A few, though, were sent to the treadmill and the city remained restless for two or three nights.

The Model Dwellings

By the 1840s the area around St Andrew's Church had become one of the most squalid and degraded parts of the city; poverty and overcrowding were desperate, with a high death rate. Between Copenhagen Street and Warmstry Slip in St Alban's Square some sort of solution was attempted: 'Model Dwellings', the forerunners of our modern council houses. To those who remember them they looked like grim barracks, anything but 'model'. Yet they were a vast improvement on the hovels and rookeries which then housed the poor.

In the 1850s public opinion did not favour interfering with slum dwellings and definitely not aided municipal housing; but in 1854 a semi-public company was formed by Dr Charles Hastings and others, the 'City of Worcester Association for the Buildings of Dwellings for the Labouring Classes', which was expected to make a 5% return on the money invested. In fact, it rarely did; but as a philanthropic venture it was a success. In ten years the death rate of the locality was reduced by nearly half: from 20 per 1000 in 1854 to 11 per 1000 in 1864. But with the improvement in working conditions the artisan class (for whom they had been built) began to want houses with small gardens and purer air; and twenty years later the Association was wound up. The Model Dwellings continued to be occupied until the late 1930s; but the corporation eventually took over the building and in it housed some of Worcester's poorest citizens. To 20th-century eyes it looked a grim and depressing building, but it was a monument to an important advance in public opinion and municipal housing.

Model Dwellings: the 1855 share certificate of James Walter, pawnbroker, who invested in this early attempt at public housing

The Wherry Inn and George Rogers, artist in stained glass

The old Wherry Inn at the corner of Copenhagen Street and Quay Street was an ancient three-storey timbered building. It was famed as a watermen's inn during the 18th century and was traditionally one of the receiving places of smugglers on the Severn, for the 'Slip' at its door made it convenient for the easy unloading of goods at night. As one of the better class inns in the area it was widely used by river travellers in the days before the railways, when a visit from the north to take the waters of Bath made it a convenient place for an overnight stay. Fire destroyed the upper storey and it was never rebuilt; and in the mid-19th century, with the decline in river traffic, it became an inn of local renown and the rendezvous of a 'set' of the better class who gathered for a smoking party one evening a week. This development was due mostly to the host, George Rogers, an artist in stained glass, whose work of considerable merit is to be found in both Worcester and Gloucester cathedrals and in many churches.

It may seem strange that a talented artist should have kept a public house in St Andrew's, but in former times a publican was by no means a mere seller of beer. He was in the true sense of the word a host whose business was to receive and entertain people and Mr Rogers made an excellent host, his geniality attracting good company. But business management was not his strong point and he did not find the Wherry a gold mine. In fact, the shadow of impending change hung over the old hostelry. Professional men and traders had begun to drift to suburban homes and no longer came back to spend their evenings in the public house smoke room as their fathers had been accustomed to do.

In the days before street lighting guests went home by lantern light (unless the moon was new). In the early 19th century Rev Benjamin Dent (the hunting parson who fell in Crowle Brook) left the Wherry and, misled by the fog, walked into the Severn. It is not certain whether the fog was inside or outside, but though he died at his brother's house at 34 Foregate Street the local view was that the immersion had had fatal results.

In 1923 the old inn was converted by the rector of the parish, Canon Philpotts, into St Andrew's Institute, a club for men and boys. The overhanging upper storey made a spacious billiard room which, on a wet and stormy night with fire blazing, created a comfortable haven from which to view the dark river.

The quays

The riverside area was a mixture of good merchants' houses and squalid tenements, of inns and warehouses. They sprawled in an unhealthy but often picturesque muddle right down to the quays. It was a maze of narrow alleys and courts with numerous watermen's inns, some dingy and of doubtful repute, frequented by the bowhauliers and their women, others, like the Wherry, more respectable. By day it was a busy, evil-smelling warren, but by night the inns were alive with laughter and snatches of song, though the alleys were dark and dangerous to strangers. The worst of these was Rush Alley which was cleared at the building of the new approach road to the bridge and called Bridge Street.

Smugglers

In the 18th and early 19th centuries, until the coming of the railways, the Severn was one of the world's great highways, carrying the greatest traffic of any river in the world. Worcester was a busy inland port and it was no unusual sight to see well over a hundred sailing vessels tied up waiting for a 'fresh' to get them over the shallows, or a 'fall' to get them under the bridge.

Many readers of H A Leicester's book *Worcester Remembered* (1935) have been surprised at the following reference to smugglers:

> Smugglers found a happy home here for a considerable period, and in the course of time they constructed an extensive cave in the neighbourhood of Birdport, which they approached through the narrow passage leading from the South Quay, through the grounds of St Andrew's Church. By way of Bull Entry, an easy entrance was possible to the trading centre of the City, where their illicit goods could be sold. When some of the old houses were demolished in Birdport about 30 years ago, the cave was discovered, extending under several of the buildings.

The cave Alderman Leicester refers to was beneath the site now occupied by the College of Technology, at that time a warren of courts and houses. It is unfortunate that the position was not recorded, for a series of cellars and passages led from the Wherry Inn and other houses in Quay Street.

Leicester was told by old inhabitants 'in the know' that goods landed by night could reach the shops in the High Street by the morning without coming

above ground. A number of the premises in the High Street have extensive cellars and could easily have been connected to those in Bull Entry (now closed at the Deansway end and in recent development renamed Chapel Walk at the High Street entrance), but the most likely was that at No. 85 High Street, now part of the Deansway shopping precinct. It was once an inn called the Bull Inn, and still has extensive cellars today. It is unlikely that the Wherry Inn was the only receiving place in Worcester, and we know that smuggling went on in many ports on the Severn. Every watermen's inn was involved in duty-free goods but this must have been on a very small scale and unlike the organised business that the facilities at Worcester seem to suggest.

Bridewell and the Monitorial School for Girls

At the bottom of Copenhagen Street, facing the Wherry Inn, was one of the city's prisons, the bridewell. It stood next door to the stone and timber building (clearly shown in the foreground of Paul Sandby's watercolour painting of 1778) and by 1784 had become William Stephens' stoneyard. After the building of the new gaol in Friar Street the old prison became a storehouse and was then demolished. In 1841 St Andrew's Monitorial School for Girls was built on the site, one of a number of schools set up by the Church of England National Society, using the system developed by Dr Bell. The first headmistress was Sarah Garrison, and the school accepted nearly a hundred girls and infants. Its history was comparatively brief however: when the Hounds Lane Board School was opened in 1873 the school was closed and was afterwards used as a store, a clubroom and scout headquarters.

Countess of Huntingdon's church

The present building is the second church on the site. The first was built in 1773 in the garden of a large town house. By the time the church was founded the area had already declined in status, some of the wealthy moving out beyond the walls to the new houses in Foregate Street and in Sidbury. Their old houses became tenements and so the new church was ideally situated for the work of Lady Huntingdon's converts — it was central and in the most populous district of the city.

Selina, Countess of Huntingdon, was born in 1707, the daughter of the 2nd Earl Ferrers. Soon after the death of her husband in 1746 George Whitefield, the renowned Calvinistic Methodist, was invited to preach regularly to the countess and her friends in her London home; and in 1756 the first of many chapels was erected for the followers of the movement which became known as the Countess of Huntingdon's Connexion — until 1779 within the Anglican Church but after that a Dissenting body outside the Established Church.

Lady Huntingdon's followers first came to Worcester in 1767. In his book *Nonconformity in Worcester* (1897) William Urwick states that 'one of Lady Huntingdon's students, named English, preached at Mr Skinner's warehouse in the Town Ditch, now Sansome Street'. The countess visited the city herself in the following year and wrote: 'Nearly 200 persons have been united in religious society, many of whom have given decisive proofs of their conversion

to God.' A chapel was erected in Birdport by subscription and by loan (she paid the interest on the latter until the congregation could liquidate the whole); and Rev Matthew Wilkes became its first regular minister. At the opening of the new building in 1773 crowds had to be turned away and the congregation increased so rapidly that in 1804 the chapel had to be taken down and replaced by one accommodating 1,000; which in turn was enlarged in 1815 to seat over 1,500.

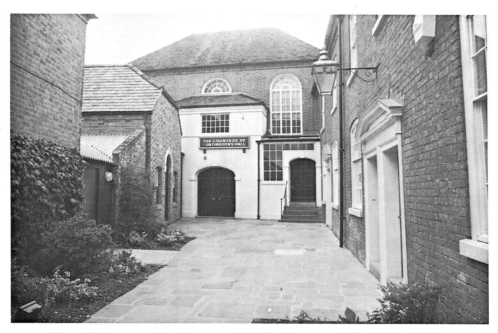

The walled courtyard at the west end of the Countess of Huntingdon's Hall

The Worcester church was independent and self-supporting. Though loyal to the traditions of Lady Huntingdon, it was prevented by provision of the trust from identifying itself legally with the Connexion. The church was governed by the minister who was appointed by a committee. It described itself as 'liturgical and evangelical', and the order of the service was the same as that in the Church of England, except that the minister changed his surplice for a Geneva gown to preach the sermon.

The Birdport church was built in the shape of a jew's-harp and was refitted in 1839 with shiny pine box-pews. A deep front gallery was added at the same time — which today creaks as you walk — and Sunday School buildings, with a house for the minister adjoining the church. The tiny walled courtyard at the west end of the building has a curious old-world charm. The entrance at the east is a bland curved facade, with an oval of early Victorian lettering, and a dignified porch leading to a panelled hall and the minister's room. This entrance, the main one, was almost unseen in the days before the slum clearances of the 1940s. The altar is a small, bare polished table, dwarfed by two magnificent eagle lecterns on either side. These in turn are dominated by the high pulpit, the church's centrepiece. In the gallery above the altar is the

organ, erected in 1840 by the Worcester organ builder, John Nicholson, and the first to be erected by the firm which still operates in the county, now in Malvern, and enjoys a wide reputation.

The church's support lay in the crowded tenements of Birdport but its influence throughout Worcester was extensive. In 1840 the church was conducting ten Sunday Schools in the city as well as what were described as Infants, British and Ragged Schools on weekdays, though some of these were evening schools. Even in the 1920s the church was so crowded at the anniversary services that people sat in the gangways between the pews.

A vivid description of the congregation of the Countess of Huntingdon's church around 1900 was recorded by Rev T C Boon of Winnipeg, whose father was minister there from 1885 to 1913:

> ... The chief exhibit of the church on Sundays, however, was a choice collection of old ladies, who used to occupy a special seat right under the pulpit, and who on one other day of the week attended with great regularity a Bible Class conducted by the Minister's wife, which her sons used to call privately and rather irreverently, 'The Academy'.
>
> There was attached to them a peculiar quality of fadedness, and they excited both interest and sympathy when they stood up in a long row and swayed gently to the rhythm of the music. I recollect Mrs C who always wore a kind of rusty black satin cloak trimmed in places with jet beads and an equally rusty black bonnet ornamented with a half-broken spray of them, which juggled in a curious way as the good lady nodded her head on one side as she talked.
>
> Mrs C's chief asset in life was a singing voice which was wonderfully cracked, and she was a tower of strength on the musical side of 'The Academy' when hymns were sung. Then there was old Mrs D who was the very double of Queen Victoria in size, shape and features, and had, I believe, though not because of this strange resemblance, the privilege of living in an almshouse in The Trinity. Another was Mrs W whose unfortunate chronic eye trouble left her in a constant state of tears, even on festive occasions. She maintained an aspect of respectability by the aid of a huge Paisley shawl which enveloped her from head to toe, and had in the course of many years faded to a delicate shade of old rose. Her chief pleasure in life was a glass of good beer, and I fear she had many lectures from the Minister's wife on the iniquity of taking it.
>
> A still more wretched specimen was Mrs H whose cadaverous features and evil smile haunt me still, and yet she must have been good-looking in her younger days. She had a son about my own age, who grew up in rags.
>
> There were others in that row, the honourable occupants of that front bench. Their faces rise up before me. Some gaunt and haggard with age, some clean and tidy, some bearing in them the marks of vice and degradation, some of them worthy members of the great unwashed.
>
> ... They lived in dark alleys, in remote courts, up back staircases, in single rooms ... I see them now, crouched around the great fire in the room where 'The Academy' was held, holding out their skinny arms to catch the brave warmth.
>
> For most of them life was maintained by a weekly dole from the parish, but it held no hope. At the end of their miserable existence came the parish doctor, the parish undertaker, and the pauper's funeral.

The last service to be held in the chapel was in 1976. Since then the Countess of Huntingdon's Hall has been beautifully restored and adapted as a concert hall, arts centre and music school, with a new administrative wing opened this year.

Webb's Horsehair Carpet Factory

There was in Copenhagen Street until 1935 the last of the city's carpet mills, all that remained of a trade which in George III's reign had had a royal inspection and was considered likely to be the most important in the city's future.

In 1835 Edward Webb, then aged twenty-seven, bought a horsehair weaving factory at 8 Copenhagen Street. The plant had fourteen seating looms and two looms for cider cloth; several winces for curling hair; machines for hot pressing and carding hair; and a four-storey weaving and dyeing building — with a dwellinghouse built in 1733. By 1843 twenty-nine Jacquard looms were weaving figured hair seatings, fancy crinolines and carpets. By 1846 there were seventy weavers on the roll and a further weaving shed was installed. In the 1850s one of their special lines was the horsehair-carpet foot rugs for the Oxford, Worcester and Wolverhampton Railway Company — and for almost every other railway in Britain.

Steam power was introduced into the mill in 1854, but the first carding machines to be powered broke up and were wrecked. After the initial disaster, however, progress continued and the number employed soon rose to 100, with a large number of children. Until 1914 women workers went to work at 6am and at 8am came trooping out for breakfast in their clogs and shawls — as they did in Lancashire. Carpets were made for the highest in the land: for Mr Gladstone when he moved into 10 Downing Street for the fourth time in 1892; and 600 yards of 'grey Worcester' for a processional way at the wedding of the Duke of York in 1893.

In 1935 the site of the dismal old factory was acquired for a new police and fire station and the firm moved to a new ground-level mill in Sherriff Street.

Webb's factory school

The only factory school in Worcester was at the Horsehair Carpet Factory. Children were employed to supply hair to the weaver's hand and, like young mill workers elsewhere, they worked long hours for little reward. Yet Edward Webb had a particular concern for the children, and he provided an evening school and library for some forty poor female children. But after ten or more hours in the heavy atmosphere of the mill the lessons must have been an arduous task.

The school was started in 1846 in a part of the factory in Bull Entry (nearest to the High Street) which had once been a public house, then a gospel hall, and subsequently, perhaps at the same time, an adult school. A schoolmaster was supplied and by 1849 the number of girls had risen to fifty, all voluntarily attending and complying with the only condition of entrance — 'that they wash before they come in'. In the 1860s the school was principally attended by boys; and it continued until the 1870 Education Act rendered it unnecessary.

Edward Webb

Edward Webb took a prominent part in the life of the city. He was mayor in 1847−8, and was a strong supporter of Dr Charles Hastings during the local battle for the Health of Towns Act, when even medical men were divided. He was responsible for local art exhibitions — Constable's *Salisbury Cathedral* was on show in one — and it is said these exhibitions led to the 'Worcester School' which produced B W Leader RA and others who specialised in landscapes. When the British Archaeological Society visited Worcester he organised a soiree at the Guildhall, a visit to Sudeley Castle and supported the lectures to which citizens were invited to see the unrolling of a mummy at the Shirehall.

The Dispensary, Bank Street

In Bank Street stood the Worcester Dispensary and Provident Medical Institution. It was founded in 1818, the building completed in 1822, and it was rebuilt in 1850 for about £1,500. The institution was established to provide medical advice and medicine for the sick poor in their homes, to carry out vaccination, and to help the delivery of women in cases of difficulty. Although termed a charity, it was rather a benevolent institution helping those who could not afford medical attention. Funds were obtained from subscriptions (each subscriber, for an annual payment of 10s 6d, entitled to two tickets of recommendation for any two poor persons) and from charity events.

At the opening of the dispensary Mr Richard Hale Jnr was appointed apothecary and dispenser, a position he held for forty years; while Dr S W Coombs was medical officer for thirty-five years. It was open daily from 10am to 5pm, except Sundays, and in 1873 a Provident branch was added, more than 1,300 people joining in the first year. In five years the number was over 5,000 and in 1918 9,000 were members, and 30,000 prescriptions were dispensed. The building was demolished in 1967−8.

The sanitary state of the city

By the early 19th century many wealthy citizens had moved out of the crowded inner areas of the city. There were still merchants and tradesmen living over their shops in the main streets; but elsewhere many of the large houses had become 'rookeries', with each room occupied by a different family. The old gardens had disappeared under cottages and workshops which were massed together, using every available space. To reach them, covered passages called 'courts' led from the street fronts. Most had no water supply, some had no sanitary arrangements whatever, and where they did exist privies and cesspools were crowded against the houses and shared by a dozen or more families.

To make matters worse, cheek-by-jowl with the houses were private slaughterhouses and tradesmen carrying on their noisesome work without any means of disposing of their waste. The gutters became receptacles for putrid filth, and often any space available in these courts was used as a midden for the contents of the privies. These were called 'bogs' and, incredible though it may seem, were regarded as valuable assets.

There was as yet no control over housing and speculative builders were free to erect back-to-back dwellings crowded together with no amenities. Even in the better properties the window tax meant there would be no windows in privies, passages or cellars. It took three outbreaks of cholera and years of work by the city medical faculty, led by Dr Charles Hastings, to remove the tax.

In 1832 the Worcester Board of Health produced a report, based on evidence gathered by the parochial committees, which confirmed that there were accumulations of filth in almost every part of the town: 'So far as the mixens and dirt heaps are concerned, it is impossible to find words in which to describe their offensive state. Particularly offensive is the bog-hole in St Andrew's Square, and also the state of Farling's Entry in the Shambles, where manure and filth of all description remains till it is perfectly alive.' The horrifying account goes on to describe the state of some of the privies as 'full even to exuding of their contents through the floor, the whole building, seat, and even the outside of the door, being made a convenience of'. Drains and sewers were choked up and pigsties were to be found everywhere, often covered up and connected to kitchens and pantries and usually in a grim state.

A second report on the sanitary conditions existing in the city was produced in 1846 by Henry Austin, secretary of the Health of Towns Society. Introduced by the great Edwin Chadwick, the report makes clear that conditions had not improved. 'The City of Worcester may, at present moment, be said to be practically almost without sewerage . . . In many of the lower parts of the City, pools of liquid filth perpetually stagnate the surface of the streets, or sink into the soil, there being no adequate drains for their removal.' Even the better class houses were often very badly supplied with 'necessaries', the latter, in some High Street homes, located in the cellars from which offensive smells perpetually poisoned the domestic atmosphere. When the refuse was removed — frequently by pumping it up to the surface — the foetid atmosphere was said to be scarcely bearable. In Bull Entry the 'one necessary . . . allotted to the use of more than 15 families' was 'one of the most horrible examples of loathsomeness and indecency' the writer had ever witnessed, so sickening that he refused to go into detail.

The report recommended a complete system of small sewers and a waterworks that, for the cost of one penny per week, would provide each inhabitant with a constant supply of pure filtered water. There was the usual opposition on the grounds of unnecessary public expense, and from those unwilling to accept the conditions as described. Within two years, however, the city was to be shaken into action when faced with the reality of another cholera epidemic.

Strickland's lodging house and some ill-gotten gains

In Merryvale (near All Saints church) was Strickland's lodging house where many strange characters dwelt, one of whom was involved in a hoard of ill-gotten wealth. At the Worcester quarter sessions in 1889 a man named David Robbins was charged with stealing from the pocket of a man near Stourbridge a bag containing £7 10s. The case was clearly established against him; and then the chief constable was asked to give evidence, and told the story of how a box containing watches, bank receipts and passbooks, totalling a value of over

£1,000, had been found at Strickland's lodging house in Merryvale, and had been in the hands of the police awaiting the claim of the owner. It was suggested that the prisoner, whose real name was Evans, should lay claim to it, but there was much more to this than met the eye.

Some years before, a woman in custody had asked the police to make enquiries about the box left at Strickland's by a man and woman, it was said, then in prison. The man, Evans, was a native of Worcester. When the box was opened it was found to contain gold and silver watches, gold chain pendants, Post Office savings books, paying-in receipts from a Worcester bank, and other valuables.

There were many claims from solicitors acting on behalf of Evans, but they were told that the owner must come and prove his ownership. Evans knew better than to do that. Later, in a fire at Exeter a man named Evans lost his life, and an application was made on behalf of 'the next of kin'; but, again, the chief constable insisted he would have to be satisfied that Evans had been the owner of the hoard. In 1889, on a visit to the Worcester city prison, he recognised Evans awaiting trial and still very much alive. The man who lost his life in Exeter, he found, was another Worcester man named Evans. The coincidence was remarkable, if not sinister. Evans, alias Robbins, was eventually sentenced to seven years penal servitude.

Broad Street inns

Broad Street still retains a number of good Georgian houses, though all have had shop windows put in and it is necessary to look above these to see the original domestic architecture. In the 19th century it was noted for its nurserymen and inns. In the 1880s all the shops of the principal horticulturists could be found there, among them Richard Smith of St John's, who at that time specialised in roses, and J S Haywood of Malvern Road, whose principal line was in ferns and herbaceous plants. It was probably better known, however, for its three important inns: the Bell, the Unicorn and the Crown.

The Bell stood halfway down on the north side until it was demolished just before the 1914–18 War when Angel Lane was widened into Angel Place. For hundreds of years it was a famous market house, and on market days its spacious yard overflowed with farmers' carts and gigs. In former times, when Tories and Whigs had their special inns for election 'entertainments', the Bell was traditionally the principal Whig house, whilst the Hop Pole in Foregate Street was the Tory stronghold.

In 1831 the Bell was the scene of a furious political riot. It was the headquarters of Colonel Lygon, the dashing commander under Wellington at Waterloo, who had represented the Whig cause five times as MP for the county without opposition. But that year change was in the air and a coalition was formed. One of Lygon's friends, irritated by remarks shouted from the street, threw a decanter at the crowd from a window at the Bell. This infuriated the crowd who stormed the inn and broke every window and all the fittings within reach. The election saw the defeat of the colonel.

In 1832, however, the year of the great Reform Bill, the city Whigs dined there in triumph under the presidency of Dr Hebb, to celebrate the return of both their 'Reform' candidates. In the 1830s the Bell was kept by William Webb, one of the Webb brothers prominent in the city's trade. He was

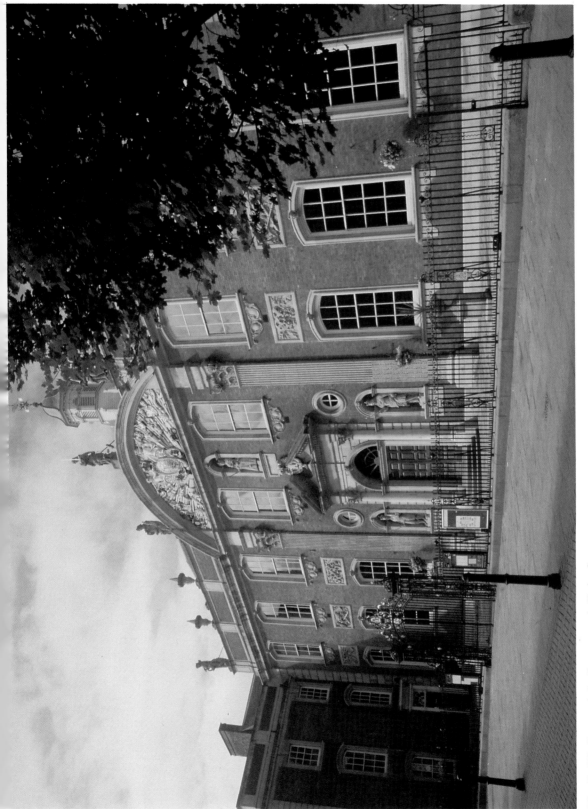

The Guildhall: one of the finest town halls in the country

The Commandery, originally a hospital, later Royalist headquarters during the battle of Worcester

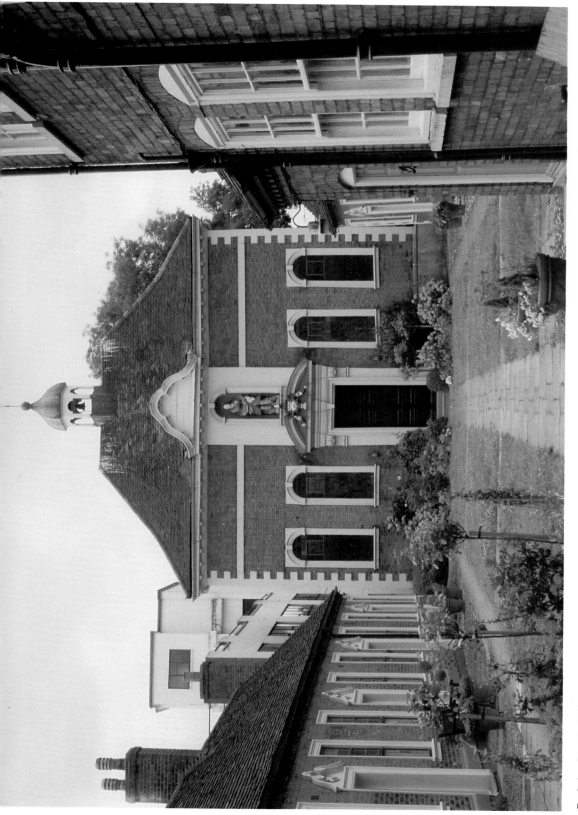

Berkeley Hospital, Foregate Street, founded at the end of the 17th century

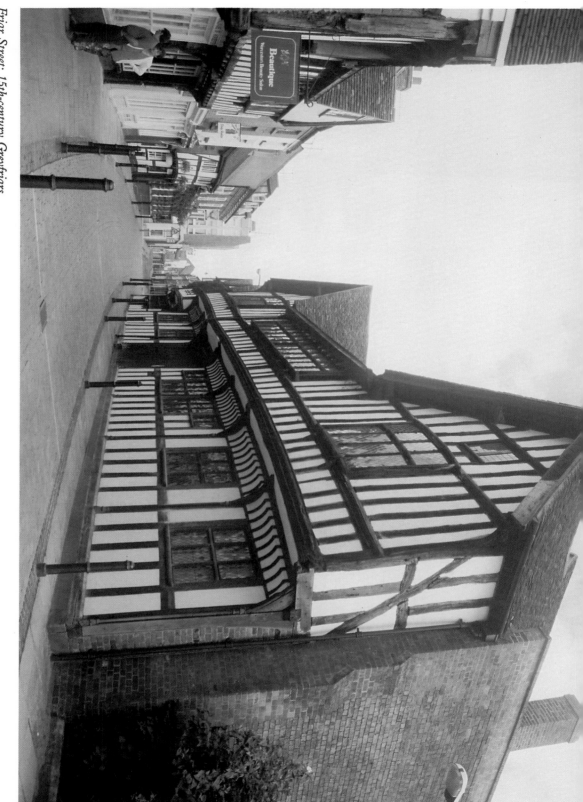

Friar Street: 15th-century Greyfriars

described by one who knew him as a 'fine gentleman, one of the best all-round sportsmen Worcester has known'. He was, it seems, the mainstay of Worcester race meetings and of local coursing, and in later years became mayor and an alderman.

The Unicorn Inn has long been closed, though the building itself still stands. In the 19th century it was a staging post for the famous L'Hirondelle coaches but, like thousands of other similar inns up and down the country, was dealt an irrecoverable blow by the coming of the train. In 1906 it was bought by Berrow's and until the 1950s served as the printing house for *Berrow's Worcester Journal*. Today its wide coach entrance leads to the Crowngate shopping centre and its former sleeping accommodation — Unicorn Chambers — houses offices.

The handsome William IV lamps at the front of the old Crown Inn, Broad Street

The Crown Inn, however, has survived, though a little altered and entered now via Crown Passage off Broad Street, rather than directly from that street itself. In its heyday it was a perfect coaching inn, stuccoed with dignified pilasters, a large coachyard and stables, ticket office, commercial rooms and a pleasant glee room. It still has its two charming William IV lamps but the renowned 'Men Only Room', which held so many memories, is silent. The inn had an interesting relic of the early railway days too, for on the left of the entrance yard was a semicircular window, from which one obtained a horse-omnibus ticket to catch the train at Spetchley Station. From 1840 to 1850 it was necessary when making a railway journey to use that lumbering conveyance, with fifteen people huddled aboard for the best part of an hour of tedious jolting. Horse buses continued to meet the down night mail until January 1851. Once started, things sometimes continue despite changing

conditions: the use of Spetchley as a station for Worcester continued until 1940, for the Birmingham to Bristol night train unloaded mails for Worcester there. After that it ran via Shrub Hill.

The Worcester glee clubs

The glee room at the back of the Crown Inn had an 18th-century atmosphere, and was the home of the Worcester Glee Club, established in 1810, and one of several such clubs in the city. The Bibbs family held official posts in the club for three generations and back in Victorian times, when it was the custom to give a silver ticket (a kind of life membership), the great John Sims Reeves, the country's leading tenor for over three decades, sang at one of their concerts. In the 1870s and '80s it was customary for the thirty or forty boys of the cathedral choir to give the first part of the programme.

The great days came when Edward Elgar founded the Glee Club Orchestra and composed for them. At the centenary concert on 23 April 1910 there were 220 members, and the orchestra consisted of two violins, viola, cello, base, flute, clarinet, cornet and piano. The conductor was A Quartermain who was followed by G Austin and J W Austin.

Worcester Sauce

The original manufactory of Worcester Sauce stood in Broad Street, at premises going through to Bank Street. There William Perrins and John Wheeley Lea had established a very successful business as chemists and druggists, which had become by far the most important in the county. But by a lucky accident Lea and Perrins were to achieve world fame.

In the 1820s Lord Sandys had returned from duty in India bringing with him a recipe for a favourite sauce, used there to stimulate the appetite. He asked the partners to make it up for him and they duly obliged. Tasting the quantity they had made for themselves they found it unbearably hot and consigned it to the cellars. Several years later, fully intending to throw it out, they rather bravely decided on a final little taste. Amazingly, it had matured into a sauce of considerable piquancy; and finding it very much to the liking of their friends as well they promptly purchased the formula and started selling it in 1837, the year Victoria ascended the throne. They advertised it as a 'sauce from the recipe of a Nobleman of Worcestershire', and it soon became known as Worcester Sauce. More than a century and a half later it still holds the field as the best and most famous of sauces — and the recipe is still a secret.

Kitson's Cash Chemist, Broad Street

A century ago at the top of Broad Street stood Kitson's Cash Chemist, the first of its kind in the city, for it introduced the system of cash payment for drugs. For years, it was said, Kitson traded upon the old lines of high prices and long credits, without ever being able to keep his head above water. The results from the new system were most satisfactory and thenceforth he floated on a full tide of prosperity. The system of credit was ingrained and greatly forced up the price of goods. Sir Rupert Kettle, a judge at the Worcester County Court, used

to say that every garment he wore cost him an extra 25% to cover losses upon credit sales to other people.

One of Kitson's recipe books has survived and contains details of strange ingredients used in the chemist's attempts to keep his customers in good health: oil of swallow's tongue, syrup of fox's lung, bear grease, goose grease (used as a poultice on brown paper and placed on the chest), powder of Irish slate (for stomach disorders), willow bark, and many another unusual item.

The Midland Bank and 'the Synagogue'

The original bank on this site was a branch of the Stourbridge and Kidderminster Bank which opened in 1864. It became the Birmingham Banking Company and later the Midland Bank; and in 1876 the premises were rebuilt in a fine French Renaissance style by H L Florence of London. That building was destroyed in 1967 and a new bank completed two years later, expanding over an ancient passage into Angel Street, which still gives the owner of that passage the right to walk through the bank.

On the opposite side to the bank is Cupola House, a tall and very narrow building (four storeys high and only one bay in width), the oldest and most attractive in Broad Street. It has curiously carved keystones over the window and a domed roof. The sculptured keystones — brightly painted figures of cheery-looking men — are very like those at the Guildhall and must date from around 1720. In the 19th century the building was referred to as 'the Synagogue'. In 1831 Edwin Lees, the Worcestershire naturalist, moved his printing and bookselling business here from the High Street, for a number of years living above the premises. It was from here he printed — and contributed to — *Illustrations of the Natural History of Worcestershire*. He also contributed to a local newspaper under the pen name of 'An Old City Surveyor'; and was a founder member and first president of the Worcestershire Naturalists' Club (still in existence nearly 150 years later). In later life Lees moved to Green Hill Summit, a house off London Road, long demolished.

All Saints church and Merryvale

The old church was much damaged in the Civil War and was rebuilt in 1715 by Richard Squire and William Davis, keeping the lower stage of the tower which is medieval. It has seen a number of changes since, however: the box-pews, the west gallery and the old organ were swept away in the drastic restoration of 1842. It was again restored in 1888 by Aston Webb, and during this restoration a very fine carved Royal Arms disappeared, but the chained Bible and civic sword-rest still remain. Among the monuments is an effigy of Edward Hurdman, the city's first mayor.

A disaster in 1703 is entered in red in the church records: 'James Collins, his wife Ann and 7 children, all burnt together in their house. The maidservant was the only one in the house to escape, and she with a broken limb.' But the maid's escape was short-lived for she later went into service with a Mrs Palmer of Upton Snodsbury and was murdered with her in 1707! The maid and mistress were the victims of the notorious murders which brought about the establishment of Bishop Lloyd's School in The Trinity.

Until the 1840s the church was surrounded by old half-timbered houses,

Birdport (now widened and called Deansway) at the beginning of this century

some of them very large and substantial, for in the 16th and 17th centuries this part of the parish had many rich merchants. There was, however, a small open space on the north side of the church steps where there was a conduit, a little domed building, where water could be obtained at certain hours. Older people still refer to the space as 'The Well'. The road round the church, now part of Deansway, used to bear the attractive name Merryvale and it was here, and in Dolday, that the custom of 'heaving' took place (see page 83).

Life around Birdport at the turn of the century

The streets of this crowded area were always lively, for people got their entertainment here. With no parks or playgrounds, the hordes of ragged children played in the streets or on the quays; and older folk brought out chairs onto the pavement to gossip and enjoy the air. An old lady sent me an account of life in Birdport around 1900:

> When I was a child, nearly 80 years ago, I remember a man coming round the streets with a large can selling trotters (pigs' feet). Another came with his bell selling muffins. The fishman came round with fried fish in a huge basket — he mostly sold to the public houses. A very interesting thing used to be the barrel organs with a monkey on the top. Copenhagen Street used to be alive when the organ played and, believe me, that is how we learned to dance.
> We had other musicians. One came round with a small table with glasses

of water on it, and the tunes he played were very sweet. A lady used to come with a large harp. She took up her position on a stool and entertained the crowd. There were plenty of street singers too. On Sundays it was a pleasant sight to see the gentry coming out of the cathedral. The dresses were beautiful and much envied by the workers.

Cheatle's Petticoat Charity

Thomas Cheatle's Petticoat Charity distributed fifty warm petticoats to poor women of All Saints parish. Thomas, whose family name was spelt in a variety of ways, belonged to a notable landowning professional class who were parishioners of All Saints and contributed high bailiffs to the city.

Thomas died in 1640. One of the family, possibly a grandson, met a violent death in 1645 during the occupation of the city by the Royalists. An old monument in All Saints church records his fate: 'Of the massacred gent: Mr. Richard Chettell, deceased, 19 March, 1645.' How he was massacred is not recorded, but probably he was killed in some violent quarrel. There were hot bloods among the Cavaliers, and they were as prompt in drawing swords on one another as upon the enemy.

Map 3

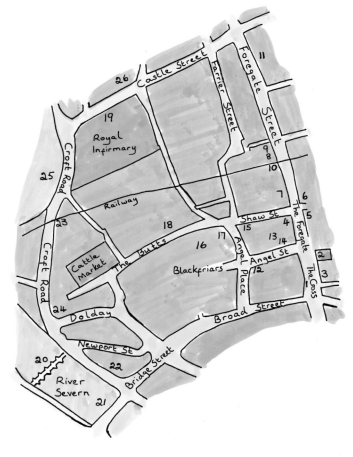

1 The Cross
2 St Nicholas
3 The Bank
4 Berkeley Hospital
5 Hop Market
6 Hop Pole Inn
7 Star Hotel
8 Natural History Society
9 Empire Music Hall
10 Athenaeum
11 Shirehall
12 Corn Exchange
13 Theatre Royal

14 Old Theatre
15 Old Sheep Market
16 Blackfriars
17 Angel Street church
18 The Butts cold bath
19 Worcester Infirmary
20 Old Worcester bridge
21 John Gwynne's bridge
22 Rectifying House
23 Railway viaduct
24 Old St Clement's
25 Pitchcroft
26 County gaol

District Three

West of the Foregate

The Cross

Since the Middle Ages the Cross has been regarded as the centre of the city, and today the steeple of St Nicholas church excellently proclaims that fact. It is a feature sadly missing in some new towns. The civic life of Worcester was concentrated on the Cross. It was the mustering ground for archers going to the Butts and the spot where the stocks stood for punishing offenders; it was where May Day was celebrated, war and peace declared, and royal proclamations made. In medieval times a cross stood there, engraved with heraldry, and there Queen Elizabeth and other royalty received a civic welcome. In those days the butchers' trade was carried on at stalls, and well into the 19th century the Cross was the centre of the fun and pandemonium of the fair.

It was still the focal point in the 1920s when Worcester was more of a country town and groups of men used to congregate there to watch the life of the city. Early photographs always show these bystanders, some standing there for hours, meeting their friends, interested spectators of the busy scene. They used the Cross as a village green is used, or an Italian piazza, and the practice was abandoned only when the city was swamped with cars.

The east side of the Cross is architecturally fine, but the west is unworthy of the city. Until about 1920 a large elegant dress shop occupied the centre on the west side, with a fine pilastered frontage which matched the buildings opposite; but the shop, Turley's, changed hands and the frontage was brutally mangled, today just a whitened brick wall with holes containing cheap windows, an example of commercial vandalism in an old country town. On the south side of the Avenue stood Stratford's Library, an elegant, privately run library, well patronised by the gentry in the mid-19th century. Nearby, in what was formerly the White Hart, was a strangely named shop called Civet Cat selling jewellery and fancy goods, opened in 1828 and owned by a family called Birley. The last of the family, Alderman G Birley, died in 1889 and the business was carried on by Alderman Cassidy, who later moved to 64 High Street.

St Nicholas church

The old church of St Nicholas was erected in the 12th century and part of the crypt and basement walls appear to date from that period. There exists a record of a female anchorite who attached herself to the east end in the 13th

century, relying, no doubt, as other anchorites did, on charitable people to supply her with what she needed.

The rebuilding of the church in the 1730s was always considered to be the work of Thomas White of Worcester; it is now thought to have been carried out by Humphrey Hollins. The design of its upper stages is closely based on one of the rejected designs for the steeple of St Mary-le-Strand, as published in James Gibb's *Book of Architecture* in 1728. Its entrance has twice suffered mutilation: the half-circular steps were removed during the restoration of 1867, and later removed from the street altogether; and the consecrated ground in front of the church is now part of the busy street.

The crypt is huge, extending beneath the whole space of the church and, when there were few burial grounds, was filled with coffins, some in an advanced state of decay. Valentine Green related the grim story of a Mrs Glover who lived next to the church and whose two children died from smallpox. The grief so unhinged her that her husband had to take her away from home whenever a funeral took place at the church. But a year to the day after the tragedy the door of the crypt was left open, and she was discovered dead on the coffins of her children.

In mid-Victorian times St Nicholas church attracted the principal Anglican congregation in Worcester — yet it had a most dismal interior, a 'low' church from which everything of beauty seems to have been moved. It was regarded as the church of the Tything, as well as of its own parish, for St Mary's had not been thought of; and it included within its sphere of influence the principal residential quarter of the city. Foregate Street was not the business area it is now and professional families and 'gentlefolk' occupied most of the houses, the superior residential area of Worcester extending from the hopmarket to Thorneloe and Barbourne Terrace.

In Canon Havergal's time the rectory for St Nicholas was adjoining the church. It was sold in about 1860 as a site for the Worcester City and County Bank, now Lloyds Bank, and a new rectory, 'The Hermitage', in the latest Gothic style, was built at Lansdowne Crescent, provided largely if not wholely by William Perrins, one of the founders of the Worcester Sauce firm.

Frances Ridley Havergal

The 19th century saw the birth of Frances Ridley Havergal, one of Worcester's most famous women. She wrote hymns and sacred songs which were greatly admired and which are still sung all over the world wherever Christian folk gather. The 50th anniversary of her death in 1929 was marked throughout the British Empire and the USA by a special celebration, 'Havergal Sunday'.

She was born in the village rectory at Astley, Worcestershire, on 14 December 1836, the youngest daughter of Rev W H Havergal, who later became Rector of St Nicholas church and lived at the old rectory on the Cross. Rev Havergal, as often happened before the days of national hymn books, published his own book of hymns with his daughter's help. Always delicate, he died suddenly; but Frances completed his *New Psalmody* and continued to write both books and hymns. She too was frail but the words she wrote were stout, amongst her best-known hymns 'Take my life and let it be' and 'Who is on the Lord's side?'. She may have been frail and gentle but she became a household name for her religious writings and a competent mountain climber.

She must also have had a sense of humour: 'I hope the angels won't rush me too much — but give me time to get acclimatised in Heaven.' She died in 1879 at Caswell Bay, South Wales (where she had gone to live with her sister), from a feverish attack probably brought on by overwork for the temperance movement, a cause, she wrote, 'quite worth being knocked up for!'. She was buried at Astley under the fir tree which her father had planted and near to the rectory where she had been born.

The bank on the Cross

The Worcester City and County Bank, founded in 1840 with premises in Foregate Street, was one of the earliest joint stock banks. The building on the Cross, the head office until 1889 when the amalgamation with Lloyds Bank took place, is one of the city's finest and was the work of E W Elmslie in 1861. The front is classical with massive double columns of polished granite, and still bears the old name. The manager's room was the old boardroom, and marble busts of the two founders, Edward Evans and Richard Padmore, once adorned the mantlepiece there. William Forsyth was responsible for all the carved work throughout the building; and Joseph Wood of Worcester was the contractor.

'The Charlies'

As one would expect in the centre (and in the days before a regular police force), the city had a 'watch' here, with a sentry-type box for shelter in the churchyard of St Nicholas. The men were known as 'Charlies', and were usually old and very inefficient. Practical jokes upon 'Charlies' were recognised pastimes of the young bloods of the period. A 'Charlie' was stationed nightly at Worcester bridge to keep a lookout on people passing over the Severn, his hours being naturally divided between smoking and sleeping in his box. A group of young men found him asleep, gently carried him down to the water's edge and set him adrift on the river. It was not until the water seeped into his box that he awoke and was rescued by watermen. Another of the Worcester 'Charlies' was secured in his box, turned over on the pavement and thus forced to wait for daylight when passers-by would release him — but since he was not popular they were in no hurry to oblige.

Sometimes it was a more serious affair. In 1823 a fraternity calling themselves 'The Lambs' used to infest the streets of Worcester at night, molesting peaceful citizens. Richard Hill, the last of the 'Charlies' in the city, was concussed in a night assault and lay near to death for some time. He eventually recovered but, unfit to continue as a watchman, was made beadle of St Nicholas church.

Worcester Fair

The Cross was the focal point of the Worcester September Hop and Cheese Fair, an important pleasure fair and annual carnival when, with the indulgence of the authorities, pandemonium reigned for several hours in the principal streets of the city. From early morning the roads into Worcester were

filled with country people carrying baskets on their arms, and farmers and country gentlemen riding on horseback, in carriages and gigs. The carriers' wagons were crowded with women and children, men and dogs, laden with produce that might be sold to buy household necessities and, if they were lucky, a 'fairing' for the children.

Droves of horses, sheep and cows had by early light been driven towards the cattle market. The sheep and cows were penned and the horses kept in Croft Road and around the 'Slip' at the bottom of the Butts, where there was a continual succession of young horse-keepers only too willing to run along the road to show off the horses' best trotting points.

By midday the Cross, High Street and Broad Street were packed with a dense throng who had already celebrated in the pubs, singing and shouting, chaffing and jostling, armed with peashooters, backscratchers, squibs and crackers, and generally making merry in a boisterous, old-fashioned style. The crowds were so great that it was difficult to make one's way around the stalls which lined the street; and in about 1860 two young men, who later became leading Worcester citizens, decided to make the passage easier. They bought some hay and straw, lit a fire in Quay Street, then yelled 'Fire!'. The streets emptied and the rifle galleries and gingerbread stalls lining the Cross were near deserted — to the delight of the two who had created the 'space'. The Norwich Union rushed their engine to the scene and, discovering the nature of the fire, began to make enquiries. They later charged the two men the brigade's usual expenses.

Robert Berkeley and the Berkeley Hospital

In the Foregate is the charming Berkeley Hospital, a group of almshouses set around a courtyard and approached by some fine wrought-iron gates. It was founded by Robert Berkeley of Spetchley who left £2,000 in his will in 1692 to erect and maintain a hospital for twelve poor men and one poor woman, of sixty years or more, and to make provision for a chaplain and a steward. It appears that the site purchased in 1705 stood mostly on what had been part of the city wall. The building was completed in 1710. From an architectural point of view there is some reason to believe that Berkeley was influenced by similar institutions he had seen in the Low Countries, where he had had a tour of duty. Up to the 1920s the beds were enclosed in cupboards; but these were removed on the grounds that they were not up to modern health standards.

Robert Berkeley, whose recessed and painted effigy can be seen from the street, was a noted horticulturist and responsible, it is said, for the introduction of cedars into Worcestershire. He was a friend and correspondent of the celebrated diarist, John Evelyn, and his earliest specimens were probably seedlings grown by him. In the 18th century a good many were planted in the suburbs of Worcester — at Henwick, Pitmaston, Lark Hill, Perdiswell, London Road and Barbourne — of which some still survive. 'The Cedars', Thorneloe, takes its name from a very old cedar tree in the garden.

The hopmarket

On the site of the old city gate a parish workhouse was erected in 1699. At that time the town ditch and the derelict defences which had been slighted by order

of Cromwell were being reused. In 1731 a hopmarket was established, using the parish workhouse buildings, the profits of the market going to the relief of the poor rates. This explains why the governing body of the hopmarket are called guardians. It remained a parish workhouse until 1794 when the union workhouse was established on Tallow Hill. In the 18th century the hopmarket was the largest in the kingdom with annual sales averaging 20,000 pockets (as the six-foot-tall bags of hops were called) — though there appears to have been extraordinary yearly fluctuations: in the early 19th century it varied from 48,000 pockets in 1808 to 1,530 in 1817.

Foregate Street had long been widened but the Hop Market Hotel jutted out, blocking by half the highway into the Foregate. In the 1890s the whole of the east side of the Foregate was demolished; and excavations for the building of the new hotel showed that the city wall ran roughly on a line with the old Foregate entry to the hotel yard. The bases of the great bastions of the city's principal entrance showed the strength of the Foregate.

The new hopmarket and hotel, built for the corporation by A B Rowe, is a fine building of terracotta work from Messrs Doulton of Stoke-on-Trent. The style, the flamboyant, decorative one of the Edwardian period, has for some time now been out of fashion, but it has great merit. A glance at the skyline shows how much poorer the townscape of the city centre would be without its pinnacles and cupolas, echoing splendidly the steeple of St Nicholas church.

The Hop Pole Inn

On the corner of Shaw Street and Foregate Street stood the Hop Pole Inn, the principal inn of Worcester during the early 19th century, first mentioned in St Nicholas parish records in 1742, and described as 'new erected or rebuilt' in 1749. The ditch had been filled in and, opposite, the Berkeley Hospital had been erected. The remains of the old Foregate had gone, and the new elegant hotel built on the corner was very spacious compared with those inside the walls, soon attracting county families and becoming the Tory headquarters. The 18th-century assembly room, once a very handsome meeting place, can still be seen from Shaw Street. It was here that an upset Nelson was entertained, furious at 'those damned glover-women' who, it is said, were aloof with Lady Hamilton. In 1830 the Princess Victoria stayed here when visiting the Music Festival and the crowds that gathered to see her were so great that the royal party became alarmed.

In 1842 the Hop Pole was taken over by a Mr Scott and soon afterwards ceased to be an inn. After considerable alterations to the frontage it became the most high-class shop in the city, Victoria House. In 1865 it changed to Scott and Oram, a partnership that lasted over twenty years. Then followed Richard Westwood and later W K Hogben, from New Bond Street, who held it until 1926. It later became Fearis's the grocers; and more recently offices.

Nelson at Worcester

It was at the Hop Pole Inn that Nelson stayed on his memorable visit to Worcester. His visit had not been anticipated; but during the afternoon of Sunday 26 August 1802 a rumour of his approach spread amongst the citizens

— for which mine host of the Hop Pole was probably responsible for it was there that Nelson had bespoken rooms.

People gathered rapidly in their thousands, lining the streets of the town and occupying every window and other vantage point. The citizens were accustomed to royal guests, for the Prince of Wales and his brothers were frequent visitors. But Nelson loomed larger in the public eye: his crowning victory had yet to come, but he was the hero of the Nile and Copenhagen and many a lesser fight now forgotten.

Towards six in the evening the carriage came in sight, and near the bridge it was pounced upon by eager hands. The horses were removed, strong men yolked themselves to the vehicle and amidst the enthusiastic plaudits of the crowd the hero was drawn in triumph through Broad Street and the Cross to his hotel. He was in good health and spirits and the warmth of his welcome delighted him. Late into the night the people lingered in front of the Hop Pole and Nelson frequently appeared at the window, bowing to them.

On Monday he visited the china factory, not the principal one but Mr Chamberlain's in Diglis, which caused much surprise; but Chamberlain was a friend of the host of the Hop Pole. They were preceded by a band and all Worcester turned out to see them pass. James Plant, a china painter, recalled long after:

> A battered looking gentleman made his appearance. He had lost an arm and an eye. Leaning on his left and only arm was the beautiful Lady Hamilton, evidently pleased at the interest excited by her companion; and then amongst the general company came a very infirm old gentleman. This was Sir William Hamilton.

Nelson declared that though he possessed the finest porcelain the courts of Dresden and Naples could afford he had seen none to equal the china shown him that day. He gave a large order for china to be decorated with his arms, including an elegant vase, with a likeness of Lady Hamilton. Only a breakfast service had been completed when Nelson fell at Trafalgar, and this has been scattered throughout the world — though the Dyson Perrins Museum has five pieces.

Nelson's visit brought changes in Worcester. Cooken Street changed its ancient name to commemorate the victory of Copenhagen; and an inn near the top of that road became the Mouth of the Nile and another at Merryvale the Lord Nelson.

The Star Hotel and the great coaching days

In the early 19th century Worcester was a main staging post from north to south on the western route: seventeen mail and other coaches, mainly daily, left the Hop Pole, Star, Bell, Crown and Unicorn Hotels for London, Bath, Bristol, Gloucester, Hereford, Chester, Ludlow, Shrewsbury and Birmingham; while thirty public wagons left weekly from the Saracen's Head, Reindeer, Golden Lion, King's Head, Talbot and Angel.

The new roads and coaches at this time enabled men to travel faster than ever before. Crowds used to gather at the Star and Garter (now the Star Hotel) and the Hope Pole to see the rapid change of horses. There were stages every

ten to twelve miles and the organisation of the posting inns was remarkable. Furious driving became such a common practice that an Act of 1838 threatened convicted persons with the treadmill. Two of the fastest coaches ever to run changed horses here. They were the two rival coaches, L'Hirondelle and Hibernia, which ran from Liverpool to Bristol and raced each other all the way. The speeds were extraordinary. In May 1832 the Hibernia left Liverpool at 6am and arrived at Worcester at 5.06pm. The following year the L'Hirondelle did the journey from Liverpool to Cheltenham (136 miles) in 9 hours 33 minutes, including stoppages.

Of the Worcester coaching inns only the Star and the Crown remain. The Hope Pole and Bell have gone and the Unicorn is no longer an inn though it still retains its wide coaching entrance. The Star has seen many changes in its four-hundred-year existence, but the entrance and stabling accommodation remain — now, of course, for the use of the motor car. At the rear was the Star Vaults where the ostlers and grooms gathered and where on 25 July 1841 there was a fatal affray between a Mr Maiden of the Shakespeare Inn in Angel Street and an ostler of the Star Hotel. The ostler died and Maiden was found guilty of manslaughter — but was only given one month and that without hard labour.

Foregate Street houses

In Tudor times there were cottages and small buildings lining the highway leading out of the city to the north. Most, probably all, were destroyed in preparation for the siege of Worcester in 1646; the walls were slighted and the Foregate destroyed. But new building soon began again. The main road was widened and town houses were built for the county gentry. By the end of the 18th century Foregate Street was regarded as one of the finest streets in Europe. Today it is the street richest in Georgian remains.

The Berkeleys of Spetchley had their town house and a private oratory there. The family were the leading Roman Catholics in the county in the late 18th century and when the 1791 Act of Parliament conceded formal recognition of Roman Catholic worship Robert Berkeley registered his house as a place with a room set apart for that purpose.

Earlier still in 1687 James II, when visiting Worcester, insisted on attending mass at the Catholic chapel which stood where Pierpoint Street joins Foregate Street. The mayor and corporation accompanied the king to the door of the chapel but would not enter. They had gone so far in paying honour to their sovereign but their Protestant principles would not allow them to enter the building, and instead they adjourned to the Green Dragon Inn across the street. The latter, no longer an inn, still stands but is now almost hidden behind the splendid facade of Dr Wall's house, No 43. This, in the Palladian style, is the grandest house in Foregate Street and was the home in mid-Victorian days of Sir Charles Hastings, the founder of the British Medical Association. Wall, a leading physician and founder of the Worcester Porcelain Works, had built the house, then sold it to Dr George Woodyatt whose daughter Hastings married. No 43, until recently the Grapeshot, displays a blue plaque commemorating the achievements of Sir Charles.

On the site of the old Gaumont Cinema stood a large and charming house which belonged in the early part of the 19th century to another Wall family, no

relation to Dr Wall. It had gardens abutting on Sansome Walk and had the air of a large country house. The owner, William Wall, and his brother, Samuel, were both members of the old self-elected corporation and partners in the Old Bank (see page 43). William was very deaf but had a hand in every money-making enterprise in the city and despite his disability always, it was said, recognised the word 'money'. Wall was followed by the great Worcester surgeon Henry Douglas Carden, and then by the well-known solicitor, Mr T G Hyde.

Other residents of Foregate Street included John Walsh at No 24, famous in the 19th century as a sporting writer under the pen name *Stonehenge*, and John Dent, the master glover, who lived at No 34.

Henry Douglas Carden

Henry Douglas Carden achieved fame as a surgeon and consulting physician of outstanding ability; and his services were for many years sought throughout the West Midlands. As a surgeon, it was claimed, he had no rival in this area. He had none of the usual sober bedside manner, but he entered a sickroom with a cheery smile and self-confidence that inspired hope. Added to his great knowledge he had the gift of inspiration and many of his successes were triumphs of faith healing. While at dinner at Hallow Park he diagnosed the fatal weakness of Sir Henry Bell, the eminent Scottish surgeon, who died there and is buried in Hallow churchyard. Carden retired later in life to Oakfield, Claines, and with his death ended the Worcester branch of the family.

The Worcestershire Natural History Society and the Hastings Museum

Cultural activity was very high in Worcester in the first half of the 19th century, and the Worcestershire Natural History Society, the first of the local 'learned societies', was founded in 1833 by a number of Worcester gentlemen. The headquarters of the society stood on the west side of Foregate Street where the Odeon Cinema now stands. For a short time the society had had to make do with rooms in Angel Street but in 1836 the Natural History Rooms were opened in great ceremony and this classical-style building stood until 1939 when it was demolished to make way for the cinema. In 1880 it had been sold to the corporation — who wanted to convert the building into a public library — but only with the city's agreement that it would be called 'The Worcester Public Library and Hastings Museum'. The public library was housed there until 1896 when the Victoria Institute across the road opened to the public.

Dr Charles Hastings was involved from the start — as was Edwin Lees — and he presented his own valuable specimens to the society's natural history collection. Hastings was one of the original founder members of the organisation that became the British Medical Association and a close friend of two of the most famous of the early geologists, Murchison and Sedgwick. Both were at his breakfast table on the morning when they set off to the Malvern Hills, one to discover and later write up his *Silurian System*, the other to investigate the system of Cambrian rocks. Hastings himself discovered the remarkable formation of salt rock at and around Droitwich. The museum which still bears his name is rich in geological specimens and birds now extinct

The city's first public library, housed in the former Natural History Rooms

in Worcestershire. In its heyday the Worcestershire Natural History Society was the richest in the county with a tastefully decorated lecture hall 60 feet by 30 feet and able to accommodate 500 people.

The Empire Music Hall and Silver Cinema

When the Victoria Institute was opened in Foregate Street in 1896 it housed the public library, the art gallery and the Hastings Museum. The old library building, further down on the other side of the street, was now vacant and its lecture hall on the ground floor became the Empire Music Hall — but not for long. Times were changing and the new bioscope films were occasionally featured with stage performances. Films were new and exciting, and much more profitable, and soon the Empire Cinema replaced the Empire Music Hall.

The Empire was Worcester's first permanent cinema; but the first bioscope films were shown at the Public Hall in the Cornmarket as travelling exhibitions of a new and wonderful invention, and Worcester was among the first places to see actual Boer War movie films. Around 1904 the Empire Cinema was showing a film entitled *The Wreck of the Aurora* with seats priced 2d. Later, in 1915, Arthur Carlton, the lessee of the Theatre Royal, took the cinema over and converted the upper and lower halls into one, with a small balcony, and renamed it the Silver Cinema. This continued until it was taken over by the Rank Organisation and closed in March 1939 when the old building was demolished and a new cinema erected. Before the building could be completed, however, war broke out and the bare shell became a wartime

store until hostilities ceased in 1945. Soon afterwards the building was completed, taking in a house on either side to increase its width, and opened as the Odeon Cinema.

The Athenaeum

The Athenaeum was founded in January 1829 on the model of a mechanics' institute. The building, a gift from William Laslett, was erected in 1834 and stood behind the Natural History Rooms in Foregate Street. It contained a lecture hall 40 feet by 28 feet which, being lit from above, was used for exhibitions of paintings. Constable exhibited a number of his great paintings there, though he only sold one, and that a small one. It also had a library, reading rooms, rooms where evening classes in music, French and mathematics were taught, and a laboratory for science subjects. It catered especially for the artisan and lower middle classes, and the subscription cost 3s. per quarter. With the opening of the Victoria Institute, the activities were transferred to the new building.

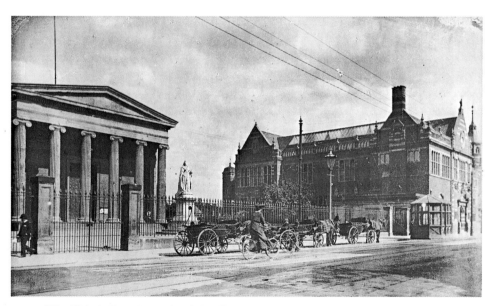

The Shirehall and, on the right, Victoria Institute at the turn of the century

The Shirehall

In the early 19th century it had become obvious that the accommodation at the Guildhall was too confined and restricted when county and assize courts were in session. In 1829 the county was advised that it would not be allowed to enlarge the courts belonging to the city: so a special Act of Parliament had to

be passed to purchase land in Foregate Street for a new Shirehall and judge's lodgings. In 1833 a neo-Grecian design by Charles Day and Henry Rowe, both of Worcester, was chosen and in 1835 the new Shirehall was completed at a cost of £32,000, thus ending the long administrative association between city and county at the Guildhall. The ground on which the Shirehall stands became an island of Worcestershire in the County of the City of Worcester, and until the merger of the police forces in 1967 the county police were always on duty inside and at the gates.

Thomas Woodward, the 'Worcestershire Landseer'

Thomas Woodward was a Victorian artist who specialised in animal paintings. He was highly thought of by Landseer himself, for in his own line he was surpassed by few. Woodward was a native of Pershore, the son of a local solicitor, and when as a boy he showed a natural talent he was sent as an assistant to Abraham Cooper RA, a famous painter of animals and battle scenes, whose picture *Marston Moor* undoubtedly prompted Woodward's most ambitious work, the *Battle of Worcester*, now at the Commandery. Landseer's recommendation of Woodward to Queen Victoria resulted in many commissions, while in Worcestershire many commissioned him to paint their favourite horses.

The Corn Exchange, Angel Street

This building is the other half of that political madness of the 1840s which was responsible for two corn exchanges in the city (an episode described under 'The drama of the Corn Exchange' on page 104).

The Angel Street building had the most imposing facade, with colossal pairs of Tuscan columns to mark its importance over its rival. Designed by Henry Rowe, it was 70 feet long, by 60.5 feet wide, and about as high as its breadth. The builder, Joseph Wood, was responsible for many of Worcester's buildings and since speed was essential to steal a march over the 'town' party he completed this one within four months, enabling 450 gentlemen of the 'farmers'' party, together with members of the nobility, to celebrate their success at its opening on 26 August 1848. It has been used for many purposes since corn ceased to be sold there: for political meetings, as a boxing hall between 1900 and 1930, but mainly as an auction room.

Angel Street took its name from the old Angel Inn which stood on the south side of the street and ran through to Broad Street. Angel Passage (the site of the inn) is blocked at the Broad Street end but the right of way has long been maintained by means of an annual walk via the vaults of the bank!

The Theatre Royal, Angel Street

In 1779 the manager of the King's Head Theatre, Mr Whiteley, erected a new theatre in Angel Street at a cost of £1,000 and by means of £50 shares subscribed by twenty persons, each of whom was entitled to a perpetual 'silver ticket' of admission.

The site of the new theatre should have been where the Angel Street

Congregational church stands, a site which the trustees of the church held from the corporation on a renewable lease. In those days there was no love lost between the Dissenters and the 'orthodox' city fathers, and there was a move in council to get rid of the chapel. The council therefore refused to re-lease the site, alleging that it was needed for a new theatre. Alderman Johnson, a leading member of the corporation, happened to meet one of the elders of the chapel and asked what they were planning to do. 'Oh, we are all right', was the surprising answer. 'We have acquired land in Mealcheapen Street.' Further enquiries showed it to be right next to the alderman's house. He was appalled. 'I can't have that!'. Soon the trustees were told they could keep the site in Angel Street for good and the theatre was built higher up the street.

According to Valentine Green the Theatre Royal contained an ascending range of twelve benches, gently incurved towards the stage. There were twelve large boxes, arranged in two tiers of three on each side. There were also three boxes surrounding the stage and one at each edge of the upper angles of the pit. Over these was a gallery. 'Of interior decoration it cannot boast', wrote Mr Green. 'All that we can justly say of it is that it is sufficiently neat and commodious for the intended purpose.'

From the 1790s to 1850 the theatre flourished. The Kembles, Mrs Siddons, Macready, Mrs Jordan, Young Roscium, Edmund Kean and other great personalities of the stage appeared there. But in the 1850s all the provincial theatres declined and were opened, if at all, for a brief and precarious season. The coming of the railway was largely to blame, for county families who once regarded periodic visits to the local theatre as part of their social duties now preferred the capital. And for ordinary people the music halls were far more attractive.

In 1875 a new theatre was built on the same site, but after only two years it was burnt down and again rebuilt in 1877. In the auditorium were comfortable tip-up seats, private boxes and a flight of marble steps to the dress circle, and evening dress was correct for the stalls and the circle for the theatre had become very fashionable.

Recollections of the old Theatre Royal

The poor standard of drama in Worcester in the mid-19th century is evidenced from the interesting recollections of Mr W Gomersal who came to Worcester as 'second low comedian' in 1852 and later, in the 1880s, as manager of the new Theatre Royal, a more lavish version of its predecessor.

> The scenery there was very limited, a drop scene representing Worcester Cross was only shown on special occasions, when announced on the bill; and the style in which effect was given to a piece may be imagined when a bow-legged local celebrity named Phillips, 4 feet 2 inches high, and another man 5 feet 11 inches in stockings, named Spiers, constituted 'the army' in *Richard III*. Phillips was 'the artist', and many of his landscapes were to be seen in Worcester public houses, and Spiers was carpenter, property man, wardrobe keeper and gas man, and also played small parts.

The public's taste was often abysmal, the audience requesting a hornpipe to be provided as part of the performance of the first gravedigger in *Hamlet*; and an

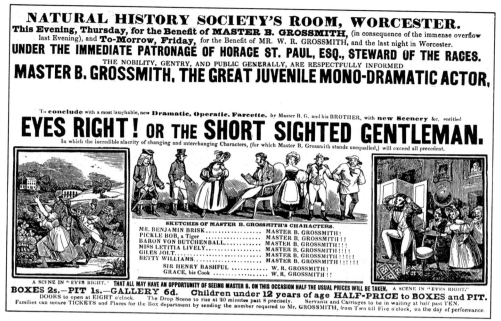

Part of an 1839 playbill, most parts played by 11-year-old Master Grossmith

actor playing Bottom in *A Midsummer Night's Dream* was called to sing 'Vilikins and his Dinah'!

The old Sheepmarket

At the bottom of Angel Street was the old Sheepmarket, an open space until 1920 when a roofed structure was built for a fruit and vegetable market, and now a shopping arcade. Traditionally, it was thought to be the site of a plague pit, used for mass burials during the last great outbreak of the bubonic plague in Worcester in 1637. But recent research carried out by the Blackfriars Group gives little support to the story, two points, in particular, making it unlikely.

To begin with, the site was within the city wall (plague pits were normally dug outside — well away from the population) on land owned by the city, originally part of the orchard of the Black Friars. Secondly, although the graveyard was first mooted in 1624 as a solution to the very real problem of a cathedral cemetery full to overflowing, it was not consecrated until 1644, seven years after the plague.

It is possible that such a disaster might have led to unusually desperate remedies — burials of plague victims within the city and in unconsecrated ground. It was certainly a serious outbreak for it swept away at least one fifth of the city's population: 1551 victims were buried, of whom 236 were from St Andrew's parish. All who could do so fled the city, but most were refused shelter elsewhere and were forced to form a camp at Bevere. Both fugitives and those who remained behind were threatened with starvation, for the country

people feared the infection and but for the courage and charity of a few, many would have died of hunger.

But a third bit of evidence makes the plague pit theory unlikely and it rests firmly on the assumption that human nature never changes. To the west of the site was the substantial house of Mr George Hemming, a man of standing and, later, member of the corporation. To the east Robert Sterrop built his even larger house in 1646, the year before he became mayor. It is not easy to imagine the former allowing a pit to be dug or the latter choosing to live next to one.

Blackfriars

The Black Friars, or Dominicans, occupied the large site between Broad Street and the northern city wall at the Butts, and from the Sheepmarket west to Dolday. The Dominican's habit consisted of white robes (a tunic and scapular) surmounted by a black cloak and hood (a cappa), the latter much more evident than the former — hence the name Black Friar. The Dominicans first came to England in 1221, but it was 1347 before they arrived in Worcester to take possession of a piece of land given them by William de Beauchamp, Lord of Elmley, in an area then called 'Belassis'.

At the Reformation the friary had only a modest income, a prior and a handful of brothers and most of the buildings were destroyed, all manner of individuals and churches buying up bits of the structure for private and public purposes. By the end of the 18th century the site was covered with small workshops and houses crowded together, but still with a lot of garden space; a century later it was an unhealthy and decidedly undesirable part of the city. A lot of Blackfriars had already been cleared when the developers moved in during the 1960s, rebuilding the area to meet the shopping and parking needs of late-20th century man and further development in the 1990s has finally removed all trace of the old site.

Angel Street church

The original Angel Street Congregational church was built in 1702 on land owned by the corporation and leased to the elders of the church. Like many another Dissenters' chapel of the time, it was erected in a 'retired position' in a garden, so as to afford a little relief from the opposition of the mob. The old church was a brick building with the interior 'antiquated in appearance'.

In 1859 a fine new church was built with its frontage well to the street, for in Victorian times the Congregationalists were rich and in no mood to build in back alleys. The facade is one of Worcester's architectural treasures. It has been well described as 'Greek Ionic and Roman Corinthian, with semicircular portico and honeysuckle, like a tiny and exuberant opera house. It has a dome under a glass roof and galleries inside.' Its classical look was a strong counterblast to Church of England Gothic — then thought by the Established Church to be the only fit style of architecture for a church. The new building seated 1,000 and towards the £6,000 cost Richard Padmore, later MP for Worcester, gave £1,000.

During the first three decades of the 20th century a very popular meeting, the Brotherhood, was held there on Sunday afternoons when the church was

crowded with men of all denominations. A very good orchestra of some 30-odd musicians played light and tuneful classics, followed by noted local soloists; and to add to good measure, some of the finest speakers were invited to give the address. Before the days of radio the Brotherhood gave many a local man a taste for good music and oratory.

Early Worcester Sunday Schools

Sunday Schools were established in the late 18th century, mostly as a way of combating the spirit of revolution which was abroad. Nevertheless, the movement marked the beginning of the education of the poor, for it showed that mass education was possible. The man given credit for the movement is Robert Raikes of Gloucester, though there were others who were doing similar work earlier; but as proprietor of the *Gloucester Journal* Raikes publicised the work, and it was this that sparked off similar endeavour in Worcester and elsewhere.

The earliest record of a Sunday School in Worcester is in St Nicholas church wardens' accounts for 1785 which mention items of expenditure for books for a Sunday School in the Trinity and, later, refer to a school held in the tower of the church. The records of St Helen's, too, mention a Sunday School dinner at the Brewers Arms in January 1794.

The city's first effective school for the poor began at Angel Street church in 1797. The minister, Rev George Osborn, wrote: 'Soon after coming to reside in Worcester, I noticed multitudes of poor, idle, miserable-looking children, sauntering and begging about the streets, it struck me that Sunday Schools might help to prevent such a nuisance. We commenced the Sunday School for boys, Aug. 20, 1797. I preached for their benefit May 27, 1798, and through the encouragement then afforded we established another school for girls.' The minute book of the Worcester Evangelical Society, quoted in Urwick's *Nonconformity in Worcester*, records that two teachers, one for the boys, one for the girls, were paid to conduct the Sunday Schools, that a rota of visitors ensured the teaching was being properly undertaken and that the children learned to read, write and spell and were rewarded with clothing if their attendance and behaviour had been good during the year.

Apart from Angel Street, there is no mention before the 1820s of instruction at any other Worcester Sunday School being more than in the reading of the Bible, and rote learning of the catechism and hymns. Education as we know it was regarded as highly dangerous — it would lead to discontent among the labouring classes. Indeed, some religious bodies forbade such teaching and opposition from the Established Church in Worcester was considerable, so much so that on 9 November 1800 George Osborn found it necessary to preach a sermon at Angel Street to defend the wider teaching in his schools from local critics who had accused him of organising 'Seminaries of Atheism'.

In 1902 a letter in the *Daily Times* described how a Mrs Aldridge, a very old lady living in an almshouse in Friar Street, remembered being a scholar in a Sunday School held in a large room at the Bell Hotel in Broad Street. It had been opened by Robert Raikes and must therefore have been an early example since Raikes died in 1811. The schools certainly prospered and generally did good work, though those who advocated them seemed oblivious to the need for some leisure for children who were working ten hours a day, six days a week.

The Butts and the Cold Bath

The Butts recalls the days when every man had to prepare for the defence of his city. Outside the city walls, to the north, was a wide open area which had long been used as a practice ground for archery. Even as late as the 19th century there had been little building west of Farrier Street except for a square of small buildings and Netherton House. There were orchards to the north and the infirmary had been built in one of them, with the line of Infirmary Walk as it is today.

A considerable stream ran from the Cold Bath and joined another from the north, entering the Severn where the railway bridge crosses. Today, of course, it flows underground in a culvert. On the south side of the Butts stood Bath Cottage and Bath House (the former gone, the latter in ruins). They mark the site of the Cold Bath which stood there in 1802, and probably earlier. Cold Bath was claimed to be one of the purest waters in the kingdom — but then many similar claims were made, for it was the fashion at that time to bathe and wash at such places which became as a result social centres. They are a reminder however of the scarcity of pure water in towns. Maps of the period show a small square building near to the house.

The city wall was effectively demolished eastwards from Bath House but considerable parts remain from there west to the river, where houses were built on top of it. One of these is Northwall House, an 18th-century house with a 19th-century facade in the Gothic style, decorated with coloured tiles. At the beginning of this century it housed the Worcester Grammar School for Girls. Further still, Rack Alley climbs over the wall into Dolday. Its name arises from its association with the cloth trade and many 18th-century engravings clearly show the racks built on the open land nearby.

The Worcester Infirmary

The first general hospital in Worcester was opened in a large house in Silver Street in 1746, only the seventh of its kind to be opened in England. The building still stands though originally it had three storeys. In 1770 the old house was abandoned for a fine new hospital on the south side of Salt Lane (later called Castle Street) overlooking Pitchcroft. It cost just over £6,000 and was designed by Anthony Keck. At the back of Dr Wall's house, on the artichoke field, the new building was started in 1768. A brickworks was set up on Pitchcroft, and anyone who could help or bring materials did so. The new hospital was declared open in 1771 and the patients transferred from Silver Street.

The infirmary was supported by voluntary subscriptions. It was the custom in the early 19th century to attend a 'charity sermon' preached by the Dean of Worcester, and then to repair to the Hop Pole Inn in Foregate Street. This old-fashioned method of attracting new governors (otherwise, subscribers) was in vogue in London well into the 20th century.

Sir Charles Hastings and the BritishMedical Association

The British Medical Association was born and cradled in the boardroom of the Worcester Infirmary. Its founder, Sir Charles Hastings, was son of the Rector

of Martley. As a boy Hastings showed unusual attention to any creature that was sick or ailing and expressed a desire to enter the medical profession. In 1810 Charles was apprenticed to an apothecary in Stourport, and at his master's instigation attended a school of anatomy in London. At the tender age of eighteen, though possessing no medical qualifications and against strong opposition — including a member of the Royal College of Surgeons — he was elected by the governors as house surgeon to Worcester Infirmary.

For three years there was a noticeable improvement in the practice and management of the hospital, all attributed to the keen young resident surgeon. In 1815 he left for Edinburgh and took a degree at the university there three years later. So high was the reputation of this young man that he was offered the professorship of physiology by the university senate; but he declined because, as he said later, 'My aim was to become the first physician of my native county'. He returned to accept the post of junior physician at Worcester Infirmary.

Hastings became president of the Worcester Medical and Surgical Society in 1819 which took the lead in urging the government to remedy the deficiencies in the law regarding the practice of anatomy. To publish his researches he promoted a local medical journal which achieved success in a wider field. This led him to found the Provincial Medical and Surgical Association which first met on 19 July 1832 when Dr Hastings delivered the inaugural address.

Early in his career Hastings became convinced that the health of the public should be the responsibility of the state. From years of experience of the occupational diseases among Worcester's glovers, leather workers, needlepointers and those engaged in making and painting china, he knew that it was not enough for a doctor to be concerned with the cure of disease — it was his duty to prevent it. He concluded that only a professional body of state doctors could forward the progress of medical science. Worcester's medical association was not unique but Hastings' personality, tact and drive led to its recognition as the most authoritative and comprehensive in the land and with the passing of the Medical Act of 1856 the Worcester Provincial became established as the British Medical Association.

Hastings was knighted in 1850. He retired from the staff of Worcester Infirmary in 1863, and from the General Medical Council on which he had been a Crown nominee since its inception. His professional life spanned the great epoch of medical reform. He was one of the first in Britain to use a microscope for medical research and was a pioneer in the use of the stethoscope. He lived during the pioneering days of anaesthesiology and survived into the age of Listerian surgery. He died in his seventy-third year and Worcester went into mourning, with shutters up at shops and private houses. The President of the BMA was staggered by the demonstration of feeling: 'Short of any member of the Royal Family, it was impossible that more respect could be shown.' He was buried in Astwood Cemetery.

Old Worcester bridge

From early days a wooden bridge of sorts spanned the river at a ford near the bottom of Dolday. In 1313 the Prior of Worcester raised funds for a stone bridge which was erected soon afterwards, and it became the chief crossing to Wales between Gloucester and Bridgnorth. It had a gatehouse in the middle which

served as a city gate. There was a dispute between the city's bailiffs and the priory about the laying of water pipes from Henwick Hill, but this was settled and the arrangements confirmed by Henry IV in 1401.

The stone bridge does not seem to have been damaged in the Civil War, except perhaps for the gatehouse which was rebuilt in 1702. The city was responsible for repairs to the bridge and there was a proposal to widen it at a cost of £7,000; but a 'packed' vote in the council decided on building a new and more elegant one. An Act of Parliament of 1764 gave leave to build a new bridge with tollhouses and John Gwynne was commissioned to build it. Eventually the old bridge was demolished, though with difficulty, for the piers were solid and gunpowder had to be used.

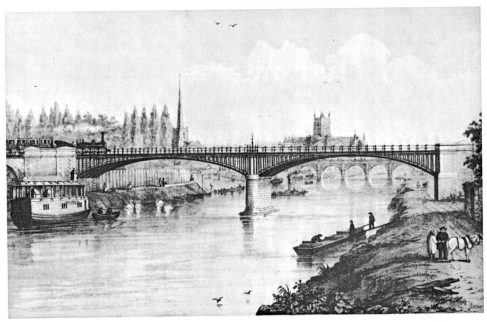

19th-century lithograph by E Doe showing an early train on the new railway bridge

John Gwynne's bridge

John Gwynne RA was an architect of some distinction, a friend of Dr Johnson and the builder of a number of fine bridges, among them Shrewsbury, Atcham and Magdalen (Oxford). The bridge over the Severn was opened in 1781 and was built lower down the stream where there was an island, the watercourse on the town side being known as the 'Little Severn'. The island was removed at the building of the new bridge.

The new bridge was a dignified structure of stone with five semicircular arches, springing five feet above the lowest water level, the diameter of the centre arch being 41 feet, and the length from bank to bank about 270 feet. It had a towing arch on either side of the river and on St John's approach two

charming round tollhouses, with pillars and a dome, each occupied by a keeper's family. The bridge and the quays cost £30,000, part of which was a gift from the Worcester MPs who were principal members of the East India Company, for it was said that the city had sold itself to that company.

Gwynne is second only to the great Thomas Telford as a designer of Severn bridges, but he was as conservative as Telford was revolutionary, and that suited the Worcester corporation. The grateful city bestowed its freedom on him in 1783 and he is buried at St Oswald's Hospital.

At the approaches to the new bridge Gwynne cut the new street, Bridge Street, through a bad slum area known as Rush Alley, and lined it uniformly with dignified houses. Not only the bridge but the quays, too, were rebuilt, the work transforming the river front of Worcester and justifying Arthur Young's remarks in 1776: 'I found the City of Worcester so improved since 1768 when I was here before that I hardly knew it again. The bridge over the Severn with its wharfs and quays and the approach broad and regular with the new pavement of the streets altogether have rendered it quite another place.' In 1841 E Leader Williams, the Severn engineer, widened the bridge by hanging over cantilever pavements of cast iron, with finely moulded decorative supports. Gwynne's bridge remained until 1932 when it was destroyed in the making of the present bridge.

On the north quay the origin of the name of a former public house called the Old Rectifying House (now Aunt Sally's Eaterie) has intrigued generations of visitors. It came simply from the fact that it was the rectifying house (where the spirits were 'rectified', or refined) for the distillery just the other side of the bridge. It was completely rebuilt in 1897 and has been a pub for most of this century.

The railway bridge and viaduct

The railway bridge was built in 1860 and was part of a notable one-and-a-half-mile long viaduct and embankment taking the Worcester and Hereford railway across the city, from Shrub Hill to Henwick. It was constructed by Stephen Ballard of Colwall, backed by Thomas Brassey, the great railway constructor. There are 68 arches, one of which, the Croft Road arch, was the first brick arch to be built 'on the skew'. The embankment, like all the railway works of that age, was the work of pick-and-shovel navvies. It would certainly have been better for the city if Brunel's scheme to cross the Severn by an opening bridge at Diglis Lock had been adopted — and less expensive — but the trade around Lowesmoor Wharf had dictated the present position.

The bridge was not built without trouble, for there was great difficulty with the foundations; and when completed, government inspectors noticed a defect in the two cast-iron arched spans and refused to pass them as safe. Because of the hold-up the first train left from Henwick, and the rolling stock was transported by wagons through the city streets and over the road bridge.

When, on 25 July 1859 at 8am, the first train ran from Henwick to Malvern Link Station, the little engine was gaily decorated with evergreens and small flags. The station was also decorated and crowds lined the route to give the train a rousing send-off. From a signal post hung a banner on which was inscribed 'Hope, Peace and Plenty'. There were 58 passengers and the journey was completed in a quarter of an hour.

The construction of the railway bridge, 1860

In 1904 the rail bridge over the Severn was replaced by a girder bridge, designed by J C Ingles, the GWR chief engineer, using the old abutments and the centre support.

Old St Clement's church , Dolday

St Clement's church was formerly on the east bank of the Severn at the bottom of Dolday. It was described as a Saxon church but records only exist from 1670, for earlier books were said to have been destroyed by floods. It was so often full of water, up to the pews, that the incumbents frequently had to row up the aisle in a boat. They had, however, the right to all salmon left stranded in their church!

It was a small, damp building, erected just inside the city walls for safety. The destruction of the city wall in this area seems to have been responsible for much flood damage, as it appears up till then to have protected the church. St Clement's seems always to have been a small parish, and church payments in 1726 show only thirty householders. The church was 'bewtifyed' in 1745, but by 1820 the old fabric was again in a bad way; and because more people now lived in the part of the parish across the river the decision was taken in 1823 to build a new church on the high ground there.

Most of the old church was pulled down, but enough of the walls were left standing to form a cottage. So it remained until the Second World War, when the old walls were demolished to make a gun site. Those were the desperate days of Dunkirk when it was believed that invasion was imminent and the gun was intended to cover the crossing of the bridge.

'Heaving' in Dolday

The strange custom of 'heaving' took place in Dolday on Easter Monday. A chair decorated with ribbons and coloured streamers was placed in the street and the women would wait for the unwary male to pass along the street and then, by a combined effort, would force him into the chair, heave him up and down and only by payment of a kiss and beer money would they allow him to go free. The next day the men turned the tables on the women. This strange custom was also practised at Kidderminster and Victorian churchmen tried to dress it up with claims of religious significance when in reality it was merely an excuse for high spirits and a little vulgarity which otherwise would have been suppressed by magistrates and others.

John Davies and the Watermen's Church

The last rector of old St Clement's, and the man responsible for building the new church at Henwick, was Rev John Davies, affectionately known in his day as 'The Apostle to the Watermen'.

He was born at Rock, Worcestershire, in 1788 and received his education at Dr Simpson's Academy in Worcester and Worcester College, Oxford. He came to Worcester as chaplain to the Berkeley Hospital and attracted considerable attention by his preaching and care for the poor. In the year 1816 he was presented to the rectory of St Clement's, a position which brought little pecuniary gain, as the outcome of the living was but £90 per annum and involved much work. In his parish stood the gaol and prisoners under sentence of execution were comforted by his ministrations. The infirmary, too, was in St Clement's and for long periods he paid a weekly visit to the wards. His zeal and devotion were especially manifested during the cholera epidemic of 1832.

John Davies became increasingly concerned about the spiritual state of the watermen on the Severn and the Worcester to Birmingham Canal, in the 1840s calculated, with their wives and children, to be about 4,000 in number. He visited every town on the Severn, and gave public lectures on the subject; and was responsible for the erection of the Mariners' Chapel at Gloucester. In Worcester he bought the old Severn barge, *Albion*, and converted it into a floating chapel which lasted many years until it sunk and the caretakers, who lived on it, had to be rescued through the roof.

John Davies died in 1858, and as a memorial to him the barge was floated during a flood and put on a brick foundation in the old St Clement's churchyard and then used as a schoolroom. Next to it in 1859 arose a large new Watermen's Church, built of iron sheets, complete with spire. The old *Albion* became a ragged school, but in the reforms of the 1902 Education Act it was not spacious enough and was not considered acceptable. It remained until 1947 when, along with the church, it was demolished. Few by then recognised it for what it was.

Nobby Guy, Dancing Dinah, and the others

Around St Andrew's and All Saints was the worst slum area in the city until the clearances began about 1912. All sorts of people lived in those terrible dwellings, some filthy in person, behaviour and language, yet the majority

courteous and in their rough-and-ready way always ready to help others when times were bad. Among the many characters were those affectionately known as Nobby Guy, Dancing Dinah and Hallelujah Lily.

Nobby Guy was the most prominent of these, a strange, powerful character who boasted, with some reason, that it took several policemen to take him to the station. He was known throughout Worcester because of what he considered to be his divine right to lead any procession in the city, including the civic procession to the cathedral on Mayor's Sunday. It was remarkable that no attempt was made to stop him, for the scene was ludicrous, like a relic from the past, but one that was enjoyed by all — except those at the head of the procession. Crowds swarming along the High Street would wait for the cry, 'Here's Nobby!', and Nobby would appear at the front, always dressed in a light suit with a straw boater and white pumps. A little way behind would come the chief constable and six of his constables, then the mace and sword bearers and javelin men, followed by the members of the corporation. The procession brought out all the wits from the alleys just off the High Street, and they were no respecters of persons. The councillors walked in procession, deep in conversation, trying to appear not to hear the ribald remarks shouted at them.

Nobby was a saturation drinker. In that state he was always ready for a fight or, for half-a-crown, would dive off Worcester bridge. Magistrates ordered publicans not to serve him, but they were afraid to refuse. Then, unbelievably, he joined the Salvation Army and turned away from his evil living and aggressive drinking, marching instead with the band, even carrying the banner; and he was found a job as a janitor at the Army's barracks. Only his pipe remained from the old life, against the Army's code but allowed by an understanding captain. Sadly, a new captain lacked that understanding, demanding that Nobby gave up his pipe. It broke Nobby and he left the Salvation Army and returned to his life of dissipation.

There were many other characters in the area. After a few pints Dancing Dinah would dance most beautifully, and the tale was told that she had once been on the stage but had been shamed by a nobleman who left her in the gutter. Hallelujah Lily's claim to fame was a voice of quite exceptional range, and she would treat all who cared to listen to pieces from grand opera. Like Dinah, she had been brought up in better circumstances, but drink had brought her there. There were others too. The Rev Gilbert Sharp helped with a lodging house mission in Dolday in 1919 and wrote:

> One man had a first-class Cambridge degree, had risen to high rank in the Services, but lived in one of the lodging houses in Newport Street. Each week he collected money from a local lawyer which was provided by his family on condition that he kept out of their way. His vice was drink and the woman he was consorting with was obviously of the same social class, but was a drunken sot.
>
> By his invitation I stayed one night there, but the smell of humanity, beer and strong twist made it difficult to get to sleep and, when asleep, the disturbers were so numerous and vicious, new blood I suppose, that I got up about 3am and went down to the river, stripped and had a short swim. It seemed incredible that this highly educated, well born scholar should live under such conditions, and at the same time read the Latin classics regularly.

The person who could and did rule these folk was Rev J Macrae, Rector of All Saints: he was a Scot, 6 feet 4 inches tall, broad-shouldered and with fists like iron. More than once he settled fights by giving both contestants a black eye. Many will recollect the true story of him getting hold of a really grubby child and taking him home. 'Is this your child?' 'Yes, sir.' 'Give me some soap and water.' Macrea set to and washed the bairn from top to toe.

Pitchcroft and the fight to get public possession

Today it is hard to believe that before 1899 the citizens of Worcester had no right to roam at will over Pitchcroft. Pitchcroft was owned by several people and there were no visible boundaries to the various properties; so they were distinguishable only on the tithe map. There had always been footpaths giving access to ferries, used for so long that the public had acquired the right to pass along them during what was termed the 'closed season'; but the acquiring of the croft for public recreation was achieved only by determination against dogged and fierce opposition.

A guidebook of the mid-19th century described Pitchcroft as the racecourse, 'a large flat meadow on the east bank of the Severn above the bridge, called Pitchcroft Ham, or as it was anciently called, Holme, signifying literally the inner island of Pitchcroft. The freemen of the City and the freeholders of Claines have the right to feed their cattle here from July 6th to February 2nd, and subject to this right, the property chiefly belongs to the charities of the town, some portion being vested in the Charity Trustees.' In fact, there was no authority for the holding of races on Pitchcroft, but races have been held there from the days of Charles II.

In 1888 an effort was made by the corporation to purchase 98 acres and the common rights, and a crowded and noisy gathering met at the Guildhall to consider the proposed purchase. The opposition believed that the move would deprive citizens of their rights — yet their rights were slender. In 1893 Major T A Hill offered to sell 56 acres for £7,000, the sum it had cost the various owners. There were two conditions to the offer: first, the yeomanry should be permitted to have their annual training there free of charge, and, secondly, twelve days should be put aside for racing. Hill offered £1,000 to improve the course if the corporation would do the same. It was not until 1899 that the final step was taken to secure the full use of Pitchcroft for the public without let or hindrance. It was fenced in by the corporation and Lord Beauchamp presented the handsome entrance gates.

Little Pitchcroft riots, 1818

The croft nearest the city walls (roughly the land cut off by the railway viaduct) was called Little Pitchcroft. It was taken up by the cattle market and other buildings, but not before there was considerable violence to stop the loss of what was regarded as the citizens' common land.

Buildings had encroached on the space after the end of the Napoleonic Wars in 1815, and a meeting was held at the Hop Pole Inn to demand their removal. Nothing was done to take them down; so the protesting populace decided to do it themselves and, led by Joseph Steers, a respectable tradesman, a token part was demolished. The mayor read the Riot Act, but nobody took any notice; so

he tried to swear in special constables, but none dared interefere. Later, the yeomanry were assembled, but were pelted with stones and forced to retreat to the yard of the Star and Garter Inn and made no further appearance. The demolition was completed, everyone said it was disgraceful, but were glad it was done.

Joseph Steers was indicted for a capital offence; but though found guilty, his sentence was light, bound only to keep the peace for twelve months, with £100 as surety — which was immediately offered. The jubilation was great and crowds endeavoured to drag the judge's carriage in triumph through the streets — until he threatened to commit the foremost of the crowd and sense prevailed.

Isaac Gordon, moneylender

Moneylenders in the past were often Jews, since so many other avenues were barred to them. One of the most notorious was Isaac Gordon, who kept a moneylending office in Bridge Street in the 1880s. He was sentenced at Worcester assizes to a term of imprisonment for defrauding a Herefordshire farmer and the exposure of his extortions contributed to the securing of legislative regulations on moneylending.

Gordon was a Polish Jew, a descendant of a too 'Gay Gordon', who some three-and-a-half centuries before had fled from Scotland to escape the penalty of murder and found refuge in Poland. There he had married a Jewess, embraced Judaism and formed a clan of Polish Gordons.

Isaac Gordon died early in March 1900 and *Berrow's Worcester Journal* carried this comment on him: 'He made the calling of moneylender stink in the nostrils of the nation . . . The ruthless barbarity of his temper almost made Shylock benevolent in comparison . . . For a dozen years he was known as the most dangerous member of his trade, and yet he was only 35 when last Tuesday he was called to his account.' It is not known what his terms were, except that they were heavier than most — and the common rate of interest then was 5/- per £1 per week or 1300% per annum.

The county gaol

Under the threat of a heavy fine if the county failed to provide a secure prison, the county gaol opened in 1813. It was built in the style of a medieval castle, and because of this the name of Salt Lane was changed to Castle Street. It originally contained ninety cells with a governor's house situated at the south-east corner of the building; but it was enlarged to give eighty more in 1839, during a time of great political agitation when the gaol was excessively crowded with Chartists from Dudley and cells intended for one were housing three. By the time the government took over the responsibility for the nation's prisons in 1878 city prisoners were already being confined at Castle Street.

The county gaol was an all-male general prison and held a variety of prisoners, from murderers and debtors (the latter until 1873) to political agitators and men of religion who preached in the streets without a licence, to boys who had committed what today would be classified as minor misdemeanours. For the young the gaol had its own schoolmaster who lived at No 1 Easy Row. It was a very secure gaol and only one prisoner is known to

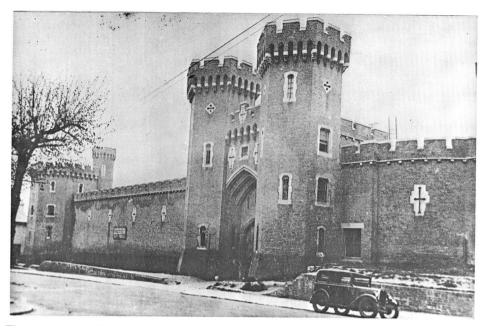

The county gaol, Castle Street, closed in 1922. Over the gate, between the two towers, public executions took place until 1863

have escaped. He hid himself under sacks on the coal cart and was driven out of the gaol. His big mistake was in going straight home for tea, for he was promptly sent back by his wife.

There were public hangings and whippings in Castle Street until 1863, when great crowds gathered to witness the spectacle which took place on the top of the gatehouse. Afterwards the bodies were displayed and usually handed over to the surgeons at the infirmary for dissection. Plaster casts of some of the heads of murderers still remain in the possession of the Worcester Royal Infirmary. The last *public* execution was on 2 January 1863 when William Ockold of Oldbury, aged 70, was hanged for the murder of his wife. The last man to be executed at Worcester was a Chinaman who was convicted of the murder of another of his race at Warley Woods in 1919. The gaol's most notorious prisoner was Herbert Rowse Armstrong, a cool and calculating solicitor, who killed his wife and was suspected of other murders. In 1922, with the Home Office closure of seven gaols, including Worcester, Armstrong was transferred to Gloucester for execution.

During the 1914—18 War, the gaol was almost empty, for many prisoners were given the opportunity to have their sentences respited provided they served in the forces overseas. The area it served was enlarged to cover the counties of Worcester, Hereford and parts of Radnorshire, but the prison at Worcester became increasingly uneconomic. At the end it held only a hundred prisoners and its closure came as no surprise.

Map 4

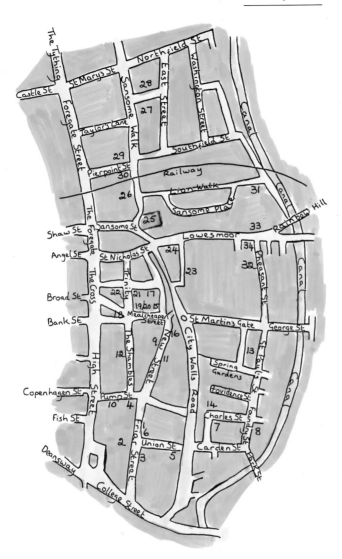

1. The Greyfriars
2. Tudor House
3. Wyatt's Hospital
4. The Eagle Vaults
5. St Lawrence's church
6. The city gaol
7. The Blockhouse
8. The Worcester Foundry
9. New Street
10. Pump Street church
11. Nash's Almshouses
12. The Shambles
13. St Paul's
14. Providence Works
15. The Cornmarket
16. King Charles House
17. Old St Martin's
18. St Swithun's
19. The Shades
20. Early Post Office
21. Queen Elizabeth's House
22. Trinity Hall
23. The Old Infirmary
24. Silver Street Baptists
25. Catholic church
26. Quaker Meeting House
27. Sansome Fields
28. Arboretum Gardens
29. Early libraries
30. School of Design
31. Lowesmoor Wharf
32. Vinegar Works
33. Lowesmoor music halls
34. Salvation Army

District Four

East of the High Street

Friar Street and the Greyfriars

Friar Street is the most interesting of the medieval streets left in Worcester, having retained more of its timber-framed buildings than any other of the city's thoroughfares. Many of its houses, whose brick facades disguise timber-framed constructions, were of considerable size and once occupied by citizens of substance; but in the 18th century some of them were divided into tenements and allowed to fall into a sorry state of dilapidation. In this century developers, keen to demolish rather than to restore, would have swept many of the old buildings away had not strong-minded individuals succeeded in preventing them. Even so, it was not possible to save the Old Deanery in Lich Street which was replaced by a multistorey car park, one of the most brutal pieces of architecture in Worcester and completely out of place in this old street. But Friar Street was largely saved; and it is in this part of the original city, between the High Street and the line of the wall, that the visitor gets the best feel of what medieval Worcester must have looked like.

Pride of place in Friar Street goes to the Greyfriars, the finest half-timbered building in the city. It owes its continued existence to Mr Matley Moore who saved and restored it when the official inclination was to let it go. For a century or more this magnificent medieval building has been known as Greyfriars and research carried out earlier this century by several historians, including J Matley Moore and Canon Buchanan Dunlop, concluded that the building was one of a group erected by the Franciscans, possibly serving as the friary's guesthouse.

The Franciscans — or Grey Friars — were an order of mendicant preachers founded by St Francis of Assisi. They came to Britain in about 1224 and though not welcomed by the older religious orders established themselves by their zeal and merit. A few years after their arrival they were given land on the east side of the city by William de Beauchamp, Lord of Elmley Castle, hereditary sheriff of the county and castellan of Worcester. The friary extended from Friar Street eastwards to the city walls, its church (St Lawrence's) and some of the other friary buildings standing outside the walls at the bottom of St Lawrence's Lane which later became Union Street. It became a very important religious house, exercising authority over others in the West Midlands, one of the seven districts into which Franciscans mapped England. During the three centuries of prosperity, however, the Order deviated from the high standards of self-denial prescribed by their founder;

contrary to his rules friars accepted houses and lands, and the simple life lost its attraction. An old ballad asserted:

> No Baron, or Squire, or Knight of the Shire
> Lives half so well as a Holy Friar

Their breaches of discipline brought about their downfall; and when Henry VIII seized their houses at the Dissolution in 1538 the Franciscan property was bought from the Crown by the Municipal Corporation of Worcester and St Lawrence's was pulled down.

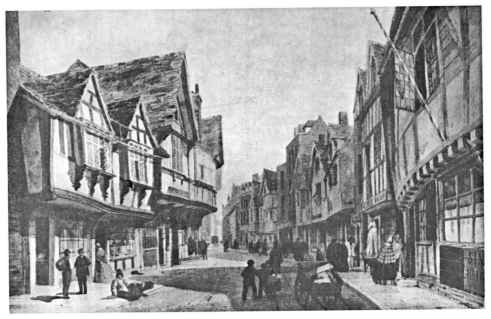

Friar Street, 1859, *a watercolour drawing by Thomas Shotter Boys*

During the 17th century the building was lived in by the Street family, who had sold it to the city in 1600 but had obtained in the negotiations a very long lease; but by 1698 the lease had been sold to the Maris family, who let it in 1724 to Daniel George, a baker and maltster. He turned the top of the house, immediately under the rafters, into a tiled withering floor (withering is part of the process of preparing the barley for malting), the tiles being cemented down to the boards. It was the George family who divided Greyfriars into four tenements and built the row of ten cottages in the garden, eastward to the city wall; the road through the gateway became known as George's Yard.

In the 19th century part of the building was occupied by Christopher Bardin, an old gentleman who conducted a private school at modest fees in the days when public elementary education was in its infancy. There he trained more than one generation of small shopkeepers, continuing to keep the school long after it had ceased to keep him. In about 1870 Henry Schaffer, a German refugee from the 1848 Revolutions, further mutilated Greyfriars by converting

the hall into shops despite the sharp local cricticism, especially from John Noake, the local historian.

It was the beginning of the process whereby Greyfriars became one of the worst of the city's slum properties. The roof was in a terrible state of dilapidation, with rain coming through to the rooms below. Part of the building had become a greengrocer's and the back rooms were filled with the vegetable debris of years. Part of the timber framing, that part of the building known as Thompson's Trust, actually fell into the street. It remained in that state until half a century ago, when the property was purchased by Mr W J Thompson and restored by Mr J Matley Moore; and it was finally presented to the National Trust.

There is another view about the origin of the Greyfriars building, recorded in 1937 by A R Martin, an historian on Franciscan architecture, and supported more recently by the research of Pat Hughes and Nicholas Molyneux, which suggests that the original Franciscan site is marked by the present nos. 11−25 Friar Street and that Greyfriars was never part of the friary buildings but was erected by Thomas Green, a wealthy brewer, acquiring its name only during the last hundred years. Hughes and Molyneux are still working on the building's history.

The city gaol

Over the centuries the city has had many prisons. There was the gaol at the east end of St Nicholas Street, a bridewell (rather like a workhouse) at the bottom of Cooken Street (Copenhagen Street), and below the gatehouse of the Foregate were cells which for a long period were used as a prison for strangers. The freemen of the city had the questionable privilege of being detained in the cells beneath their own Guildhall.

But just as the county was compelled to provide a more secure gaol after the escape of so many prisoners from the old prison at the castle, so the city had to put its house in order. George Byfield, a London architect, who specialised in designing gaols, was employed by the city authorities. In the early 18th century part of the old friary buildings had served as a prison and in 1822 these were demolished and the new gaol was begun. It cost the city £12,578 and prisoners were moved into it in July 1824. Like the county gaol in Castle Street, the city's new prison was built on John Howard's principles, and contained a treadmill. But it generally held only about thirty people and its existence was very brief.

The post of governor was very much a sinecure and was so regarded: the chief feature of the prison was the governor's house and the principal employment of the prisoners was in his domestic service, some even waiting at table on him and his guests. The prison's only governor, Mr William Griffiths, was appointed in 1819 and held the office for nearly fifty years. He was quite a local character, in his old age a bright-eyed cheery little man who wore the long antiquated garb of his youth — black with swallow-tailed coat, soft white neckcloth, such as Beau Brummell wore, and a high-crowned silk hat. He kept an excellent table and gave dinner parties to those whose hospitality he enjoyed outside the gaol. His company on such occasions was a liberal education in the art of social enjoyment. However, he suffered an embarrassing mishap. He had a favourite prisoner whose irreproachable manners and

aptitude for domestic service procured him the run of the house and the privilege of going out at night to light the retiring guests home. But one night the prisoner decided to retire himself, carrying the governor's family plate with him. The story helped to hasten the inevitable merger of the county and city prisons.

Only forty-five years after its opening the gaol was submitted for auction and bought by William Laslett who was thought at the time merely to be satisfying his insatiable appetite for a bargain.

William Laslett

Laslett bought the city gaol in 1867 for £2,250 and then adapted the cells to accommodate old married couples. At first the residents had no allowance but lived rent free; in 1875, however, he conveyed to the trustees an estate in Herefordshire to provide allowances for them. Not until 1912 were new almshouses built on the site — and they are still standing.

William Laslett was a notable citizen and a Member of Parliament. He bestowed upon Worcester larger benefactions than any who preceded or have so far followed him, gifts like Astwood Cemetery, some twenty acres of land with two mortuary chapels, consecrated in 1858. But he was a man of strange contradictions, who frequently marred his gifts by the manner of his giving, and in his own day was better known for his eccentricity than for his benevolence. Nevertheless, his impulses were generous even if his ways were somewhat ungracious. He was a solicitor in that golden period of the legal profession, the early 19th century, when many fair-sized family fortunes were made locally, with offices at No 50 Foregate Street.

The circumstances of Laslett's marriage to Maria Carr, the daughter of the Bishop of Worcester, read like the plot of a high Victorian melodrama. When Bishop Carr died owing £100,000 the sheriff's officers seized his body, and not until a month later, when sureties were forthcoming, did they release it for burial. It was Laslett who put up the money, and it was said at Abberton where he lived that the price in return was the hand of the bishop's daughter. The marriage lasted six unhappy years and proved a matter of notoriety. Thomas Southall, another solicitor, who knew them both, reckoned the fault was not all on one side. Maria openly showed dislike and contempt for Laslett, and in return his behaviour was at times abominable.

Laslett did not study physical necessities much and appearances not at all. He walked the streets of Worcester in a top hat and clothes only a ragman would want; he stripped to the waist to dig a saw-pit rather than pay workmen 2s 6d a day; and he used to boast that as Worcester's MP his journey to London and back, besides his fare, cost only 3d, breakfasting before he started and indulging only in a 1d bun and a glass of ale.

In the political field Laslett experienced the sweetness of victory and the bitterness of defeat. He was returned as a Liberal in 1852, but in 1874 suffered the mortification of coming bottom of the poll, receiving 500 fewer votes than his Liberal colleague, Rowley Hill. He never stood again.

Tudor House

The timber-framed building known as Tudor House, on the west side of Friar

Street, has been part of the city's museum service since 1971, providing constantly changing displays of life in old Worcester. It is a building of considerable interest dating from around 1600. Built for one of the city's more prosperous citizens, it has always been divided into three houses. For many years part of it was the Cross Keys Inn, one of the so called 'ecclesiastical inns' in that area (along with the Cardinal's Hat, the Angel de Trompe, the Mitre and the Seven Stars). At the beginning of this century it was a coffee house, and in the late '20s became the administrative centre for education in the city and later a school clinic.

Tudor House was restored in 1909 by the Cadbury family, when it was found that many of its old features were buried under cement, plaster and wallpaper. In the front rooms on the ground floor the timbers are in a good state of preservation, and between the two old stone fireplaces, one to each of the houses on this side of the entry, is an opening for which no satisfactory explanation has been found. While a stone chimney was being removed a number of bullets (Cromwell's 'Brown Besses') were found, and there were numerous other discoveries, including a 'chimney jack' (or smoke jack). The timber framing of the house is filled with wattle and daub, and in the cellar are large recesses in the stone walls. The room upstairs has a fine 17th-century plaster ceiling.

Wyatt's Hospital and the Eagle Vaults

Almost opposite Tudor House is Wyatt's Hospital, founded for six poor men by Edward Wyatt, Worcester's mayor in 1696. The men received 3s. a week and half a ton of coal a year. Until a few decades ago it was an attractive row of early-18th century cottages, but has now been mutilated almost beyond recognition.

On the corner of Pump Street stands the Eagle Vaults, a good example of an 1890s city tavern, with Art Nouveau tiled facade and lettering and the best sand-blasted, decorated windows in the city, including one engraved 'Snug Room'. (Other good windows can be seen at the Royal Exchange, Cornmarket, and the Beehive, Tallow Hill.) Inside the Eagle Vaults the furniture is the original mahogany with black American cloth seating, and decorative cast-iron tables. The building itself dates back to the 17th century and has been an inn for over 200 years (under several different names).

Hannah Snell, the woman soldier

One of the most celebrated characters of the 18th century was the woman soldier, Hannah Snell, who was born in Friar Street in April 1723. In some local records she is said to have been the daughter of a hosier and dyer, and when young loved playing at soldiers, parading a company of young boys and girls in the streets of Worcester.

Abandoned by her husband at the age of twenty-two and bereaved of her child, she borrowed a male suit and set forth in search of her partner. She first made her way to Coventry, a base for Hanoverian support in 1745, but did not find him there, so enlisted in the Duke of Northumberland's army which compelled the Young Pretender's retreat. At Carlisle, it is said, her sergeant took umbrage at the way his woman took to the 'young man' and gratified his

resentment by procuring 500 (her account) lashes for his rival. She deserted, made her way, disguised, to Portsmouth where she enlisted as a marine in Colonel Frazer's regiment, saw active service in India and fought at the siege of Pondicherry. She was wounded twelve times, once in the groin, but apparently maintained her secret by extracting the bullet herself and dressing the wound — though another version says she was nursed by an Indian woman who kept her secret.

Her story created a great stir in London when an account of her adventures, entitled *The Female Soldier*, was published in 1750. She appeared on the stage at Sadler's Wells and performed military drills. Three portrait artists painted her in masculine dress, and the *Gentleman's Magazine* of July 1750 investigated her claim and was impressed enough to include a poem in her honour. The Lord Mayor of London summoned her to attend him, and in an affidavit sworn before him she maintained the truth of her story. Even the Duke of Cumberland was convinced and added her name to the king's pension list. After the publicity she retired to keep a public house which she named the Female Warrior; but it was not a success. The king granted her a pension of 1s. a day for life as an out-pensioner of Chelsea Hospital. She married three times in all but eventually went insane and died in Bethlehem Hospital in 1792, aged sixty-nine. She was buried in the grounds of Chelsea Hospital.

St Lawrence's church

St Lawrence's church, destroyed at the Dissolution, stood outside the city walls. In June 1298 William de Beauchamp, Earl of Warwick, was buried in the grounds after much ecclesiastic argument and bad feeling, for the cathedral authorities wanted the body of so great a personage buried in the cathedral itself. When Sigley's sweet factory was erected on the site in the mid-19th century many human remains were found, but only one coffin — and this of elaborate design — which was broken up for concrete. Since the Franciscan rule required members to be buried without coffins, and the only person not a member of the community known to have been buried there was the Earl of Warwick, this would point to his grave. The burnt-out shell of Sigley's old sweet factory is now occupied by a pine warehouse and a bedding company, its rebuilt front housing several smaller businesses.

St Lawrence's Lane was a continuation of Union Street and connected with the High Street, a little distance north of Lich Street. The lane was later called Newdix Court, for the family of Newdicks, who were clothiers of great account in the reign of Elizabeth I, had their house there; but in later days the house had gone and mean slum dwellings had been built on the site.

The Blockhouse

The Blockhouse was the immediate area outside the city walls on the east and was part of the liberties of the city. It was a network of ditches, much like Sedgemoor; and even in the 1850s one of these ditches still remained, with its path alongside, known as Withy Walk (now St Paul's Street). The 'blockhouse', referred to as 'the fort at the Friars gate', was part of the city's fortifications, built in 1643, using £11.13.9 worth of lime. At the time of the Civil War the city walls were long and low at this point, for it was only necessary to dam Frog

Mill stream to convert the whole area into a morass. At the battle of Worcester in 1651 some of the Scots horsemen camped in the area — roughly along the present line of the canal as far as Lowesmoor — thus screening the walls and protecting a line of retreat, while Cromwell occupied all the high ground from Ronkswood to Red Hill; but in the event there was little fighting here.

In 1246 the king gave the Grey Friars permission to have a postern gate in the town wall to give access to their burial ground and the church. This gate came to be known as Friars Gate. In 1820 a new road was constructed from Friar Street to the Blockhouse, called Union Street, and it marked a distinct stage in the growth of Worcester on the east, for up to that time the city had been hermetically sealed against ordinary vehicular traffic by the city walls, although the old postern gate gave limited access to the Blockhouse fields.

The district was laid out, according to the times, as a 'garden suburb', and in comparison with the dark and narrow 'courts' within the walls well deserved the title. In the 1860s it still contained pretty gardens, some quite large, and even paddocks; but these gradually fell prey to the speculative builders. The principal street, Carden Street, was named after a venerable member of the corporation, Alderman Thomas Carden, who was mayor in 1790 and whose portrait hangs in the Guildhall.

Hardy and Padmore, the Worcester Foundry

The Worcester Foundry was in the Blockhouse on the canalside. It closed in 1967 after 153 years of business, during which the firm was renowned far beyond this country for its fine decorative cast-iron work. The name of Hardy and Padmore, Worcester, can be seen in many towns on ornamental lamp standards and other street furniture, on seats, firegrates, railings and gates. Their most spectacular pieces were made between 1850 and 1900, a period known as the golden age of cast-iron work, the beautiful, elaborate castings only recently appreciated by the public at large. Their best known work is the Dolphin lamps on the Thames embankment.

Among the examples left locally are the fountain in Cripplegate Park, the lamps on Worcester Bridge, the Rococo fuse boxes on the old tramway standards, the gates from the Arboretum (now at the infirmary) and those at Angel Street church, and a number of beautiful lamp standards at Cheltenham. On a smaller scale, the doorstops of the Duke of Wellington and of Punch and Judy are now collectors' pieces.

Richard Padmore was the technical man, a typical example of a 19th-century self-taught, self-made man. He began as a workman and became senior partner, a model employer whose workmen had a grateful and real affection for him. He took part in all the city's affairs, served in all local offices and was elected Member of Parliament for Worcester with distinctly radical views.

New Street

Originally, New Street and Friar Street were one street, the former known as Glover Street, the latter, developed later than New Street, taking its name from the Franciscan friars. The north and earlier end of Friar Street was sometimes, confusingly, referred to as Glover Street. There was no break where Charles Street (split by City Walls Road) goes to the Blockhouse; and Pump Street was a very narrow lane, the bottom of which was known as

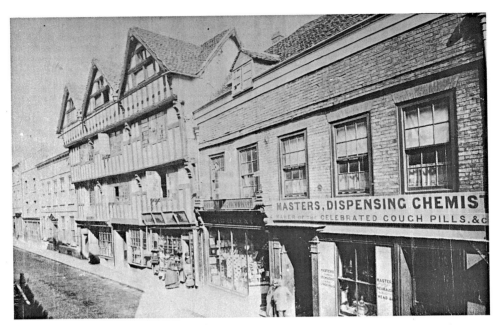

New Street, c.1870s. Nash House is just left of centre and next door to the steam printers,
Baylis, Lewis & Co

Baynham's or (later) Ballhams Vine. The east side of New Street contains a number of old merchants' houses from the 18th century and earlier. They illustrate well the late-18th century trend in which such houses were vacated by the original owners, and then divided off into tenements and small workshops. Almost all the gardens, which went down to the city wall, had industrial buildings and workers' cottages built on them. Baylis, Lewis and Co, the printers, is a good example: it began life at the back of the dwelling south of Nash's House. Most were owned by clothiers, and weaving went on in the rooms at the top of the houses. Later, when the cloth trade died out, they were used for gloving, an industry established in Worcester in medieval times. In 1820 there were seven glovers working in New Street.

The pawnshop, the last of the city's pawnshops, stood at the top of Nash's Passage until the 1960s. In the days before 1914 crowds thronged the pavements to get into the shop on Saturday evenings, when the week's wages were received. Many a wife, when the money was at hand, dashed down to the pawnshop to get her 'old man's suit out', so that it would be available on Sunday and he would never know she had 'popped it'. It was a vicious circle of poverty and deceit, for on Monday she would be short of money and back would go the suit again. It was a period of dreadful poverty, with never anything left over; and even when there was employment, it needed only illness or the death of the breadwinner to reduce a family to desperate need.

New Street inns and cockfighting

Twelve large inns catered for the trade in the Cornmarket in olden times, and

four of them were in New Street. They were the Greyhound (later called the Old Greyhound), the New Greyhound, the Swan, and the Pheasant. The Greyhound was the principal place of departure for carrier carts: no less than nine carts left the inn for outlying places on Saturday afternoons around 4 o'clock. It must have been a very busy street, for there were carriers at the other inns too. Like the inns around, the Greyhound had great storage space and stabling for a large number of horses. In the early 19th century the trade was so brisk that the New Greyhound was opened almost next door.

The Swan, now called the Swan with Two Nicks, dates as an inn from 1764; the building, however, goes back at least as far as the mid-16th century, when an Edward Elcocks, a clothier, held the lease. In 1780 it was known as the Little Swan, and in 1826 we know there was stabling for forty horses. In 1865 the veterans of the battle of Waterloo celebrated the 50th anniversary of the great battle at the inn. Another 16th-century building, the Pheasant, did not become a public house until the late 1770s when Eleanor Morris, whose husband had been the licensee at the Pheasant in Silver Street until he died, moved to a house in New Street, obtained a licence and named the inn the Pheasant (the premises in Silver Street having been delicensed). Later it was known as the Old Pheasant and a couple of years ago its name was changed to the Bishop's Rest, but only briefly for it has now assumed its ancient name. The Pheasant was a somewhat superior inn, for it had a bowling green at the back which was reserved for members of the corporation. It was laid out in 1787 and gave the name to Bowling Green Walk.

The Pheasant, along with the Star and Garter in Foregate Street, was the principal inn for cockfighting, with ample accommodation for spectators and, it is said, for eighty horses. Cockfighting was a very popular sport all over the country and a big event could last two or three days and involve very high stakes. In 1800 the sport was made illegal, forcing 'the fancy' out into the county inns where it was easier to conceal their activities.

John Wesley in Worcester

The city's first Wesleyan chapel was built in New Street in 1772, and a plaque on the wall commemorates its opening on 11 March. Wesley himself had visited the city four years earlier and in his diary records: '. . . there was difficulty to know where to preach since no room was large enough to contain the people and it was too cold for them to stand abroad.' He preached in the New Street chapel in March 1772, 'but for a time the work of God was hindered by a riotous mob, but the Mayor cut them short — and ever since we have been in perfect peace'.

Wesley visited the city every year and by 1788 the numbers of the sect had grown to 209; but only sixty were men. In 1861 there was an old lady named Jane Crump who had heard Wesley preach in 'The Riding House', before the chapel was built, and who recalled that 'people used to rise as early as five in the morning to hear him preach and so far from insulting him, would go some distance from the City to meet him when they knew of his coming to Worcester'.

St Andrew's Wesleyan church, Pump Street

In 1795, four years after John Wesley's death, the Wesleyans in the city

bought an old chapel in Pump Street belonging to a branch of Independents. It was surrounded by tumbledown houses and like many of the early dissenters' chapels was tucked away up an alley so as not to invite trouble from the mob. But times had changed since the attack on the little chapel in New Street. In 1796 the old Pump Street chapel was demolished with the houses around and a new church erected; and when this proved not to be big enough another church was opened in 1813, with seating for 1,000 and at a cost of £6,560.

In 1873 the chapel was again demolished and replaced by another, which stood until 1965 when it too was taken down. The present Wesleyan church of St Andrew's, opened in 1968 and elevated over the shopping development, is thus the fifth church on the site in under two hundred years. It is interesting to speculate how long this one will last. Behind the church, with an entrance in Friar Street, the Wesleyans had a day school, doing excellent work before the days of state education.

Pump Street was the main Wesleyan church in the city, but there were others. In the return of certifiable places of worship, ordered by Parliament in 1882, the following were enumerated as belonging to the Wesleyan Methodists: Boughton Street chapel, St John's; Bull Entry chapel belonging to the Wesleyan Reformers; and Zion chapel, Park Street, for the Wesleyan Methodists' Association. Two years later Boughton Street was replaced by Bromyard Road Methodist church and a chapel was built in Ombersley Road. There were also Primitive Methodists in George Street who joined with the Pump Street church in the mid-60s; and a mission at Glenthorne, demolished in the 1950s.

Alderman John Nash

In New Street there is a fine half-timbered building known as Nash's House. It takes its name from the Nash family. Alderman John Nash was mayor and twice representative of the city in Parliament during Charles I's reign. He lived in Nos 4 and 5 New Street and owned Nos 6 and 7. He was born of a wealthy family of clothiers in 1590, at a time when Worcester was the largest clothing manufacturing town in the country, employing 8,000 people on 380 looms. In his seventy-two years Nash was a Roundhead captain of horse, politician, local administrator and successful merchant; and in the revolutionary days of the Commonwealth as a JP he married couples in the Cornmarket, a church being regarded as unnecessary. Apart from his hospital charity, he left £300 from which young men could borrow free of interest to set themselves up in business.

John Nash's tomb is in St Helen's church, across the aisle from his old enemy, Colonel Dud Dudley. He left orders for his will, 'so far as relates to his charitable bequests, to be publickly read by the Town Clerk at the Guildhall of the said City, on the first Friday in Lent, and he to receive for his trouble five shillings'. It is unlikely that this has been carried out this century.

Nash's Almshouses

Off New Street are Nash's Almshouses, originally intended, like St Oswald's and Berkeley's, for the aged. They still occupy the original site, and have given the name Nash's Passage to the narrow way by which they were approached.

John Nash, in his will dated 1661, 'gave and devised to 16 trustees, property to be held in trust for pious and charitable uses', and with it was bought not only the land in New Street upon which the almshouses stand, but five acres which comprise the site of the Royal Infirmary. Further almshouses, built on part of that land at the side of the cattle market, have since been demolished. The twenty-five old folk lived rent free, with a small pension, free coal and light, and a clothing allowance. The New Street Hospital, as it was originally known, was not an altogether original foundation, for almshouses known as Throgmorton's had previously stood on the same site. It is conceivable that Throgmorton's Almshouses became derelict and Alderman Nash's endowment provided an opportune resource for restoration.

Nash's House in New Street dates from 1605. It was planned by Richard Nash and the timber components were left to his son John in his will. John Nash lived in the house next door (Nos 4 and 5) to Richard. It seems likely that during the Royalist occupation of Worcester Nash fled the city and Dud Dudley occupied it, for the latter recorded that when the war ended Nash's House was seized and his wife turned out-of-doors. Though it has been maintained that during Dudley's occupation the building was a shot tower there is very little evidence for this; and, in any case, shot was not made in this way until the 18th century.

The Shambles

The Shambles was originally Baxter Street (Bakers Street) and took its present name during the 17th century from the butchers' shambles built for 'foreign', ie country, butchers at the south end in 1601. Early in the century, the Shambles by day attracted a number of street musicians, if one could be generous and call them that, for few could genuinely play or sing. One played a concertina outside the Butchers' Arms (now the site of Marks & Spencer), and his repertoire consisted of *The Old Rustic Bridge* and *Abide With Me*. It must have been thirsty work, and well rewarded, for he frequently disappeared into the pub to enjoy his takings. Hymns went well in those days: two ragged individuals sang *Nearer My God To Thee*, though seemed only to know the first two lines. The man had a constant 'frog in the throat': he coughed and spat and cursed his wife and all who passed without giving alms. The woman looked for likely customers on the other side of the street and would push a cap forward and howl in a strange piping voice 'Nearer to Thee — nearer to Thee!'. So unwholesome were they that most moved further away, and those that gave a copper dropped it into the cap at arm's length.

Then there was Mouth-Organ Annie, who dressed in Union Jacks and danced to her own tuneless accompaniment, and to add to good measure did cartwheels in the middle of the street. She appeared to be well over seventy, but her agility was amazing. Very different was the group of Welsh miners who, during the Depression of the 1930s, sang in perfect harmony. There was a sad dignity about them, and the melancholy Welsh songs spoke more eloquently than words of the hardships in the valleys. Groups of northcountry brass bandsmen also wandered from town to town, but they played cheerful tunes and their poverty was not so obvious.

Not all characters were musicians. There was Salt Annie who trundled a rickety flat barrow around with huge blocks of salt which she got direct from

the saltworks at Droitwich, and cut up to whatever size was wanted with the rustiest saw imaginable. She wore an off-white apron and a man's cap turned back to front. Whether her name was Annie, or whether she acquired it because of her call, is uncertain; but she had a piercing cry: 'Anny salt? Anny salt?.'

In the late '20s youngsters had decided views on the merits of ice cream — in those days made by the people who sold it — which differed considerably in flavour and quality, mostly tasting like cold custard. For the well-to-do the stall at the front of the market hall was claimed to be the best, but in the street it was a toss-up between Lannie's and Daydo. Lannie's descended from Italians who arrived in Worcester around the 1880s, and served the ice cream from a pony and cart with gaudy lettering, bells and the bright trappings typical of the fairground. Daydo, whose name was Davies, was a cheery little man with a small handcart, self-painted, who shouted 'Daydo! Daydo!', and on days when there were few customers was inclined to give his ice cream away. Big business was taking over, however, with Wall's and Eldorado ices sold from pedal-carts with the slogan 'Stop me and buy one'.

'Buy! Buy! Buy!' Saturday night in the Shambles was like a medieval fair, with butchers vying with each other to auction unsold meat. Until about 1930 few butchers had any form of refrigeration and meat was sold off cheaply rather than left to spoil over the weekend. Many butchers in the Shambles had their own slaughterhouses at the rear of the shops, and very unhygienic some of them seemed to be. But it didn't stop crowds of poorer folk from gathering there to get a cheap bit of meat, for the shops stayed open then till after 10pm.

Day or night, the Shambles was a lively place, for as well as the street characters, the ice-cream vendors and the butchers, there were a number of greengrocers who kept up the tradition of 'barkers'. The shouts of 'Ripe tomatoes', 'Bea-utiful cu-cumbers', 'Best Jaffa oranges' were bellowed in quick repetition — each outshouting the other. The greengrocers always appeared to spill out onto the pavement, as did the refuse of cabbage leaves and empty boxes. One shop, however, needed no barker. It was Taylor's, the grocer who kept the ripest of cheeses. One's attention might be elsewhere but the shop announced itself, for the smell of cheese was strong and unmistakable. Outside, looking through the window, was usually a group of small boys, intent on testing out the theory that if the cheese was watched closely enough it could be seen to 'walk'. In the centre of the Shambles stood Millis's Fish and Chip Shop, where in the 1930s one could buy fish and chips for 3½d and a huge paper of chips for a penny; youngsters with less in their pockets could still get a ha'penny-worth of scratchings.

Still going strong after well over a century is Pratley's China Shop, surviving two fires which burnt down the premises completely. George Pratley originally travelled with a horse and dray, selling at market places up to sixty miles distance; but today the customers come to him, for the china shop in the Shambles has become a Mecca for all who like Royal Worcester, Crown Derby and other fine china at prices cheaper than elsewhere.

The Shambles was above all, however, a street of butchers; but it is not the carcasses hanging from hooks, nor the joints of meat on the slab, that are best remembered from the days before 1939, but the variety of cooked meats and dishes of offal. The butchers' shops were full of upturned buckets of pressed beef, brawn, chitterlings and tongue; dishes of tripe, pigs' feet, chawl (pigs' face), faggots, brains and hearts; pigs' puddings (black and white), 'mountains'

of thick and thin sausages; and — in pride of place, selling at 7½d a quarter — legs of roasted pork, the crackling scored and crispy brown, the centre stuffed with sage and onion.

St Paul's and Woodbine Willie

Until about 1830 the St Paul's district was a very swampy area known as Blockhouse Fields. The first St Paul's church was opened in 1837, soon after the first housing development began, a typical 'Commissioners' Church' in the semi-Gothic style, with a small tower at the west end and seating 625. The present church dates from 1885−6 and was designed by A E Street who had family connections with Worcester. His work is acclaimed nationally, and St Paul's is a good example of his style, built in red brick with black brick trim. The windows are by C E Kempe. The old church was later used as the school hall until it was destroyed some thirty years ago.

After the 1914−18 War the most famous preacher of the age, Rev G A Studdert Kennedy brought fame to the parish. He was Chaplain to the King, a poet and writer, and a preacher who filled the largest halls in Britain and abroad to overflowing. His words were as powerful as the prophets of old and his fame so great that he could have had one the highest posts in the Church of England; but he chose instead to work in one of the poorest parishes in Worcester. He became vicar of St Paul's in 1914 but by the end of 1915 was experiencing the worst of the Great War as Chaplain to the Forces. By the time he returned to Worcester he was a public figure, much in demand. He resigned the living of St Paul's in 1922 and became rector of St Edmund, King and Martyr, in Lombard Street. But his home and family remained in Worcester so that he was a familiar figure in the city until his death.

He was a remarkable man, beloved by the lower ranks in the War and nicknamed 'Woodbine Willie' from his practice of handing out Woodbine cigarettes, along with a Bible, to the men in the trenches. He was awarded the Military Cross for bringing in wounded under heavy fire with 'absolute disregard for his own safety'. In the peace and great Depression that followed he was bravely outspoken, angry with those who were Christian only in name and oblivious to the poverty around them. He had a voice like a bull, and he once described himself as 'looking like a monkey'. He was ferocious in shaking people out of their selfish ways; and yet those who worked with him knew 'he was as weak as a kitten and was moved to tears at the hardship and suffering of others'.

Studdert Kennedy was the highest paid writer of his day, but not a penny went into his pocket. All was directed to charitable funds and, like St Francis, he gave his clothes away to beggars at the door. He died in Liverpool in 1929 of pneumonia and, it was believed, without a coat to his back. At his funeral, work in the city stopped, traffic came to a standstill as great crowds lined the streets and followed his body from the cathedral to the cemetery. As someone said: 'We knew a saint had walked the streets of Worcester.'

The Temperance Hall and the Hall of Science

At the corner of Providence Street and Temperance Street stood the Temperance Hall, a large building of two-colour brick, dating from the 1860s.

It was remarkable for the text made from letters of coloured brick, 2 feet high or more, which ran round the external walls between the ground and first floor. It read: 'The Blessing of God Keep Us and Protect Us From All Intoxicating Drinks.' It was destroyed in 1900 when Williamson's tinplate factory was extended. The 1860s and '70s were the peak years of the temperance movement and temperance hotels were set up all over the country to fight alcoholism — including one opened in Lowesmoor in 1884. At first the poor were encouraged to drink ale in order to wean them away from gin, but later beer was included.

The Hall of Science stood nearby in the 1840s, opened by the English socialists. Noake wrote: 'The Socialists some years ago pitched their tent in this district, but have now abandoned their 'Hall of Science', which is converted into a schoolroom.' The halls of science were the educational spearhead of the socialist movement which was especially strong in the North of England. In Worcester it was much less effective and G J Holyoake, a lecturer in the movement and employed at the Worcester Hall of Science in the Blockhouse district at a salary of 16s. a week, wrote rather disparagingly of the efforts of the Worcester socialists:

> English socialists expected to improve society by showing the superior reasonableness of the changes they sought. A small branch of these propagandists existed in Worcester. An enthusiastic carpenter had enlarged and fitted up an oblong workshop as a lecture room, some sympathisers who never appeared in the hall furnished means of purchasing materials. These humble lecture rooms were called 'Halls of Science', not that we had much science — merely a preference for it.

The Established Church viewed the socialists with great disfavour; but a member of St Paul's commented that 'with the exception of the immoral tendencies of their Halls of Science, balls, and midnight orgies, they do not seem to occasion much annoyance to the inhabitants . . . They and their companions in recklessness may be seen on a Sabbath morning, with no coats on, smoking pipes in the open street, or at their own doors, while the decent and God-fearing population around them are quietly wending their way to Church.'

It would appear that by 1855 the socialists no longer occupied the building on the corner of Providence Street for the *Worcester Herald* of 27 October of that year reported: 'Mormon 'lecture' at the Hall of Science, Blockhouse, by 'Elder Evans' on the subject of polygamy. The hall was crowded. A great disturbance took place and the police sent for. The proprietor has since refused to lend it again for such disgusting purposes.'

Williamson's Providence Works

Over a hundred years ago a local tinsmith, William Blizzard Williamson, founded a sheet metal works in Providence Street and called it the Providence Works. From small beginnings it became the base of operations for Metal Box's biggest money-spinner in the U K, for at Perry Wood, Worcester, the firm (now called C M B Packaging) was at one stage turning out two million open-top cans a day — to carry vegetables, fruit, beer, beefsteak, puddings and dairy

cream. The Providence Works was amalgamated with a number of other U K can- and tin-box makers under the Metal Box Co Limited trade name in 1930 to fight terrific competition from American high-speed production.

In the old days the Providence Works produced travelling trunks, cash boxes, baths, general tinware and camping washstands for expeditionary forces. A specialist line was the beautiful judge's and barrister's wig box; and some Worcester people may have seen the replica of the original F A Cup which was stolen from an Aston shop window after the Villa had won it (and never, incidentally, recovered). In 1885 George Williamson, son of the founder, invented and patented the cutter-lid tin, familiar to those older readers who remember buying their favourite brands of cigarettes in 'round fifties'. On this device the British export trade in cigarettes and tobacco was built.

To meet the growing need of the late '20s, the first high-speed food-can line was installed. It soon became apparent that the need for food cans would exceed the works' manufacturing capacity; so a new factory was built at Perry Wood in 1931. The Prince of Wales, later Edward VIII, visited the plant, which by then was producing up to half a million cans a day. In 1955 the Providence Works was sold and on the original site a post office telecommunications centre erected.

George H Williamson

For a century the Blockhouse was dominated by the Providence Works: within ten years of George Williamson going into the business the labour force increased from 400 to well over 1,000, and the works had become one of the largest of its kind in the country. Williamson's greatest achievements, however, lay in his work for the city. For forty years he was identified with every movement in Worcester, political and social. He was mayor in 1893, but it is as chairman of the Streets Committee that he is best remembered. He did for Worcester in a smaller way what Joseph Chamberlain did for Birmingham.

He widened the central streets and made them modern thoroughfares — High Street, St Swithin's Street, Bank Street, St Nicholas Street and Pump Street among them. Some of the streets leading from the Cross and the High Street were almost like tunnels. St Swithin's Street was only 15 feet wide, and from the upper, overhanging storeys it was almost possible to shake hands with people across the street. In 1887 the creation of a paved footpath on the east side of the river enabled the esplanade to be used at times of high river levels when previously it had been impossible. He raised Hylton Road out of reach of all but the severest flood, and improved the access to Shrub Hill Station. He widened and fenced the New Road, broadened Severn Street, paved Croft Road and a number of similar thoroughfares.

Williamson brought great energy to all his tasks: between the years 1886 and 1893 forty-nine courts were paved and drained and otherwise improved at the owners' expense; and, in addition, the worst areas of overcrowded 'rookeries' were cleared and drained. Having thus improved the streets he added to the elegance and comfort of many of these by planting trees and providing seats. He was one of the pioneers of public lighting by electricity, responsible as chairman of the committee for the first municipal power station.

In national politics, and through no fault of his own, he was much less successful. In 1905 he was elected as Conservative MP for the city by a

majority of 129, but was unseated as a result of the corrupt practices by his agent in the notorious 'Duke of York case'.

The Cornmarket

The Cornmarket was for centuries the city's principal market place for grain. Besides commerce the space was used for all sorts of activities. The stocks and pillory stood there, and on occasions trading would stop at 2pm and punishments be administered. Public whippings took place in the Cornmarket well into the 19th century, Francis Morris, for example, being whipped for a space of one hundred yards; and in the early days there was a gallows and the severed limbs of the victims were displayed there, as they were after the Gunpowder Plot convictions. During the Commonwealth weddings were officiated in the open air, and up to the present day it has been the scene of political meetings and proclamations. In the eastern corner of the Cornmarket a 'clap gate' gave access to the fields. Old inhabitants still refer to this area — now St Martin's Gate — as Clapgate.

The drama of the corn exchange

The main commodity on sale was corn which was sold by sample in the open air. All around were inns with great storage capacity where the corn was kept until it was sold. By the 1820s however an open market was no longer thought a fit place for such transactions; and the demand for a covered corn exchange gathered strength until eventually, in 1847, it was decided to erect a building worthy of the city.

Unfortunately, the scheme coincided with a moment of strong political rivalry over the corn laws. There was so much distress in Worcester following the sharp decline in the glove trade that the Whigs were keen to abolish the laws and thus bring in cheaper bread. The Tory farmers and county landowners, however, fearing a loss, fought for their retention. Somehow the political disagreements resulted in the setting up of two committees — each to build a new corn exchange in the city. The apathy of centuries gave way to a frenzy of competition. The hotel proprietors of Broad Street and Foregate Street saw their opportunity and supported the farmers' party and a more central site, while the tradesmen around the old Cornmarket made strenuous efforts to retain the old location. The final issue wavered in the balance. There was a deluge of letters to the press, sarcastic verses were composed and sung, the mayor attempted to intervene, but neither side would listen to reason. Each committee raced ahead to complete its exchange first — and the ridiculous result was two exchanges, one in the Cornmarket, the other in Angel Street.

It was a disastrous affair. Millers and cornmerchants might frequent the Cornmarket, but few growers brought their samples there; and it was not long before the building was sold and converted into a music hall, leaving the Cornmarket almost bereft of trade. The Angel Street building survived but proved a ruinous affair for its first shareholders.

The Public Hall

The new corn exchange building in the Cornmarket was built on the side of the

old Wheatsheaf Inn. Directly in front of the old inn an arcade — called the 'piazzas' — had been used by corn merchants for transacting business since the late 17th century. The new building had two halls, the larger one — 97 feet long, 40 feet broad and 40 feet high — one of the best lit in the kingdom, with a dome which was later destroyed by fire. It cost £7,000 in £10 shares, but failing in its purpose was sold for only £1,710 as a music hall. In 1875 William Laslett sold the building to the corporation for £2,200.

For years the hall had a chequered career. It was used for Saturday 'Penny Readings', at which Harry Day was the chief attraction. In 1867 Charles Dickens twice came to read from his own works: *A Christmas Carol* and the trial from *The Pickwick Papers*. Here Mark Lennon interpreted Falstaff, Sims Reeves, the great tenor, sang 'My Pretty Jane', and Souza, with his remarkable band of exhibitionists, gave a farewell performance. Here, too, Jenny Lind sang to raise funds for a chapel at the Worcester Royal Infirmary, Dvorak conducted his own work, *Stabat Mater*, and Elgar his symphonies and *The Dream of Gerontius*. To many the hall will be remembered for the music of the Festival Choral Society, with Ivor Atkins conducting the London Symphony Orchestra and Edgar Day on the powerful organ; for the Sunday night military band concerts; or the secondary schools' prize-distribution musical items under the baton of Miss Lilian Tyers. There was entertainment of another kind from the Bijou Minstrels with Tom Thumb, Pool's Panorama, Cherry Kearton's Wildlife Lantern Lectures: and the coming of the bioscope.

By the 1890s the building had become known as the Public Hall and was the principal place for electioneering. In the days before radio and television, when public meetings were an important part of the campaign, each party tried to secure the hall for the vital eve-of-poll meeting. On one memorably hot summer evening, with the windows wide open, a band was hired to play outside and drown the speakers within. Later, during the 1939—45 War the building was used as a British Restaurant where comparatively good meals were available to help out meagre civilian rations.

King Charles House

On the corner of the Cornmarket and New Street stood the most important house in this part of the city. Now called King Charles House, it was built by Richard Durant, a wealthy brewer, in 1577 as a two-storey house.

At the time of the Civil War Mr Edward Durant, Richard's grandson, was the owner and it was he who acted as host to Prince Charles when he made the house his headquarters in 1651. It was a fortunate choice for the future king, for after the disastrous battle the house offered the only possible exit out of the city. Tradition has it that the Parliamentary troopers arrived at the front door as Charles left by the small back entrance through the city walls, and mounted his horse. With Lord Wilmot he rode across the fields along the path now called Sansome Walk, to Barbourne Brook where, feeling themselves safe for a while, they paused to consider which road to take. They decided on the Ombersley Road and to make for the crossing over the Severn. So began one of the greatest escapes in British history.

It was probably Edward Durant who modified the house, dividing and extending the northern bay (now King Charles Restaurant) to form a separate dwelling. To compensate for the lost space he built another storey onto the

existing building. In the 1660s the house belonged to William Woodward. The persistent tradition that the Berkeleys of Spetchley were the owners does not appear to be borne out by documentary evidence. Their Worcester house was in Mealcheapen Street, round the corner.

Old St Martin's church, Cornmarket

The present church was begun in 1768 and opened in 1772, designed by Anthony Keck, a local architect, of the 'new brick' made from the clay of the coal measures in the north of the county and shipped down river. An older church had stood on the site, very irregular and with a porch built principally of timber. It contained memorials to many prominent Worcester citizens, including the 'father of Nonconformity in Worcester', Thomas Badland, whose memorial was retrieved and re-erected at the Angel Street church, when Keck broke up the memorials of earlier years.

The parish seems to have had more than its share of financial troubles for, like the endowments of St Oswald's, the rents of property bequeathed to the church to be used for repairs had been allowed to dwindle to a bare trifle. The fabric had certainly decayed, for Chambers gives details of the stone floor giving way in 1819, and of a woman falling into the vaults below. During the repairs a coffin was found containing strange objects: three old tobacco pipes, a small three-handled cup of black earthenware and a pewter chamber pot. It appears to have been the coffin of an old toper.

Noake visited the church on a number of occasions but had little good to say of it. There was an Elliott organ of 1812 in the gallery, but, Noake commented, 'the congregation reaped no benefit whatever from them (improvements) — the screaming notes and careless mistakes of the female voices, being suitably responded to by the grumbling, jagged, non-interfluent tones of the instrument'. During the 1840s at the time of the controversy over the payment of church rates, there were many scenes of discord and dissension within its walls.

The church contains the first record of Freemasonry in Worcester in a memorial to Samuel Swan. The lodge was founded at the Reindeer Inn in 1791. St Martin's rectory was built behind Mealcheapen Street with access through the churchyard wall, and the tithe barn stood in the Trinity until about 1915.

Perambulation of St Martin's parish bounds

In this part-urban, part-rural parish the beating of the parish bounds was an important function, involving a long journey, with many halts for liquid refreshment, and prayers under the 'marker oaks' which stood at strategic corners. The perambulation started from the church, proceeded through St Martin's Gate to Spring Hill, across to London Road to Rose Hill, then up to Lark Hill to Nunnery Wood and on to Spetchley, where the boundary turned north to the Virgin Tavern. This very ancient inn, on the boundary between St Martin's and Claines' parishes, in Victorian times competed with the Ketch on the Kempsey Road and the Swan on the Whittington Road as a surburban resort for Worcester citizens. From the Virgin Tavern the boundary ran to Ronkswood and Shrub Hill (where there was a boundary stone set in the wall

facing the station), to Lowesmoor and up Watercourse Alley and back to the church.

St Swithun's church

St Swithun's church, just off the High Street, was built in 1736, and is one of the most perfect Hogarthian churches in the kingdom. Years ago, when the box-pews were full and the parson was droning away in the three-decker pulpit, it was easy to be transported in spirit back to the 18th century. The pulpit, crowned with its carved pelican plucking its breast, is certainly one of the best of its kind in the country, and along with the mayor's chair and wrought-iron civic sword-rest, makes a most interesting set of church furniture.

As in other Worcester churches in the 18th century, burials took place in the church crypt, and because the churches were seldom ventilated the atmosphere was frequently vile. By the 1840s there were many complaints and Noake records that the smell of dead bodies in St Swithun's was intolerable: beneath one family pew lay ten children and their parents, and only the floor boards separated the congregation from their predecessors. But St Swithun's was not exceptional in this.

The parish, like others in the city, had a mixture of well-to-do merchants and the very poor. Items in the churchwardens' account book throw light on the problems facing parish officers concerning illegitimacy and in particular their attempts to prevent charges on the parish funds. Considerable money was spent, for example, searching for a man called Hackluit, responsible for the 'maid at ye White Hart having child'. He was eventually discovered, but later abandoned child and mother; whereupon the father of Hackluit was pressed to support the child. He refused — and finally comes the entry: 'Paid to a poor woman for carrying her out of town, 1s.' There appears to have been a poorhouse or 'lying-in house' at the Cross, for there are several references to women being 'delivered at the Cross'. In an edition of *Berrow's Worcester Journal* in 1775 is an account of a widow remarrying at St Swithun's church. It shows an old belief being used as a 'legal' practice.

> A widow, being married again, to exempt her future husband from payment of any debts she might have contracted, went into one of the pews and stript herself of all her clothes except her shift, in which only she went to the altar, and was married, much to the astonishment of the Parson, Clerk, etc.

Some early schools

The city has had a wide variety of schools, but none has made a greater impact than the Lancastrian Monitorial School in St Martin's Gate, for this was the first day school for the 'children of the labouring poor of Worcester', and its establishment set off a spate of school building all over the city.

Mass education can be said to have begun in England when Joseph Lancaster devised the 'monitorial' system of education. He was followed almost immediately by Dr Andrew Bell who introduced virtually the same system. In the early 19th century education was regarded as the concern of the churches, and two rival societies were set up. The Lancastrian system was

supported by the *British and Foreign School Society*, a nondenominational body; the Bell system by the *National Society for the Education of the Poor in the Principles of the Established Church*. They were known for short as British Schools and National Schools and their method of teaching came to be known as the 'monitorial system', because monitors, a few selected children, passed on to other children the simple lessons they had been taught by the teacher. As a system it clearly had its defects. Nevertheless, it stirred the imagination of many earnest people and made possible the provision of education on a scale previously unknown.

Lancaster's lecture at the Hop Pole in Worcester in April 1809, on his 'new and mechanical system for the use of schools', resulted in Dissenters and Anglicans co-operating to set up a school called the Worcester Subscription Free School. Eight gentlemen bought a plot of land in St Martin's Gate where a school was erected and subscribers had the privilege of nominating children for the school according to the amount of their subscription. A young man, H Clements, who had no relevant experience, was sent to a school in Birmingham for a few weeks to learn the system, and with 352 boys on the register the school opened on 23 February 1811. Within a week the governors were advertising for a new master: it was obvious Clements could not cope. However, the school continued with Thomas Reynolds in charge, but the numbers appear to have been drastically reduced. By 1820 the boys numbered 162, all of them children of the 'labouring poor'. Thomas Reynolds remained in charge until 1842.

It was unlikely that in a cathedral city like Worcester the officials of the Established Church would co-operate for long in an educational establishment avowedly nondenominational. In 1812 a National School was opened at the old riding school in Frog Lane, with 117 boys and 148 girls attending; and the rivalry between the two societies led to other schools being set up in quick succession: Girls' National School (Lowesmoor) 1815; Girls' School of Industry (a British School) 1821; Catholic Charity School 1829; Girls' National School (Holy Trinity) 1834; and St Martin's National School (Pheasant Street) 1837.

At the British Schools in St Martin's Gate finances had long been difficult. Subscriptions had fallen and most children had to pay 'school pence'. In 1850 the fees were as follows:

Boys' School

Reading, Spelling and Writing on the Slate	1d per week
Reading, Spelling, Writing in Copy-Books and Arithmetic	2d per week
The above, with Grammar, Book-keeping, Geography and Map and Linear Drawing	4d per week
All the foregoing, with English History, Natural History and Geometry	6d per week

Girls' School

Instruction in Reading, Writing, Arithmetic, Knitting, Plain Needlework and Marking	2d per week

In 1856 the British School for Boys departed from the monitorial system by engaging the services of two pupil-teachers. The master's salary was £35.16.5d with the addition of some of the 'school pence'. In 1872 the school received its first government grant, £65.19.0d, and the master's salary was fixed at

£95.16.0d, but no 'school pence'. In 1880 education became compulsory for children between the ages of five and ten, but not until 1891 were school fees abolished. In 1893 the compulsory school age was raised to eleven, and so it still was when the school finally closed in 1915. It had lasted 105 years, the building itself standing until 1975 when it was demolished to make way for the new City Walls Road.

The Shades

The imposing building in Mealcheapen Street, almost opposite the old Reindeer Inn, (the latter now a cafe and having given its name to a new shopping arcade), was once known as the Shades Tavern; but originally it was the home of the Johnsons, one of the principal families in St Martin's parish, along with the Berkeleys and the Nashes.

Now a stationery supermarket, the house was formerly one of the best in Worcester; but during its 250-year existence it has been used for many different purposes: a coffee house, then the Shades Tavern (where Elgar's father stayed when he first came from London), the city's first post office, then a bank, and in the 20th century it reverted to the old name of the Shades.

The early post office

Well over a century ago Worcester Post Office stood in Mealcheapen Street, occupying the building twice known as the Shades Tavern, when that area was the very centre of the city's commercial life. The building of two corn exchanges, however, brought changes, and the post office, along with the rest of the commercial business, moved north to the Foregate area. It next moved to Shaw Street to a building (still standing) erected especially for the purpose by Mr John Hughes, a wealthy contractor, who built the entire north side of the street; but as the city's business came to centre more and more around Foregate Street, it moved back there in the 1880s.

When the General Post Office stood in Shaw Street in the 1870s it was the only place where letters could be posted. There were no branch offices and no pillar boxes; so letters had to be posted there from Barbourne or St John's. Nor was it much easier to purchase postage stamps, which could only be bought at 'the General' or at the shop of Thomas Lewis, the stationer, near the top of Broad Street; and the free delivery of letters was confined to a restricted area forming the central portion of the city. Lewis's shop later became the Broad Street Post Office and remained so until the 1920s when the office moved to the other side of the street, near Angel Place.

The first telephone was installed in Worcester in November 1880 by the Midland Telephone Company whose offices in St Nicholas Street connected with its wharf offices in Lowesmoor. The press commented: 'If 20 firms could be obtained as subscribers, the Company would be ready to establish a Telephone Exchange in the City.'

Queen Elizabeth's House in the Trinity

There is a tradition that Queen Elizabeth's House, a 16th-century half-

timbered building, is so called because when the queen came to Worcester in 1575 she ascended to the gallery to watch a pageant and address the populace. However, the name more probably derives from the fact that it is the sole survivor of the old Trinity Almshouses which were refounded by the queen in the early years of her reign. The gallery on the upper floor provided access to two 'bed-sits' for deserving almspeople. Until 1877 a portrait of the queen, painted on an oak panel, hung outside the gallery of the house. For thirty years the portrait was missing but was recovered about 1908 and replaced. On the eve of Trinity Sunday this portrait used to be wreathed with evergreens, gilded laurel leaves prominent, and in the arches of the gallery a large golden ball was inserted.

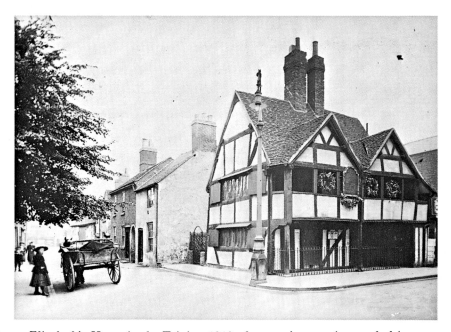

Queen Elizabeth's House in the Trinity, 1910, the queen's portrait wreathed in evergreens

In 1890 the house was in danger of being demolished. St Swithin's Street had to be widened and the Trinity Passage improved, but the old house blocked the way. Fortunately, it was saved by public-spirited citizens who found the money to acquire the property. But it was decided the house had to be moved bodily to a new site across the road and out of the way of the new road. A Worcester firm, Bromage & Evans, undertook to effect this by screw jacks and the building, reputed to weigh over 200 tons, was moved along on greased metal railway lines, a distance of about 30 feet — no mean a feat in those days.

The Trinity Hall

The Guild of the Holy Trinity, founded over 600 years ago, had its religious origins in St Nicholas parish, and the hall of the guild fell into the hands of the

Clothiers' Company at the suppression of the religious bodies in the reign of Henry VIII. It contained a number of large rooms which were assigned to the trading companies, according to their importance. The main hall of the building was probably the largest meeting place in the city. It was a lofty and spacious room, with a dais at one end, seats and a canopy over the central seat.

The guilds used to meet there on St Stephen's Day, and for more than a century held their business meetings there. During that period the building was let to players and showmen, and used for assizes and quarter sessions. When the cloth trade declined the Trinity Hall ceased to be of much use to the companies and the use of an inn was preferred. Eventually, in 1796, the Trinity Hall was sold by the Clothiers' Company for £185 to Mr Tymbs, a member of the corporation. It was then partially demolished, the remainder being used as a furniture store and a schoolroom. The fittings were considerable and fetched far more than the hall when they were sold in London. The final demolition was completed with the widening of St Swithin's Street and the cutting of the Trinity roadway.

The old Worcester Infirmary, Silver Street

The Worcester Infirmary opened its door to the poor and sick in January 1746. The infirmary was inspired by Bishop Isaac Maddox, President of the Smallpox Hospital in London and extremely concerned about the physical as well as spiritual welfare of his flock; but the establishment of the hospital was due to the presence in the city of a group of singularly able medical men who devoted many years service to the care of the sick — Dr John Wall, painter, designer, founder of the Worcester Porcelain Works and skilled physician; Dr James MacKenzie who finally retired at the age of eighty-one to write *The History of Health*; and two outstanding surgeons, Henry Vaughan Jeffreys and William Russell, the latter on the staff for nearly half a century. There were also three members of the Johnstone family associated with the hospital, one of them, James, dying at the tragically early age of twenty-nine from a fever caught during zealous attendance on prisoners in Worcester gaol. Among a number of influential laymen who supported and contributed to the building fund were Sir John Rushout, MP for Evesham, and Edward Garlick of Bristol who gave the purchase price of the site in Salt Lane for the new building.

Bishop Maddox, the inspiration behind the hospital's foundation, had started life as a pastry-cook's boy and by his own abilities had become Bishop of Worcester. He used his position well to appeal for help to aid the poor and the sick and his burning zeal, based on personal faith, stirred people's consciences and brought money in. It was a small beginning, but by 1765 the building was so crowded that it was agreed other premises had to be found and five years later the move to Salt Lane (Castle Street) took place.

The Working Men's Institute

When the building ceased to be a hospital it became a notable private boys' school, known as Dr Simpson's Academy, and many a local man of standing received his education there.

In the 1850s, when culture and self-improvement were of growing interest to the new artisan classes, the building became the Working Men's Institute, and

was supported by all the 'progressives' in the city and neighbourhood. The promoters of the institute were recruited from a wide range of backgrounds and included a member of Worcester's aristocracy and at least four socialist fugitives from the European revolutions of 1848, a German, a Pole, and two Hungarians. A spacious lecture hall was built in the grounds and a library formed under the guidance of the headmaster of King's School.

The aristocrat was John Slaney Pakington, later the 2nd Lord Hampton, one of many amateur lecturers and a local intellectual. Two men prominent in the management were Frederick Marcus, a Polish emigre, and Henry Schaffer, a German refugee. Also in this company were Franz Kossuth, another political exile, who later became a Hungarian statesman, and his father, the leader of the Hungarian Revolution of 1848, the collapse of which had driven both to seek refuge in England.

The Working Men's Institute formed a most important function in the city by showing the need and the demand for adult education. Its heyday was in the 1860s and '70s and then it passed; but it prepared the way for the more important Victoria Institute, for many of the most active promoters were old members of the Working Men's Institute. It helped, too, to pave the way for public libraries for the working classes.

The Worcester Co-operative Society

The Co-operative Movement was started in the 1840s to combat high prices and poor quality food and such practices as the iniquitous 'truck system' which was widely used in North Worcestershire. Co-operation was much in the mind of enlightened groups of workers in the city, and in the early 1860s a dual effort was made by the workmen from the West Midland Railway Company (the most advanced group in the city) and those from Dent and Allcroft, Glovers, to set up a co-operative business. For a while it had a measure of success. But eventually it failed through over-confidence and inexperience. A new company was formed with a shop in New Street but this too failed and it was thirteen years before another attempt was made.

The present Co-op dates from 1881 when the 'Co-operative Baking Society' was formed by James Manning, a joiner, who was concerned with the high price of bread (7d for a 4lb loaf), and who maintained that the Worcester Millers and Bakers Association was keeping up the price of bread by close association and price fixing. At the initial meeting eight men paid 1s. for the hire of the room, a book and stationery, but not one of them had any business experience. Nevertheless, after initial difficulties a management committee was elected and premises in Mealcheapen Street rented from John Stallard. Despite every kind of opposition from local bakers and millers the business eventually prospered and a larger bakery in Union Street adjoining the old city police station was used. Dividends were paid to customers and — what was more startling to other traders — bonuses paid to employees and the shop closed to give them a half-day holiday each week. The latter really caused alarm, as well it might, for it sparked off the half-day closing movement in the city.

1887 saw the opening of drapery, footwear and hardware shops adjoining the main grocery stores in St Nicholas Street. This caused a commotion, too, since they were opened by the Dean of Worcester amidst continuing opposition —

some from his own clergy. The Co-op set the pace. In 1891 shop-closing hours were reduced to 7pm on Mondays, Tuesdays and Wednesdays, 1pm on Thursdays, 9pm on Fridays and on Saturdays 10pm, bringing further outcries from other shopkeepers. A coal delivery service was introduced and by 1892 all the loans had been paid off and the Worcester Society now stood on its own feet. Shop hours were reduced again that year; and at the turn of the century branch shops were opened in the outlying parts of the town. Dr Gore, the Bishop of Worcester, became a purchasing member. The Co-op had arrived!

Silver Street Baptist church

The old Baptist church used to be known as the 'Silver Street Meeting House', and stood at the corner of Silver Street and Lowesmoor. There were Baptists in Worcester by 1658, much persecuted at first and meeting, as was usual, in various houses. The church was reconstituted with twenty-one members in 1666; but it was not until 1693, during Elisha Hathaway's long pastorate (1674 to 1714), that land was bought — for £40 — to erect a meeting house. This was rebuilt in 1797 and subsequently enlarged in 1817 and 1827. It was a singularly unattractive building, but spacious enough to seat 600. In 1864 the building was sold to William Laslett for £1,350 and the congregation moved to a new church in Sansome Walk. The old building became a hop warehouse and the adjoining burial ground was later built on.

The school over the saw-pit

One of the earliest schools for the very poor in Worcester was held in Lowesmoor, in a room above the saw-pit. It was opened in 1802 as the Baptist Sunday School for Boys, and at the same time a school for girls was held in the Baptist chapel in Silver Street. By 1823 there were 213 children in the schools. Mr Henry Heath who was a scholar in the Lowesmoor school remembered the old room and the rickety steps up to it and described it as having bare, whitewashed walls, with a desk placed on one side, at which sat Mr Edward Price, superintendent. At the desk hung a cane which was split at the end, testifying to active service and considered then a necessary adjunct. Boxing of the ears was frequently indulged in and one teacher, especially, gave force to his instruction by rather frequent whacks.

At the girls' school it was customary to wear tippets and trimmed bonnets, white in summer and grey in winter. At the close of the school the tippets were collected and placed in boxes. The children generally came from the poorer class and it was the custom to give each child a bun at the conclusion of the service.

The devotion of the Sunday School workers is instanced by J S Hanson who was in charge of the teachers' library. In the discharge of his duties, while he was busy with his books, he heard St Nicholas church clock strike five on six mornings in succession, only Sunday interrupting the pattern. The library must have had a wide range of books for, though mainly religious, it included the publications of the Hansard-Knollys Society.

John Martin, bellfounder, Silver Street

In Silver Street there used to be an opening leading to Bellfounders Yard. It

was there in 1644 that John Martin set up his foundry and in nearly fifty years cast some 175 bells. After the Restoration there was a great demand for bells and John Martin cast almost a hundred for the church towers of Worcestershire.

He loved to ornament the crown and add an inscription. On one at Himbleton he put the following:

> Bee it known to all that doth wee see
> John Martin of Worcester has made wee.

And at nearby Grafton Flyford, rather curiously:

> We wish in heaven their soules may ring
> That gave us six here for to ring.

John Martin cast his last bell in 1693 and died four years later.

St George's Roman Catholic church and a fine painting

The present church in Sansome Walk was built in 1829, the year of the Catholic Emancipation Act, on the site of an earlier chapel of 1764. The architect was Henry Rowe, the builder of the Shirehall. A still earlier chapel stood at the corner of Pierpoint Street and Foregate Street. Though earlier repressive laws were repealed, there were still outbreaks of violence against Catholics well into the 19th century, and St George's followed the pattern of other Catholic churches built at that time of having no windows on the ground floor level as a safeguard against attacks from the mob. The facade, too, though now dignified in Renaissance style, had a well-secured entrance.

Over the altar is a fine and valuable copy of Raphael's picture of *The Transfiguration*. The Worcester copy was made to the order of the 16th Earl of Shrewsbury at the beginning of the 19th century by one of the foremost artists of the day, and was presented by the earl to the Jesuit Order when the church at Worcester was built. When the pope granted permission for the copy to be made, however, he stipulated that to avoid confusion the canvas should not be in one piece, and at the bottom of the picture can be seen the seam where the two portions were sewn together.

The Quaker Meeting House

In the little burial ground off Sansome Street is the Meeting House of the Society of Friends. It is a neat and unassuming building, erected in 1701 on land bought from Robert Steynor, just beyond the line of the old city walls.

Quakers were first recorded in Worcester in 1655 when they were sent to prison for interrupting services — speaking to the priest was a form of their witness. In 1657 Thomas Allington went 'into one of the Places of publick Worship, where he stood still and spake not a Word, and was taken out and set in the stocks'. Edward Bourne, a physician and mainstay of Worcester Quakers, was imprisoned for thirteen weeks for 'exhorting the People in the College (cathedral) at Worcester to Fear the Lord God and repent'. Not all the faults were on one side: Richard Baxter, the Kidderminster Puritan minister,

tells us that the Quakers at that time went naked through the streets 'as a Prophetical act' and entered churches during the services to shout abusively up the aisles, calling the ministers deceivers, hirelings and liars.

George Fox, the founder of the Quaker sect, was imprisoned in Worcester castle gaol in 1673 for fourteen months, and it was there that he wrote his famous journal. Fox was taken by coach to London and his sentence quashed (the first reference, incidentally, to a stage coach in Worcester; the journey took four days).

In the 18th and 19th centuries Quakers became the gentle people of plain speech and sober dress. In Worcester they were among the leaders of almost every reform that benefited their fellow men: abolition of slavery, prison reform, provision of soup kitchens, improvements in housing and working conditions and universal education. In 1824 Elizabeth Fry visited both the city and county prisons, 'and at the latter addressed the prisoners in plain and forcible language'. Quakers insisted on remaining non-political, leading by encouragement and example.

Sansome Fields

Sansome Fields had long been the favourite promenade of the citizens of Worcester. During the 18th century green fields and pastures stretched from Sansome Stile, outside the city wall near the site of the present Roman Catholic church, north to the hamlet of Barbourne and to the eastern limits formed by the hills of Rainbow Hill and Merriman's Hill.

Laird wrote in 1818 that 'the principal walk or mall is in Sansome Fields, for which Worcester is indebted to the taste and liberality of Sir Charles Trubshaw-Withers, Kt, who has laid open to the public a very agreeable line of footway, traversing a great portion of the pasture ground of his own premises, on the eastern limits of the city. At the southern end of this, his mansion, a handsome but not very modern brick building, is a considerable ornament to this part of Worcester, and the walks themselves consist of a gravelly way, shaded on each side by embowing elms, with footpaths leading to pleasant rambles in the surrounding fields.'

The 'gravelly way' was later called 'Sansome Fields Walk', now just Sansome Walk. It was the favourite promenade of the inhabitants, visitors, and especially the belles of Worcester in the 18th century. Something of the atmosphere of the period remains in the name 'The Mall' which can still be seen (though only after heavy rain!) on the wall of a house in the Upper Tything, now part of the Alice Ottley School. In the corner of St Oswald's graveyard, now tucked away and almost forgotten, is an obelisk, a feature of the promenade, which marked where the paths divided, going either to the sophistication of 'Little London' or the rural retreat of the Whey Tavern.

The Whey Tavern was a popular port of call for the citizens until about 1840, when houses began to encroach on the area and the rural retreat became a lace factory. It stood on the piece of ground which now forms the corner of Lansdowne Road and Flag Meadow Walk. It offered a charming rural atmosphere as an alternative to the sophisticated Talbot Inn; and whey, that part of milk that remains liquid when the rest forms curds, was then regarded as being good for health and complexion.

After the death of Sir Charles the grounds, or part of them, came into the

*Part of the Arboretum
(with lodge, fountains and cannon)
and the 1865 proposal for a new Royal
Porcelain Works which never materialised*

possession of Mr T Blaney of Evesham who, by deed of gift dated 24 April 1815, left the Sansome Fields Walk to the city for the use of the inhabitants. Sadly, it did not stop the break-up of the estate, and the city lost the most beautiful of its environs.

The Arboretum Gardens

After 1840 Sansome Fields was in danger of being lost to the city. Part of the Trubshaw-Withers' estate was bought by a private company, the Worcester Public Pleasure Grounds Company Ltd, and laid out by the eminent landscape gardner, William Barrow. The gardens opened on 30 July 1859 and consisted of twenty-five acres, laid out in terraces, flower beds and promenades, with a large central fountain, a cricket ground, bowling green and archery butts. The mayor performed the ceremony, 200 dined in the pavilion erected on the cricket ground, two marquees housed horticultural exhibits, the Worcester Harmonic Society gave a concert, and there was a band to provide music.

The corporation gave £1,000 towards the laying out of the grounds, and in return the public were allowed free access on one day of the week, though, since the day chosen was Monday, this could have benefited few citizens. The main entrance was at the present Arboretum Road, and had a lodge house and imposing iron gates of a medieval design, furnished by Hardy and Padmore's foundry. The grounds had dwarf boundary walls with massive, ornamental palisading. The fine fountain, similar to one at Witley Court, and a crystal pavilion at the end of the main drive (now Arboretum Road) added to the

attractions. On either side of the drives stood two Russian guns taken during the Crimean War. The gardens were regarded by the experts of the day as among the finest pleasure grounds in the provinces.

For four years the Pleasure Grounds Company organised fetes, tightrope performances, firework shows and similar attractions. On one occasion they engaged the band of the Coldstream Guards; and in 1863 a three-day horticultural show was attended by 6,000 people. But neither shows nor fetes paid the expenses and the company went into liquidation. The land was purchased for around £13,000 by the Worcester Engine Company whose directors agreed to let the corporation have the grounds at cost for public use. Lord Dudley offered to give £5,000, leaving only £8,000 to be raised, and the ad hoc committee pointed out that the annual expenses of upkeep need not exceed £250, or 1d rate. But the corporation did not buy the grounds and in 1866 the whole of the land was sold for building purposes.

The crystal pavilion was dismantled and sold, the guns removed to the forecourt of the Shirehall where they remained until taken for scrap at the outbreak of the Second World War. The main gates and some of the dwarf boundary railings were used at Worcester Royal Infirmary, where they stand today at the Infirmary Walk entrance. Even Trubshaw-Withers' magnificent elms were sacrificed to widen the walk for carriages, and the 18th-century promenade became an ordinary street. The loss to the city was great and the grounds were quickly obliterated by an undistinguished housing estate, hop warehouses and two churches. The most prominent reminder of the pleasure grounds is the lodge house on the corner of Sansome Walk and Arboretum Road.

The skating rink

One reminder of the pleasure grounds lingered into the next decade, when the skating rink was built on the site of the crystal pavilion. The drab housing that by now covered the Arboretum must have affected the design, however, for though built for the purposes of pleasure the building had not a spark of gaiety about it. Constructed from corrugated iron sheeting, with cast-iron pillars, it was one of the ugliest buildings in the county. It was used for public meetings and circuses, and at the turn of the century the two had something in common. Great political rivals like Asquith and F E Smith, Lord Randolph Churchill and Sir Charles Dilke, debated the political issues of the day, the speeches given on successive evenings to avoid confrontation.

Later the skating rink was used as a laundry, then became the Midland Red bus garage in 1915; later still it was a fruit and vegetable market, and once more a main bus depot for Worcester. It was demolished in 1972.

Matthew Pierpoint

Matthew Pierpoint, surgeon, was a strange, turbulent character, an ardent Tory of the old school who gave his name to the new road which was cut through his house and garden to connect Foregate Street with Sansome Walk. He was appointed to the Worcester Infirmary in 1819 and had the backing of prominent local Tories, taking a leading part in the hard fighting which restored the Tory party to power under the leadership of Sir Robert Peel, in the

interval between the wave of reform of the 1830s and the triumph of free trade later.

He also had a number of business interests. He was the first chairman of the Worcester Gas Company in 1818; and in the forefront of the squabbles connected with various railway projects of the 1830s and '40s. In 1835, when the Birmingham and Gloucester Railway Company proposed to bypass Worcester by way of Spetchley, he led the agitation for bringing it nearer the city, with the result that Parliament ordered the company to provide a bond which guaranteed the construction of a loop line to Worcester or the forfeit of £70,000. The bond was a mystery for the next twenty years: no-one saw it, but it was understood to have been given Pierpoint personally, and he treated it as at his own disposal. At a public meeting he threatened to throw it in the fire unless he could have his own way, although the mayor claimed it was obtained on behalf of the city. This led to a violent altercation between Pierpoint and Thomas Waters, clerk of the peace, who later published a letter charging Pierpoint with deceiving his fellow citizens. Subsequently, the Birmingham and Gloucester Railway Company repudiated the bond and promoted a new Bill rather than accept the clause relating to the loop line.

The outcome is dealt with elsewhere, but the affair sheds light on Pierpoint's personality, as does his involvement in the notorious fracas at the Diglis Bowling Green with Charles Bedford of the Shrubberies, Barbourne (see page 166). He married an heiress from Crow's Nest (now called Crown East) and set up as a country gentleman. For a brief season he lived in splendour, but soon ran through the property and died in embarrassed circumstances.

The Pierpoint Street libraries and newsroom

When Matthew Pierpoint sold his house and garden to make a new avenue, the street became a centre for libraries. The first public library in Worcester had been established by the Presbyterian Society in Angel Street in the 1790s. In 1795 it was removed to a room adjoining the chapel there; and in 1829, according to Eaton's *A Concise History of Worcester*, had a collection of nearly 5,500 books, the property of the shareholders who numbered 180. With the opening of Pierpoint Street the library moved to a handsome building erected in 1831, ornamented by four fluted pilasters, supporting an entablature and pediment. It had a dome lantern, giving adequate light for the library which was on the upper floor.

Financial difficulties led to part of the building being let to the Law Society and the Medical Society, both societies housing their libraries there. The lower room was occupied by the Worcester News Room, the proprietor of which was Mrs A Deighton, the owner of *Berrow's Worcester Journal*. In 1868 the city council adopted the power given by the Public Libraries Act of 1850, after twice rejecting the scheme; and from then on the Pierpoint Street Library could not meet its financial commitments. In 1877 the trustees were ordered to quit and two years later the building was sold.

A copy of the 1860 rules was found in the building. The subscription then was 21s. per year, 12s. per half year and 7s. per quarter. A fine of 1s. was enforced for breaking the rules and for lending someone else a library book the fine was 2s. 6d. A subscriber living within three miles of the Cross might borrow four volumes at a time (those living further afield could have six) for up to thirty

days with 1d-a-day fines for each overdue book. In 1960 the elegant front had become badly scarred and the building was demolished. An office block now occupies the site.

The Worcester School of Design

On the south side of Pierpoint Street, near the Sansome Walk end, is the building that once housed the Worcester School of Design and Art, which acquired a national reputation in the mid-19th century. The most distinguished names associated with the school were Sir Thomas Brock RA, and B W Leader RA. Other students who gained fame in various degrees were Leader Williams (a brother of B W Leader), J M Swan ARA, H H Martyn, sculptor of Cheltenham, and T Brown, sculptor of Worcester — the latter considered when at the school to be the superior of Thomas Brock. Others were Edward Davis, W C Eddington, Josiah and Thomas Rushton and James Hadley who had been artists and modellers doing fine work at the Royal Porcelain Works.

Thomas Brock was born at Worcester in 1847. His father was a decorator and contractor, while his maternal grandfather was a designer at the porcelain works. He was early interested in the fine arts and at the age of ten attended the School of Design where he studied after school hours. Two years later he was apprenticed to the art of modelling at the porcelain works. In 1866 he completed his training and went to work as a pupil of John Henry Foley RA, the leading sculptor of his day, a post obtained for him by Lord Dudley who was impressed by the young man's work. In 1867 he entered the Royal Academy Schools and two years later won the gold medal for sculpture.

In 1874, when Foley died, Brock was selected to complete his former master's commissions, among which were statues of O'Connell for Dublin, Lord Canning for Calcutta and an equestrian statue of Lord Gough for Dublin. Other fine examples of his work can be seen in this county and further afield: the statues of Bishop Philpott in the cathedral, Richard Baxter and Rowland Hill in Kidderminster, Longfellow's bust in Poets' Corner, Westminster Abbey, Lord Leighton's monument in St Paul's Cathedral and the equestrian statue of the Black Prince in the main square in Leeds.

Of Queen Victoria he probably executed more monuments than any other artist, among them the statue in Victoria Square, Birmingham, and the courtyard of the Shirehall, Worcester. The equestrian statue of Edward VII which forms the All India Memorial at New Delhi was his work. But his masterpiece is acknowledged to be the Victoria Memorial in front of Buckingham Palace, a noble piece of work, finely and imaginatively conceived and executed with massive strength and beauty of symbolism. Brock was one of the small but gifted band of artists who created the British School of sculpture.

Another distinguished member of the School of Design was *Benjamin Williams Leader*, one of the most celebrated and popular landscape artists of the Victorian period and the most prominent of what was then known as the 'Worcester School'. He was born Benjamin Leader Williams at Diglis House in 1831, but later reversed his middle and last names since there were several artists at that time with the same surname. His father, E Leader Williams, was Chief Engineer to the Severn Navigation Commission and responsible for

the building of the locks and weirs. He was also a painter and lover of art and clearly a strong influence on Benjamin. The Williams family were friends of John Constable who often stayed at Diglis House, and this must have been a further contributory factor in encouraging him to take up painting as a career. He was trained, like his brother, as an engineer and worked in his father's office; but his love was art and he spent his evenings studying at the School of Design. When he was twenty-three he left engineering behind and entered the Royal Academy Schools, achieving the rare honour of having a picture hung in his first year as a student.

He was always interested in the rural landscape. His early works were of the lanes and fields of Worcestershire and the hills of Malvern. His most famous picture, *February Fill Dyke*, depicting a grey, wet winter's day in Worcestershire, can be seen in the Birmingham City Art Gallery; but there are others equally good in other galleries and the Worcester City Art Gallery possesses several examples of his work. Leader exhibited over 140 paintings at the Royal Academy and earned a very high income from his work. In 1888 he left Worcester and lived until his death in 1923 near Guildford.

The cutting of the canal

The first discordant note to the peace of Sansome Fields came with the cutting of the Worcester and Birmingham Canal from 1811 to 1815. Its construction more than any other event caused Worcester's industry to be sited on the east side, and because of this attracted the railway there at a later date. It brought industry, with prosperity in its train, but it divided the city in a way that can only be appreciated by walking its banks. It dissected Sansome Fields from the pleasant walks on the higher ground of the hills to the east. There was opposition from landowners along the route but none from Worcester, for though the Act of 1791 was one of the most expensive ever to be presented to Parliament the city felt it could only bring prosperity. When the Bill authorising the building of the canal had passed through Parliament there was general rejoicing in Worcester. The news was brought by post-chaise, and 'with the display of a flag, announced the gladsome tidings . . . a general joy seems to have defused itself through all ranks, which was testified by the ringing of bells, bonfires, etc'.

A local poet expressed the mood as follows:

> Come now begin delving, the Bill is obtain'd,
> The contest was hard, but a conquest is gain'd;
> Let no time be lost, and to get business done,
> Set thousands to work, that work down the sun
>
>
> With pearmains and pippins 'twill gladden the throng,
> Full loaded the boats to see floating along;
> And fruit that is fine, and good hops for our ale,
> Like Wednesbury pit-coal, will always find sale.

In theory the canal had great advantages, but it met the maximum of vested interests from landowners, hauliers and other canal companies. And it was expensive: the final cost of each single mile of canal was £20,333, at least

£4,000 per mile more than any other canal built between 1760 and 1840, and £10,000 per mile more than most. The company was also mismanaged, there was trouble with treasurers, money was promised but failed to come in, and many shareholders, instead of making fortunes, came to ruin. In addition to this, the canal was late on the scene: 1830 saw the coming of the railways — far too competitive for canals.

The engineering task was immense: the 30-mile long canal had to be lifted 425 feet from the Severn to the Birmingham plateau. It was carried out mainly by Thomas Cartwright; he was succeeded in 1809 by John Woodhouse who, with William Crosley, finished the summit level and built the rest of the canal to Worcester. The work, begun in 1791, necessitated the building of fifty-eight locks and five tunnels and it was not completed until 1815.

The new commercial centre around Lowesmoor Wharf

The port of Lowesmoor was intended as the principal canal wharf of Worcester, but there was a change of plan and two larger basins were cut near the Severn at Diglis, served by two barge locks which enabled river-going vessels to unload and transship there.

John Charles Westwood, last portmaster of the port of Lowesmoor, c.1870

This relieved the Sansome Fields area considerably. Nevertheless, the amount of traffic at Lowesmoor was very great and changed the area drastically. The new engineering industries, the Vulcan Iron Works and Larkworthy's Agricultural Machinery Works, the gas and vinegar works were all located on or near the canalside. Around the wharf coalyards, storehouses,

mills and granaries were constructed, for until the coming of the railway the port handled very large shipments of goods and raw materials, especially coal shipments from the Black Country. Traffic was congested at the gates of the wharf where farmers' wagons, having made an early morning start from places ten to twelve miles distant, assembled in long queues. So important was the trade there that there was an official 'Portmaster of the Port of Lowesmoor' until the 1880s.

With the great increase of activity in that area, amenities for workmen and merchants developed. Speculative back-to-back housing schemes were undertaken in Pheasant Street and in the area towards Tallow Hill; but it is the large number of inns and commercial hotels in Lowesmoor which indicate the commercial development. With the inns came the missions and music halls. The Wesleyans erected Lowesmoor Mission chapel opposite the wharf gates in 1823 and another small mission hall was built inside the dock area.

The vinegar works

The Lowesmoor vinegar works of Hill, Evans & Company were the largest of their kind in the world. They occupied an area from Lowesmoor to St Martin's Gate, and in order to extend the premises it was necessary to purchase several streets. The firm was established in 1830 by William Hill and Edward Evans, and was carried on with marked success by Thomas Rowley Hill MP and Edward Bickerton Evans, sons of the two founders. By 1844, the year when the duty on vinegar was repealed, the works were as large as, if not larger than, any of the London breweries.

In 1902 the brewery buildings covered about seven acres of ground. The filling hall, stated a Worcester guide, 'is one of the wonders of Worcester, and has as great a span as the roof of Westminster Hall, and the enormous tuns therein stored dwarf to ridiculously small proportions the hitherto famous tun of Heidelberg'. The hall is certainly monumental: its dimensions are 120 feet by 160 feet, and its glass roof rises to a central height of 70 feet. The firm's own private railway ran into the hall and the casks were loaded directly into railway trucks.

Six grades of vinegar were made, and a tremendous quantity of British wines. The establishment was a complete unit of all the brewery crafts and processes. It contained its own mill and cooperage, where all the vats and barrels were made, and a distillery; and all the processes associated with vinegar and wine making were carried out there. The vats were among the largest in the world and nowhere else was there such an array to be seen. In 1902 the great vat was easily the largest, measuring 32 feet high and 32 feet in diameter. It was further enlarged to 120,379 gallons, dwarfing the Heidelberg tun at 40,000. Furthermore, there were 150 vats at the works, all of great size.

The British wine stores was most extensive, and it was by no means impossible to get lost amidst the many subterranean passages, some of them 240 feet long. The wines were of every description from cowslip to port and sherry. William Hale, the caretaker, remembering the days before 1914, said: 'In those days, raisin and elderberry wine was 9d a bottle, cider 1d a pint, and I can recall the gypsies arriving with their loads of elderberries picked from the surrounding countryside. Wages were low and hours long. 15s. for labourers, apprentices 5s. with a rise of 2s. 6d each year till it reached 17s. 6d at twenty-

one, then an odd shilling a week every two years until 27s. was reached. We did 54 hours and the only holidays were Christmas Day and Good Friday and if Christmas Day came on a Sunday, that counted as the holiday.'

The firm was taken over by Holbrook in the 1960s and production ceased at Worcester in 1966. Two years later the premises were converted into an industrial estate and the vats, engines and equipment destroyed.

The Lowesmoor music halls

The music halls developed from the tavern concert rooms in the 1850s. By the early 1860s there were two recognised music halls in the city: the Railway Bell and the Alhambra.

The Railway Bell was at No 1 St Martin's Gate (later Burnham's Garage site) and the proprietor in 1868 was W S Smith. In 1855 it had been listed as a beer retailer; but it must have developed into more than a tavern concert room, where glees and the like were performed, for it to be included with the Alhambra in the 1860 *Era Almanack*.

The Alhambra Music Hall was a wooden building situated halfway between Rainbow Hill canal bridge and the gates of Lowesmoor Wharf, a site occupied by Harper's Brewery. In 1863 there was a resident company, for to mark the visit of the Royal Agricultural Show (held in Battenhall) there was a parade through the streets in which 'The Alhambra Company with their band carriage containing Maori chiefs, and one or two natives of the celestial kingdom' took part. The company was then performing at the Arboretum Pleasure Grounds.

At the gates of Lowesmoor Wharf was the Navigation Inn, kept for over twenty-four years by John Hill. In June 1869 Hill was joined by a Mr Brook, and the two decided to demolish the inn and build a large new music hall on the site. They called it the Worcester New Concert Hall, and the building stands today, looking end on like the bow of a large vessel. The New Concert Hall opened in the first days of August 1869 under the management of Mr Fred Lawson, and was filled nightly 'almost to suffocation'! The prices of admission were: front gallery and stalls, 1s, side gallery, 6d, the body of the hall, 3d. Refreshments were served continuously in all parts, with wines and spirits 'obtained direct from the docks'; and the management boasted of a new 'Oriental Lounge, which for elegance and comfort is unsurpassed'.

The *Worcester Herald* carried short reviews of both the Lowesmoor music halls. They betray an anxiety to assure readers that they were not the depraved places some thought them to be. Of the New Concert Hall it reported: 'There is nothing in the slightest degree offensive'; of the Alhambra: 'The talent is of high class, and the entertainment which is very interesting is conducted in an orderly and respectable manner.'

The entertainment consisted mostly of singers, comics and acrobats, but there was always an extravagantly advertised chief feature, usually a ballet sketch or a living tableau such as 'The Death of Nelson' with 'novel mechanical effects', or 'The Grand Divertissement, Fire and Water with Gorgeous Transformation Scene, Cascades of Real Water, and Showers of Real Fire'. In November 1869 the entertainment became less inhibited. The Alhambra presented 'Sylvester, the Charmed Monster', while the rival house had 'Madam Colonna, the Premier Danseuse and her renowed Parisian Can-Can Dancers'.

The Alhambra could not, it seems, compete as a music hall with its brash neighbours and its can-can dancers, and in December 1869 it was converted into an 'Amphitheatre for Bell's Great International Circus'. By 1880 the centre of amusement had moved back to the Theatre Royal in Angel Street and the music hall closed its doors. In 1881 the Salvation Army took on the lease of the building, almost without alteration, and the pay boxes remained and the gallery was unaltered until 1906.

Vesta Tilley

The Lowesmoor music halls were associated with one of the most memorable music hall artists of the late-Victorian days, Vesta Tilley. Her real name was Matilda Alice Powles and she was born in the Blockhouse, Worcester, on 13 May 1864. Her father, Harry Powles, was once a painter at the Worcester Royal Porcelain Works; but he had a passion for the stage and performed in the music hall as Harry Ball, the tramp musician. He left the porcelain works and became the manager of the music hall at Gloucester, and later took up an appointment at Nottingham.

His daughter made her first appearance in public at his benefit concert and later, at St George's Hall, Nottingham, appeared as 'The Great Little Tilley'. She began her full-time career at Day's Concert Hall, Birmingham, as a £5-per-week 'male impersonator'. Then the family returned to Worcester, and Vesta appeared as the 'Pocket Sims Reeves' at the New Concert Hall, also fulfilling engagements at the Alhambra. It has been suggested that she took

Vesta Tilley, later Lady de Frece, music hall darling and renowned male impersonator

her stage name after she had asked someone for a light during one of her sketches and been given the reply: 'Have a Vesta, Tilley.' At a concert in Birmingham it took twenty minutes for her to quieten the cheering crowd so that she could continue and she remained one of the darlings of the music hall until the end of the Edwardian period. She died in 1952 at the age of 88.

The Salvation Army

The Salvation Army commenced its work in Worcester in 1881, three years after William Booth had founded the movement. Captain Osborne acquired the Alhambra in Lowesmoor 'for a song', and the purchase included the goodwill and connections; for many old frequenters, accustomed to hearing the 'Great Vance', Vesta Tilley, and other comic singers of the day, flocked to the new entertainment, and some 'who came to scoff, remained to pray'. On the stage where the old-time artists had sung the children of the Army were dedicated (christened).

The gospel was preached in the streets and outside the pubs and met with a rough reception from a group who called themselves 'the Skeleton Army'. The processions were the signal for rowdyism, and it was only by firmness and punishments by the magistrates that the disturbing element was supressed. The action was not one-sided for Captain Osborne was arrested for preaching without a licence — and in the streets on a Sunday afternoon! The captain was gaoled in Worcester prison, but not for long. The authorities were glad to be rid of him, for every Sunday afternoon the whole Army contingent followed the band round and round the gaol, and the message 'We are marching, praying and singing for you' reached Captain Osborne in a stirring way. Until the gaol closed in 1922 the Salvation Army continued to play in the streets around the prison every Sunday afternoon.

By means of popular tunes (for why should the Devil have all the best tunes?) Osborne took the church into the gutter, street services at first viewed with horror by churchgoers; but in this way the Army reached out to the poor and the prisoner, the drunkard and the dissipated. The Saturday night 'Conversion on the Drum' was often dramatic: at the top of the Shambles crowds gathered to hear some of the well-known outcasts of society tell of their conversion.

Map 5

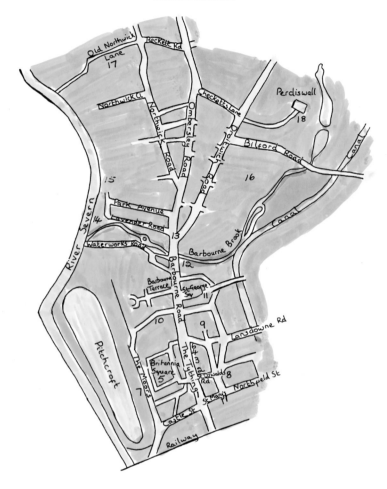

1 Tything
2 St Oswald's
3 Worcester Royal Grammar School
4 Britannia House
5 Britannia Square
6 White Ladies
7 The Moors
8 Park's Baths
9 Paradise Row
10 Three Barbourne houses
11 St George's church
12 Barbourne Brook
13 Barbourne Gate
14 Old Waterworks
15 Kepax Ferry
16 The Blanquets
17 Northwick Manor
18 Perdiswell House

The Tything and Beyond

The parish of Claines and the City of Worcester

Before 1816 only sixteen acres of Claines lay in the 'liberties' of the city; yet a century later the ancient parish included half of Worcester. All north of Castle Street and east of Lowesmoor Wharf became part of the parish; but even after the extension of the city boundary the area remained under the authority of the Droitwich Board of Guardians. The curious result was that until 1885 many people living in the central parts of Worcester, like Sansome Walk, for example, paid poor rates to Droitwich, tramped there to seek relief, and there, instead of at Worcester, registered their births, marriages and deaths, recorded at Somerset House under the town of Droitwich.

The boundary was marked by a liberty post which stood at the south corner of Salt Lane (Castle Street) and Foregate Street. The area between the post and the city wall was under the control of the city. Tradition has it that the position of the liberty posts was always decided by an arrow shot from the walls, and archers confirm that a very powerful man could shoot an arrow that distance.

Salt Lane was the ancient saltway from the main highway to the Severn slip which avoided the gates and tolls of the city. The name was changed to Castle Street with the building of the new county gaol in 1813.

The Tything of Whistones

The Tything had long been part of a spasmodic ribbon development along the road leading north from the Foregate to beyond St Oswald's Hospital, but well into the 19th century there were fields on both sides of the road, where harvest was reaped and the stubble beaten for partridges. This was the ancient hamlet of Whistones (or Whiston) which extended from the liberty post to Barbourne (Little London), and from Pitchcroft to Sansome Fields.

Whistones was originally one of the Northwick hamlets, and because of its proximity to Worcester on the one hand, and exemption from municipal control on the other, grew as a slum suburb in the late Middle Ages. Many of its houses were destroyed during the Civil War and by the end of the 18th century, when Worcester had blossomed into a fashionable social centre, the main road had become a street of substantial houses, the surburban residences of many well-to-do citizens and the town houses of county families. On the extension of the city boundary following the Municipal Reform Act of 1835, the Tything was absorbed into the city and its postal address of 'near Worcester' was dropped.

The original Whistones was a mortuary chapel and cross, built in an orchard between the White Ladies Convent and St Oswald's Hospital, where mass was offered daily for the souls of priests buried in the hospital yard. The revenues of the land between the hospital and the city gate were appropriated for that purpose and are still held by the dean and chapter. Originally of white stone (hence the name), the cross and chapel were demolished in Henry VIII's reign. From this orchard, tradition has it, a pear tree was taken and replanted on the Cross in 1575, and from the tree Queen Elizabeth I plucked three pears and ordered that they be added to the city's arms. Controversy, however, has long surrounded Worcester's coat of arms and there are other legends associating Worcester archers at Agincourt in 1415 with the pear tree.

St Oswald's Hospital

In 1539 John Leland recorded that Worcester had 'a long and fayre suburbe by north, without the Fore-gate; and at the north-east part and very end of it . . . an ancient and fayre large chapell of St Oswald'.

Tradition has it that the chapel was originally founded by the great Oswald. There is more reliable evidence that during the episcopate of Bishop Cantelupe the house became an almonry attached to the priory of Worcester, affording shelter to five poor men and two poor women; but in one report it is called a leper hospital. On the eve of the Reformation the estates were let out on a 99-year lease. While Sir John Bourne, a fervent Catholic, held the lease he demolished the church and used the stone for his great house at Holt. When

The presiding figure of St Oswald on the front of St Oswald's Hospital, Upper Tything

challenged he declared he would rebuild the church when the government restored 'true religion'. Other tenants cut down timber and dug gravel pits on the estates. The early 17th century saw attempts to recover the revenues and re-establish the hospital. The completion of an extensive rebuilding coincided with the onset of the Civil War, when much of the newly built hospital was dismantled for strategic reasons.

Credit for re-establishing the stability of St Oswald's is given to prebendary Samuel Fell before the Civil War and his son, Dr John Fell, Bishop of Oxford who, in Charles II's reign, 'by dint of extra-ordinary exertions, succeeded in regaining various alienated lands to the value of £200 yearly'. In 1681 Thomas Haynes erected six houses and settled £50 per annum on the hospital.

The new settlement provided that the hospitallers should consist of a master appointed by the dean and chapter; a steward; and ten almsmen and a woman, who were each to receive 2s. a week and three tons of coal and a garment once every two years. The garment was to be 'sad-coloured cloth or kersey' in the form of a gown or coat, 'down to the ankles'. The poor men, to be chosen by the mayor and two aldermen, had to be at least fifty years of age, and possessing no 'land, pension or annuity above 40 shillings p a or goods and chattels above the value of 20 marks'.

During the 18th century the dean, to his great financial advantage, frequently elected himself as master, and the stewardship was held by the chapter clerk. By the early 19th century the endowments of the hospital had been so whittled away that they were almost negligible; and in 1824 an enquiry was made into the mismanagement of the property and information filed against Dr Jenkinson, the master and dean, about the appropriation of the charity's funds.

The affair created a considerable scandal and the reformers pressed a claim for the return of all the property to the charity. What followed was a 'Dickensian' law suit lasting fifty years, during which time a goodly portion of the property was transferred into the pockets of the legal profession — but at least some property was left when the affair was finally settled in 1875. The income of the charity, even with its great losses, went up from £450 to almost £20,000.

The old 17th-century buildings, rebuilt after the Civil War, remained until 1873 when the new hospital, designed by Henry Rowe (in the Gothic style), replaced them. A little later, the footpath through the churchyard was widened into a carriage road and called St Oswald's Road.

Dean Jenkinson

Dr J B Jenkinson is a good example of the cynical, worldly senior clergyman of the early 19th century. He came from aristocratic stock, rising to high position not through outstanding ability but because he was the first cousin of Lord Liverpool, the Prime Minister. He held many livings simultaneously, as did others; but his pluralities were a little more glaring than those of some of his contemporaries.

He was only twenty-seven when he was appointed a canon at Worcester, and in 1815 he was made dean. A few months later he appointed himself master of St Oswald's Hospital, an office which brought him considerable benefits. In 1825 he became Bishop of St Asaph and Dean of Durham, the latter worth

£9,000 a year, a great sum in those days. His duties, however, did not worry him much, and he lived mostly at Malvern, holding onto both offices till his death there in 1840. He was buried in our cathedral to which he owed so much!

Worcester Royal Grammar School

No-one knows precisely the age of Worcester Royal Grammar School, but it is certainly one of the oldest schools in Britain. Some claim it dates from the 7th century. A document of 1291, signed by Bishop Gifford, proves the school's existence at that date. For at least three centuries the school was closely associated with the Trinity Guild and the parish of St Nicholas. In 1538 Bishop Latimer wrote of its improverished state, and for two years after the King's School was founded by Henry VIII the school almost ceased to exist; but Worcester citizens 'hastened to revive the guild school' by bequeathing property to the city corporation (by this time responsible for the school) for the school's endowment; and it was reborn when Queen Elizabeth granted the school a Royal Charter, creating the 'Six Masters of Worcester', the governing body which still administers the school today.

For three centuries the school was housed in a gloomy room attached to St Swithun's church, but in 1843 Queen Victoria granted the school a second Royal Charter, and in 1868 the governors put in hand the building of a new school in the Upper Tything, which by Royal Warrant was given the title 'The Royal Free Grammar School of Queen Elizabeth'. The word 'free' meant not that the pupils paid no fees, but that the school was free of church or ecclesiastical control. The school is now large with impressive buildings, notably the Perrins Hall of 1915. A postwar high mark was the visit of the Queen Mother in 1961 to mark the 400th anniversary of the signing of the school's first Royal Charter by Elizabeth I.

Britannia House

Adjacent to St Oswald's Hospital is Britannia House, the old mansion of the Somers family. It was the most ambitious private house in Worcester and has been attributed to Thomas White, the local architect and sculptor, since it so closely reflects the style and ebullience of the Guildhall and was built at the same time, the 1720s. The figure of Britannia on the front of the house gave the name to Britannia Square. The workmanship of the interior is excellent, as is the front of Severnside bricks with stone dressings. The staircase has fine twisted and columnar balusters. In Victorian times the house, for nearly two centuries a private residence, was reputed to be haunted: sometime about 1859 a servant committed suicide there, an event embroidered over the years.

In the 1860s the house became a school for young gentlemen, two of its tutors later well-known figures: Mr Huddlestone, the last Judge of the Court of Exchequer; and Leycester Lynes, who took Holy Orders, assumed the ancient garb of the monks, styling himself the first Anglican monk, and obtained some notoriety as a preacher under the name of Father Ignatus.

In 1883 the house was acquired by some score of public-spirited men and women who established the Worcester High School for Girls, a title later changed to the Alice Ottley School in honour of the first headmistress. Earl Beauchamp bought the house and let it to the governors at almost a nominal

Britannia House, Upper Tything, the city's most ambitious private house, now part of the Alice Ottley School

rent, and at his death the property was secured in perpetuity with the help of John Corbett, the 'Salt King'.

Britannia Square and the Roman fort

In February 1818 the land to the west of the Tything, Britannia Square, was owned by Mr Handy of the Tything and used for growing flax. Plans and a catalogue had been prepared in 1818 for Worcester's first housing surburb, and the building operations between 1820 and 1830 produced some of Worcester's most charming houses.

When excavations were being made in 1829 to lay the basement of the house known as Springfield, in the centre of Britannia Square, the foundations of a circular tower or fort of sandstone were found, some 30 feet in diameter, and about fifty Roman coins were discovered, some of Constantius (Constantine the Great). The tower or fort was probably one of those constructed on the Severn in the reign of Claudius I (1st century AD) and John Ross, a writer on antiquities in the reign of Edward IV, suggested Constantius was the founder of Worcester, on the basis of an old British chronicle he had met with.

One of the most charming houses in Britannia Square is No 49, once the home of Christopher Hebb, an eminent physician who for many years took a leading part in local affairs, and served as Worcester's first mayor after the Municipal Reform Act of 1835. He founded two charities for 'decayed' members of the council and their widows; and another to commemorate the Municipal Reform Act by distributing tea and sugar on 9 November each year.

The White Ladies

The present house incorporates fragments of the Cistercian nunnery, originally called St Mary Magdalene at Whistones but later known as White Ladies after their white habits. It was founded in about 1250 by Bishop Cantelupe, the friend of Simon de Montfort. Bishop Gifford, Cantelupe's successor, added to the endowments and gave land bought from the de Flagge family; though some accounts say that Alice Flagge entered the convent and brought to it lands leading up to Perdiswell, part of which, after 700 years, is still called Flagge Meadow. The nunnery was endowed with 53 acres of land at Aston (or Eston) which afterwards became known as White Ladies Aston; but the foundation was never rich, and the nuns laboured hard at their farm beyond Pirie Wood. It was the only nunnery ever founded at Worcester.

At the dissolution of the religious houses in Henry VIII's reign the White Ladies fell to the Crown. John Callowhill was granted the land and in Elizabeth I's time it came as an additional endowment to the local grammar school, which was why the Queen Elizabeth School was able to move in 1868 from its old school house in St Swithun's Yard to the White Ladies of Whistones.

The most prominent of the medieval fragments is in the west wall of the long range of 18th-century domestic buildings. It is of red sandstone, has two lancet windows and is part of the chapel dedicated to St Mary Magdalene in 1255. The present house is believed to have been built by Richard Blurton, the brickmaker, whose wife was Mary Somers, aunt of Lord Chancellor Somers. In the 18th century the Cookseys, Blurtons and Somers families, tied by marriage, dwelt together in this long range of buildings. Lord Somers as a boy was brought up at White Ladies; Holland Cooksey gives a charming account of the patriarchal life of the three families, each having a separate set of apartments, with a further set reserved for their common use for meals and social intercourse.

The subterranean passage

Tradition has it that subterranean passages led from the vaults of the nunnery to the cathedral and to Hindlip House. The distances to either place make this unlikely. That there was a passage cannot be denied for numerous proofs have been found of its existence. Nash, the historian, has put it on record that he entered the passage in the Tything in the hope of tracing its course, but had only proceeded about one hundred yards when foul air forced him to return and his lantern went out.

The tradition gathered strength when a story, *The White Witch of Worcester* by James Skipp Borlase, was published in serial form in the *Worcestershire Chronicle* during the 1880s. It was a lurid piece of Victorian fiction, set in the period of the Barons' Wars of the 13th century.

The Worcester writers' circle

During the mid-18th century Worcester was a provincial capital of considerable importance, the resort not only of the country gentry but of visitors from a wide area; and it was well provided with social, artistic and scientific coteries.

Worcester society comprised a 'circle' described by Chambers as 'a bright constellation of men of genius and talent'.

The circle included *Richard Ingram*, of the White Ladies, a non-practising barrister, an accomplished gentleman, scholar and critic, and with considerable scientific attainments; *William Russell*, the eminent first surgeon to the Worcester Infirmary, who held office for forty-eight years and whose portrait hangs in the boardroom; *Sir Charles Winnington*, heir to Sir Thomas Winnington, MP for the city; *Rev Charles Dunster*, Rector of Oddingly, a brilliant conversationalist and elegant writer, but who, says Chambers, impaired his health 'by too freely complying with the claims of that society of which he was the life and soul'; *William Coombe*, author of the popular *Tours of Dr Syntax*, written to Rowlandson's illustrations; *Dr James Johnstone*, able and devoted physician to the infirmary who died of gaol fever through attending inmates at the county gaol; *Thomas Goodinge*, headmaster of the King's School, which he raised from a declining condition to great respectability; *Robert Berkeley*, of Spetchley, and his chaplain *Thomas Phillips*, author of a life of Cardinal Pole, a work which provoked such a storm of Protestant wrath that the king was asked to have it burnt by the common hangman; *Captain Michael Clements*, a gallant naval officer, who greatly distinguished himself in the wars with France and Spain, on one occasion encountering with his single ship no fewer than twenty-four Spanish vessels, a feat recalling memories of Grenville and *The Revenge*; and *Theophilus Swift*, a voluminous writer, but chiefly remembered as a duellist, and for his denunciation of a partner who neglected to call for honours at long whist. 'Sir,' stammered the unhappy delinquent, 'I . . . I winked.' 'Winked!', stormed Swift. 'Why, sir, are you a gentleman and wink at whist?' Whereupon the winker fled precipitously from the wrath he had provoked and didn't rest until he had placed the Severn between him and his disgusted partner.

Another member of the circle was *Richard Cooksey*, a somewhat impetuous poet and political ballad writer. When he was planning to go on the Grand Tour he asked Lord Coventry, as Lord Lieutenant of Worcestershire, permission to sport a uniform of the County Militia. He was not a member of the militia, but knew that an officer was more acceptable in society abroad. Lord Coventry refused the young man's petition and Cooksey challenged him, signing himself, 'Your enemy, Richard Cooksey'. Coventry reported the matter to the House of Lords and Cooksey was brought to the Bar and bound over for three years.

Social life in the late 18th century

All in all, the city was a very pleasant place for a man of leisure, and social life at this time was a well organised activity. Dean Swift, kinsman of the celebrated Dean of St Patrick's, Dublin, has left us an intimate picture of this society in a letter written to Sanderson Miller in 1765:

> At Worcester I think we have no kind of news, except the Elopement of Girls, burning of houses on purpose, and letters incendiary to burn more; suicide, increases in Popery and wild fanaticisms spouting from brainsick Methodists. In all other respects we comfortably enjoy the passing of hours; in the morning we traverse the fields; destroy Game; coquet in the Cloisters;

and slander the Inhabitants. In the evenings, we dance at Assemblies, cheat at Whist, abuse Matrons, ruin Damsels and, like birds in an *Ollio*, swim in the midst of a delicious *Farrago*, made up of all sects and opinions, both of Religion and Scepticism.

A few years later Dr Nash, having spent a little time criticising the sewers and gutters and the unhealthy mounds of manure, went on to admire the 'beauties and advantages of the town, which indeed are many, and great: the streets are broad, handsome, well-built and very well paved, and no projecting signs; the markets are well supplied with all kinds of provisions, and as cheap as in any town in England, sea fish only excepted . . . the great concourse of polite strangers that come here to reside from every quarter, shew the superior excellence of this town and neighbourhood'.

Pitchcroft and its associations

Pitchcroft is mentioned as early as 1558 in the city records. Thomas Wylde, a clothier, is recorded as having given Little Pitchcroft and 4½ acres of meadow in Great Pitchcroft to the corporation, on condition that within two years of his decease they should erect and establish a free school in the city. From that date a considerable part of the moor-like ground became recognised as public property.

The Civil War brought Pitchcroft into some prominence. It is recorded that the Princes Rupert and Maurice, having breakfasted, 'went forth to Pitchcroft

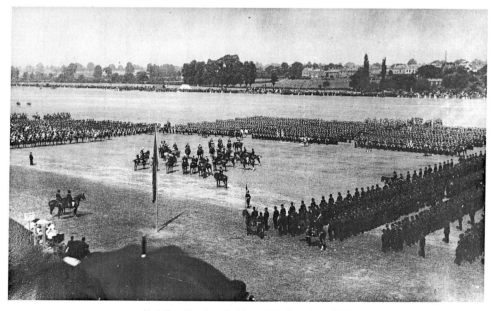

Jubilee Review held on Pitchcroft, 1887

— a green field by the river — without the walls, there to amuse themselves and their soldiers with shooting of effigies of the Parliamentary leaders'. Their sport, however, was rudely interrupted, since the enemy had quietly surrounded the city and 'suddenly a troop of 500 horse attacked the Royalists, who retired in confusion into the town'. Nine years later, before the battle of Worcester, Charles issued an order calling upon all men in the county between sixteen and sixty to attend him on Pitchcroft. Two days later he went down to Pitchcroft, doubtless expecting to behold a great crowd of supporters; in fact, very few attended and the muster was a failure.

During the greater part of the 19th century Pitchcroft was the scene of military camps and inspections; and a piece of ground which formerly adjoined it was known as Militia Field. This must now be Thorneloe, the school field. In contrast, the ground has also been home to 'Wild Beast' shows and pleasure fairs for well over a century. One of the great characters that came with Pat Collins' fair was Sequah, the Prince of Quacks, the most colourful showman since Barnum. He toured the country dressed as a Sioux Indian chief, surrounded by his Indian braves. He harangued the crowds and held them spellbound with his tales of miraculous cures. One of his best sellers was 'Prairie Flower', which he claimed would cure anything from rheumatics to 'flu; and he was reckoned to be the fastest puller of teeth in the business, once extracting 74 molars in 57 minutes. He always pulled teeth to the sound of a brass band and so drowned the shouts of his patients. In the 1920s he was known as Dr Hannaway Rose, assuming a most dignified and cultured appearance. The 'great healer' died in poverty at Southampton in 1934.

H H Martyn

H H Martyn, an apprentice of William Forsyth, achieved considerable renown as a carver in stone and other media. Martyn was a native of Worcester and worked for Forsyth in the Tything. On serving his term of apprenticeship he migrated to Cheltenham, and after some years organised an architectural decorating business in a big way, by 1914 having some 400 assistants and a reputation which was worldwide.

Some of the finest carving in the country was carried out under his direction, including work at Buckingham Palace; and he enjoyed the appointment of 'Architectural Decorator to the King'. Among his local work are the fine carving at Stanbrook Abbey church, Callow End; the picture gallery and other works at Battenhall Mount; and the altar piece in the Jesus Chapel in Worcester Cathedral.

The firm's ornamental woodwork resulted in an interesting by-product, for during the 1914–18 War Martyn gained a sub-contract for parts of aircraft, and by 1918 he was producing complete aircraft. The firm carried out the earlier operations of what later became the Gloster Aircraft Company, and until 1928 aircraft work was done at the Cheltenham factory.

McNaught's Carriage Works

McNaught's Carriage Works and showrooms in the Tything occupied the site where Kays building (with the 1851 lamps) now stands. It was one of the most famous of all 19th-century carriage works, with a large export trade and

showrooms in London, Liverpool and Birmingham. The firm was conducted by J A McNaught for over fifty years. He was the son of a coachbuilder in Kendal and was responsible for the design of the prize chariot at the Great Exhibition of 1851.

McNaught's speciality was the building of state coaches. A number were made for Indian princes and at one time the firm kept nine just for the conveyance of the king's justices. These were maintained in the most elaborate state and when in operation were drawn by four horses and attended by javelin men. A state coach specially built for the Lord Mayor of London in 1887 was also annually overhauled by McNaught in Worcester, together with two state chariots. Every part of the coach was made on the premises and special heraldic painters were employed to ensure the highest standards were reached.

But a disastrous fire in 1892 destroyed a large part of the premises with serious financial losses; and worse was to come for the motor car had begun to replace the carriage. So McNaught turned to building cars, and supplied many to foreign royalty staying in this country. After 1918 the company was wound up though McNaught's son continued in business, until his death in 1934, as a coachbuilder and motor engineer with works in Farrier Street and a showroom in Foregate Street.

H H Lines, landscape painter

H H Lines was a landscape painter and a draughtsman of singular merit, ranking among the 'Worcester School' as second only to B W Leader. Among his works in the possession of the city are the line-and-wash drawings of the cathedral and monastic buildings which were being destroyed in the mid-19th century.

He came from a family of Midland artists, two of whom have entries in the Dictionary of National Biography. His father, Samuel, a Warwickshire man, was a successful drawing master, a good landscape painter, but an even better teacher; and his influence on Midland artists was very great. Son Henry settled in Worcester in Albany Terrace where his particular talent made a great impression upon local art. Many of his landscapes were of great excellence; but still more valuable were his sketches of local buildings and antiquities, a large collection of which his daughters presented to the city. His draughtsmanship was superb, and his works record features of Worcester of which we possess no other visual evidence.

The Moors

The Moors, originally enclosed fields, on the east side of Pitchcroft was once a favoured residential area, made up of the attractive dwellings of businessmen who had moved outside the city walls and could enjoy an uninterrupted view across Pitchcroft; and there were other houses dotted along the Moors as far as the old Duke of York Inn. But in the mid-19th century the area fell upon evil days: mean little houses and tenements crowded into the gardens, and a series of courts occupied the land where once there were pleasure gardens overlooking the croft. Today only a few Georgian houses remain in the group facing the Swan Theatre and in Severn Terrace.

Park's Baths and the swimming 'barges'

The baths in Sansome Walk were established in the 1850s at a time when the fashion for 'natural' cold baths in the 18th-century style had declined and the more exotic baths had been introduced from the Continent. They were privately owned and had an entrance porch supported by two splendid caryatids, identical to those to be seen at Cheltenham — it was said they were left over from the work done there. Inside were some brilliant-coloured, fine glass panels, supposed to create a Turkish atmosphere, and a maze of rooms where different kinds of baths could be taken — sulphur, iodine, salt, calomel and others. In 1890 William Park assumed charge and eventually became the owner. As the cult for exotic baths died out the establishment ran its Turkish and slipper baths and had the only swimming pool, other than the sunken barges in the Severn, available to the city. In fact, for some time Park successfully fought off any plan to build a municipal bath which would have put him out of business.

The 'barges' moored in the Severn were oblong wooden cages let into the river and allowing the water to flow through. They were situated just south of the grandstand and remained in use until about 1946. They were most primitive affairs, one each for boys and girls — there was no mixed bathing then! Albert Webb, the waterman, was in charge, a great character, but with a Victorian approach to public bathing. One of his official jobs was to recover the bodies of persons drowned in the Severn.

Paradise Row and the Talbot Inn

Paradise Row is one of the pleasantest Georgian terraces in the city. In the 18th century it was built to form the 'high street' of the fashionable hamlet of Barbourne. There were trees in front of the terrace until the 1890s and the row itself was untouched until the 1920s, when a Birmingham brewery desecrated it by pinning mock Tudor beams to the front of the Talbot Inn, turning a genuine old building into a sham 'ye olde worlde pub'.

The Talbot was a very important and historic inn, and because it lay outside the city limits it was used frequently for county business. Sheriffs' courts and coroners and justices' courts were held in the large room at the rear, and it was there that the inquest was held on Hemming's skeleton, the murderer and victim of the remarkable Oddingley murders.

The Saracen's Head Pleasure Grounds

The Saracen's Head Inn in the Tything was a very popular hostelry during the 19th century, much patronized by the upper and middle classes of Worcester. It had a considerable area of land attached to it, and its bowling green was for long the favourite recreation ground of the well-to-do citizens from the north of the city. An engraving of the green exists showing many notable Worcester characters of the 1840s.

The land next to the green was the favourite pitch for travelling circuses and, what were almost circuses of another kind, the travelling preachers. In the mid-19th century were heard (in great marquees which accommodated 2,000 people) some of the greatest preachers of the day. Here, Charles Spurgeon,

then a young man of great vitality, held an audience spellbound by his eloquence.

Here too were held 'friendly bouts' with gloves, when people like Tom Sayers, the most famous of English champions, and Jem Mace, the cleverest boxer of that age, delighted the great crowds that gathered. Other popular spectacles were balloon assents from the green. In 1848, for example, 'a thousand spectators paid admission to see the balloon *Rainbow*, while the adjacent meadows and eminences were literally crammed with twenty times that number . . . and upwards of 250 persons availed themselves of the opportunity of partial assent by captive balloon, taking a bird's-eye view of the City'.

Charles Bedford and the Shrubberies

The Shrubberies off Barbourne Road was a charming country residence in the hamlet of Barbourne, standing back from the road and with gardens occupying all the land from Barbourne Road to Flagge Meadow, centring on what is now Shrubbery Avenue.

Its most notable owner was Charles Bedford, a leading Worcester solicitor and a typical Regency buck. He was tall, well-built and exceedingly handsome, a jovial and very popular figure. But, as a renowned amateur boxer who had once defeated a champion prize fighter, he was a little too eager to pick a quarrel and marred his career with a fight at Diglis Bowling Green with Matthew Pierpoint, the Worcester doctor. Both men were headstrong and Pierpoint had many faults, but it was said that the fight was ill-matched and without adequate justification. Bedford was never forgiven; and he met a premature death after a life of pleasure and hard drinking.

Three Barbourne houses

When Baskerville House was built in the 18th century it lay back from the main highway in rural surroundings. It was erected for his own occupation by William Smart, a bookseller in the High Street, who named his new house in honour of the great Worcestershire printer. John Baskerville was born in Wolverley and counted amongst his work some of the most beautiful Bibles ever printed — despite remaining a confirmed atheist — and gave his name to a typeface still widely used. So great was Smart's admiration for Baskerville that on the printer's death he at once bought £1,100 worth of books from his widow.

Thorneloe House, built nearby, is now the Eye Hospital. It derived its name from a family socially prominent in the later days of George II and probably its first residents. In the 1760s it became a private school kept by Mrs Harris and boasted among its pupils Sarah Kemble who, as Sarah Siddons, became the greatest actress on the English stage.

Thorneloe was also the home of Rear-Admiral Francis Decimus Hastings, a hero of the storming of Acre in 1840, a feat of arms which repeated the most famous exploit of Richard the Lion-Heart and thrilled early Victorian England. The Turkish Viceroy of Egypt, Mehemet Ali, was attempting to re-establish the Turkish Empire and it was the defeat at Acre which proved decisive. Hastings was followed at Thorneloe by Edward Evans, one of the

founders of the vinegar works, and of the Worcester City and County Bank (now Lloyds on the Cross) and the Worcester Chamber of Commerce.

A little further along, on the main highway out of Worcester, Thames House was built, facing St George's Square. It too was occupied by a number of prominent citizens, the most noteworthy Rev W Thorn, a man of wide learning and special interest in natural phenomena. In the 1860s he was something of a phenomenon himself, for he was very much an eccentric, agreeable and distinguished in appearance, but of overpoweringly loud speech, accentuated by Gallic gestures. He was much appreciated, however, his peculiarities, it is said, relieving the monotony of everyday life in Worcester. Thames House was demolished in the 1920s to provide a site for a new girls' grammar school which soon proved too small for its purpose; and in the 1950s a new school was built in Spetchley Road, the older building in Barbourne becoming the Bishop Perowne Secondary School.

Thomas Chalk, proprietor of the Worcester Herald

In the late 1850s one especially good house was built in Barbourne Terrace, then a medley of Georgian villas and gravel pits. It was designed for Thomas Chalk by Henry Day whose fondness for towers can be seen in this particular Italianate-style house and in other houses in the area — Elderslie in London Road, Rupert House in Wick Fields (now destroyed) and Aldwyn Towers at Malvern, on the way up to St Anne's Well. Chalk, notable among Worcester newspaper proprietors of his day, was credited with drawing an enormous income of £3,000 a year from the *Worcester Herald*; and under his care it became *the* county newspaper, outdistancing other competitors both in circulation and influence. It was Chalk who introduced John Noake to the staff and published that writer's valuable historical notes.

He was a very little man, lively and florid, a bon vivant who could tell a good joke, and who enjoyed driving about in his handsomely turned-out carriage and pair. His cook bore a high reputation, and he kept an excellent cellar of old port. In later years Chalk's house was called Lindisfarne and considered one of the domestic show places of Worcester. For a number of years it has been used as offices by the National Farmers Union.

St George's chapel of ease

St George's, or Claines St George's, was built where, says Noake in 1848, 'within recent memory, children gathered buttercups and daisies, and rioted in the tall grass'. The need for such a chapel was forcibly expressed by the minister of Claines, for the suburb was in the 'vicinity of a large city and was attacked by dissent of every kind'.

The site was purchased at half-price and two architects, James Lucy and Lewis Belling, were employed. It was a neat stucco building with a 'modest Gothic front', seen to advantage from the Barbourne Road. The foundation stone was laid on 11 March 1829, and the chapel cost £3,500, mostly from a Treasury grant. It was a typical 'Commissioners' Church', with a simple interior and a western gallery where 'one man and one or two children sang in unison with the addition of a flute and bass viol' — for up to 1848, at least, there was no organ. But the building of St George's was an important event,

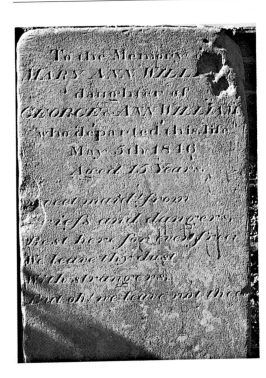

Headstone in St George's churchyard to Mary Williams who died aged 15 in 1846

confirming the fact that the hamlet of Barbourne had become a fashionable residential suburb.

Towards the end of the century, in 1894, the old church was demolished and Sir Aston Webb, one of the most distinguished late-Victorian architects, was given the commission to build a new church worthy of the situation, spectacularly placed at the far end of a long green. The facade is reminiscent of St George's, Windsor, but with a character of its own; and it is a key work of Webb's early and best period. Webb was born in London in 1849, but connected with Worcester through his marriage in 1876 to Maria Everett, the daughter of a doctor who practised for many years in Foregate Street. His local architectural debut was the building of the six masters' almshouses at the Royal Grammar School. He then designed the school for the Angel Street Congregational church which still stands on the Butts corner, above its entrance a charming carving of a child reading a book (but it is a long time since it echoed to the sound of children). He also restored St Helen's and All Saints' churches and in 1885—6 the exterior of Claines church; and he achieved national fame with his buildings in London, which included the new front to Buckingham Palace, the surroundings for the Victoria Memorial there, the Admiralty Arch, the Britannia Naval College and the completion of the Victoria and Albert Museum.

The school in the cowshed

The rest of St George's Square was let off in freehold lots. The north side was

completed before the south, and halfway down the south side, on one of the empty plots, stood an open cowshed which was to be the first parish school of St George's.

Rev I Bradshaw Tyrwhitt, the chapel's first curate, was alarmed to find that nearly thirty of his parishioners had sent their children to the Catholic school near Sansome Walk. In his view the Catholics were 'exerting every energy in proselytising, by bribing and other means'; and he was moved to action, obtaining the use of the cowshed to start a school. The shed was soon filled to overflowing with children from five to thirteen years of age. But when approached for help the National Society insisted on a reasonable teaching space: by the Society's standards the shed would accommodate eighteen, not the 120 the curate claimed to be comfortably educating. Tyrwhitt resigned within the year; but a start had been made, and two years later school buildings were erected on the present site in St George's Lane North.

Barbourne Brook and Gregory's Mill

When Barbourne was annexed to the city in 1837 Barbourne Brook formed the city boundary and for some half a century it remained the Rubicon which no annexationist dreamed of crossing — though it was no barrier to the speculative builder. Barbourne bridge was a mere footbridge, almost at water level, with a ford for vehicles beside it. At the east side of the bridge was an old inn, the Swan, a picturesque, old-fashioned place where one could often see hay wagons and horses at the stream, the wagoners sitting on benches outside, usually with the host, enjoying home-brewed ale. Inevitably, the inn has long since been rebuilt and modernised.

A quarter of a mile upstream stood Gregory's Mill, a grist mill built by the master of St Oswald's Hospital in 1369. Thomas Gregory rented the mill from the six masters in the early 17th century, from which time it has been known as Gregory's Mill. It was still working in the 1914-18 War, but by 1950 it had been completely demolished. There was another large mill in the mid-18th century in the park itself, between the road and the main pool. Beyond the pool, however, the course of the brook to the river had been greatly changed with the building of the waterworks.

Barbourne Lodge, Bedlam and the Burneys

Barbourne Lodge was an ancient farmhouse standing on the south side of Barbourne Brook, at the junction of Barbourne Lane and Waterworks Road, then very narrow and, in wet weather, very dirty lanes.

Richard Burney lived at Barbourne Lodge in the mid-18th century and conducted a school there for dancing and music. His family of five sons and three daughters were members of the intellectual circle which made Worcester a prominent provincial capital at that time. His eldest son, Charles Rousseau Burney, was a well-known performer on the harpsichord, and among the instrumentalists at the Three Choirs Festival of 1767. His portrait by Gainsborough, now in America, shows an elegant, handsome young man with a music score in his hand. Charles married his cousin, the sister of Fanny Burney, the novelist and diarist.

Another son of Richard, Edward Francis (1760-1848), was a pupil of Sir

Joshua Reynolds and considered to have had artistic genius; but he was so shy that he could not bear to exhibit, except intermittently. Edward fell in love with Fanny Burney who with her sister stayed at Barbourne Lodge (known in the family as 'Barebones Lodge'); but presumably he was also too shy to do anything about it. He produced some valuable drawings and paintings of Worcestershire churches and places which were intended to be additions to those in Nash's *Worcestershire*.

Early in the 18th century the house was called Bedlam, which suggests that it was a lunatic asylum of sorts; but it must have become a private residence soon after for there are references to it having a cockpit used by county teams at that time. In the latter half of the 19th century it was used as a 'pest house', or fever hospital, and because of this no-one would buy it. When the building was due to be demolished in 1898 there were fierce arguments in the council as to whether it should be burnt down to kill any remaining infection. Finally in 1905 it was deliberately burnt down by order of the council and only the cellars and outhouses remained. The horror in which such places were held in the early 20th century can be judged by a lady who knew the place and wrote: 'The house was standing when I was very small, and when passing it to go to the Dog and Duck Ferry my aunt would always say, "Close your mouth, dears, and run!". She always thought the germs would fly over the high garden wall.'

Barbourne Park and Colonel Newport's Port

The picturesque grounds of Barbourne Park, originally part of very extensive pleasure grounds covering an area from the main road to the river and from the brook to Kepax, have been much reduced. In the 1920s the park was acquired by the Worcester municipality and renamed Gheluvelt Park in memory of a gallant defensive battle fought in Belgium in the First World War. The Worcestershire battalion held the line in a dire emergency, blocking the advance of the victorious German army to the Channel ports, and so saving a desperate situation.

Barbourne House stood on a high platform of land and was once the home of Colonel Newport, a noted bon vivant, and at his death the dispersion of his wines caused a local sensation. In early Victorian times the climax of a special dinner party in the best Worcester houses was the circulation of a bottle of 'Newport's Port'. The host of the Hen and Chickens, Birmingham's most exclusive hotel, was believed to have bought twenty-four bottles of the port at the auction, and over the years to have retailed 2,000 dozen, at a guinea a bottle, as a special favour for privileged guests! The old house was finally demolished to make way for ex-servicemen's homes.

Barbourne Gate and Pope Iron

At the junction of Ombersley Road and Droitwich Road stands the 'Round House', now an antique shop but once the Barban Gate, a tollhouse famed throughout England in the late 18th century as the gate where Robert Sleath stopped King George III on his way to visit Bishop Hurd at Hartlebury and insisted he pay the proper toll.

The name Pope Iron has intrigued generations of local historians, one of whom believed it to be a corruption of an inn name, Pope Joan. The old half-

timbered inn stood at the waterside slip at the end of the lane now called Waterworks Road. The slip was a regular staging place when the river carried passenger traffic. Nearby was a building called the Salt House which suggests it was a storage place for transshipping salt from Droitwich. In the opinion of the present writer, Pope Iron refers to a 17th-century ironworks on Barbourne Brook, owned by Bromwich Pope. Barbourne Park had waterfalls and three pools, typical of the system used in early ironworks to ensure a steady supply of water to drive the bellows and hammers. The site of the tennis courts was a pool well into this century. During one of the extensions to the waterworks, in about 1880, houses were built across the slip and the lane turned into the north entrance of Pitchcroft. The old inn was destroyed and a new Pope Iron Inn was built some distance away.

The old waterworks

At the top of Pitchcroft stood the old, ivy-clad tower of the 18th-century waterworks, a feature in this part of the city for a couple of centuries. It was really an elevated water tank on the top of the tower: water from the Severn was pumped to it by a waterwheel and, from the top, then flowed by gravitation to the central reservoir in the Trinity. The waterwheel and pumps of the even older waterworks on the Little Severn on the site of the present Worcester bridge were re-erected here in 1795. It supplied water until 1858, but the tower itself remained until the 1950s.

The city's new waterworks in Waterworks Road took over in 1858, designed by Thomas Hawkesley, the greatest authority of his day on public water supplies. It was driven by a 50 hp steam-powered beam engine and the water was pumped up 160 feet into a reservoir on Rainbow Hill. But it was completely unfiltered and the medical officer of health's proposal in 1884 to filter the river water met with strong opposition on the grounds of expense. Not until 1894 was filtration introduced — with the result that there was an immediate and dramatic drop in the cases of typhoid.

At the same time another reservoir was constructed on Elbury Hill but the steam pumps proved unequal to the task and additional electric pumps were installed. In 1902 an up-to-date steam plant was installed. The gardens, laid out around the water tanks in the 1880s and made accessible to everyone, were the earliest of Worcester's public parks.

Kepax Ferry and Lavender House

Near the old waterworks tower were six houses including the Ferry House, all of them occupied by the Bailey family in about 1900. Mr Bailey kept the ferry and his six married daughters lived in the other houses. E W Barnard, who knew the ferry well, wrote in 1929: 'I cannot remember ever hearing anyone call it by the name Kepax. When I was a boy the ferry was invariably spoken of as 'Bailey's Boat'.

Lavender House, destroyed in the 1970s, was a pleasant late-18th century residence, a stucco building with an ornamental wrought-iron balcony, overlooking Barbourne Brook. There used to be a bridge immediately opposite the house which led across the fields to the main road.

Both house and road were named after the Lavender family, partners in the

banking firm of Farley, Lavender, Owen and Gutch, who carried on business at the Cross in premises now occupied by the Westminster Bank. The bank came to grief at the close of the 1850s and although this was long after the Lavenders had ceased to be connected with it Miss Jane Lavender was most distressed by the event, particularly as her deceased father's name appeared on many of the bank notes issued by the firm and still in circulation at the date of its failure. In vindicating his memory she provided funds for honouring all such notes.

Today the family is remembered for the benevolence of Miss Lavender and her sister, Mrs Mary Gutch, who in 1862 endowed a church, dedicated to St Stephen, for the new ecclesiastical parish formed from the part of Barbourne lying north of St George's. Mr F Preedy, the builder of St Mary's, was the architect and the church contained some good windows and carvings.

The Blanquets

The area west of Bilford Road belonged to the Blanket family until the close of the Wars of the Roses, when for five generations it passed into the possession of the Freres. After the late-Elizabethan period it passed through several hands and around 1820 was owned by the well-known family of Stallard who carried out great improvements. The growth of the city to the north, however, inevitably overwhelmed this surburban beauty spot; and during the 19th century the name was 'Frenchified' from Blankets to Blanquets.

The importance of Northwick Manor

Northwick was once the principal manor of the bishops of Worcester and it was here, at their most important manorial court, that tenants of a score of dependent manors rendered 'suit and service'.

In the course of the centuries the relative importance shifted, perhaps because Northwick was too near Worcester. It was superseded by Hartlebury and the dependent manors became independent. The manorial title was changed to Northwick and Whistones and later superseded by Claines where the parish church had been built and a village had grown. Yet in Domesday Northwick was the centre of the vast possession of the see of Worcester, the manor having nine distinct 'tithings', or hamlets, subservient to it: Beverburn (now Barbourne), Bevereye, Tapenhall, Holy Claines, Astwood, Mildenham with Hawford, Smite with Tolladine, Whistones and probably Tibberton.

Not only the hamlets but about ninety houses in Worcester, half of them in the marketplace, were held by Northwick Manor — which must have been a large slice of Worcester at that time. Added to this, the bishops as lords of Northwick received the 'third penny' in the city, which appears to have been one third of the public revenue. The bishop's ownership lasted some twelve centuries, finally ending only in 1860 with the transfer of the bishopric estates to the Ecclesiastical Commissioners.

The old hamlet of Northwick surrounded the small triangular green on the Northwick Road at the point where Old Northwick Lane runs down to the ancient wharfing, or slip, on the Severn. This was a very ancient crossing of the river and the place where Prince Edward (later Edward I) recrossed the Severn to surprise and defeat Simon de Montfort at the battle of Evesham.

The Perdiswell torc

In 1840 a very valuable early British or Romano-British bronze torc was found in a field on the north side of Checkett's Lane. It was more than a third of a circle, eight inches long in the curve, and weighed half a pound. An iron rod ran through the centre connecting twenty pieces of bronze, or vertebrae, all curiously twisted and tooled, and between each pair was a thick ring, shaped like a pulley. When it was intact the torc must have been about 18 inches in circumference. It was exhibited at the Society of Antiquities in London in 1844 and is described in *Antiquities and Folklore of Worcestershire* by Jabez Allies into whose possession the torc had come. Allies suggested that the name of the adjacent field, 'Barrow Cop', indicated that there was once an ancient barrow on the site which had probably been demolished for the sake of the gravel.

The Wakemans of Perdiswell

Perdiswell Hall, the handsome home of the Wakeman family, was built in 1787-8 by George Byfield and a fine avenue of limes formed a feature of the route to Fernhill Heath. The Wakemans were actively involved in both the government and business life of Worcester in the 18th and early part of the 19th centuries. Thomas was mayor in 1761 and later sheriff, James was mayor in 1806; and there were connections with glove manufacturing and with Farley's Bank on the Cross. In 1828 a baronetcy was conferred on a member of the Wakeman family by George IV, probably to balance the Lechmere title bestowed on Anthony, the head of the competing firm. Farley's Bank came to grief after the Wakemans ceased to be partners.

The Wakemans, however, inherited greater estates in Shropshire to which they moved; the house, no longer so desirably set, was sold in about 1860 for a song. For a few years it was let to the MacLeods, an Anglo-Indian family; then to Mr A C Sherriff, the Worcester MP, who opened its grounds to the public. There were several charming walks through the grounds and its beauties were captured by a number of local artists. But during the 1939—45 War the house and grounds suffered when the park became an aerodrome and the house was used for billets, and after the War squatters moved in. On 12 January 1956 the great house was gutted by fire and the shell was demolished in the same year.

Map 6

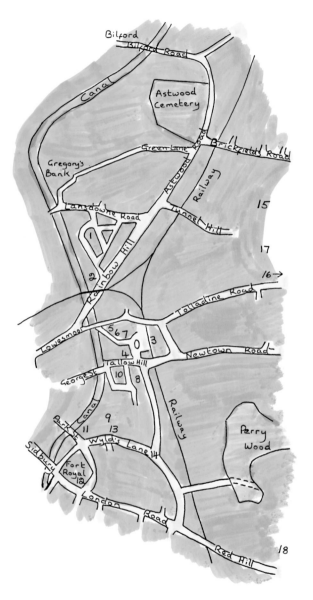

1 Roger's Hill
2 Rainbow Hill
3 Railway station
4 Railway Institute
5 Worcester Engineering Co
6 Worcestershire Exhibition
7 Holy Trinity church
8 House of Industry
9 Taking the Waters
10 Old Cemetery
11 Apollo Cinema
12 Fort Royal
13 Garibaldi Inn
14 Wylds Lane
15 Elbury Mount
16 Virgin Tavern
17 Port Fields
18 Last duel on Kempsey Ham

District Six

East of the Canal

Roger's Hill and Lansdowne Crescent

Roger's Hill and Perry Wood were the two favourite duelling places for those who lived in the city. Old maps show that the lane from Barbourne to Astwood (now St George's Lane North to Merriman's Hill and on to Green Lane) was called Cut Throat Lane. During the 1646 siege of Worcester the Parliamentary forces planted their principal battery on Roger's Hill and fired their shot a full mile, even as far as the fortified bridgehead across the Severn.

Lansdowne Crescent, originally Prospect Crescent, was part of the extensive pleasure grounds attached to Sansome Lodge. 18th-century engravings show a temple on the heights of Rainbow Hill, and the property on the south side of Astwood Road is marked 'The Fort' on an 1824 map. Halfway up the hill was a building called the Red House, the site of which was occupied later by the house called Coleshill, the home of Sir Arthur Carlton.

Many notable citizens have lived in the Crescent, including Bishop Gore who refused to live in antiquated splendour at Hartlebury. He took over the house, now known as Bishop's House, which had been the Worcester penitentiary until the mid-19th century but which by then had been transformed into a very charming residence. William Perrins, a founder of the Worcester sauce firm, and his son, James Dyson Perrins, also lived in the Crescent. William took no part in public affairs, for his chief and absorbing interest was his Worcester sauce. He was justly proud of its success and on his dinner table it was the custom for a small decanter of the sauce to stand at each corner, the four pillars of the festive board. Joseph Wood, builder of so many Worcestershire houses, including Chateau Impney, also lived on the Crescent. He was the mayor, mentioned earlier, who met with violent opposition when he stopped Sunday trading.

Rainbow Hill and Doctor Dixon

At the bottom of Rainbow Hill, at the junction with Tolladine Road, was a turnpike gate which until the 1860s marked the boundary between town and country. All beyond was green pastures and orchards and Rainbow Hill was a rural and picturesque place, with a sprinkling of pretty villas halfway up. Astwood Road still had steep marl banks from the cuttings made by the turnpike trust to ease the gradient for carriages.

Near the present rail bridge, on the north side, stood Dr Dixon's house, Grove

Villa, now sadly demolished. Dixon was the original of *John Halifax, Gentleman* (see page 44) and it was with him and his family of Quakers that Mrs Elizabeth Fry, the prison reformer, stayed on her memorable visit to Worcester in 1824. A grand public breakfast was given at the house before the party proceeded to the new county gaol in Salt Lane. Mrs Sherwood, a writer and local celebrity, had also been invited to the breakfast and was selected by Mrs Fry to sit in her carriage. An immense crowd met the party at the gaol gates and Mrs Sherwood reported being pushed aside in order that well-dressed ladies might touch the famous visitor's garments. Every word Mrs Fry uttered was said to have been gathered and stored in the memory. She was even permitted to address the prisoners in the prison chapel from the preacher's place, though with clergymen of the Church of England standing on each side of her.

Further up the hill was a house called The Knoll, occupied by Alderman William Lewis, a director of the O W & W Railway, and three times mayor of Worcester. He was the last man to hold the valuable sinecure of 'Stamp Distributor', receiving a substantial percentage of all Revenue stamps sold in Worcester. Lewis had several sons who were prominent in the life of Worcester in the latter half of the 19th century, one a renowned railway engineer who supervised the Worcester to Hereford line and was responsible for the Malvern tunnel. The Knoll later became Holy Trinity vicarage.

Marl Bank and the end of the 'Great Siege', 1646

In its time the house on the summit of Rainbow Hill has had a number of names — The Mount, The Round Mount and, later, Marl Bank. Its most distinguished resident was Sir Edward Elgar whose last home it was. But whatever the name, it is an historic site; for it was there in 1646 that the last force to uphold the cause of Charles I surrendered to Parliament.

Worcester was besieged twice in the Civil War, in 1643 and in 1646. The siege of 1646 was comparable in duration to that of Ladysmith and lasted from 26 March to 23 July. Most of the early attacks came from the north side of the city, and the high ground to the east provided sites for the Parliamentary guns. The Royalist cannon replied from the walls, and the garrison made spasmodic raids at night as far as Kempsey and Pirton, bringing back fat cattle and provisions.

With the fall of Oxford in late June, Worcester alone was left to try to hold out for the king. The citizens were for surrendering, knowing the position was hopeless but the governor, Colonel Washington, refused to capitulate. The Parliamentarians released greater forces to strengthen the siege, two great guns at Red Hill sent cannonballs as far as Broad Street and with more men a battery was set up on Windmill Hill (Green Hill, Bath Road). The garrison countered this heightened activity by carrying guns to the top of the cathedral tower and placing a great iron culverin on top of St Martin's Gate to dislodge the battery on Roger's Hill; but it burst on discharge and wounded the chief gunner.

When the news came that the king had surrendered the city at last gave in, and with the governor at their head and the principal citizens in attendance the garrison marched forth, flags flying, from the stronghold of the city walls which they had so stubbornly defended for four months. At the Round Mount

they made their formal submission and accepted the honourable terms of capitulation accorded to brave men; and on pledging not to bear arms again against the Parliament, everyone received a pass permitting them to depart, the gentlemen amongst them being allowed to retain their swords. 'Thus,' records Townshend, one of the Royalist garrison, 'the ancient city was delivered up into the hands and use of Parliament, being the first of the cities that declared for the Crown, and the last which held in defence thereof.'

When Prince Charles brought a Scottish army to disaster at Worcester five years later he came as an invading force, having been crowned 'King of the Scots'. The pledge given at the Round Mount on Rainbow Hill explains why so few Worcestershire gentlemen took part in the battle of Worcester in 1651; the vast majority were not prepared to incur the dishonour and risk the consequences of a breach of the promise to which they owed their freedom.

The railway comes to Worcester

By 1845 over forty railway schemes were projected in Worcestershire, and thirteen of them affected the city. Only six received legislative sanction. The real struggle lay between the Oxford, Worcester and Wolverhampton Railway

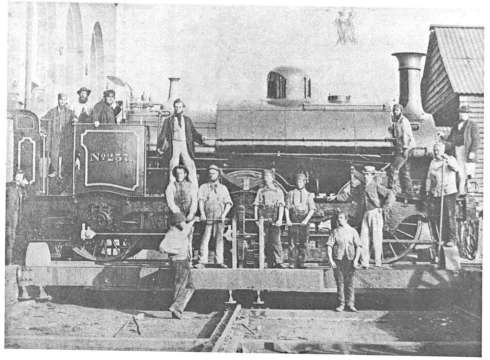

GWR engine No. 237, the last to be built at the O W & W's works in Tolladine Road

Company (OW&W), backed by the Great Western Railway (GWR) on the one
hand, and a line from Worcester to Tring, supported by the London and North
Western Railway, on the other. Worcestershire became the cockpit in which
was fought out the battle of the rival systems of Stephenson and Brunel (the
latter addressing a meeting in the Guildhall in 1844 in favour of the OW&W
scheme). The contest became known in railway history as the 'Battle of the
Gauges': the GWR with interests in Worcester had a gauge of 7 feet; the other
lines were 4 feet 8½ inches, a width deriving accidentally from the pit rails in
the north.

 Up to 1845 the broad gauge had not made headway north of Gloucester, and
the control of the Severn Valley was expected to decide its future. The battle
was long and costly and all the great engineers and the pick of the
Parliamentary Bar were engaged. Following packed public meetings in the
city the broad gauge champions won all along the line, largely through the
help of Worcester witnesses; but the legal and engineering expenses cost
£1,000 for every mile of the company's line, more than had been anticipated,
and this led to disputes between the OW&W and the GWR who were providing
the guarantee. Peto and Betts, the railway contractors, ultimately took the
construction in hand, and it became known as 'a contractors' line', the cost
being paid in shares at a discount. The company fell into hopeless financial
embarrassment, however, and its shares dropped from £100 to £14. By 1849
£2½ million had been spent without opening a single mile of track. On the
running side, too, things went very badly. The carriages were old and let in
water, the engines were ramshackle and frequently broke down. It is no
wonder that the OW&W line soon came to be known as the 'Old Worse and
Worse' line.

Alexander Clunes Sherriff

It was not until 1850 that the railway came to Worcester, and after years of
frustration and mismanagement the OW&W Railway appointed A C Sherriff,
a former schoolmaster but trained in railway management. He brought
tremendous Yorkshire skill and energy to the job of station master so that
under his control order was produced out of chaos. Traffic developed, new lines
were laid in the areas around, and Worcester became a really important
railway centre. The OW&W became the West Midland Railway, absorbing the
newly constructed Worcester and Hereford line, the Newport and Aberga-
venny and Hereford, and the Severn Valley Companies, and ultimately
controlling over 200 miles of line. The West Midland was in turn absorbed by
the GWR nineteen years after Brunel's first visit to the city.

 Alexander Sherriff was about forty when he came to Worcester, full of energy
and with wide experience in the North Eastern Railway. He brought in men
like himself and Shrub Hill — and with it, Worcester — 'began to hum'. He
modernised the whole of the antiquated OW&W set-up, and saw to the future
by encouraging and training local boys, many of whom rose to lofty positions
in later life. At the amalgamation of the GWR the heads of the West Midland
were pensioned off, but A C Sherriff's great reputation provided him
with other opportunities. The calls on his time and energy were enormous,
but Sherriff did not desert Worcester. He twice served as mayor and in
1865 became MP for the city, a position he held until his death in 1878.

Tunnel Hill and Shrub Hill Station

Harbour Hill became Tunnel Hill when the railway came to Worcester. The tunnel was longer than it is at present, because when the line was extended westward over the Severn in 1859 part of the tunnel was bared to provide ballast for the great embankment across Sansome Fields to Foregate Street Station. The railway yards have provided entertainment for generations of Worcester children (and their fathers) right to the end of steam in the early 1960s. The great cuttings offered grandstand viewing for half of Worcester who watched the disastrous fire that swept away the carriage works of the West Midland Company, and dealt a staggering blow to the prosperity of the city. Amalgamation with the GWR and the loss of these great works provided the incentive to remove further works to Swindon, and Worcester, from being the headquarters of a railway system, declined to a mere divisional centre.

The hill between Tolladine Road and Newtown Road, where Shrub Hill Station now stands, was known in the 18th century as Harp Fort, and like all the heights in the neighbourhood of the city was fortified more or less in ancient times. Across the valley an embankment was built (now called Midland Road). On it the Midland Goods Station was erected and, a little to the north, Shrub Hill Station. The latter, a very good Georgian-style building of engineering brick with stone facings, was built by Edward Wilson in 1865. On the east platform is an attractive ladies' waiting room, most unusually decorated with Maw's ceramic tiles on a cast-iron structure, with classical pilasters.

The railway line that failed to get there

The engineers of the Worcester and Hereford Railway originally planned a branch line that was to connect Diglis Docks with the main line at Foregate Street, the 'Butts spur line' (or the 'Butts siding'). The hope was that big ships would come up Severn to Diglis and there the goods would be transshipped to rail.

Work started in 1860, the line running down from Foregate Station on a sloping viaduct. On reaching the river near the railway bridge it turned south and ran along the riverside, under the eastern towing arch of Gwynne's bridge to the south quay as far as Dent's factory and Stallard's distillery. Unhappily for the engineers, however, the cathedral chapter vetoed the line running in front of the cathedral. It is hard to believe that the planners would have overlooked this fact, and one is led to believe that there was a change of decision on the part of the cathedral authorities.

The Railway Institute at Shrub Hill

The directors of the West Midland Railway took a deep interest in the welfare of the workmen and established a friendly society, a remarkable social organisation which provided for sickness as well as for fetes and excursions for families and friends. The Railway Institute was housed in the large handsome rooms beneath the driveway to Shrub Hill Station and the carriage sweep in

front was kept in neat order with flowering shrubs (the beautiful gardens living up to the name of that area).

The institute library contained some 3,000 volumes, very selective but a tremendous source for self-education. The funds were swelled by one of the era's 'railway kings', Sir Edward Watkins, a railway manager of great ability, who was the West Midland Railway Company's vice-chairman and controlled the destinies of half-a-dozen great companies. He had a great belief in adult education and did much to promote the movement, speaking at the Guildhall on behalf of the Railway Institute and becoming at twenty-one a director of the Manchester Athenaeum. He helped to promote the same facilities in Worcester, organising and lecturing at soirees to popularise the Worcester Athenaeum.

The Worcester Engineering Works

The large works in Shrub Hill Road, later occupied by Heenan and Froude's Engineering Works, is one of the finest Victorian industrial buildings in the Midlands; sadly, it was also one of the great local financial disasters. After the amalgamation of the West Midland and the GWR, and the fire which destroyed the carriage works, the GWR took the opportunity to transfer the mainline work to Swindon, making a great many local craftsmen redundant.

The enterprise had started on a high note. In 1864 a number of chief executives of the old West Midland Railway established the Worcester Engineering Works Company in order to construct locomotives and rolling stock and employ the craftsmen made idle. The men concerned — Sherriff, Thomas Rowley Hill, Walter Holland and others — were men of ideas, used to working in a big way, and everything was planned on a grand scale. But success generally starts from small beginnings; and after one prosperous year money became difficult to obtain and a slump knocked the bottom out of the locomotive market. The company lingered until 1871 when the firm ceased and the works, which covered the whole of the Shrub Hill estate, were sold for a song. The building became the home of various industries: the West Central Wagon Company quickly went into liquidation; Kay & Company had part of the works; then in 1903 Heenan and Froude took over the engineering shops. During the two wars the works were producing guns and aircraft parts, and it is said that in 1918 a considerable number of aero-engines, which were no longer needed, were buried in pits at the back of the main shop.

The Signal Works, Shrub Hill

The founding of McKenzie, Clunes and Holland was due to the absorption of the West Midland Railway into the GWR. McKenzie, superintendent of the locomotive carriage and wagon department of the OW&W, was a typical Scot, hard working and dour in business, but revelling in the jollifications at Shrub Hill when workshops were decorated and converted into 'banqueting halls'. Holland had been in the secretary's office of the railway, and these two joined with Thomas Clunes in a comparatively small business at the Vulcan Ironworks.

The partnership provided a happy combination of technical skill, business

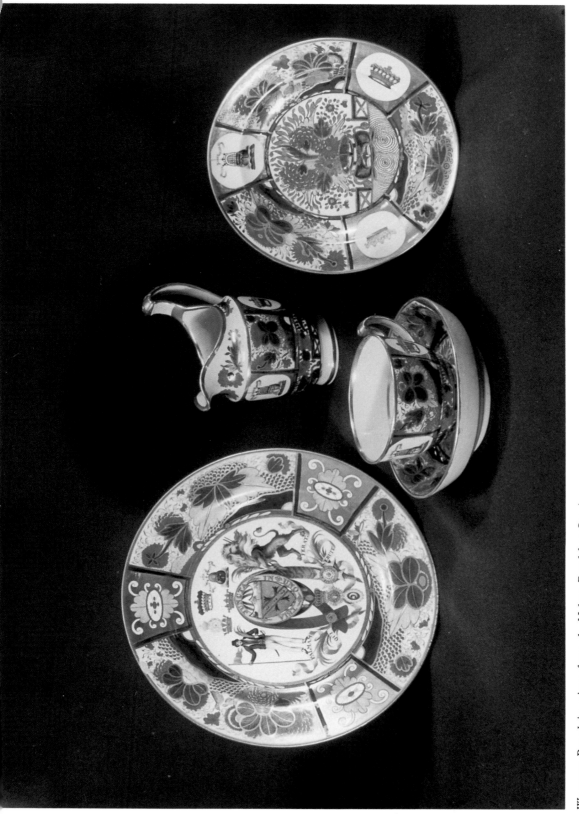

Worcester Porcelain: pieces from the Nelson Breakfast Service

Worcester County Cricket Ground, one of the loveliest in the country

The Severn Bridge, with St Andrew's spire and the cathedral in the background

Old Powick bridge, scene of the first skirmish in the Civil War

aptitude and a capacity for handling workmen. McKenzie and Clunes supplied technical knowledge while Holland knew about accounts and administration. Unlike the Worcester Engineering Works, the business began on a small scale, and after some anxious years, due to legal and patent problems, it developed into one of the chief local industries.

The Worcestershire Exhibition in 1882

After the failure of the Worcester Engineering Company, and the West Midland Wagon Company that followed, the great engine works lay empty and desolate. Then someone suggested the building would be ideal to house a Worcestershire exhibition, its 54,000 square feet of space much greater than that of similar provincial centres. The exhibition opened in July 1882 and brought together Worcestershire people to an extent never previously known, and was for months most entertaining and instructive. On show were Old Masters from many local collections, and modern works by Brock, Leader and others; and only industrial exhibits from the city and county were accepted for display.

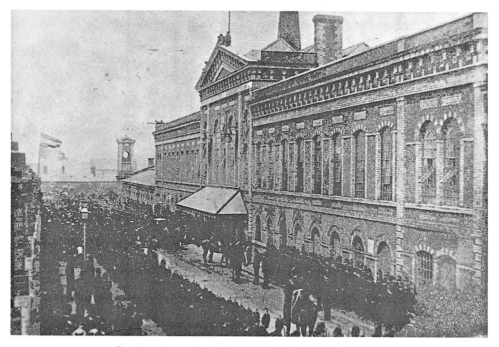

Opening day of the Worcestershire Exhibition, 1882

The main entrance hall contained an organ with a stage capable of seating a large orchestra; and opened into four courts, two on each side. The first of these was devoted to fine arts and historical objects; the second to carriages, anvils, nails, boilers, fenders and other ironwork, bricks, baths, chemicals, mineral

waters and sauces; the third to the processes of manufacturing carpets, horsehair weaving, needles, gloves, boots, buttons and porcelain; and the fourth was given up to the display of the finished products, such as ranges, furniture, porcelain and carpets. The exhibition remained open until October 1882 and was visited by over 200,000 people. Its financial success rendered possible the subsidising of various educational schemes in the county and its influence ripened public opinion in favour of establishing the Victoria Institute.

Elbury Mount

Elbury Mount was once the most picturesque spot in the immediate vicinity of the city, a waste of gorse and briars with wonderful views. Jabez Allies considered it to have been a key place in druidical times, and a bonfire on its summit could be seen all over Worcestershire. In 1850, when Allies was writing about it, there remained on the summit evidence of the site of a camp, 200 yards long on the north side, 100 yards on the east and south, and 150 yards on the west side. Later, the hill was bought by the city for a reservoir, and during its construction all traces of the camp were destroyed.

In his Civil War diary Townshend wrote that in 1646 Colonel Whalley placed a battery on the hill and erected huts there, but that on 28 May the captain in charge was drunk and the huts were set on fire and burnt to the ground. Whether the remains of the camp that Allies measured were druidical or Parliamentarian is difficult to say.

The Virgin Tavern

On the Tolladine Road, on the crest of the hill, is the Virgin Tavern. It has been rebuilt this century and inevitably has lost its original character, but there has been an inn there for centuries. In Victorian times it competed with the Ketch and the Swan at Whittington as a favourite resort of Worcester citizens. Set in rural surroundings, the inn was a boundary marker for Claines and St Martin's parishes, and visited regularly in the days before accurate maps when walking the bounds of the parish was essential. The name denotes its association with church and parish and though there are many 'ecclesiastical' inns no other inn is known to have been called the Virgin Tavern.

Port Fields

The southern slope of Elbury Mount has from time immemorial been known as Port Fields. Jabez Allies believed the name was evidence of a Roman port or military way leading from Worcester. In medieval times Port Fields belonged to the White Ladies of Whistones, but after the Dissolution the land passed through many hands and in the last century a few superior suburban villas were built there.

In the 1860s, when France seemed to be following the French colonels who threatened to avenge Waterloo, volunteers clambered for rifles. Butts remained on Tunnel Hill and a 600-yard range was secured with the target backed against the escarpment of Elbury. Inexperienced recruits can be

dangerous with live ammunition, and when a cow was shot dead in Port Fields meadow the jest was considered well worth a few pounds; but later on it was decidedly serious when a barrage of bullets swept Tolladine Road, and the butts were closed.

Holy Trinity church

Holy Trinity church in Ronkswood was built between 1863 and 1865 at a time of high Victorian religious zeal, and the building was planned and executed with great regard for its decoration. The architect was W J Hopkins, who employed R L Boulton, one of the country's leading ecclesiastical sculptors, and James Forsyth to do the carvings. The intention was to build a fine tower and spire, but this did not materialise. The site was badly chosen: the district became very industrialised, the church surrounded by factories. In 1965 it was closed and later destroyed.

During its century in existence, however, Holy Trinity was notable for having as its roof the medieval roof from the Guesten Hall. The hall, over 500 years old, was destroyed in 1860, and its magnificent roof badly mutilated to fit a narrower church. The sad record of official vandalism continued for when Holy Trinity itself was demolished the fine sculpture by local crafstmen was deliberately and wantonly destroyed, the 'Last Supper' by Boulton smashed up by a priest with a hammer (to the consternation of the workmen dismantling the roof), so as 'not to allow it to fall into secular hands'!

House of Industry and Workhouse

When the House of Industry was built on the summit of Tallow Hill in 1794 one of Worcester's loveliest amenities was destroyed for at that time it was a park-like meadow, described by Valentine Green as 'a delightful eminence' where citizens picnicked among the gorse and picked primroses. The institutional building, however, the work of George Byfield, was rather like a large country dwelling set in its own parkland, overlooking the city, and with views to the Malvern Hills.

When it opened the intention was to run it as a home and occupational centre for the unemployed poor. Children were admitted as apprentices to the making of flannels, coarse woollen cloth and especially gloves; and for a time there were some successes. In 1795 there were 223 paupers housed there, 132 of them children.

Sadly, times and attitudes towards the poor changed. The house came to serve as the Union Workhouse, receiving the poor from a 'union' of eight city parishes; and after the Napoleonic Wars a different view prevailed, and the house on Tallow Hill came to be regarded as a place of detention. Conditions were so harsh that only the most desperate would go. The 'Workus' became a spectre that hung over every working man's head. Married couples were separated into different parts of the building, rarely to see each other again; children were dressed in the same ugly coarse clothing; and all were badly fed.

The old cemetery on Tallow Hill

The House of Industry on Tallow Hill was reached through Lowesmoor and the

Crowle Road, for there was no road direct from the city and a large pool lay at the bottom of Tallow Hill (shown on Green's map). When a new road was cut from St Martin's Gate it had to curve round the pool; but when the canal reached Worcester in 1815 the pool was drained into it, and the land used as a cemetery from 1832 when a mass grave was dug for victims of the cholera outbreak. The road is still bent, part being George Street.

The cemetery site was nearly square, dissected by paths and with a surrounding dwarf wall. A small mortuary chapel stood at the centre, and a postmortem house near the canal. Burials ceased there in the 1860s after William Laslett's gift of Astwood, though the walls and chapel remained until the 1920s, and a number of gravestones can still be seen today. Later it became a playground, and later still a car park.

Cholera and the mass grave

At the north-east corner of the old cemetery, nearest the Beehive Inn, a mass grave was dug for the victims of the first cholera outbreak of 1832. Though all trace of it above ground has long disappeared, in the 1920s a small wall still surrounded it.

Doctors had been well aware of the spread of Asiatic cholera from India and the Worcester faculty, led by Dr Hastings, was prepared for the worst. The first alarm came when eleven-year-old Eliza Caldwell went down with symptoms very like those of cholera. The doctors gathered in some trepidation to examine her but failed to agree and, eventually, scarlet fever was diagnosed. On 14 July 1832 a travelling brazier and rag collector from the Pinch took ill and died within sixteen hours. There was no doubt this time, cholera had arrived; and during the summer months the cases reached epidemic proportions. Most of the first cholera cases occurred in the Pinch, in Hylton Road, a very dirty locality. It continued to rage until the middle of October, with 293 cases and 79 deaths.

Many churchmen put the visitation down to evil living, and the local press echoed the theme:

> Young man, drunk the night before, died of cholera next day.
> A female in the Butts died of malignant cholera. Jury returned verdict of 'Died by the Visitation of God'. The deceased was between 30 and 40 years of age, she lived a very dissolute life, and occasionally drank large quantities of gin.

Even more dramatic was the following: 'At the meeting of the Ranters or Primitive Methodists, in Tybridge Street, a young man, about 20 years, interrupted them with abusive and blasphemous language. He appeared quite well and sober, but a few hours later, he was seized with Cholera, and by 2 o'clock the following afternoon he was a corpse.'

A special hospital was set up on Henwick Hill together with a 'pest house'; and near Berwick's Bridge there was a house of refuge. The health authorities ordered that victims of cholera should be buried within a day and under Charles Hastings' guidance the people in low-lying areas were encouraged to live in tents and shacks set up on Ronkswood Hill during the hot summer months.

Hastings had already done some work on the health hazards facing particular occupational groups in the county — glovers, porcelain workers, needle-pointers, salt workers; and he had given warning of the health problems suffered by those living in the low-lying parts of Worcester, largely the poor, where drainage was bad and living conditions squalid and unhealthy. The mayor and corporation must have been glad to put themselves into his hands. He attended, it is said, every case of cholera; and he saw to the speedy burial of the dead and to the cleansing of insanitary places.

A second outbreak of cholera occurred in 1849 with forty-nine fatalities and a third in 1853. By that time the evidence that the disease came from dirty water was clear; and yet councillors who were in a panic during the outbreak still fought against using rates to supply clean water. It is worth remembering there was no public health officer during these years, nor was there any general sanitary legislation until 1872.

Taking the waters at Spring Hill

The fashion for taking the waters in the 18th century led to the development of a number of springs. On the southern slopes of Tallow Hill in the area now known as Spring Gardens a small building called the 'Cold Bath' was set up; and it became the fashion to stroll through the pleasant pastures (along the path across Blockhouse Fields — opposite where St Paul's church now stands) and drink the pure water and bathe. It is hard to appreciate today how greatly pure water was prized, until we realise that the water obtainable in the city from the conduits was pumped direct from the Severn without any kind of treatment. As late as 1849 it was taken from the river, just below a great city depot for stable manure, roadscrapings and night soil, and close to the drain from the infirmary and gaol.

Unfortunately, the days of Cold Bath Fields (as Spring Gardens was then known) were numbered: in the cutting of the canal in the early 19th century the path was severed and the spring lost. In 1816 a chalybeate spring was discovered on the west side of the newly dug canal, near Sidbury bridge, which was said to have been the equal of that at Tonbridge and a benefit to hundreds of people. But this too was lost when sewers were laid, though Spa Row and Spa Gardens existed until a few years ago as reminders of the spring.

Gentleman John Tustin

At Ronkswood Farm, halfway up the hill, lived 'Gentleman John Tustin', a handsome well-groomed man, a haulier and coal merchant by trade. His blighted romance amply illustrates the strict class structure which existed in the early Victorian period. John Tustin had won the heart of Sir Henry Wakeman's daughter and was practically engaged to her. The baronet, however, would not entertain the idea of his daughter marrying a coal merchant; consequently, she dutifully withdrew. Though his was a large business, Tustin was not considered 'class' in the mid-19th century. But it was said that though he lost a bride he gained the respect of her father, for he made a point of bearing himself in such a way that Miss Wakeman never needed to be ashamed of the early attachment.

Miss Wakeman has passed into obscurity but evidence of John Tustin's practical skill and organisation lives on. When Lord Ward (later the Earl of Dudley) set about transforming Witley Court into one of Europe's greatest palaces, he chose the Forsyth brothers of Worcester to carve the glorious Poseidon and Flora Fountains — to Nesfield's designs — and it was Tustin who by means of a huge team of shire horses organised the removal of these gigantic pieces of statuary from the Forsyths' studio in the Tything to the Court (part of the road at Little Witley first raised by the earl to reduce the steepness of the hill at that point). The fountains are currently being restored.

The Apollo Cinema at the Zion chapel

The Zion chapel was opened by the United Methodist Association on the Sunday before Christmas Day in 1838. It was built to cater for the new suburb which had grown up outside the Sidbury Gate. It seated 167 but was rebuilt with an imposing frontage in 1845. In about 1910, however, the United Methodists withheld their grant and the chapel had to close.

The building became the Apollo Cinema, typical of many in those early days which began life in converted premises. Despite its fine facade, the chapel was a small building with a tiny gallery, and to get a reasonable 'throw' the projection box was built out through the window over the street. Film was

The Apollo Cinema, once a chapel, in 1918. Note the projection box built outside to obtain a reasonable 'throw'

highly inflammable in those days and a bucket of water was kept immediately above the projector.

For many years the Apollo was very much a family affair. S F Evans recalled those early days:

> My grandfather converted the chapel. My mother was in the pay box, my father was the cinema operator (by hand) and my two older brothers took the tickets and sold chocolates and cigarettes during the interval, when it was twice-nightly. I was too young to do much, but my job was to take the films into the back room after they had been shown and wind them back by hand for the second house.

Entrance at matinees was 2d or, for children, two glass jam jars which piled up in the yard for the ragman to collect; and the children who thronged to the Saturday matinees were offered blood-and-thunder serials like 'The Clutching Hand' and 'The Face at the Window', the themes of Victorian melodrama translated to the new medium of film, with heroines like Pearl White, tied to railway lines with a train approaching at breakneck speed. And every week, just at the moment of crisis, the film would end with the caption 'To be continued next week', bringing shouts and groans of frustration.

Fort Royal

The Commandery was spared the demolition of the Sidbury suburb at the sieges of 1643 and 1646, but experience in those events revealed how exposed the city was to artillery attack on its south side, the walls there dominated by the high ground of Green Hill. At the 1651 battle the Royalists hurriedly erected defensive earthworks, placed cannon on the highest point and, after the custom of the day, styled it 'Fort Royal'. It served its purpose in keeping the enemy at a distance, for instead of an enemy battery on Green Hill, as in 1646, the nearest Parliamentary post was at Camp Hill at the top of London Road.

In 1651 the future Charles II invaded England with a Scottish army and marched to Worcester where he expected to be joined by reinforcements. Cromwell advanced on Worcester from the Evesham direction, thus getting between Charles and London. On 3 September Fort Royal was the principal defence of the city. It is shown in an old engraving as a defensive platform, like a star with four points, and a bastion at each point of the star. From this fort were 'lines' of banks and ditches, one of which extended to the city wall near the Blockhouse, the others southerly, crossing London Road to the city wall near St Peter's church.

During the battle Charles and his council of war assembled on the tower of the cathedral, and when it became obvious that the lines at Lower Wick had been breached it was decided to create a diversion by attacking towards Perry Wood which had been weakened by detachments that crossed by the bridge of boats to the west side of the river. The Royalists advanced from the Sidbury Gate in two columns, the right led by Charles, the left by the Duke of Hamilton. They were outnumbered four-to-one and the Parliamentary forces were entrenched with guns behind earthworks; but, nothing daunted, they pushed across St Catherine's Vale to Perry Wood. The duke stormed the

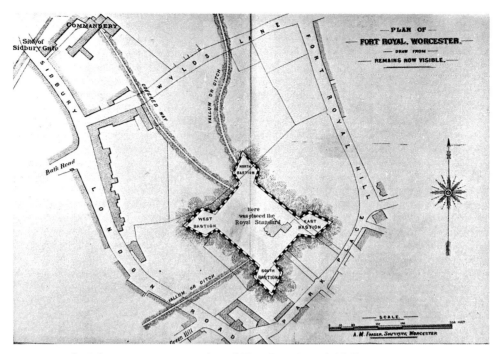

A 19th-century reconstruction of Fort Royal by A M Fraser, surveyor

earthworks, capturing the guns, and drove Cromwell's militia in full flight from the wood to the top of the hill.

Charles met with similar success and gained the crest of Red Hill; but here, uncertain whether to follow, he failed to push home the attack. At that decisive moment Cromwell arrived, having ridden through the Royalist lines, rounded up his shaken troops and ordered them into close column. He led them in a charge down the hill, his inspiring leadership changing the fortunes of the day. The Royalists retreated down the hill, confused and disorderly, the guns were recaptured, and when he was most needed the Duke of Hamilton was wounded, his legs mangled by cannon shot.

The fight for the fort continued for a number of hours. Cromwell offered the Scots quarter, but they refused and after severe hand-to-hand fighting the fort was taken and all within ruthlessly put to the sword. The guns were immediately turned upon the city to add to the terror and confusion that now prevailed everywhere. At Sidbury Gate it was butchery, and the garden of the Commandery was filled with the dead and dying.

Fort Royal was bought and presented to the city by Canon Wilson in 1914, and opened as a park a year later. Here, more than in any other place in the city, one can capture the drama of the battle of Worcester.

Thomas Parker, the last of the duellists

Thomas Parker, whose family lived at Pirie Manor, was better known in his

day as 'Old Tom, the Huntsman'. He was the master of the Worcestershire hunt and his duel with a future Lord Hampton was the last to be fought in Worcestershire. His opponent was John Somerset Russell of Powick Court, and the duel took place on 3 March 1827 on Kempsey Ham, as a result of a quarrel about matters connected with the hunt and an accusation of vulpicide at Westwood Park. The challenge was sent by Russell.

The duel took place on a Saturday afternoon, with Captain Barneby of the Hereford Militia attending Russell, and Lieutenant Palmer of the same corps attending Parker. It was a pretty straightforward affair: the parties fired at each other, but without effect; the seconds intervened, and the combatants shook hands and left the ground. Information had been conveyed to the magistrates of the intended meeting but a warrant to arrest the disputants was 'too late'. In fact, the officer holding the warrant judiciously waited behind a bush until it *was* too late, then made his official appearance. The honour of all was satisfied; and on the following Monday Russell and Parker met at the foxhounds' meeting at Cliffey and cordially shook hands.

Wylds Lane

Wylds Lane took its name from the 16th-century owners of the Commandery. It wound its way round Fort Royal, just touching the Georgian suburb of Park Street, and on towards Perry Wood, and was once no more than a rural cul-de-sac. It terminated in a bridle path which crossed the railway on the level, then proceeded up through Perry Wood by the old medieval road, which is now a deep cutting made by centuries of travellers before the present London Road was made.

Wylds Lane was widened in 1863, and six years later St Peter's Mission Hall was built at the Sidbury end. It was the gift of J D Allcroft, the glove manufacturer, and was originally three storeys high. It was built before the days of state education and during a period of increasing demand for adult education. In this building were Bible classes, working men's lectures, a reading room and a night school. Such places were milestones in the march of working-class progress.

The sign painter and the Garibaldi Inn

The Cole Hill district of Wylds Lane was laid out as a housing estate in the 1860s when Garibaldi's fame was at its height. An application for a beerhouse in that area was obtained by Mr Padmore of the nearby Worcester Foundry and as Garibaldi was his hero he was anxious to add more than just a name to the new pub: he wanted a sign depicting the great Italian patriot.

Unfortunately, no David Cox offered himself as a sign painter (as happened at the Royal Oak in Bettws-y-Coed), which was surprising considering the number of china painters in the area. However, a house painter in the Trinity, a man named Albert, who had lost an arm, emerged to take up Mr Padmore's challenge and produced a life-size portrait of Garibaldi in his flaming red shirt, copied it was believed from an illustration in the *Illustrated London News*. It was a powerful, if naive, work of art which for a long time was

quite an attraction to connoisseurs of public houses; and it helped to sell beer.

The success spurred the house painter to further artistic efforts and he became a regular contributor to local exhibitions. His work, however, was stiff and wooden and produced many critical reviews — one suggesting he was quite good at painting a turnpike gate, providing it was with one coat of white paint.

The Garibaldi Inn murders

In 1925 the Garibaldi Inn was the scene of a tragic event which involved the murder of three people — the publican, his wife and their little boy of two — and the eventual execution of a policeman.

Ernest George Laight had recently taken over the inn where he lived with his wife, Doris, and their children, Joan aged six and Bobby aged two. He became a close friend of Herbert Burrows, a policeman living nearby, who had come from London and had served seven months' probationary period with the Worcester City Police Force.

On Thursday 26 November Burrows was at the Garibaldi when the last customers left. Early the following morning the charwoman found the place in disorder and, on entering the cellar, Mr and Mrs Laight dead on the floor. She fetched neighbours who searched the inn and found Joan asleep in the bedroom, but the baby, lying face downwards on a pillow, was dead. Mr Laight had been shot in the body and the head, Mrs Laight through the chest; and two-year-old Bobby had been battered to death. There had clearly been an unsuccessful attempt to start a fire in the cellar, and the accumulated inn takings were missing, the bar cash boxes lying on the floor empty.

Shortly before 8 o'clock on that same morning PC Devey was on the Cross when he met Burrows, who asked an incredibly incriminating question: 'Have you heard of this affair at the Garibaldi Inn?' PC Devey, of course, had not, and with good sense reported the conversation to his sergeant. Burrows was questioned about his knowledge of the affair and, his answers being unsatisfactory, was detained pending further enquiries. He was found to have £19 in cash upon him (a large sum in those days) and his lodgings were searched. In a locked drawer an unlicensed revolver was found with three spent cartridges, some £63 in cash and a mounted sovereign identical to the one known to have been worn by Mr Laight. At Burrows' appearance at the Shirehall great crowds booed him, and again at Shrub Hill Station when he was taken to Gloucester Gaol. He later confessed to the murders and was executed in February 1926.

Cromwell's meeting in Perry Wood

At the battle of Worcester Cromwell occupied all the high ground from Ronkswood to Red Hill, and portions of his entrenchments are still visible near Perry Wood and below the golf course at Ronkswood. It was in Perry Wood that, according to tradition, William Guise, a Worcester cloth worker or tailor, and a strong supporter of the Parliament, disclosed to Cromwell the projected night sally to surprise and overwhelm him in his sleeping quarters. Guise was said to have lowered himself over the city wall by means of a knotted rope. It is

clear that Guise was regarded both by the Royalists and Cromwell as the informant. The Royalists, wreaking vengeance for the disaster of the 'camisade' (the story of which is told elsewhere), hanged Guise as a traitor from the sign of the Golden Cross in Broad Street the very next day; but a traitor he was most certainly not. Parliament immediately recognised his service and only six days after the battle gratefully voted his widow an immediate cash payment of £200 (a huge sum in those days) and a life annuity of equal amount.

The coincidence that Cromwell died seven years to the day from his great victory at Worcester led Royalists to change his meeting with Guise to a meeting with the Devil, and to assert he had bargained his soul for victory and seven years of life.

Map 7

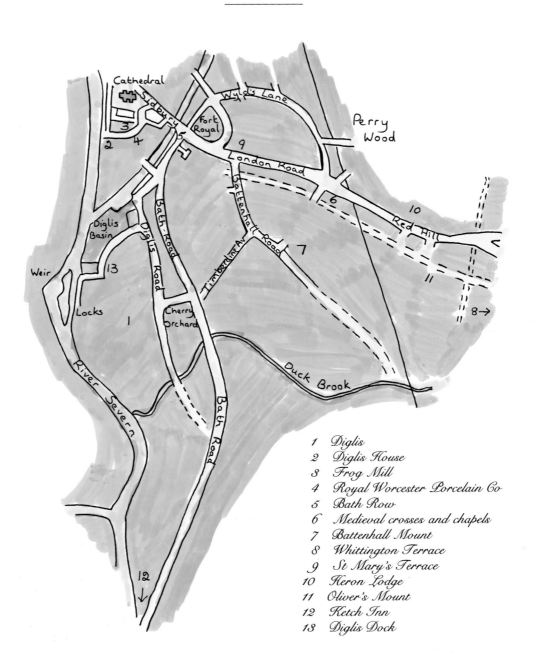

Cathedral
Sidbury
Fort Royal
Wyld's Lane
Perry Wood
3
2
4
5
London Road
9
6
10
Red Hill
Diglis Basin
Bath Road
Battenhall Road
7
13
Weir
Timberdine Av
11
8 →
Locks
Cherry Orchard
1
Diglis Road
River Severn
Duck Brook
Bath Road
12
↓

1 Diglis
2 Diglis House
3 Frog Mill
4 Royal Worcester Porcelain Co.
5 Bath Row
6 Medieval crosses and chapels
7 Battenhall Mount
8 Whittington Terrace
9 St Mary's Terrace
10 Heron Lodge
11 Oliver's Mount
12 Ketch Inn
13 Diglis Dock

Diglis and Battenhall

Diglis

For more than a thousand years Diglis was the 'home meadow' of the church of Worcester, just as Pitchcroft was of the city, and may appear to give colour to the suggestion that the name is an Anglo-French form of *d'Eglise* (of the church), but Mawer and Stenton in *The Place-names of Worcestershire* (1969) show that the name is first recorded as *Dudeley* and it is more likely to mean a clearing of someone called *Dudda* or *Dydda*. Part of the meadow seems to have been retained by the bishops, providing their establishment with hay and grazing ground, and part was allotted to the prior for similar purposes. It was some of the first land outside the city to be given to the priory. The meadow extended along the Severnside from the city wall at the bottom of Frog Lane, as far as the outfall of Duck Brook, and eastward from the river to Green Lane, now Diglis Road, a road of prehistoric antiquity, as shown by excavations made at various times, here and at Ripple, where it followed the line of the Severn.

The meadow was semi-marsh until very recent times, subject to frequent floods, and intersected by wide and deep ditches of stagnant water, best negotiated with the use of leaping poles after the fashion common in the Fens. Even in mid-Victorian times Diglis afforded capital snipe shooting and, occasionally, wild duck.

Diglis House

The present Diglis House is built on the site of a more ancient one belonging to William Berkeley. In 1643, when General Waller made his attempt to storm the city, the old house stood just outside, or on part of, the defences of the city; and Waller succeeded in establishing his troops in Berkeley's house. It was in and around this house that the hardest fighting took place. Colonel Sandys succeeded in driving the Parliamentary forces out of the house and then, because its proximity to the walls offered shelter to the attackers, had it demolished. A special body of 400 women joined with the defenders to level and clear the approaches to the wall for, besides the house, the outbuildings and hedges gave cover to the attackers.

In 1908, when excavating for new drainage at St Alban's Home, just opposite Diglis House, a number of human bones and three skulls were discovered just 18 inches below the surface. They were doubtless the remains of soldiers engaged in the battle.

Frog Mill and Diglis Pleasure Gardens

From Sidbury Gate to the Severn strong defences covered the castle wall. Running outside and along the old wall was Frog Brook which drove Frog Mill. The mill stood some distance below where the Potters Inn now stands in Severn Street and was probably the castle mill in earlier times; but when the castle became a prison it would have been worked by an outside miller. It was then known as the Frogging Mill and nestled under the high timbers of Castle Hill. Though situated outside the boundary, the mill was dependent on streams descending from the manor of Pirie. It ceased to be a working mill during the Civil War. At the end of the 18th century it was a picturesque part of old Worcester, quite a feature for visitors at the nearby Diglis Assembly Rooms and Bowling Green, adorned with two statues known as Gog and Magog, the handiwork of Nathaniel Wilkinson who built St Andrew's spire.

The Diglis district became a fashionable resort in the 18th century and continued so until the 1830s. Here there were assembly rooms, a riding school and a bowling green, all occupying the site of a bastion in the city defences where the wall abutted onto the river. The bowling green existed for a long time and was famed as the 'Hand in Glove Club'. Here the gentlemen played bowls on the green, and afterwards joined the ladies in a dance in the long room on the ground floor. After dusk the members were accustomed to card playing, and for the duration of the assizes and the Three Choirs public breakfasts and 'tea parties' were very popular. Nearby in Frog Lane was a cockpit, still in use in 1825. The downfall of the pleasure gardens was due to an unfortunate fracas in which a disagreement ended in violence, one member receiving a stab wound from which he died. As a result the green was abandoned.

The Royal Worcester Porcelain Company

By the middle of the 18th century the cloth trade, for centuries the principal industry of the city, had declined and some of Worcester's leading citizens were anxious to bring new industries to the city. At that time 'china' was a fashionable rage throughout Europe and several attempts were made to emulate the imported porcelain from the Far East. The English approach was different to that of France and Germany where state factories were set up: here it was left to private enterprise. But the hour brought forth the men in the shape of Dr John Wall, artist, scientist and physician of more than local repute, and John Davis, an apothecary in Broad Street. Wall had already made investigations into Malvern water with the idea of making Malvern Wells as fashionable as Tunbridge Wells; and now he and Davis began to conduct pottery experiments at the latter's shop.

The two men formed a company with thirteen of their acquaintances, and a lease was taken on Warmstry House, next to the Bishop's Palace. Their experiments in soft soapstone paste china were similar to those of the Miller & Lund factory at Bristol with whom they were in communication; and within a year Wall had acquired the secret processes of the Bristol firm, with their tools, moulds and other equipment and had brought them to Worcester. By 1754 a great variety of ware was available at the Three Choirs Festival, and within ten years 200 people were employed at the Worcester factory.

At first Oriental pottery was copied with exactitude, but soon Worcester began to develop a style of its own, the ware produced distinguished for its high level of craftsmanship and excellent taste. This was the period of the famous 'scale blue', exotic birds and the compositions of Donaldson and O'Neale. It was also the era of transfer-printed decoration — and if Worcester was not the first to execute it, it was certainly the earliest pioneer. Worcester engravers were held in great respect, the first, and probably the greatest, Robert Hancock, who set up later as a printer of illustrations for fine books. His successor, Valentine Green, became an ARA and Keeper of the Gallery of the British Institution in Pall Mall.

In 1771 the lease of Warmstry House ran out and a few years after Dr Wall's death, in 1776, Thomas Flight, the company's London agent, bought the business for his two sons. Though most of the workmen stayed on, the works manager, Robert Chamberlain, left and set up his own works at Diglis, Martin Barr joined the original company in 1793 and the name was changed to Flight & Barr and later, in 1807, to Barr, Flight & Barr. In 1840 an amalgamation was effected with Chamberlain, who had built up a considerable business and, his premises being the newer and better situated, the old factory was closed and joint activities began at the present site. The company was acquired by W H Kerr and R W Binns in 1852 and ten years later its name was changed to the Royal Worcester Porcelain Company, although it had held a Royal Warrant since the visit of King George III in 1788.

Meanwhile, in 1801 Thomas Grainger (Chamberlain's brother-in-law) set up a porcelain factory in Clapgate, where it continued in rivalry for nearly a century, being especially successful with what it styled 'semi-porcelain', all the vogue for dinner services. It was sold in 1889 as a going concern to the Royal Worcester Porcelain Company, and continued in production until 1902. The showrooms, house and shop in the Foregate are now occupied by W H Smith.

Bath Row

During the reign of George III a residential suburb grew up along the Tewkesbury Road, and in recognition of the fashionable pleasure resort of those days the principal terrace was named Bath Row. It was occupied by some of the best families of Worcester, including that of Robert Chamberlain, the Worcester potter, and his two daughters.

In this row also lived a lady who was involved in a love affair with John Hill Clifton, a prominent diocesan registrar of the 1850s. When they were both young he was attracted by her good looks but although she came of a good family she was of slender means and family objections barred the union. Both remained loyal, however, and neither married. She continued to live in Bath Row and once a week, when they were very old, Clifton's carriage became a familiar feature outside the terraced Georgian house.

The London Road

The London Road from Sidbury Gate to the top of Red Hill has seen many changes. The present road is a turnpike coach road, for the medieval road ran a little to the south and can be traced almost the whole way by a line of back

lanes. The old road climbs the steep hills without any attempt to modify the natural gradient. It explains why Queen Elizabeth left Worcester by a specially 'made way' leading to Battenhall Park and why crosses were set up at the foot of each hill to give thanks for a safe descent.

The present London Road was built in the 18th century, and two major cuttings helped to ease the gradient for the London coaches. The first, at Wheatsheaf Hill, was cut through part of the old Fort Royal defences and called Wheatsheaf because of an inn of that name that occupied a site halfway up the hill. The second, at Red Hill, was cut through the southern tip of Perry Wood. Twice this cutting has been blocked by landslides and for weeks London coaches had to reach Whittington by way of Middle Battenhall Farm. During the making of the coach road the valley called St Catherine's Vale was raised and Pirie Brook, which flowed down from the foot of Pirie Wood and once crossed the road, now runs below the road in a pipe.

Crosses and chapels

Two medieval crosses stood on the old London Road until the end of the 17th century, one at the junction with the Tewkesbury Road at the bottom of Green Hill, the other at the foot of Red Hill. They were destroyed by the followers of Sir Edward Harley, a well-known Puritan, at the 'Glorious Revolution' of 1688 when there was a scare about popish things.

There were also several chapels in the area. On Cobhill (possibly St Catherine's Hill), near the road leading to Red Hill Cross, there was a chapel dedicated to St Catherine, not far from which stood St Ursula's chapel and St Ursula's hermitage. Another possible chapel, discovered at Green Hill, was recorded by Jabez Allies: 'In January 1843, as workmen of Mr Holland were making an excavation for a building yard in the Marl Bank, just above Sidbury Place and opposite Fort Royal, an ancient, square underground apartment was discovered. Its walls consisted of bricks and tiles, in alternate courses, set in marley clay, the tiles being considered Roman or Brito-Roman . . . The roof had fallen in, and among the debris were found fragments of Early English stonework.' Opinions differed as to whether the room was a Roman hypocaust, a military oven used by the troops stationed at Fort Royal, or, a third suggestion, part of the ancient chapel of St Godwald which, according to Leland, stood in the suburb outside Sidbury Gate and appears to have served as chapel to the Commandery.

Turnpike gates

At the top of Wheatsheaf Hill, opposite the Fort Royal Inn, was Marks' 'Blue Bus' Garage. Marks' was one of the earliest private bus companies, operating in 1918, if not earlier. What intrigued people was the slogan painted in large letters on the rear of the buses, *Pride of the Pike*. It stemmed not from any fishing connection but from the fact that the garage occupied the site of the London Road turnpike gate. (The tollhouse was demolished after the turnpike ceased to operate in 1870.)

It is very difficult now to appreciate how (up till 1870) the urban areas of the town were cut off from the country by these gates. From every direction the way into the city was barred and every vehicle and animal had to be paid for on

the way in and on the way out. One result was that just outside the gates there was usually a public house; and it was the practice to park your vehicle, get some liquid refreshment and then to avoid paying the toll by walking through the gates. Inns like the Mount Pleasant were built for this trade; but as towns grew and expanded their boundaries the toll gates, once on the outskirts, now cut off large suburbs, and there were strong demands to resite them. The London Road gate was moved from the bottom of Wheatsheaf Hill to the top; the Bath Road gate was moved twice — from the joint gate with London Road to the junction with Diglis Road and, later, to near Timberdine Avenue, the Berwick Arms catering for the 'outside' trade.

The Feilds of Green Hill

South of Fort Royal is Green Hill, a Georgian suburb overlooking the south of the city and built on two terraces because of the steep gradient. The lower is approached from Bath Road and the upper from London Road. On the hill, before the houses were built, was a considerable mound of earth which Allies suggested was the remnant of a fort erected by King Stephen in 1149, and which still existed in 1796. During the Civil War it was known as Windmill Hill and was used by the besiegers to bombard the city. The windmill itself stood some way to the north of the Hill Avenue.

The Feild family lived at Hill House which crowned Green Hill, just north of the Hill Avenue which takes its name from the house. Edward Feild ranks as one of the chief founders of the colonial Church of England. He was born in 1801 at Worcester into a well-known family whose surname, looking like a misspelling, is commemorated by a terrace in Bath Road. In 1844 he was appointed first Bishop of Newfoundland, where he spent the remaining thirty-two years of his life in self-denying devotion to a most arduous duty. His diocese included the wild Arctic coast of Labrador and tropical Bermuda — 1,200 miles apart.

Battenhall

Battenhall lies in a secluded hollow beneath the high ridge of Whittington. In Norman times the Poer family held this and much more land immediately south of Worcester on the rent of a lamprey. Later it belonged to the priors of Worcester, who formed a deer park and built a lordly pleasure house. The site may still be identified near the present Middle Battenhall Farm by mounds and excavations in an orchard of old trees. A rivulet enabled the monks to surround the mansion with a moat and well stocked fish ponds. During the reign of Henry VIII Prior More held the place and enjoyed it greatly. He spent a lot of time (nineteen weeks in one year) entertaining there with feasting, games and minstrelsy, plays and bear-baiting. It was at Battenhall that Princess Mary (later Queen Mary) stayed as a forlorn child of nine, when there was no welcome for her at her father's court. At the Dissolution most of the priory estates passed to the cathedral and More became the first Dean of Worcester. But the manor of Battenhall where, successive Crown Commissioners had reported, the priors lived in lax and luxurious style, lapsed to the Crown. It was leased by John Bourne, a steward of the cathedral, who later acquired the freehold.

Queen Elizabeth visited Battenhall in August 1575 on her visit to Worcester. She was attended by a distinguished retinue and intended to hunt in the park; but the days when as many as nine fat bucks were killed on one occasion were gone — Bourne's fortunes had decayed and she returned to the city without hunting. She left Worcester not by the common highway but 'with a great trayne before and behind' through Battenhall Park, from 'beyond the Cross at Tewkesbury Lane' to Whittington and on to Elmley Castle.

The Bournes were succeeded by the Bromleys, Sir Thomas, the Solicitor General and later Lord Chancellor. He was responsible in particular for the fate of Mary, Queen of Scots. When Parliament induced Elizabeth to sign the death warrant Bromley lost no time in affixing the Great Seal. But the strain was great: he broke down seven days after, and two months later, aged fifty-seven, he was dead and buried in Westminster Abbey. When the Bromleys left Battenhall the property was purchased by William Sebright of Wolverley, who had amassed a large fortune as a merchant and lord mayor of London. The Sebrights held Battenhall for over two hundred and fifty years, as long as it had been held by the Norman Poers and the Worcester monks.

Battenhall Mount and Battenhall Grange

One of the first houses erected on the Sebright estate was Battenhall Mount, easily the best late-Victorian house built in the city. It was built on the site of old entrenchments which had been an outpost of Cromwell's defences and had

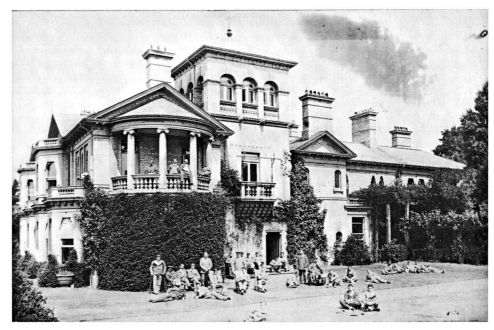

The best late-Victorian house in Worcester: Battenhall Mount, a convalescent hospital in the First World War and now St Mary's Convent

remained almost intact until mid-Victorian times. The grounds were opened for the Royal Agricultural Society's show, and for that purpose Battenhall Road was made, until then a very narrow lane with high banks covered with wild roses and blackberries.

Battenhall Mount became the residence of the Honourable Percy Allsopp who enlarged it and added much of the decorative work. During the 1914–18 War it was used as a convalescent hospital for wounded soldiers, and later became St Mary's Convent. It is a delightful and elaborately decorated house with a charming Tudor-style gatehouse, and superb ornamental wrought-iron gates and carved woodwork. Much of the excellent craftsmanship and richly decorated plasterwork of the house's interior was executed by H H Martyn.

Battenhall Manor, the old half-timbered house known as Battenhall Grange in Victorian times, was destroyed in the 1960s. It is believed to have been built of the timbers from Prior More's house when it was taken down in the 17th century. The Grange was the parish workhouse in the 18th century, for before the formation of the Poor Law Unions in 1782 each parish maintained a separate workhouse. On the establishment of the Union Workhouse that at Battenhall was acquired by a Mr St John, son of a dean of Worcester, who tastefully converted it into a charming residence.

The execution of Father John Wall

For several centuries the public gallows for Worcestershire stood at Red Hill on a piece of waste land, but long since enclosed by the Sebrights. It is still possible to place the site of execution, for two ancient roads crossed here and these roads are now very narrow footpaths. The one, the old London Road, runs up the hill at the back of the houses; the other goes from north to south, crossing the traffic roundabout, and has a sign marked 'Footpath to Upper Battenhall'. Like many another ancient road, it has been used as a marker, or boundary of property, and so has remained. A wooden cross in a garden a few yards from the modern road, on the south side, marks the site of the gallows. Father John Wall, executed at Red Hill on 22 August 1679, was the last Worcestershire martyr and almost certainly the last man to be executed in England on the score of religion.

Father Wall was a northcountryman whose real name was Francis Johnston. From his youth he devoted his life to the Roman Catholic faith, was ordained in Rome in 1648 and in 1656, during the Commonwealth period, was sent to Worcestershire to take charge of the Harvington mission. For twenty years he laboured uneventfully, twelve of them as priest-in-charge of the Catholic chapel at Harvington Hall. But he became a victim of the infamous fraud known as the 'Titus Oates Plot', when scares and agitation — and in particular the so-called revelation of a Jesuit plot to kill the king and overthrow Protestantism — led to the immediate introduction of repressive legislation. Wall happened to be staying at Rushock Court when a sheriff's officer, with attendant bailiffs, arrived in the middle of the night to arrest a gentleman for debt. They broke into the room and arrested Father Wall who was in bed, under the impression that he was the debtor they were seeking.

The mistake was subsequently discovered but one of the bailiffs recognised Wall and denounced him as a priest. He was taken by Henry Townshend,

barrister-at-law and son of the diarist, to Sir John Pakington, people he must have known personally. But from first to last he declined to purchase either liberty or life by swearing oaths of allegiance and supremacy. The justices had no option but to commit him for trial and at Worcester assizes he was charged with high treason. Nine months after his arrest the priest was sent to the scaffold.

Although 'quartered' in accordance with the practice in cases of execution for treason, Wall was first strangled to save him from the agonies of the brutal sentence, and his remains were not denied burial. His body was laid in St Oswald's graveyard, and his severed head was taken to Douai in France, where his early manhood had been spent.

The last executions

The last executions at Red Hill took place in July 1809 when two men were executed for robbery with violence. Those were the days when hangings were frequent. A severe judge, like Baron Parke, infamous as the 'hanging judge', would leave a dozen or more under sentence of death at a single assize; and although some would be reprieved, three or four were frequently executed and left to hang on the gibbet as a warning to others. In the last century John Noake tried to get formal evidence of executions at Worcester, but found that the governor of the county gaol at that time had sold all the books and papers to the landlord of the Saracen's Head in the Tything for conversion into spills for the smoking concerts held there!

Whittington Terrace

From the top of Red Hill the old coach road ran along a natural terrace with fine views of the Malvern range. It was a favourite promenade with Worcester people in the 19th century and at the end of the terrace the old wayside inn, the Swan, was the usual rendezvous for refreshments before strolling back to the city.

The terrace must have been well populated in prehistoric times, for aerial photographs show considerable occupation marks right along to Crookbarrow Hill. The hill, known locally as Whittington Tump, is so smooth and perfectly shaped from every angle that it must have been made so by man. In 1780 Richard Ingram of Whiteladies, to whom the farm and hill had descended, made some experimental excavations in the sloping ground to the south-west side and found a number of Roman coins of Titus and Constantine. Crookbarrow Farm at the foot of the hill was moated according to Nash; but today only a large pool remains.

The Clifton family

At Norton Villa, Whittington, a house now called The Firs, lived the Clifton family who had long and important connections with the city. Henry Clifton was mayor in 1832, a time of great unrest, public disputes and riots, due to the agitation over the great Reform Bill. He was strongly reactionary and ruled the city with a firm hand; but although he was hated by many he was

presented with plate at a public dinner at the Guildhall for his 'vigilance and energy' shown in repressing the Worcester riots!

In Victorian times John Hill Clifton lived at Whittington and gave memorable wine parties. The astounding capacity for drinking is indicated by the story of one of the Clifton parties (told on good authority) when fourteen people sat down to dine 'of whom two were but indifferent drinkers', and at the close of the entertainment were found to have disposed of fifty-two bottles of port (as well as such trifles as sherry and champagne which were not accounted for).

Heron Lodge

Heron Lodge dates from the 1830s and is the most attractive of all the houses off London Road. The house itself lies back beneath the rise of Perry Wood. It was built by Admiral Powell and named after a French vessel which had been captured in action and which Powell had commanded with distinction during the Napoleonic Wars. On a lawn at the side of the house is a very old weeping willow tree, grown from a cutting of the historic one which Admiral Powell planted over Napoleon's grave at St Helena. In Whittington church there is a monument (dated 1857) to Rear Admiral Powell, a very gallant sailor whose feat of arms won him recognition in the standard history of the Royal Navy, and in later days would surely have won him the Victoria Cross.

In 1816 the British fleet, no longer engaged againt Napoleon, set out to deal with the organised piracy of the Moors; and Lord Exmouth was sent to Algiers to demand the liberation of the Christian slaves. Exmouth's demand was met with a contemptuous refusal and the fleet shelled the strong forts which gave the Moors protection. The bombardment was heavy on both sides and British casualties were high. Commander Powell, as he was then, was serving on the *Impregnable* and on that ship alone there were 50 killed and 160 wounded. It was clear other means were needed to force a decision. At dusk a vessel loaded with explosives left the shelter of the *Impregnable*, screened by continuous broadsides from the fleet. The vessel was run ashore and exploded close to the principal Moorish battery. The damage was so great that when Exmouth threatened a renewal of the bombardment at daybreak the Moors surrendered. Over 1,000 Christian slaves were liberated and the Moors never recovered from the blow. Strangely, however, it was this bombardment of Algiers which opened the way to the French conquest of North Africa. Heron Lodge is now offices.

Oliver's Mount and Red Hill

The area from the summit of Red Hill to Battenhall Mount was occupied by Cromwell during the 1651 battle of Worcester. On a knoll, within bowshot of the ancient gallows, Cromwell had his main post, for from this point he could command the view to the city and personally direct operations. It was for long called Oliver's Mount and is the high land at the side of the old London Road, now encircled by Cromwell Crescent and Cannon Street.

It was here on 31 August, three days before the battle, that a disastrous 'camisade' was made on Cromwell's camp, when 1,500 picked Royalists were detailed to surprise him. They wore white shirts (or camisoles) over their

armour or leather coats, so that in the dark they could recognise each other. But it also made them good targets, and as the Parliamentary forces had been forewarned the surprisers were themselves surprised. The Parliamentary defences had been prepared and strengthened; and though the attack was made with great courage Royalist casualties were disastrous. The ground around Battenhall was strewn with the dead — most of them being buried on the spot. This ill-fated episode led to the legend (see page 163) of Cromwell's meeting with the Devil in Pirie Wood.

St Mary's Terrace and John Noake

The flat high land at the top of Wheatsheaf Hill was well named 'Mount Pleasant': in the early 19th century when fevers and cholera frequently raged in the low-lying, insanitary parts of the old city, many prominent citizens built fine houses there. St Mary's Terrace on the north side was called Rose Terrace in Victorian times and among its notable inhabitants were Richard Padmore, Ellen Price (Mrs Henry Wood), local historian John Noake and Canon Richard Cattley, who was known as 'Clock and Bells Cattley' because he was a bell enthusiast and expert. He was the chief promoter of the cathedral clock and chimes and advised on the carillon and clock in Abberley Tower.

John Noake came to Worcester as a journalist when he was a young man and worked on three different newspapers. He became the senior reporter and, later, sub-editor of the *Worcester Herald*; but he is best remembered for the column he wrote under the pen name 'Rambler' and for his devotion to local history research which, in his fifty-six years here, seems to have involved him in covering every blade of grass in the county. His book *The Rambler in Worcestershire* was published quite early, and the flowery reporting of that time may not be appreciated today; but with the years Noake became more of a historian, an indefatigable recorder (whatever his style) of so many things now long lost to us. His *Worcester in Olden Times* is one of a number of valuable works, his last, *Worcestershire Nuggets*, published just three years before his death in 1894. For many years Noake was Secretary of the Worcester Architectural and Archaeological Society and wrote many papers for its journal. He was also very active in the city's affairs, instrumental in getting the old Guildhall preserved, when others wished to demolish it, and served as sheriff and mayor of Worcester.

The Corbetts — father and son

At St Catherine's Hill, London Road, lived Edward F Corbett, a successful solicitor who became a local historian. His firm was something of a legal institution in the city, and many well-known men in the legal profession received their training at his hands. The practice came to a sudden end, however, when it was found that Corbett had been using clients' money in business speculations that had failed. In 1902 he was sent to prison for embezzlement; and after serving his prison sentence, and no longer able to practise as a solicitor, he turned his attention to local journalism, writing articles for the *Worcester Herald*. He had an unrivalled knowledge of local people and affairs and between 1924 and 1930 his ambitious series retraced John Noake's footsteps of fifty years earlier under the pen name 'Stroller'. The

articles continued in *Berrow's Worcester Journal* and are a useful source for today's local historians, provided they are approached with some caution since Corbett was in no sense a disciplined researcher.

Corbett's son, Edward, was also a solicitor, but it was said he was bitten by a 'travel bug'. Days spent in the office were tedious and irksome to him and he found relief by going to Shrub Hill Station and watching the trains go out. One who knew him well told how, after putting the usual notice on his door, 'Back in an hour', he went one glorious May morning to Shrub Hill and was about to return when the London express came in from Hereford. Quite unable to resist the urge to board the train, he bought a ticket and eventually spent the day at London Docks. In the evening as the tide turned and the ships began moving down river, he was approached by a ship's officer who offered him a berth to Australia. He signed there and then and by nightfall was on his way. It was nearly two years before he returned and by that time the 1914−18 War had started. He had a flair for languages, and a particular interest in folklore; and he was reputed to be a wonderful storyteller, regarding it as a serious art.

The building of Diglis Lock and Weir

The iron and coal industry up Severn grew rapidly after 1750, and vast quantities of coal and iron goods came down Severn to all parts of the world. Navigation had been increasingly difficult, though, for the bed of the river was silting up. James Bradley, the superintendent at Diglis, who died in 1912, remarked that it was possible to walk across the Severn at Worcester bridge before the locks were built. Elsewhere, bars and shoals brought traffic to a standstill in dry weather, as they did in May 1827 when 200 sailing vessels were held up below Upton, and in June 1839 when 120 vessels were aground on numerous shoals near Worcester.

The work of building the locks and weirs at Diglis and above took two years. Lincomb Lock and Weir were completed first in December 1843, Holt next in June 1844, and Bevere and Diglis works were finished simultaneously in October 1844. The work provided a minimum of 6 feet of water between Stourport and Worcester. On the lock island at Diglis there was a chapel (on the site of the workshops), built during the 1844 works, when it was thought necessary to cater for the spiritual needs of the navvies engaged there. The navvies were certainly a tough lot, among them the ex-pugilist champion Tom Sayers, and boxing was a favourite pastime. Old river men remembered the tales told of the battles that took place on the lawn in front of the worksheds whilst waiting for their pay. The spring tides still affect the water levels at Diglis Lock. In the great storm of August 1847 the water rose 18½ feet in five hours: it stopped the river current, backed up the water like a tide and forced Camp Lock gates to open themselves — something never known since.

Joseph Berwick and Timberdine

The manor house of Timberdine, a half-timbered building erected by the Mittons some 300 years ago, lies on the east side of the road, almost opposite the Ketch Inn. The building today is partially late-19th century, and has recently been restored and added to and converted into a restaurant.

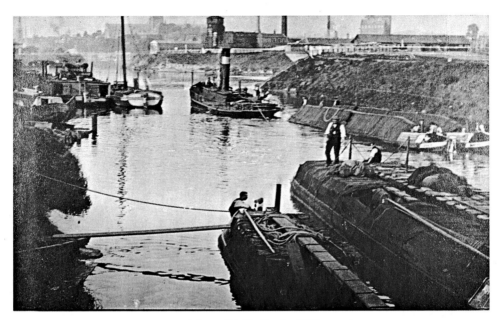

A busy Diglis Dock, 1890

This ancient priory manor had been a key position at the battle of Worcester, extending from Duck Brook as far as the Ketch Ford. Here Joseph Berwick, founder of the first Worcester bank, planned to build a residence and to convert all between the Tewkesbury Road to the Severn into a park, with a lake fed by Duck Brook and a waterfall for outlet. Below it, where the stream flows through a copse, he built a lovely ornamental stone bridge which became known as Berwick's Bridge. In *The Worcester Miscellany* (1831) Edwin Lees describes the area as 'covered with plantations' and known as 'Berwick's Shrubberies', its wooded walks greatly appreciated by the citizens of Worcester. In Victorian times the neighbourhood remained completely rural, a place of remarkable beauty; but Berwick's house — which was to have stood on the hill overlooking the pool and bridge, commanding noble views of the Severn Valley to the Malvern Hills — was never built. He stayed at Hallow Park and ended his days there.

The high ground of Timberdine overlooking the river has been known for many years as Bunn's Hill. It was at this point that Cromwell built his bridge of boats which contributed so largely to his victory over the Royalists in 1651; and it was under the cover of guns planted on the summit that his forces crossed and made their vital attack to break the Highlanders on the banks of the Teme at Powick.

The Ketch

The Ketch is a very ancient inn. Here Cromwell's troopers drank their ale, and

Samuel Butler, son of a Strensham farmer, wrote his long burlesque poem *Hudibras*. The name comes from a type of sailing vessel once common on the Severn. Edward Corbett knew the inn in mid-Victorian times and wrote of it: 'When public gardens were in fashion and every town had its 'Vauxhall' or 'Portobello', the gardens of the Ketch were laid out in elaborate imitation of the famous gardens with alcoves, fountains and dancing greens; and pleasure boats carried passengers from Worcester Bridge to the riverside gardens. The vogue was temporary, but before and after, the Ketch inn was a favourite summer resort of Worcester citizens . . . a stroll along the river . . . a dip in the river at Teme's Mouth, and then . . . a drink and a game of skittles in the Ketch alley. This was usually followed by a frugal supper of ham and eggs in the pleasant parlour, whose seated bay windows overlooked the long and lovely stretch of the river where Samuel Butler wrote poetry in his schoolboy days. The kitchen was spotless, and the company of the kindly hostess, Mrs Clarke, and her jovial son, Ned, who was brewer, ostler and tapster, completed evenings of delight.'

The transshipping dock at Diglis

For many years the dock at Diglis was regarded as a white elephant. It had been built with the intention of promoting trade by bringing seagoing ships to Worcester, part of the forward thinking of the energetic corporation of a century ago. But the Cardiff dock authorities who backed the scheme did so only until they managed to wring better terms from G W R and for many years only a few timber barges came through to Worcester. Then in the 1930s Diglis became a petrol station for the Midlands, and in the Second World War river transport boomed and a great variety of cargoes were carried. The dock built under an 1890 Improvement Act, was completed in 1894. The bed is of marl with the summer level of 11 feet of water in depth. It is 318 feet long by 115 feet broad, with an opening of 40 feet, above which was a swing bridge, later replaced by a permanent humpback bridge.

Pleasure steamers on the Severn

The great days of the pleasure steamers were from the 1880s to the 1920s when regular trips were run to Tewkesbury and to Holt and Stourport. There were other attractions beside the scenery, for the moment the steamer left its moorings the bar was open, well patronised by fishing clubs, works' outings and other thirsty travellers.

The first steam packet on the Severn was the *Sovereign*, launched in 1821 at Gloucester for passenger service to Worcester; but whether she ever arrived is doubtful for she blew up on her first voyage. Remarkably, she was a catamaran with twin hulls 5 feet apart, 80 feet long and 20½ feet wide.

In 1846 came the *Sabrina*, a paddle steamer, 90 feet by 14 feet beam, with two 12hp engines. Her arrival at Worcester bridge was announced by the firing of a cannon. Her owners claimed she could carry 300 passengers and was 'a formidable rival to the Birmingham & Gloucester Railway'! In 1854 the *Severn*, another paddle steamer, was built in London. She was 90 feet by 11 feet, could steam along at 10mph and carry 300 passengers.

For many years the most popular vessel on the Severn — and the largest —

was the *Perseverance*. She was launched in 1868 from Mr Stevens' yard, on the west bank of the river near the railway bridge. Originally a paddle boat and converted to screw later, she was 91 feet by 14 feet and propelled by two 10hp engines. She was very slow, and her progress could be detected across the Severn meadows by a cloud of smoke. Her last trip was in 1904, and she was finally broken up in the 1950s.

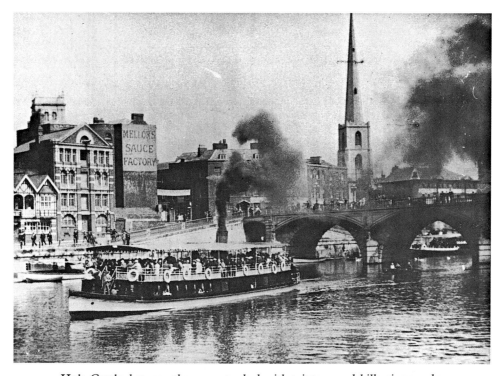

Holt Castle *between the wars, packed with trippers and billowing smoke*

Her rival was the *Lady Alwyn*, smaller, but faster and more modern. Built by Mr Everton in 1881, in a shed off Hylton Road opposite the tanyards, she always sailed with a list to one side. She was 61 feet by 11½ feet and was named after Lady Alwyn Compton, wife of the Dean of Worcester.

In 1910 Mrs Roberts owned the Castle Line of steamers, with offices on the south quay. The vessels were the *Holt Castle* with accommodation for 320 passengers, the largest on the Severn; the *Avonmoor Castle* which carried 300; and the much smaller *Hanley Castle* for up to 50 passengers.

The favourite of the trippers was the *Belle*, over one hundred years old and now back on the Thames. She has beautiful lines, in marked contrast to the converted tankers that now run as pleasure craft. She was brought round the coast from London in a remarkable voyage by J W Everton in 1896. Almost identical in style and age was the *Duchess of York*, owned by Mrs Huxter, and renamed *Duchess Doreen* after her baby daughter in 1928.

'River Steamer Runs Out of Coal'

Berrow's Worcester Journal of 23 June 1900 recorded a rather unusual river trip: 'A river picnic party made a journey from Tewkesbury last Saturday in record time. Not a record of haste by any means, but one of calm, slow deliberation. A pleasant trip downstream and the enjoyment of several hours' sunshine raised the spirits of the merry party to a high pitch. But the machinery aboard became lazy for the engineer could not light an effective fire. Coal had run short. By scraping the coal box, by using spent matches and trifles of that sort, a little blaze was produced, and a pressure of about 20 lbs was obtained when 60 lbs was wanted. Bye and bye, the engine stirred the screw, and the boat moved, but oh! so slowly. Soon the pressure went down to 10 lbs, and the boat's pace was reduced to the rate of a snail's crawl.

'Now came the urgent demand for paper and other combustibles. The picnic party provided an abundance of these, and enough energy was raised to take the steamer a little farther. Between Tewkesbury and Upton all the rubbish on board was consumed. The engineer consulted everybody; and the advice of every amateur aboard was exhausted. Nearly every man (and woman) had a turn at stoking; and now, when the machinery came to a full stop, they were sent spying out the land for bits of stick and coal. There was a terrible famine of both. Money would not command much either, but when the whole countryside had been ravaged, another start was made.

'There was no likelihood of hurry and some of the party suggested that they should wait a bit, then follow on foot and catch up the steamer. On the second and longer stage of the journey the engineer had plenty of amateur advice and lots of rubbish to eke out his scraps of coal. He used it sparingly lest it should be spent before the journey was complete, but he prodigally retailed instructions on engine driving to beguile the time of the party. And they in exchange sang glees to him. When they were tired of his department they went to the man at the wheel and took lessons in steering. This occupied more time, but there was a lot of it on hand.

'From Upton to Worcester took a matter of three hours, and the leisurely disposition of the engine allowed calls to be made here and there, and more searches for fuel. Everybody saw the humour of the situation, and even if the journey had lasted far into the Sabbath they would have been tempted to make mirth. Happily for them, they landed at midnight.'

Map 8

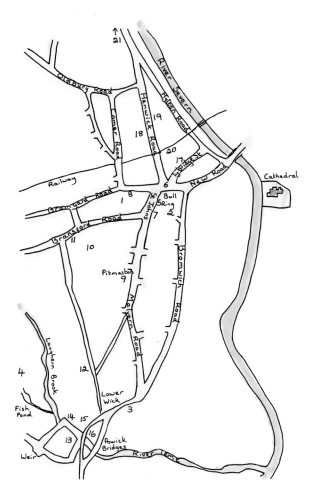

1 St John's
2 Hardwick Manor
3 St Cuthbert's
4 Wick Episcopi
5 St John's Fair and Mop
6 The Bull Ring
7 St John's Cinema
8 Charity School
9 Pitmaston
10 Boughton Gardens
11 Portobello Inn
12 Wick Fields
13 Powick mills
14 Powick forge
15 Power station
16 Two bridges
17 Tybridge Street
18 R A Orphanage
19 Holy Well
20 Happy Land
21 Dog and Duck

District Eight

West of the River

St John-in-Bewardine

A nciently, St John-in-Bewardine was quite a separate township, situated wholly in the county and customarily referred to as 'near Worcester'. The connection with Worcester dates only from 1837, the original encroachment by the city restricted to a small area centring around the church and ancient Bull Ring; but since then further annexations have carried the city boundary to Powick bridge and to Rushwick. Valentine Green, writing at the beginning of the 19th century, described St John's as a village of only one street, beginning at Rosemary Lane at the head of Cripplegate, and extending to the turnpike at the junction of the Ledbury (now Malvern) and the Bransford roads.

The approach from Worcester had always been somewhat inaccessible. For nearly five centuries a traveller would have had to wind his way from All Hallows, at the bottom of Broad Street, down Newport Street, and across the Severn by the ancient bridge which was obstructed for defence purposes by gates and barriers. Then came the built-up causeway of Tybridge Street across the flood meadows and the climb up the narrow and winding Cripplegate, leading to the bottom of the Bull Ring. It was only in 1781, with the new bridge and the 'New Road', that a direct route was opened from the centre of Worcester to St John's.

Originally St John-in-Bewardine comprised a much larger area, reaching from Shrawley Brook in the north to the Teme's mouth in the south, and approximately to the course of Laugherne Brook. Portions became independent parishes, and the present St John's parish is made up from the various remnants which failed to attain parish status. These remnants may be conveniently grouped as Hardwick, a central area adjacent to Worcester City, and extending to where Laugherne Brook crosses the main roads to Bromyard and Bransford; Wick, lying west of Hardwick, and running alongside the Teme from the Severn to Bransford Road; Lawern, including the Laugherne Valley north-east of Hardwick; and Clopton, situated in the north-west.

The origin of the word Bewardine has prompted a number to speculate, including Nash who argued in *Collections for the History of Worcestershire* (1781–2) that it arose from the fact that the area 'was allotted to supply the table of the monks with bread and provisions'. But the manor of Wick belonged to the bishop not the prior and the monks drew on other areas beyond the city including Barbourne, Powick and Tibberton. Both Ekwall in *The Concise Oxford Dictionary of English Place-names* and Mawer and Stenton in *The Place-Names of Worcestershire* point out that Bewardine comes from two

words — *Beda* (a person) and *worðign* (an enclosure) and thus means Beda's enclosure. In the 13th century there was an anchorage, or cell, at St John's, probably a small shelter in the churchyard or, like the one at St Nicholas in Worcester, a part of the church itself. The anchorage was formally sanctioned by Bishop Gifford in 1269, but apart from the woman's name, Juliana, little is known about her.

Hardwick Manor

The priory land developed into a manor — with tenants, courts, leets and barons, and other accustomed manorial rights — recognised as early as 1236 as separate from the bishop's manor of Wick; and under the name Hardwick still functioned in Victorian times. Primarily, it was a great dairy farm and the name of the manor was originally Herdwick, but in this part of the country 'herd' was always pronounced as 'hard'. At the Dissolution the manor passed to the dean and chapter of Worcester.

Wick Episcopi and Bishop Gifford

King Offa of Mercia, having subdued the land between the Teme Valley and the Severn, entrusted it to the church of Worcester. In the apportionment of these possessions between the see and the priory, Wick, the most valuable and comprising areas now known as Upper and Lower Wick, was reserved for the bishops. They kept it in demesne and built a manor house with garden, curtilage and two fish ponds, and a private chapel. In the 13th century it became the favourite retreat of the celebrated Bishop Gifford, perhaps the most feudal of the medieval bishops whose long and stormy episcopate made him many enemies.

The importance of Wick as an episcopal residence was diminished by the superior attractions of Hartlebury, but the manor was distinguished from other Worcestershire Wicks by the title 'Episcopi', and remained episcopal property until Tudor times, when it passed to the Crown. In 1586 it was granted by Queen Elizabeth to her Lord Chancellor, Sir Thomas Bromley, and in 1743 the Bromley family sold Wick Episcopi, which was divided between two county families, the Vernons of Hanbury and the Bunds who had bought Golden Wick a generation earlier.

St Cuthbert's and Lower Wick

In the farmyard of Lower Wick manor house, now Bennetts Dairies & Farms Ltd, are the remains of the church of St Cuthbert of Wick, an ancient building of red sandstone and some architectural merit but long used as a farm building (today, a stable). When Wick Episcopi was no longer used by the bishops the chapel of ease in St John's provided for the prior's servants became more convenient for the village which had grown up by Cripplegate. In 1371 Bishop William de Lynne held an enquiry at the request of the inhabitants and, finding St Cutherbert's half deserted and attended by very few, decided to make the chapel of ease the parish church of St John's. He ordered St Cuthbert's to be demolished but — for whatever reason — this was not done.

The east and west walls are probably those of the original Norman church as is the central section of the south wall; but there is plenty of evidence of much later rebuilding elsewhere. In the 16th century a timber-framed upper barn was built on top of the stone remains of the old church — perhaps to store fleeces at a time when Worcester was still an important wool centre. The building is said to have been used as a parish workhouse in the late 17th century, for a barn at Wick was frequently mentioned as a place where paupers died. In the 18th century it appears also temporarily to have housed Worcester prisoners when epidemics of gaol fever broke out, remains of an iron grille in one of the windows still evident. Around the turn of the 19th century St Cuthbert's was fitted with hop kilns and rented to the Smith family who were successful hop growers and merchants.

The manor house at Lower Wick dates from the 18th and 19th centuries, but remains of an extensive moat, or fish ponds, indicate that the site is of an earlier house. Wick passed from the Bromleys to Thomas Vernon of Hanbury in 1743, and that family retained it for more than a century and a half. The estate was broken up at the beginning of the present century. In 1918 Lower Wick Farm was bought by the Bennett family who abandoned hops in favour of soft fruit, storing vast quantities in the barn above St Cuthbert's. The housing explosion in the 1960s changed this area of hopyards and apple orchards into a housing estate. Today, the land behind the dairy offers not only a view of St Cuthbert's but a nature trail, a Civil War battle site and a farm park.

Upper, or Golden, Wick

For at least six centuries Upper Wick was known as Golden Wick. Under that name it became a separate manor, mentioned in records as early as the 12th century and as late as the 17th. The fertility of both Upper and Lower Wick had been notable since time immemorial — and perhaps that is the reason for the name 'Golden'. Golden Wick passed through a number of families and eventually to Thomas Bund whose family owned the seat for two centuries. The house at Upper Wick dates mainly from the turn of the 18th century when the Bunds took possession and still retains part of the older house with its ancient beams and fine old staircase, and long narrow pond on the south side, considered to be part of a moat. In later years two great hop gardens flourished at Upper and Lower Wick, both held for a considerable time by the Powell family.

Colonel Thomas Bund and J W Willis-Bund

A number of Bunds succeeded to the ownership of Wick Episcopi, the last member Thomas Bund in 1815. He was renowned as 'Colonel Bund of the County Militia', retiring in 1852 at the age of seventy-eight. He was a fervent Whig, presiding over the Brunswick Club, and strongly Protestant, taking an active part in the protest against the concessions to Catholics and against the Oxford Movement. Bund outlived an only son, who died childless, and the family property descended via his daughter to his grandson John William Willis, then a minor, but destined to become the most powerful man in the county's affairs during the late 19th and early 20th centuries.

Judge Walpole Willis, Thomas Bund's son-in-law, was a man of immense

energy and ability, but with little tact. He was a writer of legal textbooks, one of which, *Willis' Equity Pleadings*, became a standard authority. The Home Office wished to establish an equity court in Canada and sent out Willis; but on arrival he found that neither court, pleadings, nor judge were welcome.

Judge Willis' son, John, was born in 1864 and on attaining his majority assumed by licence the additional name Bund, pursuant to the will of his maternal grandfather, Colonel Thomas Bund. For many years he was the most powerful man in Worcestershire affairs and a historian of ability and great energy. He had a brilliant career at Cambridge and later became Professor in Constitutional Law at London University. For some time he practised at the Chancery Bar, and was the author of several legal books. For a great many years he was not only chairman of the county council and quarter sessions, but also of the Cardigan quarter sessions, the Worcestershire Fishery Board, the County Education and Licensing Committee and the County Highways and Bridges Department. His energy, knowledge and ability were at once the admiration and despair of his fellow members. But he was a giant among public workers.

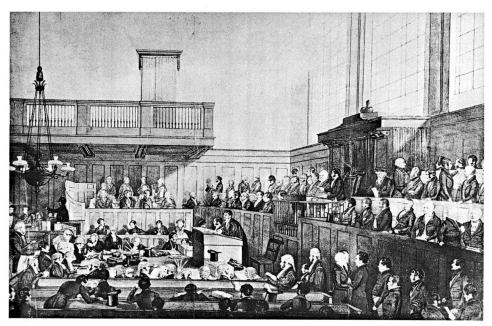

Worcester Quarter Sessions at Shirehall, from an 1845 print (artist unknown)

His historical publications and researches rank him with Habington and Nash. He was editor-in-chief of the Victoria County History, and made extensive contributions to it. It was typical of his drive that the Worcestershire VCH was one of the first to appear. *The Civil War in Worcestershire* and *Calendar of Quarter Session Papers* for the first half of the 17th century are works of great labour.

He inherited his father's authoritarian manner and personality, however, and many stories are told of his quarrels and outbursts in local affairs. He

clashed with teachers, publicly calling them 'whining mendicants' and in court he likened trippers to locusts devouring the countryside. As chairman of the bench and of the county council he was almost a law unto himself. He established himself in the Judge's Lodgings at the Shirehall and it took years of protest to get him out. On one occasion the military, who customarily assembled in the courtyard of the Shirehall when attending cathedral services, found the gates locked on them. They had omitted to ask permission and WB refused to have the gates unlocked. The military sent word that if the gates were not open in ten minutes they would remove them — which they did!

Yet for all his authoritarian manner and contempt for lesser men, he could show practical humanity as, for example, on the occasion when as chief magistrate he tried a woman for stealing goods from a shop. Asked what to do with some unclaimed articles, he told a clerk: 'Give them to the woman, I expect she needed them.'

Willis-Bund was of striking stature, stooping to become less tall, indifferent, almost shabby, in his dress, and with prominent side-whiskers. His way of life was almost Spartan: he walked wherever he could and travelled only 3rd class on the railway. He died in January 1928.

St John's Fair and the 'Pie Powder Court'

Prior to the extension of the boundary in 1837, the city had no jurisdiction over St John's; but as an act of neighbourly courtesy, and under a grant made in 1460 by the prior of Worcester as lord of the manor, the mayor and aldermen were permitted to attend St John's Fair, held on the Friday before Palm Sunday, and then to walk in procession through St John's, attended by the sword bearer, constables and other officers, and a band.

St John's Fair was held on the eve of the Worcester Fair and came to be known as 'Fetching the Fair'. The main street assumed the dignity of a township for the occasion and the ancient 'Pie Powder Court' (a corruption from *pieds poudreux* meaning 'dusty feet') was held at the Church House, now the Bell Inn, to settle disputes arising from the fair 'before the dust of the fair was off the feet of the litigants'. The last time the court sat in St John's was in 1814, though it was revived in this century as an 'historical scene' by Alderman Leicester when he was mayor.

St John's Mop

St John's Hiring Fair or Mop was held on St John's Green (the lower part of Bransford Road) and survived until the 1870s. Hiring fairs were very common but St John's and Hanbury's were the most notable in the county, the former mainly for domestic servants, the latter for farmhands. These annual events played an important part in rural life and helped to vary its monotony. Servants and farmhands gathered at the mop, women on one side of the road, men on the other, and most of them displaying some symbol to show their trade — the milkmaid with a tuft of cow's hair, the wagoner with a piece of whipcord. Farmers and wives would walk amongst them, trying to assess their accomplishments and qualities, looking them over as they would a horse. When all was settled it was usual to pay a shilling to bind the bargain, just as a man enlisted in the army by 'taking the Queen's shilling'. The shilling was a

part-payment of the hire, and all engagements made at the mop were probationary in the sense that they could be terminated without notice at the end of the first month. If either employer or employed proved unsatisfactory they parted without more ado and went to a second, or 'runaway' mop to try their luck again. This was not so popular an occasion, for the domestics who sought engagements were usually not the pick of their class.

The Bull Ring

From medieval times to the 19th century bull-baiting was an acceptable English pastime. John Noake quotes good authority for statements that at Worcester it was a recognised duty of the mayor to secure a sufficiency of bulls, and that butchers who killed unbaited ones were guilty of a punishable offence. When public opinion became outraged at this barbaric sport, butchers still believed the practice to be beneficial to the sale of their meat, rendering the carcass tender. Despite the outcry, bull-baiting continued on Pitchcroft, and not until a campaign was started to publish in the press the names of the butchers organising the baiting did it cease.

The Bull Ring at St John's was set aside for bull-baiting. It was a natural piazza and more level than now, for when New Road was made, part of the old roadway was raised to reduce the incline, shown by the steps to the houses on the south side of the Bull Ring. When the levels were changed the base of the post used for bull-baiting was discovered.

Horse-drawn trams in Worcester

On the north side of the Bull Ring was the old tramway depot. Tramways were very much a part of life in Worcester until 1928, and there was some regret at the passing of these rumbling, awkward vehicles from the street; but the motor car was taking over and the trams caused many obstructions.

The first Worcester tram was horse-drawn, starting in 1881 and covering a distance of 3½ miles on two routes: the first from the Portobello Inn, Bransford Road, to the Vine Inn, Ombersley Road; the second from the Cross to Shrub Hill Station. The company had six horse-drawn cars and employed nineteen men whose united earnings amounted to £15 per week. These buses were of an antiquated type, single-horse affairs, with no outside seats. There were no conductors, and the driver looked after the pence which was dropped through a slit in a box. The Tramway Trust Company sold out in 1889 and the City of Worcester Tramway Company, which took over the system, lasted only a short while before going into liquidation in 1892.

The most successful horse-drawn trams were those of Worcester Tramways which, in 1894, appointed R R Fairbairn as manager. He was a determined, energetic man who improved the financial position and later became Liberal MP for Worcester. He introduced two-horse vehicles with 'garden seats', and with conductors as well as drivers. A third horse was necessary to get the cars up the Bull Ring, and it is a comment on the conditions of work in those days that a lad of fourteen was employed to do the job, working from 7am until 11pm and paid 3s. 6d per week. (There was no cover and every quarter of an hour the horse pulled up the car and then went down to wait for the next.) The service was extended to Kempsey, Ombersley, Callow End and Powick

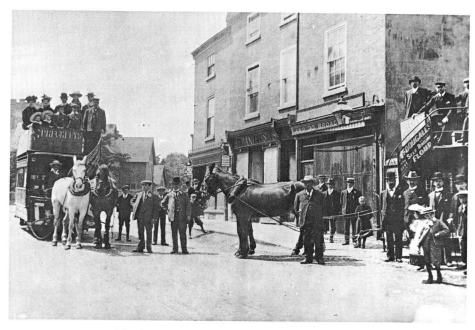

The last day of the horse trams, 25 June 1903

Asylum, the company paid a 5% dividend, staff wages were substantially increased and the hours of work reduced. In 1899, when the company ceased to operate, the town mileage was 4, the weekly mileage 1,900 and the number of passengers 10,000.

The Worcester Electric Tramway Company

At the beginning of the century there were moves to electrify the tram system in Worcester which gave rise to several years of stormy debate at council meetings. Eventually, permission was given to the newly formed Worcester Electric Tramway Company to go ahead with the new system which involved ripping up the old lines, laying down new ones, installing overhead power lines and extending the route to Bath Road, London Road and Rainbow Hill. The work of electrification was long remembered for the havoc caused to the city during the early months of 1904. The chief routes, centred on the Cross, were in confusion for months; and many a family album contains photographs with the caption 'The Worcester Electric Tramway Siege, 1904'. Horse trams ceased running in 1903.

The official opening of the new service took place on 6 February 1904, with services to Barbourne, Shrub Hill and St John's. Three new routes were constructed in the same year — to the cemetery via Rainbow Hill; from the Cross to London Road (in April); and from the High Street to Bath Road (in June); and in 1906 the St John's route was extended along Malvern Road to the Brunswick Arms. A terminal spur in St Swithin's Street to relieve congestion at the Cross completed the system. The total route and track mileages were

then 5.86 and 5.58 respectively. The horse tramways are believed to have been laid to the 3-feet gauge, but the electric system was built on the 3-feet-6-inch gauge. Approximately three fifths of the track was single and the sharpest curve was the one from the Cross into Broad Street which had a radius of 45 feet.

There was originally a uniform fare of 1d from the city centre to any terminus, but in 1920 this was increased to 1½d, except on the Shrub Hill and London Road routes where the old fare remained unaltered. Malvern Road also had 1d fare to St John's. The entire tramway system ceased operation at the end of May 1928 and the Midland Red Omnibus Company began its bus services on the following day. It is worthy of note that in their heyday the Worcester trams carried a yearly average of 3,000,000 passengers, an impressive figure for so small a system.

St John's Cinema

For over fifty years St John's Cinema was the focal point of family entertainment for those living west of the Severn. An old public house stood on the site until July 1914, when a cinema was built by the Godsall brothers, providing the new and popular film shows. It was to have been opened in great style, but Mr Goulding, the Worcester MP, failed to turn up. Nevertheless, there were members of the corporation present who saw '*The Oath*', and other dramatic films, marvelled at the clarity of the pictures despite a 'throw' of 80 feet, and stood to sing the national anthem. Tickets cost 3d, 6d and 1s. and in those days there was always a piano, sometimes accompanied by a small orchestra comprising two violins and a cello.

The cinema's greatest occasion came in 1929 when it secured the first talkie for the city. '*The Singing Fool*' starred Al Jolson, and the crowds were so great that they stretched down to the Bull Ring for the evening performances. After a fire in 1939 the cinema was taken over by the Odeon and finally closed in 1959.

St John's charity school

In 1719 Milberrow Doelittle founded a small school 'for the teaching of 12 poor children of the parish'. The income came from rents from a dwellinghouse and land in the parishes of Claines and St Swithun, and was to be put to the following charitable uses: '£5 yearly to be paid to the school dame, who should be one of the Church of England communion, and who should, in the school house lately erected, constantly employ herself at the usual school hours to instruct in reading, particularly the Bible, Common Prayer and the Church Catechism, 12 poor children above the age of four years, who should not continue at the school above five years; of such parishioners who do not receive weekly pay from the parish.'

Three years later, Milberrow's sister, Mercy Herbert, gave the income from property at Doddenham and Martley worth £250 to found a similar school for boys, so presumably the Doelittle charity catered only for girls, which was unusual in those days. The schools were united by indenture in 1749, but continued to use the two buildings first occupied in 1719. The dame occupied a small cottage, and her children were taught in the kitchen. The master used a small building adjoining his house.

In 1816 another floor was put in above the old schoolroom; the dilapidated cottages next door were taken down; and a house for the master was built. When completed the twelve boys were taught above and the twelve girls were taught below. In 1842 the old school closed, the buildings being used for parish purposes. A new boys' school was erected half-a-mile from the church in School Road, and a new school for infants and girls built near the church. The old charity school completely lost its identity in the new parish schools, but twelve boys and girls continued to receive their education free, with their books provided (except writing books), while other children paid 1d per week.

John Williams and Pitmaston

The high grey stone wall of Pitmaston House is a feature of Malvern Road. Today, Pitmaston is a teachers' centre and a public park, but not so long ago it was a noted private house outside the 'township of St John's', and famed throughout the horticultural world. It was built in the early 19th century by John Williams, a distinguished horticulturist and a man prominent in the affairs of both the city and county, serving as sheriff in 1823.

John Williams was a full-blooded, crusty old Tory of the 18th-century school, violently opposed to change and convinced that the Reform Bill of 1832 would lead to a reign of terror similar to that in Paris in 1793/4. As soon as the Bill became law he set workmen to build the high-walled frontage to the Pitmaston property to keep the newly-franchised ragtag and bobtail out. It was a topic of conversation for many years, and coachmen travelling to Malvern regularly related the story to box-seat passengers. Williams was not alone in his fear of a revolutionary uprising: there were others who had heavy shutters and similar defences fitted, and who lived in a state of anxious preparation against the Radical mobs that never came.

While politically very conservative John Williams was one of the most advanced horticulturists of the 19th century. He was known especially for his new varieties of fruit, many of which are still standard today and is best remembered for his *William* and *Pitmaston Duchess* pears. As a result of his experiments he was a contributor to the Royal Horticultural Society's journal on grapes, mulberries, peaches, nectarines and melons, as well as the more common fruit. But it was not only fruit that interested him. He was a great recorder of the weather, for example, and once, at a dinner given by the Highland Agricultural Society, he was toasted as 'the benefactor of his species — the man who gave to mankind the *Bruce* potato'.

Behind the forbidding walls the house is of the charming 'Strawberry Hill Gothic' style. Apart from the tower and the ice house, destroyed about 1945, the house remains intact with delicately moulded doorways, windows and conservatory. The walls of the fruit garden remained complete until the 1950s, still supporting many of John Williams' award-winning trees. After 1947 the gardens were used by Christopher Whitehead Boys' School and the peaches and nectarines were a sore temptation to the boys.

Richard Smith and the Worcester Pearmain

Richard Smith came to Worcester a little before 1820 and settled at Boughton as a nurseryman and jobbing gardener, and so began what was to become one of the largest nursery businesses in the world. He supervised many gardens at

the great houses, including Boughton Park next to his nurseries, the home of the bankers, the Isaacs — into whose household he eventually married. Smith's son, another Richard, succeeded in 1848 to the business, and possessed all his father's enterprise, establishing a seed business at the corner of the High Street and Broad Street which dealt with orders from all over the world. Amongst his other successes, he introduced the Worcester Pearmain apple to the public's notice, still one of the most popular varieties. It was found in the market garden of William Hales of Swan Pool, St John's, in 1872. He had two which were outstanding, one a yellow fruit, the other a coloured one. Richard Smith offered £10 for the exclusive right to remove the graft from the coloured one, called it Worcester Pearmain and marketed it in 1876 at one guinea for each maiden and 30s. for a two-year-old. It was many years before the price dropped to 5s.

The boom in horticulture in mid-Victorian times helped Richard Smith to accumulate a large fortune and to begin his climb up the social ladder. He bought Barbourne House and Park; found some remote family connection and changed his name to Smith-Carrington; married Patty Leader Williams, the daughter of the Severn engineer, a well-known lady in Worcester who brought him social status; and then bought an old property in Leicestershire, achieved an entry in *Burke's Peerage* and at an advanced age became sheriff in 1900. The typical progress of a Victorian exponent of self-help!

The nursery business was handed over to a third Richard Smith and survived until 1911. Today it is just a few acres in size compared to the vast layout of the Victorian business which in the 1880s amounted to 157 acres, with 18 miles of walks and a central drive of 2,300 yards, planted on either side with trees. There were two-and-a-half acres of glasshouses and a staff of over 200.

Boughton Gardens and the Portobello Inn

Boughton Gardens was the first garden suburb of Worcester, started in 1811 as a colony of small villas around a cul-de-sac approached from Bransford Road. The 'gardens' were built in Boughton Fields, but it took a generation to digest the scheme before a similar speculation was attempted nearer the city.

The Portobello Inn in Bransford Road became a favourite pleasure resort in the early 19th century, and remained so until the 1914—18 War. It was one of those inns, like the New Inn, Ombersley Road, which lay beyond the outskirts of the town but within strolling distance; and, like the Ketch, the Portobello had ornamental grounds. The name Portobello came from the Spanish naval base of Porto Bello in Panama which was captured by Admiral Vernon during the reign of George II in the 'War of Jenkins' Ear'.

At Boughton, John Gower 'built a fair house' which became the seat of his family for many generations. The Gowers lived there for two-and-a-half centuries, until they sold it in 1729 to Joseph Weston, Mayor of Worcester in 1720 and 1727. The Westons were merchants and held Boughton until 1778. Part of the estate was later bought by Elias Isaac, a partner in the Worcester Old Bank; and from the early 19th century the Isaacs of Boughton were amongst the most influential of Worcester's families.

Boughton cricket ground

In mid-Victorian days Boughton was closely identified with the beginnings of

Worcestershire county cricket. In 1865 the County Cricket Club was formed by Lord Lyttleton, supported by many local families including the Isaacs. A suitable field with a pavilion was made available by J S Isaac, and for many years it was the club's headquarters and ground, until the present ground in New Road afforded better prospects of gate money.

Before the move to New Road, and for some time after, county matches were of the picnic type, played all over Worcestershire; but the opening of the Boughton ground was an event which substantially enhanced local interest in the game. Here Dr W G Grace made his first appearance in the Midlands and, though only twenty years old, he was already the greatest cricketer in the country. The occasion was the meeting of the twenty-two of Worcestershire and the United South of England eleven. Victory was gained by the home team by 57 runs, fielding such noted players as the Honourable C G Lyttleton, H Foster, A B Martin, the Honourable G H Allsopp and E W Isaac. W G Grace also played at Boughton in 1870, this time for a Worcestershire eleven against the North of England. In 1878 the first Australian team's visit created great local excitement and Boughton went on being used by the county club until 1896.

The Worcestershire cricket team just before the First World War. The suited gentlemen are the changing room attendant and the club secretary

Mrs Sherwood

Mary Martha Butt was born at Stanford-on-Teme in 1775, the elder daughter of the Rector of Stanford. As Mrs Sherwood she became the favourite storyteller for children in the first half of the 19th century. In eight years at

Lower Wick she wrote eighty books, mainly stories for the young, which won her distinction as one of the most prolific and successful writers of her period and a place in the Dictionary of National Biography. Her works were translated into many languages, including Hindustani — and pirated in America; and her popularity was so great that the editions of her books filled thirteen pages of the British Library Catalogue. Especially notable was the story of the Fairchild family, upon which the majority of English middle-class children of the 19th century were brought up. Forty years after her death in 1891 her works were still being published.

Mrs Sherwood returned from India in 1816 with her husband, Captain Henry Sherwood, her five children and three adopted orphans and took a house in Malvern Road, Lower Wick, and to help keep her large family opened a boarding school. She had no training, but charged high fees (100 guineas) and perhaps because of this, in a snobbish age, had no difficulty in getting pupils. When her children grew up and her books became famous she gave up teaching.

As well as writing, she also found time to do good works and organised parties to read to the female glovers of Worcester who toiled from dawn to bedtime but could listen while they worked. In 1822 she took a leading part in founding the Worcester penitentiary in the building now known as Bishop's House in Lansdowne Crescent. Later in life Mrs Sherwood moved from Lower Wick to Britannia Square and then in 1849 to Twickenham. Not long before she died she wrote: 'My lines are placed in pleasant pastures, and old age steals on so gently that now in my 74th year, I can declare myself, with grateful heart, one of the happiest of old women that ever encumbered the earth.'

Wick Fields: the first battle of the Civil War

Just before the old road from Powick crosses the ancient narrow bridge over the River Teme, a lane led north to the Bransford Road, now Swinton Lane, but once called Cut-throat Lane. At the Powick end of the lane was Wick Fields, now a housing estate but until comparatively recently a place of hopyards and apple orchards. In 1642 Wick Fields — then just a large unenclosed grassy area — was to witness the first, and unexpected, clash in the Civil War, the battle of Powick Bridge.

Colonel Nathaniel Fiennes with a force of Parliamentary troops had been shadowing a convoy carrying gold and silver plate from the Oxford colleges which, at the suggestion of Bishop Prideaux of Worcester (who was also Vice-Chancellor of Oxford), was being sent to the king at Shrewsbury to raise an army. Sir John Byron, at the head of the convoy, had reached Worcester on 16 June, marched in, meeting no resistance, and was sheltering behind the defences of the city. But his position was precarious and Charles I ordered Prince Rupert to make for Worcester and escort the convoy. Fiennes, having persuaded Essex, commanding the Parliamentary army, to allow him to make a dash from Alcester to Worcester to try to capture Byron and the convoy, arrived at the city on 22 September, tried to surprise Byron at the Sidbury Gate and, failing rather miserably, assembled his forces at Worcester to cut off the convoy's road west across the river. All of which was very interesting to the citizens, crowds walking out to Powick 'to see the soldiers'. Prince Rupert meanwhile arrived in St John's on 23 September, sent a detachment of his

troops into the city to help Byron and then with the rest marched up into Bransford Road and turned down Swinton Lane into Wick Fields. There they rested in the shade on that hot afternoon without even setting a sentry.

Neither side knew of the other's whereabouts. Receiving information that the convoy had started from Worcester, Fiennes marshalled his men on Powick Ham, sang a psalm and set off for Worcester. They crossed the narrow bridge and almost immediately stumbled on Rupert's force in Wick Fields. Both sides were astonished, but Fiennes was on the move and should have had the advantage. He was a poor leader, however, and it was the cavaliers who mounted their horses and charged wildly. With the narrow bridge behind him, Fiennes could not form up to meet the attack.

It was a short fight, probably no more than a quarter of an hour, but it was fierce while it lasted. More than fifty Parliamentary troopers were killed or drowned in the Teme, and the rest retired in panic and disorder towards Upton. All the Royalist officers were wounded except Rupert, and they did not bother to record the casualties in the lower ranks. The next day Essex reached Worcester in angry mood, and though the city surrendered without resistance he did not spare it. Gallows were set up in the Cornmarket, the mayor was humiliated and sent to London as a prisoner. The cathedral was turned into a stable and the church treasures pillaged. It was the first of a series of disasters which, in a period of ten years, left the city almost wrecked and impoverished.

The battle of Powick Bridge was the first skirmish of the Civil War and, though on a small scale, was of great importance, for had it ended in a Parliamentary victory it would have led to the capture of the gold and silver plate and the king's cause would not have got started for want of money. It also led to the belief that Rupert was unbeatable and to the Royalist delusion that a cavalry charge was enough to win a battle — an idea that proved disastrous at Edgehill, Marston Moor and Naseby.

Powick mills and forge

The immediate area around old Powick bridge is one of the most historic sites in the whole of Worcestershire. Not only did the first and last battles of the Civil War start here, but from medieval times it has also been an important industrial site. Two mills were recorded here in the Domesday Survey of 1086. One was for the use of the hall, but by 1291 both were held by the Prior of Malvern. The prior cut the mill-leat from the Teme weir to Wyke Mills at that date and, it is said, diverted Laugherne Brook, which then flowed into the Teme below the bridge, to supplement the water above the mill.

The water power at Powick was used for iron working from the 16th century and continued into the early 19th. An advertisement of 1771 described the forge as having three fineries and a slitting mill, with a corn mill, a dressing mill, storehouses for coal and charcoal, a manager's house and lesser tenements for the workers. Some twenty years earlier the Birmingham ironmaster, Sampson Lloyd II, had bought the forge and was producing around 150 tons of bar iron for the nailers in the north of the county. As long as water was the only source of power available Powick ironworks prospered, but with the growth of steam power, which required an abundance of coal, the works declined.

The buildings were used for three mills which, with the corn mill on the city

side, made four, with seven waterwheels in a row. From east to west there were: Hadley's Corn Mill, Chamberlain's China Clay Mill, a clover dressing mill and a malt dressing mill. These stood until the building of the electric power station, the last of the mill buildings pulled down after the severe floods of 1924 when the water courses were filled in. The manager's house and workers' tenements remained until 1967.

Powick electric power station

The City of Worcester was the first municipality in Britain to build and operate on a long-term basis its own hydroelectric power station. This, moreover, was with a water-generated power up to about 400 kW, by far the largest hydroelectric power station built in Britain in the 19th century for public supply.

In the early 1890s Worcester had a very dynamic and far-seeing corporation. Nowhere in Britain had electric lighting been used on a major scale, and the council decided to lead the way. Tenders were invited for an electric light scheme of an estimated demand equivalent to 14,000 − 10 candle-power lamps. It was expected that £15,000 would meet the cost, but this proved to be a gross underestimate.

Mr G E Preece, the GPO's chief electrician, was called in as consulting engineer. He estimated an expenditure of £40,000 and suggested that the water power from Diglis Weir be used; but the Severn Commissioners placed obstacles in the way, and so it was decided to go to Powick. In 1893 the council purchased Powick Mills from Willis-Bund for £5,000 and entered into an agreement with the Brush Electrical Engineering Company to supply at a cost of £21,005 a combined steam and water-power plant, using alternating power, with street lighting additions of £19,970. The station began supplying current in November 1894.

In 1895 output by water and steam was 340,000 units; in 1900 this rose to 840,000. There were twenty-seven arc lamps in the six central streets, and current was supplied at 5d per unit for lighting to Worcester consumers who, by 1900, numbered 502. In November 1902 a second generating station was built in Hylton Road, at a cost of £7,180, to supply current to the electric tramway system which began operating in 1904.

The steam plant at Powick Station was closed down in the late 1920s and that part of the building was taken over by the Metropole Laundry. The hydroelectric part continued in operation until 1950 when the turbines and generating machinery were removed.

The two bridges

Old Powick bridge is thought to have been built in the early 15th century. It was certainly standing in 1550. It is divided into two parts: the eastern with two arches over the mill stream, and the western with three arches over the River Teme. The bridge featured in two Civil War battles: it was the scene of Prince Rupert's attack in 1642 and at the battle of Worcester in 1651 its two arches on the Worcester side were broken down to bar the way into the city. Montgomery's Highlanders ranged the eastern bank in force and held off the fierce attacks of the Parliamentarians until Lambert's forces crossed the river

lower down on the bridge of boats and the Royalists were compelled to retire to save the retreat. The two arches were probably rebuilt at the end of the 17th century, though the state of the bridge was often dangerous. Its upkeep was divided, the eastern part the responsibility of Lower Wick Manor, the western the responsibility of the lord of the manor of Powick, Lord Coventry.

The 'new' bridge is a fine turnpike bridge, built in 1837 to the design of William Capper of Birmingham. It was constructed of cast iron, with sandstone arches and abutments in the Gothic style to match the ancient bridge 100 yards upstream. Built for stagecoaches, it currently carries the main-road traffic to Malvern.

Tybridge Street

For centuries the street called Tybridge Street was the principal entrance into mid-Wales and consequently the scene of many bloody affrays with the Welsh and other medieval armies needing to use the strategic crossing over the Severn. In 1651 a fierce delaying action was fought here by the Royalist forces. Although it is one continuous street it was formerly known by two names, Cripplegate and Turkey; but the present single name, conferred in comparatively recent times, is itself of ancient origin, first recorded in 1254 as the name for that part of the street that eventually came to be known as Turkey.

Centuries ago there was a long-established colony of Welshman in the western suburbs around the bridgehead – possibly because no person born in Wales or of Welsh parents could purchase land or property within the city. As late as 1766 a letter revealed that 'one part of the town is inhabited by Welsh people, who speak their own language'.

Tybridge Street was a particularly busy one. Nails and tobacco pipes were manufactured; and there were rope walks where the ropes used by the bowhauliers on the Severn were made. At the bridgehead on the south side was Williams' Distillery which from 1750 made spirits – their gin was said to be unsurpassed in England. The Old Rectifying House on the other side of the river belonged to this firm. Like all dock areas it contained many pubs and squalid houses. On the corner with Hylton Road was the Bear Inn, a house belonging to the parish and used for adjourned vestry meetings and drinking bouts. All around were crowded courts of hovels, the most notorious and insanitary known as the Pinch where the first case of cholera appeared in the 1832 epidemic.

'Cold Comfort' and 'Happy Land'

In the mid-19th centry popular names had a habit of sticking. 'Cold Comfort' was the name given to a group of cottages in Church Walk (later School Walk) off Tybridge Street, a nickname thought to have been due to poor soil or the absence of amenities. The most interesting of the popular names is 'Happy Land'. In the 1850s an enterprising Worcester family, the three Watkins brothers – a solicitor, a surveyor and an auctioneer – secured for building purposes land fronting the Bromyard Road, which was first exploited as a sand and gravel pit. It proved so profitable that it was popularly compared with the then newly-discovered gold deposits in California and in fact called California

by the people of the area. Subsequently, this was changed to 'Happy Land', suggested, according to tradition, by the old doggerel:

> Gornal is a happy land,
> Breaking stones and wheeling sand,
> Far, far away.

The name stuck and the brothers built an estate on the site. When the streets were named they were called 'Happy Land North', 'Happy Land West' and so on; and when the land was covered with houses and the inevitable corner pub its name commemorated the origin of the colony — the Sand-pits Inn.

The Royal Albert Orphanage

A relic of Victorian philanthropy exists in Henwick Road. Now used as a YMCA hostel, it was formerly the Royal Albert Orphanage. The building was large and costly, designed by William Watkins, a native of Rushock, near Droitwich, and erected in 1869 for thirty-eight boys and thirty-eight girls. Though institutional inside, it is one of the best Victorian buildings in Worcester, the front a delightful essay of Venetian Gothic in brick. The orphanage was established by means of a donation from Mr J Wheeley and in 1862 occupied a house in St John's; but, later, Richard Padmore gave £4000 to erect the present building.

The Holy Well and Comer Gardens

The Holy Well at Henwick was an exceptionally fine spring which in medieval times had been piped to the cathedral and which the prior had used in the baths he had erected for the monks on Holywell Hill (in return for the transference of St John's tolls to the Worcester bailiff in 1461). The water was credited with possessing curative properties for the eyes, and was extensively used for that purpose. The lead pipes which conveyed the water to the cathedral were pulled up by the Parliamentary troops during the siege of Worcester and used for bullets.

Later, a celebrated porter brewery in Hylton Road began using the water and acquired a great reputation in the Midlands; but the brewery was destroyed by fire in 1791. The water was regarded as the purest in Worcester and sold at ½d a can; yet, despite its fame, the well was despoiled in the 1870s and bricked up.

Comer Gardens, built in the 1850s, was once an isolated 'garden village' of detached houses on both sides of a lane, well set back with long gardens in front. The lane was a mere unlit track, without water mains or sewers, but its trees and shrubs, mainly golden chain, were very beautiful. The village was the outcome of the second cholera epidemic of 1848 and became the dormitory home of a colony of Worcester tradesmen.

The Porto Bello Gardens and the Dog and Duck

On the high ground overlooking the Severn in Henwick Road, just north of the Dog and Duck Ferry, were the Porto Bello Gardens, pleasure gardens open to

the public. There was a fine view from the 18th-century house to the cathedral, and it was a very popular place with the young bloods of the city. In Regency days the gardens were famous and an enthusiastic writer of the time described them as superior to the London tea gardens. Sadly, they were closed in the 1850s because of maliciously spread 'rumours of evil reports'.

The Dog and Duck, opposite Pitchcroft on the other side of the river, was once a well known watermen's inn and ferry. It took its name from the 'sport', then popular among watermen, which involved the catching of ducks by dogs. After the tendons of their wings were cut to prevent them flying the ducks were taken out into the middle of the river and the dogs were loosed from the bank. The 'sport' provided the usual opportunities for betting; but some time before the 1850s it disappeared, perhaps due to the pressure from churchmen who had taken an interest in the watermen.

The site, both beautiful and interesting, was a Severnside wharfing, and its donkey path still remains. The ferry, one of the most used in the city, was well placed to serve the Martley area, and goods, especially bricks and coal, came downstream and were carried in panniers on the backs of donkeys up to the main road.

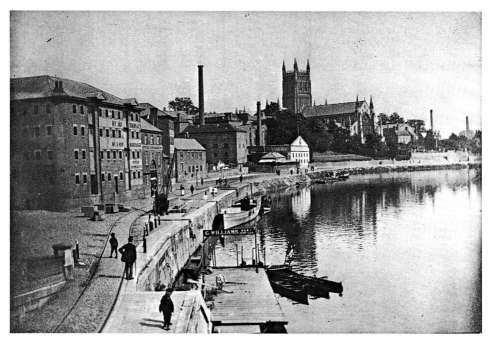

South Quay, River Severn, around the turn of the century

The Severn: storms, floods and periwinkles

The River Severn which separates St John's from the rest of Worcester has played a crucial part in the beginnings and development of the city. Its tidal bore enabled Worcester to flourish as an inland port and up until 150 years ago

this great waterway — once known as 'The King's high stream of Severn' — was alive with commercial traffic. Only the coming of the railway ended the city's dependency for prosperity on the river. But the Severn always has been, and always will be, a force to be reckoned with for Worcester people — to admire and enjoy, and from time to time to fear.

In the first half of the 19th century two great storms caused the Severn to rise at what must have been a frighteningly phenomenal speed. The 1847 storm which caused an alarmingly rapid rise in Diglis Dock has already been mentioned. The hailstorm of 1811 was of a ferocity scarcely known in this country: hailstones, according to the 19th-century historian Turberville, 5—6 inches in diameter, the windows in almost every south-east facing house smashed, gardens laid to waste. All this was succeeded by tropical rain and the Severn rose 25 feet above normal level, sweeping away whole herds of cattle. Vast numbers of birds were found dead and thecity's glass replacement bill amounted to some £5,000.

An unusual storm took place at Henwick in 1881 and was recalled by Mrs Millward of Bromyard Road:

> I was 8 or 9 at the time. There was an awful storm. When we left school in the afternoon, as soon as we heard what had happened, we ran there and picked up shellfish, putting them in our pinafores. They were alive and sodden with water, making our clean pinafores wet and dirty. Mother said they were snails. There was much talk about it at the time. They were chiefly on the Oldbury Road. They were all over the road, the banks were full of them, and they extended over the hedges into the gardens. They began about where Laugherne Road is now, continuing along Oldbury Road to Comer Gardens corner. It was a sight! There seemed to be tons of them.

The greatest flood of all is considered to have occurred in May 1866 when the water almost reached the crown of the arches of Worcester bridge. In the parish of St Clement's alone it was estimated that no fewer than 250 houses were flooded. This century has seen two particularly disastrous floods. The flood of June 1924 destroyed the Three Counties Show on Pitchcroft, and prize cattle and exhibits had to be rescued from one of the fastest rising water levels known. The flood of 1947 — still remembered — cut off all road communication to St John's and a free rail service was run from Foregate Street Station to Henwick. Twenty buckets of lamperns were picked up at the coal tips at the power station in Hylton Road and sold for 6/9d per gross, or two-a-penny.

References

The following key has been used:

B — *Berrow's Worcester Journal*; GwTh — H W Gwilliam, *The Provision of Education for the Poor in the City of Worcester during the 18th and 19th Centuries* (University of Birmingham thesis, 1966); H — *Worcester Herald*; K — *Kidderminsteriana*, the Palfrey Collection; KS — *Kidderminster Shuttle*; NoNQ — John Noake, *Notes and Queries for Worcestershire* (1856); Stroller — Edward F Corbett's series of articles in the *Worcester Herald* and *Berrow's Worcester Journal* (1924—32); TWAS — *Transactions of the Worcestershire Archaeological Society*; W — *Worcesteriana*, the Palfrey Collection; WEN — *Worcester Evening News*; WME — W Moore Ede, *The Cathedral Church of Christ and the Blessed Virgin Mary of Worcester: Its Monuments and Their Stories* (1925); WPL — Worcester Public Library; WRO — Hereford and Worcester County Record Office, St Helens.

Kidderminsteriana and *Worcesteriana* are part of the Palfrey Collection of newspaper cuttings in the WRO. Most of the cuttings are dated, but give no indication of the newspaper from which they have come. The reference W5 17.5.1905 therefore is an abbreviation for *Worcesteriana* Vol 5 and the date of issue.

1 The cathedral and Sidbury

Page

1　Beginnings of Worcester — H 4.8.1906

2　Early cathedrals — C C Dyer, 'The Saxon Cathedrals of Worcester', TWAS, 1968—9, p 34; R D H Gem, 'Bishop Wulfstan II and the Romanesque Cathedral Church of Worcester', *Medieval Art and Architecture at Worcester Cathedral*, BAA Conference Transactions (1975); B 21.7.1900, 15.4.1905

2　Sancturary — J Noake, *The Monastery and Cathedral of Worcester* (1866), pp 97, 401

3　Cathedral and city — H 17.6.1911

4　Shrines of Oswald and Wulstan — WME, pp 7—10, 20—4

5　Dissolution of priory — Noake, *Monastary and Cathedral*, pp 208—235

5　Royal tombs — WME, pp 37—8, 76—80; H 7.11.1914

7　Cathedral library — Noake, *Monastary and Cathedral*, pp 406—455; B 19.1.1901

8　Edgar Tower — J M Wilson, *The Figures on the Outer Face of the Edgar Tower, Worcester* (1912); B 27.7.1912, 3.8.1912, 21.8.1912

8　Old Palace — W2 8.3.1906

9　Guesten Hall — WPL 4238/42; W6 6.4.1912; H 27.8.1910

9　Cathedral charnel house — J Noake, *Worcester in Olden Times* (1849), p 97

10　'Cathedral Bell Stolen!' — *The Ringing World*, May, 1863

10　Old and new St Michael's — NoNQ, p 3

11　Great Victorian preacher — B 2.6.1900, 28.7.1906, 15.10.1904; H 29.4.1911, 2.12.1911

12　Water Gate and ferry — Stroller, 'St Peter's Parish'

13　Three Choirs and George III — WME, pp 265—7; H 23.9.1911, 31.1.1920

14　'Black' festival — H 18.7.1914

14　Lord Somers — Rev F E Hutchinson, B 9.1.1943

15　County prison — B 5.1.1832; H 21.1.1911

17　St Peter's parish workhouse — NoNQ, pp 41—2

17　Commandery — W2 19.3.1910

18　Cameron family — H 18.9.1920

19　Bishop Gore — H 21.10.1911

20　Old Talbot — H 1.7.1911, 27.1.1912, 4.1.1913

20　Mrs Henry Wood — W7; B 22.2.1919

2 West of the High Street

23　City walls and gates — J W Willis-Bund, 'The City of Worcester during the Civil War 1642—46', *Assoc. Arch. Reports*, xviii, part 2; John Leland, *The Itinerary of*

John Leland, ed. L Toulmin-Smith (1908)
24 Growth of the city — H 29.3.1902
26 Changes in the city boundaries — *Worcester Daily Times*, 7.10.1905
27 Old corporation — H 16.3.1912, 21.4.1912
27 Municipal privileges — B 12.11.1910
28 Guildhall — N Pevsner, *The Buildings of England: Worcestershire* (1968), p 323;
 W53 4.9.1937, 11.9.37
29 Guildhall restoration — W3 7.6.1913
30 Oak Apple Day — H 7.6.1913
30 Mayors and municipal uniforms — H 25.10.1902, 30.11.1912, 21.3.1914;
 B 31.3.1904
32 Mayor's chaplain — B 12.11.1910
32 St Helen's church — B 15.4.1905; H A Leicester, *Forgotten Worcester* (1930),
 pp 55–6
33 King's Head Theatre — H 21.2.1912
34 Elgars — B 5.5.1906, 1.10.1904, 16.3.1912
35 Austin family — H 28.1.1905; B 16.3.1912
35 St Andrew's parish — H 19.2.1910, 26.2.1910, 5.3.1910
36 St Andrew's spire — NoNQ, p 46; *The Builder*, 4.6.1870; WPL M4.599; *Stanley's
 Guide to Worcester (1852)*
37 Beating the bounds — W6 27.5.1911, 18.5.1912
37 St Alban's church — B 2.11.1918
37 Warmstry Mansion — *Stanley's Guide to Worcester*, p 138
38 ·Market hall — H 1.2.1852; W80 25.5.1955
39 Social life at the inns — B 25.3.1911; H 21.12.1912, 20.2.1915
39 John Oswen — W15
42 Pretty Peggy Cocks — H 15.5.1909
42 Arthur Cocks — champion — *Ibid*
42 County banks — B 23.12.1905; H 29.9.1917
44 Failure of Farley's bank — H 20.11.1909
44 Fishmongers' Hall — W1 26.1.1907
46 Memorable election — T C Turberville, *Worcestershire in the 19th Century* (1852),
 p 29
47 Model Dwellings — *The Builder*, 27.8.1864, 1.8.1874; WRO5589:134
48 Wherry Inn — H 10.12.1910, 19.8.1911
53 Webb's Horsehair Carpet Factory — *Worcester Echo*, 30.1.1905; W4 6.9.1913
53 Webb's Factory School — GwTh (in WPL and WRO)
54 Edward Webb — Stroller, 'St John's'
54 Dispensary — W12 29.3.1919
56 Bell Inn — B13.1.1912; H 21.12.1912
58 Worcester glee clubs — W21 21.3.1925; H 26.3.1927
58 Worcester Sauce — B 9.12.1939
59 'The Synagogue' (and Edwin Lees) — Mary Munslow Jones, *The Lookers-Out of
 Worcestershire* (1980), pp 31–2
59 All Saints church and Merryvale — NoNQ, p 60
61 Cheatle's Petticoat Charity — B 5.11.1904; H 1.11.1911

3 West of the Foregate

63 St Nicholas church — Pevsner, *Worcestershire*, p 320
64 Frances Ridley Havergal — K7; K21; KS 5.12.1936, 19.12.1936; Janet Grierson,
 Frances Ridley Havergal: Worcestershire Hymnwriter (1979), p 172
65 Bank on the Cross — WI 23.12.1905; H 15.2.1913, 29.9.1917
65 'Charlies' — H 3.7.1915; W3 29.6.1912
65 Worcester Fair — H 16.7.1910, 23.9.1905
66 Berkeley Hospital — H 16.5.1914
67 Hop Pole Inn — B 26.1.1901, 13.3.1926
67 Nelson at Worcester — H 6.11.1909
69 Foregate Street houses — H 11.12.1909

70 Worcestershire Natural History Society — Jones, *Lookers-Out*
71 Empire Music Hall — W56 11.3.1939
72 Athenaeum — B 24.4.1897
72 Shirehall — Brotherton Papers, Guildhall Archives, WRO
73 Corn Exchange — W12 12.4.1919
73 Theatre Royal — H 3.8.1912; B 27.7.1912
75 Old Sheepmarket — Pat Hughes (ed.), *Worcester Streets: Blackfriars* (1986)
76 Blackfriars — *Ibid*
77 Early Sunday Schools — GwTh (in WPL and WRO)
78 Butts and the Cold Bath — H 17.4.1802, 12.4.1902
78 Worcester Infirmary — H 15.8.1914, 22.8.1914; Joan Lane, *Worcester Infirmary in the Eighteenth Century* (1993)
78 Sir Charles Hastings — William H McMenemey, *The Life and Times of Sir Charles Hastings* (1959)
79 Old Worcester bridge — B 24.2.1912, 10.1.1925; David Whitehead, 'John Gwynne R A and the Building of Worcester Bridge 1760–86', TWAS, Vol 8, 3rd Series, 1982
82 Old St Clement's church — W23 5.12.1925
83 Watermen's Church — W7, p 157, 6.2.1915
85 Pitchcroft — W56 29.4.1939, 6.5.1939; W20 7.4.1924
86 Isaac Gordon — B 10.3.1900; H 29.3.1913
86 County gaol — W15 14.2.1922; H 6.3.1926

4 East of the High Street

89 Friar Street and the Greyfriars — Rev W R Buchanan Dunlop, TWAS, 1947; A R Martin, *Franciscan Architecture in England* (1937); Pat Hughes and Nicholas Molyneux, *Worcester Streets: Friar Street* (1984); H 21.1.1911; H 17.2.1912
91 City goal — Hughes and Molyneux, *Friar Street*; H 21.1.1911; B 27.5.1911, 27.7.1912
92 William Laslett — H 21.1.1911; B27.7.1912
92 Tudor House — Hughes and Molyneux, *Friar Street*
93 Wyatt's Hospital — B 5.11.1904
93 Hannah Snell — H 16.9.1911, 6.9.1924
94 Blockhouse — Hughes and Molyneux, *Friar Street*
97 John Wesley — J Noake, *Worcester Sects* (1861), p 313
97 St Andrew's Wesleyan church — *Ibid* p 338; WEN 8.1.1968; W7 25.10.1913
98 Alderman John Nash — H 4.1.1913; WEN 13.2.1937; Hughes and Molyneux, *Friar Street*
102 Williamson's Providence Works — B 6.4.1918; *Metal Box News* (1975)
104 Drama of the Corn Exchange — W 12.4.1919
104 Public Hall — H 29.4.1905; B 26.1.1911; W56 (May, 1939)
106 Old St Martin's church — H 10.10.1909; J Chambers, *A General History of Worcester* (1820), pp 255–8; J Noake, *The Rambler in Worcestershire* (1849), pp 68–9
107 St Swithun's church — H 26.3.1910; 'The Threatened Worcester Churches', TWAS, Vol XIV, New Series, 1937, pp 82–5
107 Some early schools — GwTh (in WPL and WRO); B 24.12.1912
109 Early post office — H 5.11.1910, 10.5.1913; W55 19.11.1938
109 Queen Elizabeth's House — B 7.9.1895; W56 15.4.1939
110 Trinity Hall — Stroller, 'St Martin's'; B 26.5.1906
111 Working Men's Institute — H 6.6.1914; Stroller, 'St Martin's'
112 Worcester Co-operative Society — H 31.12.1910; Charles A W Saxton, *The Origin and Progress of the Worcester Co-operative Society Limited 1881–1931* (1930)
113 Silver Street Baptist church — CAB 13 Box 23, Worcester St Martin's, WRO; E Berry, *History of the Baptist Church, Worcester* (1914)
113 School over the saw-pit — GwTh (in WPL and WRO)
113 John Martin, bellfounder — NoNQ, p 17
114 Quaker Meeting House — Memorandum of Worcester City Quarter Sessions,

WRO, BA 1204/1 Ref 898.2; J Besse, *A Collection of the Sufferings of the People called Quakers* Vol 11 (1753), p 60; J Punshon, *Portrait in Grey*, Quaker Home Service (1984), pp 67, 224; Richard Baxter, *Reliquiae Baxterianae* (1696), p 77; W Urwick, *Nonconformity in Worcester* (1897), pp 180–1; Noake, *Worcester Sects*, p 248; Turberville, *Worcestershire*, p 258

115 Sansome Fields — C Hebb, *An Account of the Public Charities in the City of Worcester* (1842), WPL W361.8
116 Arboretum Gardens — *The Builder*, 26.6.1869
117 Matthew Pierpoint — H 5.3.1913; B 6.7.1913
118 Pierpoint Street libraries — WEN 22.2.1960
119 Thomas Brock — H 25.5.1911; W16 26.8.1922
119 B W Leader — 24.3.1923
120 Cutting of the canal — B 31.3.1906; 19.4.1919
122 Vinegar works — H 9.10.1909
123 Lowesmoor music halls — WEN 27.2.1970
124 Vesta Tilley — B 6.9.1932
125 Salvation Army — H 19.4.1919; WEN 2.1.1968

5 The Tything and beyond

127 Parish of Claines — Stroller, 'Claines'
127 Tything of Whistones — W2 1.5.1909
128 Three black pears — City of Worcester leaflet on the Coat of Arms
128 St Oswald's Hospital — H 1.5.1909
130 Worcester Royal Grammar School — F V Follett, *A History of Worcester Royal Grammar School* (1951); Alan D Dyer, *The City of Worcester in the Sixteenth Century* (1973), pp 244–8
130 Britannia House — W1 25.10.1908
131 Britannia Square and Dr Hebb — H 11.11.1911
132 White Ladies — H 5.4.1902; B 14.5.1910
134 Pitchcroft and its associations — H 9.9.1911; W20 17.4.1924, 31.5.1924
135 H H Martyn — B 28.7.1917
135 McNaught's Carriage Works — W12 27.4.1918
136 H H Lines — H 17.1.1914
137 Saracen's Head — *Worcester Chronicle*, 28.6.1848
138 Charles Bedford — Stroller, 'Claines'
138 Three Barbourne houses — B 29.10.1904; H 9.10.1909; B 15.9.1917, 24.11.1917
139 Thomas Chalk — H 16.7.1910
139 St George's chapel of ease — W9 25.1.1919
140 School in the cowshed — GwTh (in WPL and WRO)
141 Barbourne Brook and Gregory's Mill — *Worcs. Arch. Newsletter*, xxiii, 1981–2
141 Barbourne Lodge — Stroller, 'Claines'
142 Barbourne Park — Stroller, 'Claines'
142 Barbourne Gate and Pope Iron — *Worcs. Arch. Newsletter*, xxiii, 1981–2
143 Old waterworks — Brotherton Papers, Guildhall Archives, WRO
143 Kepax Ferry — H W Gwilliam, *Severn Ferries and Fords in Worcestershire* (1982)
144 Blanquets — Stroller, 'Claines'
144 Northwick Manor — Stroller, 'Claines'
145 Perdiswell torc — H 1.2.1913

6 East of the canal

147 Roger's Hill — Stroller, 'St Martin's'
147 Rainbow Hill — H 20.11.1909, 6.7.1912, 21.3.1914
148 Marl Bank and the 'Great Siege' — J W Willis-Bund, *The Civil War in Worcestershire* (1905), pp 180–95; B 1.10.1904; WEN 13.10.1967
149 Railway comes to Worcester — H 11.12.1909, 11.6.1910, 21.8.1909; Turberville, *Worcestershire*, pp 150–164
150 A C Sherriff — H 11.11.1911; Stroller, 'St Martin's'; H 10.10.1914
151 Railway Institute — H 11.11.1911

152 Worcester Engineering Works — *The Builder*, 23.2.1867, 13.4.1867; H W Gwilliam, 'The Worcester Engine Works at Shrub Hill', *Worcs. Arch. Newsletter*, xiv, 1972–3
153 Worcestershire Exhibition — H 10.9.1909; W4, p 76
155 Holy Trinity church — WEN 9.8.1966; W3 6.12.1913
155 House of Industry and the Workhouse — *Dudliana*, Palfrey Collection (in WRO), 18.10,1930, 25.10.1930
157 Taking the waters — H 9.12.1911, 10.7.1920; Chambers, *Worcester*, pp 387–90
157 Gentleman John Tustin — H 22.10.1910; M Brown and G Stansfield, *The Fountains of Witley Court* (1992)
158 Apollo Cinema — H W Gwilliam, *The Theatre in Worcestershire*, WPL
159 Fort Royal — W9 20.4.1918
160 Thomas Parker — H 8.7.1911
161 Wylds Lane — H 10.10.1914
161 Sign painter — H 3.12.1910
162 Garibaldi Inn murders — B 30.1.1926

7 Diglis and Battenhall

165 Diglis — B 8.1.1910
166 Frog Mill — Noake Papers, WPL, M645
166 Royal Worcester Porcelain Company — B 16.6.1883, 30.4.1904
167 Bath Row — Stroller, 'Whittington'
168 Crosses and chapels — Stroller, 'Whittington'
169 Feilds of Green Hill — Stroller, 'Whittington'
170 Battenhall Mount and Grange — W9 20.7.1918; B 9.12.1933; Stroller 'Whittington'
171 Execution of Father John Wall — H 31.7.1909; J Humphreys, *Studies in Worcestershire History* (1938), pp 132–141
172 Clifton family — H 16.11.1912
173 Heron Lodge — H 28.9.1918
174 St Mary's Terrace and John Noake — Stroller, 'Whittington'; H 11.1.1913
174 Corbetts — E C Corbett, 'Some Worcestershire Fairy Tales', TWAS, Vol xxi NS, 1944
175 Diglis Lock and Weir — B 26.6.1900
175 Joseph Berwick — H 14.2.1912
176 Ketch — Stroller, 'Whittington'

8 West of the river

181 St John-in-Bedwardine — Stroller, 'St John's'; H 1.2.1913
183 Upper, or Golden, Wick — W80 30.9.1955
183 Thomas Bund and J W Willis-Bund — H 18.6.1927; W54 8.1.1938; W80 18.3.1955
185 St John's Fair — W1 14.4.1906, 28.3.1910; H 7.10.1911
185 St John's Mop — H 30.10.1909
188 St John's charity school — GwTh (in WPL and WRO)
189 John Williams and Pitmaston — R C Gaut, *A History of Worcestershire Agriculture* (1939), p 300
189 Richard Smith — B 16.2.1901; Gaut, *Ibid*, p 299; H 24.2.1912
190 Boughton cricket ground — H 15.5.1909, 18.5.1912, 4.12.26; B 21.6.1919, 28.6.1919, 14.9.1918
191 Mrs Sherwood — H 27.11.1909; B 24.9.1910
192 Wick Fields — Willis-Bund, *The Civil War in Worcestershire*, pp 41–6
194 Powick electric power station — D G Tucker, *Industrial Archaeology Review*, 1977
195 Tybridge Street — B 7.4.1924; H. 8.9.1906
195 'Cold Comfort' and 'Happy Land' — H 12.3.1910
196 Porto Bello Gardens — H 12.3.1910
197 Severn — B 13.8.1904; H 31.12.1926

Index

of people mentioned in the text

Allcroft, J D 161
Allies, Jabez 145, 154, 168, 169
Allington, Thomas 114
Allsopp, Hon. G H 191
Allsopp, Hon. Percy 171
Annie, Mouth-Organ 99
Annie, Salt 99–100
Arrowsmith, Isaac 41, 46
Arthur, Prince of Wales 5–6
Asquith, Lord Herbert 117
Atkins, Ivor 105
Austin, Henry 55
Austin, J W 35, 58

Badland, Thomas 106
Bagnall, William 24
Baldwin, Stanley 8
Ballard, Stephen 81
Ballard, William 31
Bardin, Christopher 90
Barnard, E W 143
Barr, Martin 167
Barrow, William 116
Baskerville, John 138
Baxter, Richard 114, 119
Beauchamp, Lord 44
Beauchamp, William de 76, 89, 94
Bedford, Charles 118, 138
Bell, Dr Andrew 107
Bell, Henry 70
Belling, Lewis 139
Berkeley, Robert 66, 69, 133
Berkeley, William 165
Berrow, Harvey 40–1
Berwick, Joseph 43, 176
Bidlake, W H 29
Binns, R W 167
Birley, G 63
Blaney, T 116
Blurton, Richard 132
Boon, Rev T C 52
Borlase, James Skipp 132
Bosel, Bishop of Worcester 1, 8
Boulton, R L 155
Bourne, Anthony 13
Bourne, Edward 114
Bourne, Gilbert, Bishop of Worcester 13
Bourne, Sir John 13, 128, 169
Bradley, James 175
Brassey, Thomas 81
Brock, Thomas 119
Bromley, Sir Thomas 170, 182
Brown, T 119

Bryan, Stephen 40
Bund, Thomas 183
Burlingham, Samuel 17
Burney, Charles Rousseau 141–2
Burney, Edward Francis 141–2
Burney, Fanny 141
Burney, Richard 141
Burrows, Herbert 162
Butler, Samuel 177
Butt, Lucy Lyttleton 18
Byfield, George 91, 145, 155
Byron, Sir John 192

Caldwell, Eliza 156
Callowhill, John 132
Calvin, John 39
Cameron, Anne 18
Cameron, Archibald 18
Cameron, Rev C R 18
Cameron, Dr Charles 18
Cameron, Francis 18
Cameron, Jane 18
Cantelupe, Walter de, Bishop of
 Worcester 8, 128, 132
Carden, Dr Henry Douglas 20, 70
Carden, Thomas 95
Carlton, Sir Arthur 147
Carr, Maria 92
Carr, Robert, Bishop of Worcester 92
Cartwright, Thomas 121
Cattley, Canon Richard 174
Cattley, Thomas 121
Chalk, Thomas 41, 139
Chamberlain, Robert 68, 167
Charles I 9
Charles II 24, 30, 105, 135, 149, 159–60
Cheatle, Thomas 61
Chettell, Richard 61
Churchill, Lord Randolph 117
Clements, H 108
Clements, Michael 133
Clifton, Henry 47, 172
Clifton, John Hill 167, 173
Clunes, Thomas 152–3
Cocks, Arthur 42
Cocks, Charles 42
Cocks, Peggy (Countess of Hardwick) 42
Cole, Solomon 31
Collins, James 59
Constable, John 120
Cooksey, Richard 133
Coombe, William 133
Coombs, Dr S W 54

Corbett, Edward C 175
Corbett, Edward F 41, 174, 177
Corbett, John 131
Cromwell, Oliver 67, 159−60, 162−3,
 173−4, 176
Crosley, William 121
Crump, Jane 97

Darke, Leonard 16
Davies, Rev John 83
Davis, Edward 119
Davis, John 166
Davis, William 59
Day, Charles 73
Day, Harry 105
Day, Henry 139
Deerhurst, Lord 18
Deighton, Mrs A 118
Deighton, Henry 41
Dent, Rev Benjamin 49
Dent, John 70
Devey, P C 162
Dickens, Charles 105
Dilke, Sir Charles 117
Dinah, Dancing 84
Dixon, Dr— 17
Doelittle, Milberrow 188
Dudley, Dud 33, 98, 99
Dudley, Ist Earl of (3rd Viscount Ward)
 14, 46, 117, 119, 158
Dunlop, Canon Buchanan 89
Dunstan, Bishop of Worcester 8
Dunster, Rev Charles 133
Durant, Edward 105
Durant, Richard 105
Dvorak, Antonin 105

Ecgwin, Bishop of Worcester 8
Eddington, W C 119
Edgar, King 8
Edward I 4, 144
Edward II 4
Elcocks, Edward 97
Elgar (Roberts), Alice 34
Elgar, Edward 32, 34, 35, 58, 105, 148
Elgar, Frank 34
Elgar, W H 34, 109
Elizabeth I 9, 63, 110, 128, 130, 168,
 170, 182
Elmslie, E W 65
Essex, 3rd Earl of 193
Ethelred I 8
Evans (alias Robbins), David 55−6
Evans, Edward 65, 122, 138
Evans, Edward Bickerton 122
Evans, S F 159
Everett, Maria 140
Everton, J W 178

Fairbairn, R R 186
Feild, Edward 169
Fell, Dr John, Bishop of Oxford 129
Fell, Samuel 129
Fiennes, Colonel Nathaniel 192−3
Flagge, Alice 132
Flight, Thomas 167
Florence of Worcester 8
Forsyth, James 155, 158
Forsyth, William 65, 135, 158
Foster, Rev H 191
Fox, George 115
Frith, George 36
Fry, Elizabeth 115, 148

Garlick, Edward 111
Garrison, Sarah 50
George, Daniel 90
George III 9, 13−14
Gifford, Godfrey, Bishop of Worcester
 130, 132, 182
Gomersal, W 74
Goodinge, Thomas 133
Gordon, Isaac 86
Gore, Charles, Bishop of Worcester 19,
 113, 147
Gower, John 190
Grace, W G 191
Grainger, Thomas 167
Green, Valentine 25, 64, 74, 155, 167
Griffin, Rev J 7
Griffiths, William 91
Guise, William 162−3
Gutch, Mrs Mary 144
Guy, Nobby 84
Gwynne, John 80−1

Hadley, James 119
Hale, Richard 54
Hale, William 122
Hall, George 35
Hamilton, 2nd Duke of 17−18, 159−60
Hamilton, Lady Emma 67−8
Hamilton, Sir William 68
Hampton, Lord John (John Somerset
 Russell) 14, 112, 161
Hancock, Robert 167
Hanson, J S 113
Harley, Sir Edward 168
Hastings, Dr Charles 47, 54, 55, 69, 70,
 78−9, 156−7
Hastings, Rear-Admiral Francis D 138
Hathwey, Anne 33
Hathaway, Elisha 113
Havergal, Frances Ridley 64
Havergal, Rev W H 64
Hawkesley, Thomas 143
Haynes, Thomas 129

Haywood, J S 56
Heath, Henry 113
Hebb, Christopher 131
Hemming, George 76
Hemming, Richard 137
Henry III 4, 27
Henry IV 3, 80
Herbert, Mercy 188
Hill, John 123
Hill, Sir Rowland 119
Hill, T A 85
Hill, Thomas Rowley 32, 41, 122, 152
Hill, William 122
Hind, John 24
Hogben, W K 67
Holbech, Prior Henry 5
Holl, Frank 41
Holl, Harvey B 41
Holl, William 41
Holland, Walter 152—3
Hollins, Humphrey 64
Holmes, Benjamin 31
Holyoake, G J 102
Hopkins, W J 155
Hornyhold, T C 18
Hough, John, Bishop of Worcester 8
Hughes, John 109
Huntingdon, Selina, Countess of 50, 51
Hurd, Richard, Bishop of Worcester 8
Hurdman, Edward 30, 59
Hyde, T G 18, 70

Ingles, J C 82
Ingram, Richard 133, 172
Isaac, Elias 190
Isaac, E W 191
Isaac, J S 191
James I 27
James II 9, 30, 69
Jeffreys, Dr Henry Vaughan 111
Jenkinson, Dr J B 129
John, King 5—6, 7, 8
Johnstone, Dr James 111, 133

Kean, Edmund 74
Keck, Anthony 78, 106
Kemble, Roger 33
Kempe, C E 101
Kennedy, Rev G A Studdert 101
Kerr, W H 167
Kitson, Edward John 58
Knight, James 37, 41, 46
Knox Little, Canon William 11—12
Kossuth, Franz 112

Laight, Ernest George, 162
Lancaster, Joseph 107—8
Laslett, William 72, 92, 105, 113, 156

Latimer, Hugh, Bishop of Worcester 4, 130
Laud, William, Archbishop of Canterbury 7
Lavender, Jane 144
Lawson, Fred 123
Lea, John Wheeley 58
Leader, B W 54, 119—20
Lees, Edwin 59, 70, 176
Leland, John 23, 24, 128, 168
Lennon, Mark 105
Lewis, Thomas 109
Lewis, William 31, 148
Lilley, Moses 31
Lily, Hallelujah 84
Lind, Jenny 105
Lines, H H 136
Lloyd, Edward 31
Lloyd, William, Bishop of Worcester 8
Lucy, James 139
Lygon, Colonel H B 56
Lynes, Leycester ('Father Ignatus') 19, 130
Lynne, William de, Bishop of Worcester 182
Lyttleton, Hon. C G 191
Lyttleton, Lord 191

Mace, Jem 138
MacKenzie, Dr James 111
Macrae, Rev J 85
Macready, William Charles 74
Maddox, Isaac, Bishop of Worcester 8, 111
Mainwaring, Dean Roger 7
Manning, James 112
Marcus, Frederick 112
Martin, A B 191
Martin, John 114
Martyn H H 119, 135, 171
Mary, Queen 27, 169
Maund, Benjamin 41
Maurice, Prince 134
McNaught, J A 135—6
Mills, John 16
Moore, J Matley 89, 91
More, Prior William 5, 169
Morris, Eleanor 97
Morris, Francis 104

Nash, John 33, 98, 99
Nash, Richard 99
Nash, Dr Treadway 132, 134
Nelson, Horatio, 1st Viscount 67—8
Newport, Colonel 142
Nicholson, John 37, 52
Noake, John 36, 41, 91, 102, 106, 107, 139, 172, 174, 186

Ockold, William 87
Ogilvy, Diana 19
Osborn, Rev George 77
Osborne, Captain 125
Oswald, Bishop of Worcester 2, 4, 5, 128
Oswen, John 39
Ottley, Alice 130

Padmore, Richard 32, 38, 65, 76, 95, 161, 174, 196
Pakington, Sir John 172
Park, William 137
Parker, Thomas 160−1
Pepys, Henry, Bishop of Worcester 8
Perrins, James Dyson 147
Perrins, William 58, 64, 147
Phillips, Thomas 133
Philpott, Henry, Bishop of Worcester 119
Pierpoint, Dr Matthew 117−8, 138
Plant, James 68
Poer, William 12
Powell, Rear-Admiral H B 173
Powell, James 37
Powles, Harry 124
Preece, G E 194
Preedy, F 32, 144
Price, Edward 113
Price, Thomas 20
Prideaux, John, Bishop of Worcester 8, 192

Quartermain, A 58

Raikes, Robert 77
Reeves, John Sims 58, 105
Reynolds, Thomas 108
Robarts, Abraham 46
Roberts, Mary 18
Roberts, Captain Thomas 18
Rogers, George 48
Roscium, 'Young' 74
Ross, John 131
Rowe, Henry 29, 30, 73, 114, 129
Rupert, Prince 134, 192−3, 194
Rushton, Josiah 119
Rushton, Thomas 119
Rushout, Sir John 111
Russell, Dr William 111, 133
Russell, Sir William 30

Sandys, Edwin, Bishop of Worcester 13
Sandys, Colonel Edwin 165
Sandys, Lord Marcus 41, 58
Saunders, James 31
Sayers, Tom 138, 332
Schaffer, Henry 90, 112
Scott, Sir George Gilbert 30

Scott, Joseph 46
Sebright, William 170
Shakespeare, William 33
Sharp, Rev Gilbert 84
Sherriff, A C 145, 150, 152
Sherwood, Henry 192
Sherwood, Mary Martha 148, 191−2
Siddons, Fanny 33
Siddons, John 33
Siddons, Sarah 33, 74, 138
Sleath, Robert 142
Smart, William 138
Smith, F E 117
Smith, Richard 56, 189
Smith, Richard Jnr 190
Smith, W S 123
Snell, Hannah 93−4
Somers, Lord John 11, 14−15, 28, 42, 132
Somers, Mary 132
Southall, Thomas 92
Spurgeon, Charles 137
Squire, Richard 59
Stallard, John 112
Steers, Joseph 85−6
Stephen, King 169
Stephens, William 50
Sterrop, Robert 76
Steynor, Robert 114
Stillingfleet, Edward, Bishop of Worcester 8
Stillingfleet, Rev James 18
Strayne, Richard 16
Street, A E 101
Street, George 9, 35
Street, John 35
Swan, J M 119
Swan, Samuel 106
Swift, Theophilus 133

Taylor, Samuel 31
Tenducci, Guisti Ferdinando 13
Thomas, William, Bishop of Worcester 8
Thompson, W J 91
Thorn, Rev W 139
Tilley, Vesta 124, 125
Townshend, Henry 149, 154
Townshend, Henry Jnr 171
Trubshaw-Withers, Sir Charles 115, 117
Tustin, John 157−8
Tyers, Lilian 105
Tymbs, John 41, 111
Tyrwhitt, Rev I Bradshaw 141

Vernon, Thomas 183
Victoria (Princess), 67 (Queen), 130

Wakeman, Sir Henry 157
Wakeman, James 145

Wakeman, Thomas 145
Wall, Dr John 38, 69, 78, 111, 166−7
Wall, Father John 171−2
Wall, Samuel 43, 70
Wall, William 70
Waller, Sir William 165
Walsh, John 70
Ward, John 33
Ward, John William 46
Washington, Colonel Henry 148
Waterhouse, Alfred 30
Waters, Thomas 118
Watkins, Sir Edward 152
Watkins, William 196
Webb, Albert 137
Webb, Aston 32, 59, 140
Webb, Edward 53, 54
Wesley, Rev John 97
Weston, Joseph 190
Westwood, Richard 67
Whalley, Colonel Edward 154
Wharton, Nehemiah 24
Whateley, Anne 33
Wheeley, J 196
White, Thomas 24, 64, 130
Whiteley, James Augustus 73
Whitgift, John, Bishop of Worcester 8
Wigley, Edward 46
Wilding, Rev J H 37

Wilkes, Rev Matthew 51
Wilkinson, Nathaniel 36, 166
Williams, Ann 16
Williams, E Leader 81, 119
Williams, Leader 119
Williams, John 189
Williams, Patty Leader 190
Williamson, George H 103
Williamson, William Blizzard 102
Willis, Judge Walpole 183
Willis-Bund, J W 23, 184−5, 194
Wilmot, Judge 28
Wilmot, Lord Henry 105
Wilson, Edward 151
Wilson, Canon J M 160
Winnington, Sir Charles 133
Winson, Prior 8
Wood, Mrs Henry 18, 20−21, 44, 174
Wood, Joseph 32, 65, 73, 147
Woodhouse, John 121
Woodward, Thomas 73
Woodward, William 106
Woodyatt, Dr George 69
Wulstan, Bishop of Worcester 2, 4, 5, 8,
 17
Wyatt, Edward 93
Wylde, Thomas 134

Young, Arthur 81